RICK SAMMON'S

Complete Guide to
Digital Photography

ALSO BY RICK SAMMON

Camera Angles: Pro Tips and Techniques

The Complete Guide to Underwater Photography

Seven Underwater Wonders of the World

Rhythm of the Reef

Hide and Seek under the Sea

RICK SAMMON'S

Complete Guide to Digital Photography

W. W. NORTON & COMPANY NEW YORK • LONDON

Manufacturing by R. R. Donnelley, Willard Division
Book design by Rubina Yeh

ISBN 0-393-05729-1
ISBN 0-393-32551-2 (pbk.)

W. W. Norton & Company, Inc., 500 Fifth Avenue, New York, N.Y. 10110
www.wwnorton.com

W. W. Norton & Company Ltd., Castle House, 75/76 Wells Street, London W1T 3QT

2 3 4 5 6 7 8 9 0

This book is dedicated to all the enthusiastic, dedicated, talented, and fun students who have participated in my photography workshops over the years. I have learned something from each and every one of you, creatively and personally. At each workshop, I am reminded of one of my many favorite expressions: "We are a part of everyone we meet."

Contents

PART VI: SPECIAL DIGITAL EFFECTS AND TECHNIQUES

SIDEBARS

The Camera Looks Both Ways...

"In picturing the subject, we are also picturing a part of ourselves."

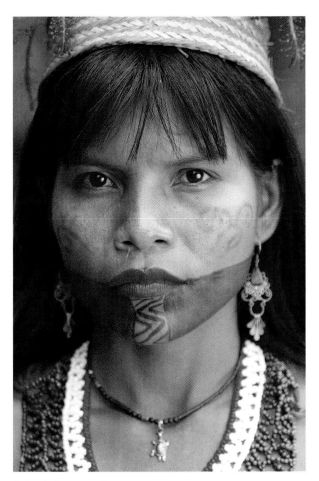

Embera Indian woman, Panama.

Brazilian friend, Miami Beach.

Sunset, Montana.

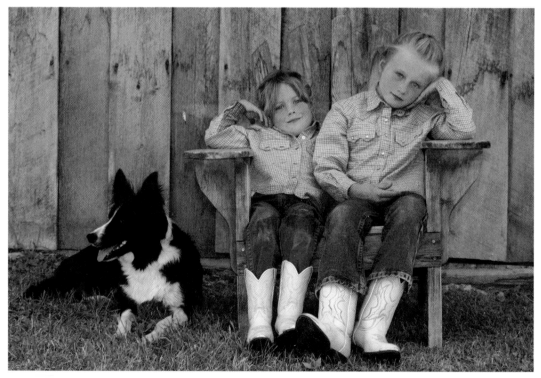

Girls with their dog, Montana.

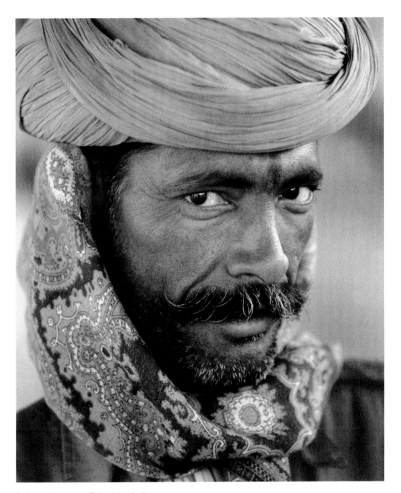

Train station porter, Rajasthan, India.

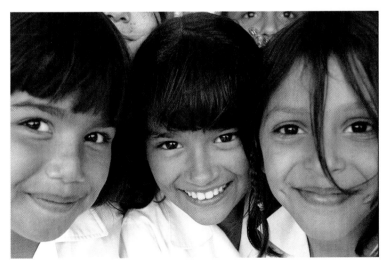

School girls, Costa Rica.

"You cannot depend on your eyes when your imagination is out of focus."
—MARK TWAIN

PART I BEFORE WE BEGIN

This first part is important to my book, but that's easy for an author to say.

This part of the book does not include much technical information nor my best photography tips for enhancing pictures in the digital darkroom. What these early pages will do is show you why I enjoy photography so very much and why I think photography can be so exciting and rewarding!

You'll get to know a bit about me. You'll read about my philosophy of photography and you'll see a few of my favorite photographs. And you'll find out how I can get to know a bit about you and your interest in photography, if you want to share it.

Enjoy!

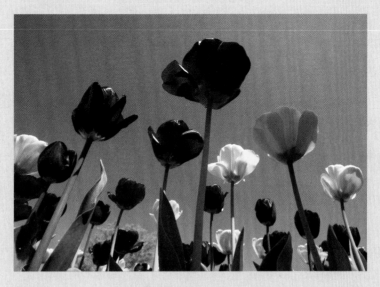

Tulips,
Washington, D.C.

"Photography is a perfect medium for one whose mind is teeming with ideas, imagery, for a prolific worker who would be slowed down by painting or sculpting, for one who sees quickly and acts decisively, accurately."

—EDWARD WESTON

LESSON 1 Photography or Bowling?

Learning is the first step to becoming a good photographer.

You are holding this book, so obviously you care about your photography. That's the first step to becoming a good photographer. After all, if you did not care, you might as well spend all your leisure time and money on bowling, which can be less frustrating than photography, but never, in my view, quite as rewarding.

Caring about our art, our craft, our hobby, and our subject helps us improve the skills that go into photography. We will see pictures, perhaps where others don't see them. We will take pictures, from our own unique viewpoint. We will make pictures, perhaps works of art, in our digital darkroom and print pictures for display at home or maybe in a local gallery.

When we care about a subject, we automatically pay more attention. And, as the nuns in Catholic school told me and showed me with a ruler, paying attention is very important. Attend to what is going on around you, and I guarantee that you'll see, and therefore enjoy, the world differently from anyone else on the planet—even when you don't have your camera with you.

Simply being photographers makes us pay close attention to the world around us. It helps us see the world differently—and it increases our enjoyment of what we see.

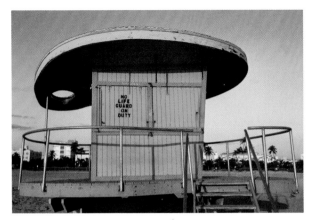

⇑ Which one of these two pictures of a lifeguard stand in Miami Beach's South Beach do you think was taken by a photographer, by someone who cared about his

or her craft? (Actually, I took both pictures to illustrate my point.) Both pictures were taken with a Canon EOS 1V 35 mm **single-lens reflex (SLR)** camera and a 17–35 mm zoom lens. (**Boldface** terms are defined in the Glossary at the end of the book.)

The boring shot on the left was taken at the 35 mm setting; the more creative shot on the right was taken at the 17 mm setting. The real difference, however, is the angle at which I photographed the Art Deco structure. Rather than simply taking a head-on, standing-up-straight picture (most people take standing-up-straight pictures) of the lifeguard stand, I walked around the structure, looked at it from just about every angle, and chose an angle (and zoom lens setting) that I thought would give me a creative picture.

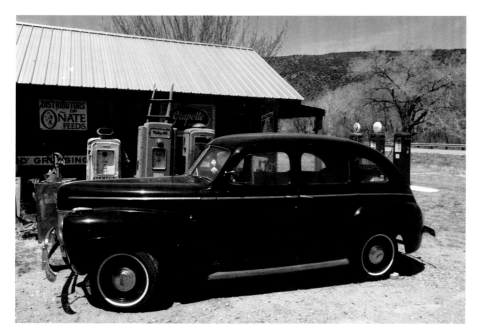

⇐ While driving in New Mexico from Santa Fe to Taos and thinking about this book, I spotted this old car near some gas pumps on the side of the road. I took both of these pictures with a Canon EOS 1D digital SLR and a 16–35 mm lens. Which one is more dynamic?

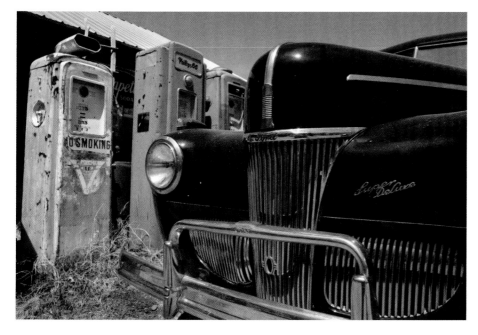

⇐ See what happens when we take our time, look at a subject through different lenses, and, most important, think creatively? We will cover these and other topics in this book, rather than going bowling. I'm glad you're with me.

"Photography is a major force in explaining man to man."

—EDWARD STEICHEN

Let Me Introduce Myself

Why this book took 52 years to write . . . and why you'll see photos from only a few seconds of my life.

If you are thumbing through this book and decide not to buy it, that's okay. I understand. There are a lot of photography books out there.

I'm not sure, however, that you'll find so much information on seeing, taking, making, printing, and sharing pictures in another book, or information conveyed by someone who is as passionate about photography as I am. I think that being a photographer is the next best thing to being a rock star. In addition, every lesson in this book is designed for those interested in digital photography. What's more, you get "The Digital Photography Tutor" CD-ROM as an added bonus. It's a Microsoft PowerPoint slide show of some of my photography tips that you can view on your computer.

If you have decided that this book is for you, that's great! Read on to get to know a little bit about my work and me. More important than those things, though, you'll gain an understanding of what goes into the complete process of photography—so you don't have to rely only on digital darkroom techniques to fix your pictures. The result: You'll become a better picture-taker and picture-maker. Plus, you'll be happier with your pictures. This book teaches all the steps that lead up to capturing a great picture. It also teaches how to improve a picture digitally after you snap the shutter, although digital cameras technically don't have shutters.

I love teaching and sharing what I know about photography, which is why I've worked hard to make this book the most comprehensive and fun-filled of my 22 books so far.

I also enjoy hearing from students and photo-workshop attendees. And, of course, I like seeing some of their pictures. So feel free to e-mail me your best JPEG file (5 × 7 inches, 72 dpi) if you'd like a quick critique (very quick). (We'll find out later what a JPEG file is if you don't already know.)

You are probably wondering why this book took 52 years to write, and why you'll see in it photographs from only a few seconds of my life. Let me explain.

"We are a part of everyone we meet." This sentence is one of my favorite photography expressions. We all pick up personality traits—good and bad—from others and incorporate them into our own personality. Photographers, similarly, pick

up the techniques, styles, and effects they like from other photographers and incorporate them into their style.

I have been around photographers since I was a kid. Both my parents, Bob and Jo Sammon, took pictures and developed them in our home's basement. So I've been absorbing photo tips for a lifetime. For the past five years, I have been soaking up everything I can about digital imaging from the best in the business.

As important as photography tips are, I have developed a unique "photo personality," like all photographers have (including you), with likes and dislikes, passions and attractions, fantasies, hopes, and dreams. A quick look through this book unveils my personal photographic passion: people. I enjoy meeting strangers wherever my work sends me and getting them to like me, or at least accept me, in a matter of minutes. (Okay, I admit it: I have a need to be liked!) My people pictures illustrate another photo expression: "The camera looks both ways—in revealing the subject, we are also revealing a part of ourselves." Take a look at some of my portraits, and you'll see a side of me, reflected back into my camera's lens.

You will develop your own "photo personality," too. If I can help you bring out that personality, that's good for both of us. But don't be too impatient. All good things take time. Plus, your photo personality may change and continue to evolve over time.

While I was developing my photo personality, I learned a lot about photography, by attending workshops, reading photo magazines and books, watching instructional CD-ROMs on my computer, and making every mistake possible—and then some! I have tried to condense just about everything I know about photography, as well as some photo psychology, into the book you are holding. (That's why this book is rather heavy!)

You are probably wondering what I mean about sharing pictures that I took during only a few seconds of my life. I travel to take pictures and I take pictures to travel. Although I have traveled the world for more than 20 years with my camera, the pictures in this book represent only the seconds when I exposed a piece of film or a digital-imaging sensor.

I have taken thousands of pictures that I would not show to anyone because they are "photo failures." I have, however, included some of those in this book for teaching purposes. What's more, I have hundreds of other good pictures that I'd like to share with you, but space does not permit that in a book of this size and nature. (Hint hint: I'm working on other books that I hope you will eventually add to your collection.)

Although snapping a photograph takes only a fraction of a second, my digital darkroom work took much longer to do—and even longer to master. I had Adobe Photoshop (the digital-imaging program I recommend and discuss throughout this book) on my computer for two years before I tried even a single effect. The program was simply too intimidating. So, if you feel the same way about digital imaging, you are not alone: I understand. I'm here to help, and to show you how much fun you can have in the digital darkroom, where the creative possibilities are unlimited. (One quick tip for now about Photoshop: learn one and only one feature, such as Curves or Cropping, each day or even each week. If you learn just one of Photoshop's features a week, you'll know 52 features a year from now. That's more than most people know!)

I think the most important message of this book can be summed up in another one of my favorite photography expressions (I told you I liked photo expressions): "Cameras don't take pictures, people do." In other words, you can have the greatest camera on the planet, as well as the most sophisticated digital darkroom in the galaxy, but it's you who takes the picture. It's you who makes the picture better on your computer. And it's you who makes that wonderful inkjet print right on your desktop. Actually, it's all about *your* vision and *your* pictures! Always keep that in mind.

⇒ I photographed these schoolchildren on the island of Lombok, Indonesia, using a 16–35 mm lens set at about 20 mm. I had just finished doing some magic tricks for them in their school— one of the techniques I use to get people to accept me when I travel. After the magic session, I wanted to take a group shot, so I asked the kids to come outside, with their teacher's permission, of course. I think this photograph

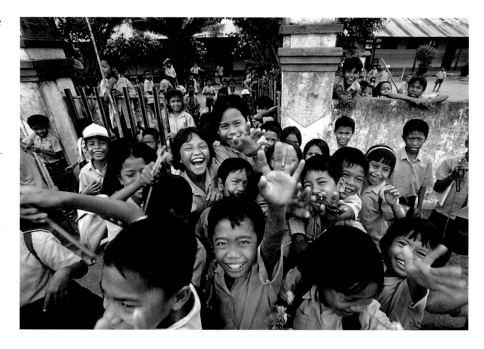

illustrates my love of photographing people. If we don't project a positive feeling and affinity for our subjects, we will not get these kinds of reactions from our subjects.

This next series of images offers just a peek at the power, creativity, and fun of Adobe Photoshop that you will read about in this book.

⇒ My brother, Bob, took this snapshot of my son, Marco, and me. The gray background made it easy to extract us in Photoshop. If you plan to extract a subject, try to shoot the subject against a relatively plain background. We will explore how to change the background in the "Extract a Subject from Its Background" lesson.

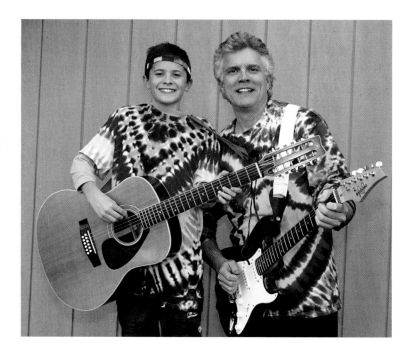

⇐ We will find out how to add a sense of motion to our images in the "Add Action to Still Photos" lesson.

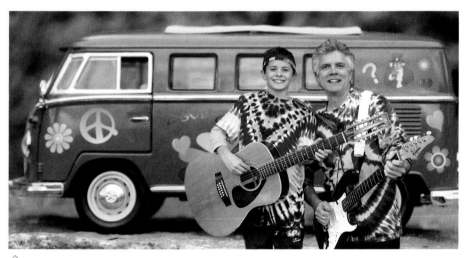

⇑ And in the "Learn about Layers" lesson, we will see how to combine two images, as I did by combining a photo of a toy Volkswagen van with a photo of us.

> *"'The time has come,' the Walrus said,*
> *'to talk of many things.'"*
>
> —LEWIS CARROLL

LESSON 3 | Using This Book

This book is about photography and ideas. It is filled with tips for digital photographers and film photographers who use the digital darkroom.

Do you really need Adobe Photoshop? Well, yes and no.

Should you read this book on your living room couch or at your computer station? Well, it depends.

This is a book about photography and, perhaps more important, ideas. So you may want to begin by reading Part II, "Build on the Basics," especially if you are a beginner. I've included information in that section that will give you a good understanding of photography's basic rules (which of course can be broken), basic concepts (about light, for example), and basic techniques (of composition and even focusing). You'll learn about lens selection and indoor and outdoor flash photography, among other important topics, in "Build on the Basics." You'll find more tips on taking pictures in Part VII, "More Photography Tips."

If you are familiar with digital imaging and can't wait to start working and playing in Photoshop, then go right to Part V, "Working and Playing in Photoshop" or if this is the first time you are even thinking about digital imaging, you may want to begin by reading Parts III and IV, "Cameras: The Way We Record Light" and "Welcome to the Digital Darkroom."

I've included bonus tips in many of the lessons throughout this book. For example, you might think that Lesson 74, "Add Action to Still Photos," covers only that topic. Well, the "bonus" tips include 1) a basic rule of composition, 2) a fashion photographer's retouching technique, 3) how to add a spotlight to a scene, 4) making an animal's eyes brighter, and 5) an interesting fact about moray eels.

Adobe Photoshop is undoubtedly the most powerful digital darkroom tool available. I now work exclusively in Adobe Photoshop version 7, although some of the pictures and screen shots in this book were created in Photoshop's version 6. Photoshop is a rather expensive computer program, costing around $600—but that is only about half the cost of a good 70–200 mm or 16–35 mm lens (two of my favorite lenses).

With Photoshop, you can turn your snapshots into great shots in no time at all (after you have learned how to use Photoshop's tools).

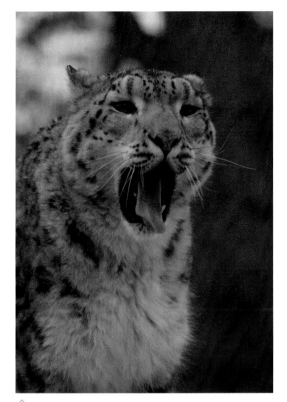
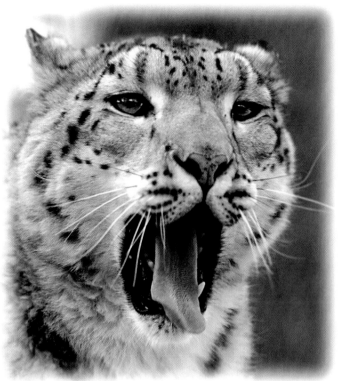

⇑ In Photoshop, I turned an underexposed picture of a snow leopard that I photographed at New York's Bronx Zoo into a much more dramatic image. Cropping, vignetting, brightening, and color and contrast correcting techniques were all used to liven up this shot—and these are all techniques you will have fun learning in Part V of this book, "Working and Playing in Photoshop." Now check this out. Take a close look at the animal's eyes. In the original image, you can hardly see them, but in the corrected image they are lighter and have a twinkle. Another Photoshop technique!

When you have read through this book, you will be able to create works of art that you may have thought were not possible. You will be able to fix your mistakes and produce images that look picture-perfect with a few clicks of your mouse. You will be able to create professional-quality pictures—the kind it took me 20 years of field shooting to perfect—because you'll understand and be able to control, among other things, light, shadows, contrast, and color.

In this book I refer to Photoshop exclusively among digital-imaging programs. But if you don't want to invest $600, Adobe also offers a terrific program called Photoshop Elements that sells for much less than the price of Photoshop, yet includes the most useful of Photoshop's features. You can do some good work with Elements and have lots of fun, too. What's more, Elements users can apply many of the techniques I cover in Part V of this book.

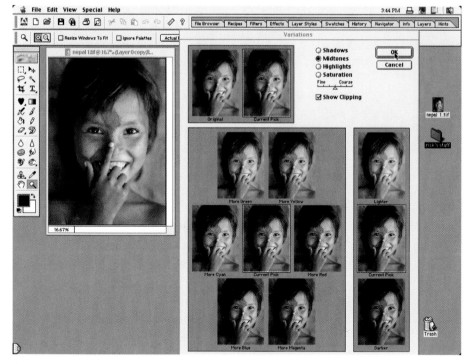

Adobe Photoshop Elements.

Photoshop Elements offers about 70 percent of the features of Adobe Photoshop—for about one-sixth the cost. Many tools and functions, such as Variations (shown), look virtually the same on both programs. For the beginner, Elements is easier to learn. For the serious photographer, though, I recommend the full edition of Photoshop.

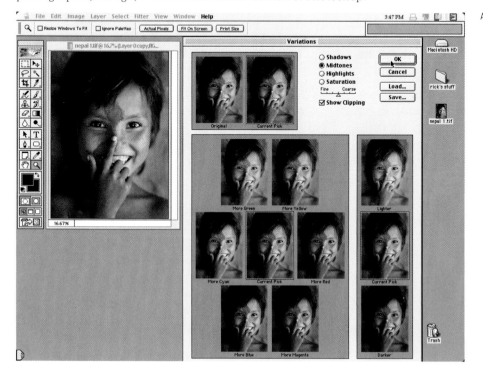

Adobe Photoshop full edition.

If you have another imaging program—one with layers and basic imaging tools—you can also apply many of the techniques I cover. It's just that your tools may have different names (such as "Rubber Stamp" instead of "Clone Stamp") and they may be in different places on your screen. Other digital-imaging programs you can use include Microsoft's Picture It!, Jasc's Paint Shop Pro; Procreate's Painter; Corel's Photo-Paint; MicroFrontier's Color It!, Enhance, and Digital Darkroom; and Ulead's PhotoImpact. All of these programs, for example, accept Photoshop-compatible plug-ins (an accessory for Photoshop that enhances editing), some of which I mention in this book.

No matter which program you use, I recommend that you become familiar with the basic features of the program *before* you read Part V. So, please, at least glance at the instruction manual that comes with your imaging program. That way, you'll have an idea of where to find stuff like the Tool Bar, Filters, Layers, and History palettes—or whatever your software program might call similar items.

It also does not matter if you are a Macintosh or Windows user. I am an avowed Mac user. Although the screens may look slightly different, Photoshop and Elements, as well as their plug-ins, work the same on a Windows computer.

For Parts II and III on traditional photography techniques, you can relax on your living room couch as you read the text and look at the pictures. Have your camera handy to play around with the techniques you learn. But for the lessons on the digital darkroom in Parts IV, V, and VI, you really need to be at your computer station so you can try each technique step-by-step. That way, you'll gain an understanding of the process of getting from "here to there."

I've tried to make all the lessons as simple as possible. Photography is easy to learn, if you practice one technique at a time, just as a classical musician practices a difficult piece a few measures at a time.

In Anne Lamott's wonderful book on writing, *Bird by Bird*, she recounts a story from her childhood. Her brother is working on a school project on birds—the birds' markings, songs, habitats, and so on. The boy is overwhelmed and close to tears. He does not know where to begin! The project, which he had months to write, is due the next day. Their father looks at all the unopened books, papers, binders, and notes and listens to his son explain his dilemma. "Son," he says, "bird by bird, buddy. Just take it bird by bird."

I think if you keep that story in mind, and learn photography "bird by bird," all this stuff will sink in.

Learning is just part of the process. Doing is another. While you are exploring Photoshop, it's a good idea to keep the following words in mind, which I copied from a poster that was on the wall of my son's nursery school.

> I hear, I forget.
> I read, I remember.
> I do, I understand.

Happy reading, happy shooting, and happy Photoshopping!

"Vision is the art of seeing the invisible." —JONATHAN SWIFT

Film or Digital?

Photography is photography, no matter what the medium.

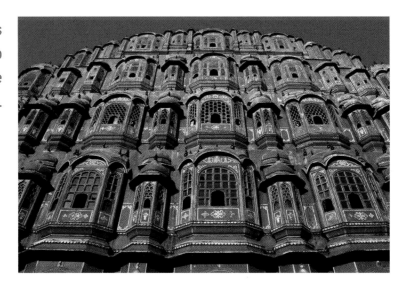

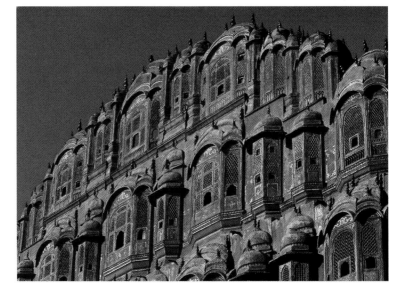

⇒ Can you tell which of these photographs of the Palace of the Winds in Jaipur, India, was taken with a digital camera, and which was taken with a film camera?

The fact is, the medium does not really matter, which is why I'm not revealing which is which. Regardless of the medium used, a **camera** is simply a device that captures a visual record of a moment in time. **Digital cameras**, however, are easier, faster, more interactive, and more fun than film cameras for a growing number of photographers. And the quality of the digital sensors of today equals the quality of film in reproducing an image.

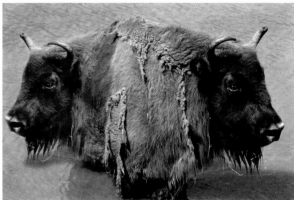

⇑ Here's my take on digital photography. I would agree that images created in the digital darkroom of a two-headed bison and the like are not "straight" or traditional photographs. (This book is not about creating wacky images from "straight" photographs. That's why I'm not going to tell you how I created this mutant bison image, which started with a "straight" shot I took at the San Diego Wildlife Park.) But "straight" photographs taken with a digital camera are still photographs. What's more, film photographers also distort, enhance, and otherwise manipulate reality and have been doing so since the early days of photography.

If you disagree, please consider the following. We see the world in color. So, I guess, one could argue that film photographer Ansel Adams, perhaps the most famous landscape photographer of all time, used black-and-white darkroom tricks to get the viewer's attention. He was the first to admit that making (and remaking and remaking) a print in the darkroom was an important step in creating a photograph.

Some color films do not show the world as we see it. These days, supersaturated color slide and print film is all the rage. The very colorful pictures such films produce are often more appealing to picture-takers than photos taken with film that produces accurate colors. Traditional photographers also use **filters** on a film camera to eliminate reflections or to add color to a scene.

Now let's talk about lenses. **Telephoto lenses** compress elements in a scene, whereas **wide-angle lenses** have the opposite effect. The effect produced at the extreme wide-angle range is that of rounded, distorted picture, as with a fisheye lens. Our eyes can not see what those lenses "see," unless we use binoculars or special devices.

Photographers have long manipulated film **grain** and soft focus, as well. Several photographers, including Robert Farber, have built their reputations on the effect created when using a grainy film and a soft-focus filter. Presto change-o—reality is turned into an impressionist scene!

In sum, photography is photography, no matter what the medium. In fact, I think most people looking at a "straight" (traditional) picture in a newspaper or magazine, in this book, or on a Web site could not tell if it had been taken with film or with a high-quality digital camera. The same is true for pictures printed on inkjet printers, which, if done correctly, rival traditional photographic prints.

So in reading through this book, please keep in mind that an image that pleases you is still photography, no matter how it is made.

 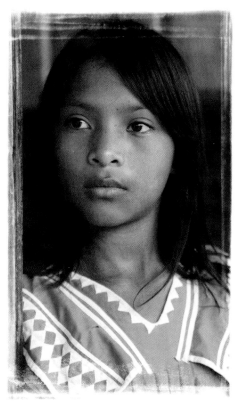

⇑ These two pictures—one of my son, Marco, and the other of a young Ngabe girl in Panama—illustrate an important aspect of this book: seeing pictures and connecting with the subject. The digital frame around the picture of the girl was added with a program called Extensis PhotoFrame.

Awaken the artist within you! This book, I hope, will show you not only how to fix and save a poor snapshot, but also how to turn a "straight" picture into a more artistic image.

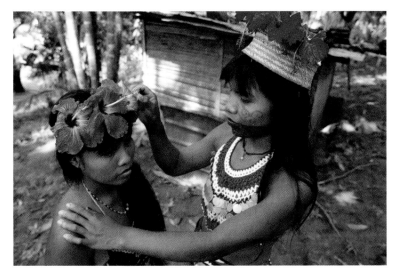

⇐ For example, my original picture of these Embera women, photographed in Panama, has a distracting background filled with washed-out highlights. Worse still, the girl on the left looks as though she has palm trees growing out of her head!

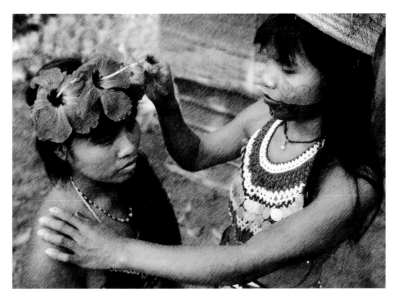

⇐ Those problems were easily fixed in Photoshop using the Clone Stamp tool. To give the picture an artistic touch, I used Photoshop's Graphic Pen filter and then faded the filter (techniques we'll explore later). I also cropped the picture for more impact. Retouching and enhancing techniques like these will be covered later in this book.

"We see, hear, smell, and taste many things without noticing them at the time."

—CARL JUNG

Seeing Pictures

Cameras don't take pictures, people do.

Simple as it sounds, we have to see a potential picture in a scene before we can take a picture. And what makes photography so interesting is that we each see pictures differently.

To illustrate that point, let's imagine that you and I and ten of my professional photographer friends show up at your house. Then we head off to the local firehouse, where we challenge ourselves to each take one great picture. Yes, only one. No doubt we'd all see a different "best picture," using hard or soft light, wide-angle or telephoto lenses, including or not including a fireman in the scene, and so on. We'd all be happy with our "best picture," but we'd also appreciate how the other shooters (that's what we call ourselves in the pro world) used their mind's eye to get their own unique photographs.

This lesson is about seeing pictures. The images here illustrate how I saw different pictures in a scene when I was on location. Some photographs I definitely like better than others in the same pair or set. Sometimes I have a difficult time choosing. Take a look. See what you think—and think about how you can see different pictures in the same scene, too.

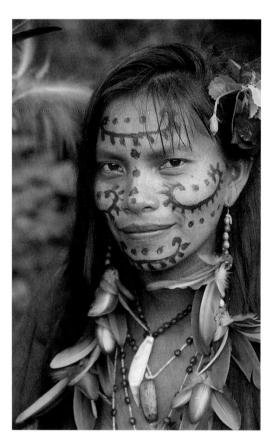

⇐ While photographing the Taraino tribe in the Amazonas, Brazil, rain forest, I had a portrait session with this beautiful young woman. The first picture (28–105 mm lens at 105 mm) is a nice head-and-shoulders shot, with direct eye contact—which is dramatic in a photograph.

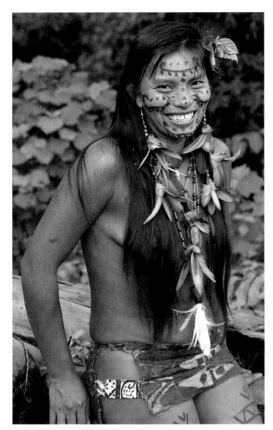 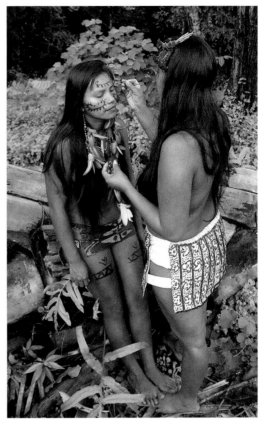

⇑ The three-quarters photograph (16–35 mm lens at 35 mm) reveals more of the subject. Now you can see her long hair, full necklace, skirt, and painting on her legs.

⇑ The last picture (16–35 mm lens at 16 mm) in this series, taken while her friend was painting my subject's face (so the spirits in the rain forest would recognize and protect her), has much more of a sense of place. Plus, take a close look at the bottom of the picture: The subjects' feet are touching—in Amazonas, that's sort of like holding hands here in the United States.

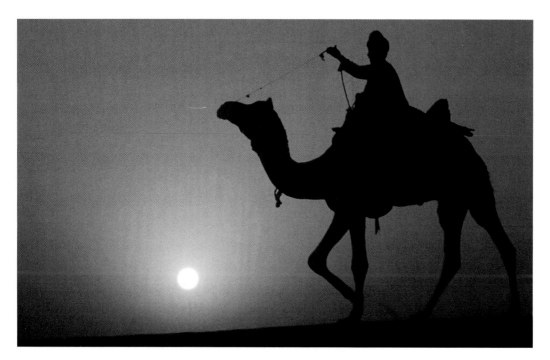

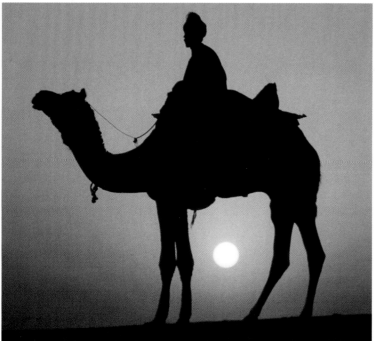

⇑ While photographing this sunset scene in Rajasthan, India, I took more than 200 pictures (some of which you'll see elsewhere in this book) with my 70–200 mm zoom lens. The two main elements were the sun and the camel with its driver. As you can see, I experimented with placing the subjects in different areas of the frame. In addition, one picture has action, the other does not. I also experimented with cropping (in the digital darkroom); one picture is cropped square, the other is more oblong like the High Definition Television format.

When I saw the marks on the body of this young man who lives in a village on the Sepic River in Papua New Guinea, I had to get a picture, because I wanted to show others how the men scar their bodies to "gain some of the power of the crocodile." People in Papua New Guinea believe heavily in spirits and the spirit world.

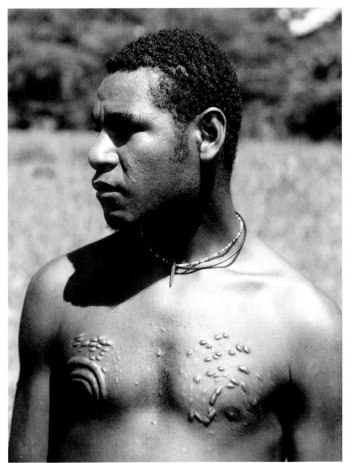

⇐ The first shot does show the scars on the man's chest, but the lighting on his face is atrocious (although Francis Ford Coppola used similar top lighting in many scenes of *The Godfather* so that viewers of the film would not be able to see into the subjects' eyes, which created a sense of mystery). In addition, I don't like the way the tree line in the background is cutting the subject's head in half. Because I wanted a picture with impact, I took my time and thought about what would make a good picture.

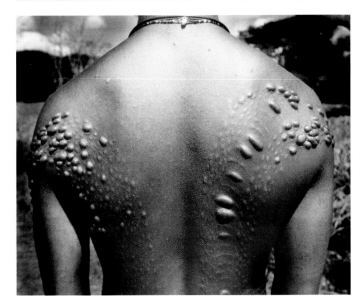

⇐ Eventually, I decided to photograph only the man's back. I cropped out his head to draw even more attention to his scars. Which picture do you think has more impact?

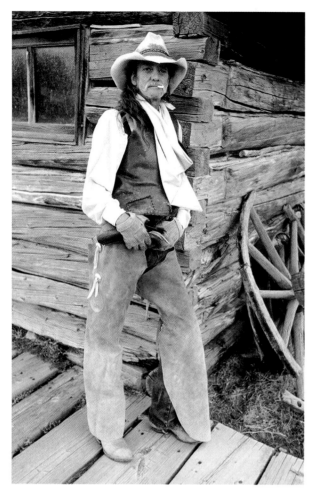

This one's simple. I took these environmental portraits (pictures that show some of the surrounding environment) of a cowboy in both horizontal and vertical formats. I happen to like the horizontal picture, but I have the other in case a publisher asks for a vertical. Both pictures were taken with my 16–35 mm lens set at about 24 mm.

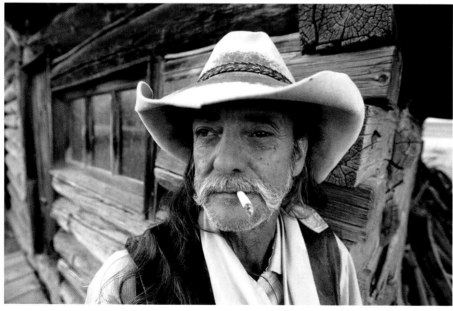

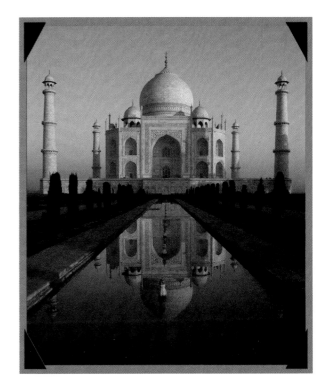

⇒ We've all seen postcard shots of the Taj Mahal. So during a trip to Agra, India, I had to get my own postcard shot—shown here with photo corners that were automatically added by using Photoshop's Actions menu (more on Actions later in this book). But I thought it would be interesting to shoot the Taj from several different angles and at different times of the day.

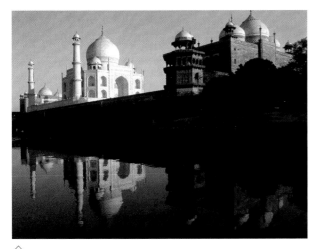
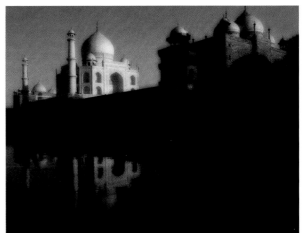

⇑ So, in addition to my postcard shot, I have a nice picture of the Taj reflected in the river that runs behind this mausoleum, as well as a picture that looks like it was taken at midnight—an effect that I created using a nik multimedia Midnight filter (discussed in Lesson 63, "A Tour of Plug-Ins"). I saw the midnight picture in my mind's eye, and Photoshop let me create it. You see, Photoshop has changed the way I see pictures.

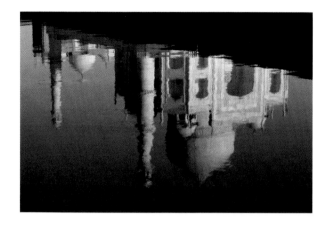

⟸ For my next shot, I zoomed in for a closer view, capturing only the Taj's reflection in the river.

⇑ After shooting the Taj for hours, I was treated to a spectacular sunset, which was a perfect background for the magnificent structure. Without a cloud in the sky, I promised myself to return the next morning for a sunrise shot, which I felt would round out my pictures of this wonder of the world.

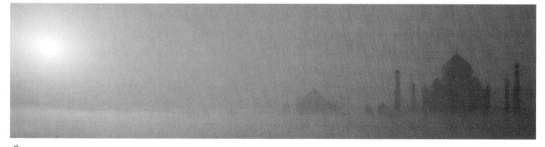

⇑ The next morning, I went for the extreme wide view, capturing the scene with a 16–35 mm zoom lens set at 16 mm and using only a small portion of the center of the frame. This image, I think, is the most creative of my Taj Mahal images.

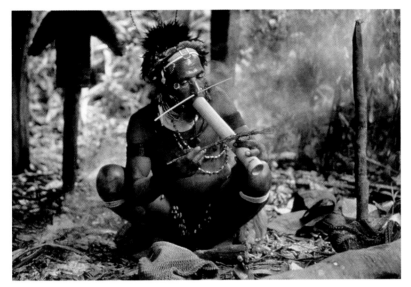

⇐ This Huli Wigman, from a clan that lives in the highlands of Papua New Guinea, was preparing for a ceremony in which the tribe was going to honor the spirit of a loved one. Their headdresses attract the spirits. I saw the picture possibilities and, after being on the scene for almost an hour to get to know my subject, I started to shoot. This soft picture, taken only with available light, captures the subject as he would look if I were not there—engaged in the activity of smoking a pipe. This is one of my favorite pictures, even though it is a bit soft. (I could sharpen it in Photoshop, but I like the soft touch.)

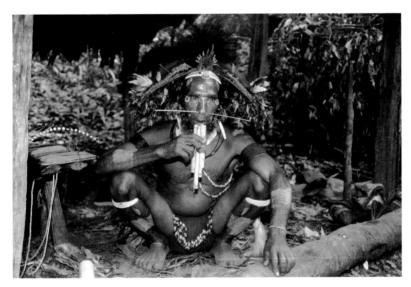

⇐ The second picture is taken with a flash. The harsh light from the flash ruins the mood. Plus, the man is looking off-camera. He looks distracted and not interested in the photo session.

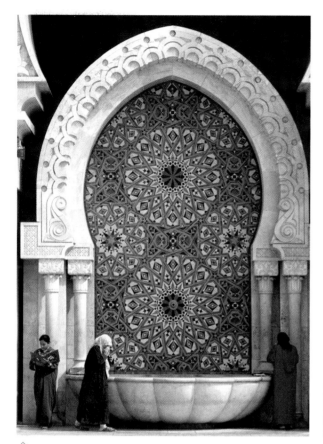
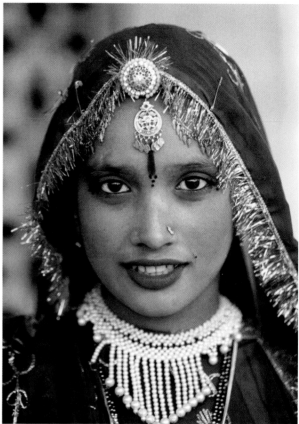

↑↑ Both these pictures were taken with a 70–200 mm lens set at around 200 mm. The fountain picture was taken in Casablanca, Morocco, and the head shot of the girl was taken at a train station in Rajasthan, India. This pair illustrates how you can use one lens and one zoom lens setting to get two entirely different types of pictures.

As you can tell by now, when I go on location, I shoot a subject in many different ways. That's good advice to follow.

Here is another one of my favorite photo expressions that may help you see pictures differently, and where others may not see them. *Always look up, always look back, and always look down.* Put another way: keep your eyes open for pictures—everywhere.

"Photography has not changed since its origin except in its technical aspects, which for me are not a major concern."

—HENRI CARTIER-BRESSON

PART II BUILD ON THE BASICS

With the advent of digital photo technology, it is easy to fall into setting your camera on both **autofocus** and **program mode** and shooting away. Many times during my photo workshops, people just point and shoot and can't wait to get back to their computers to enhance their new images.

It is important to realize that we can fix an image only just so far. Before we click the shutter, it's up to us to create the best possible picture by considering the following:

- What is the main subject?
- Where should I focus?
- What lens will give me the best results?
- At what aperture should I shoot?
- How will my shutter speed affect the picture?
- Should I use a flash, or would natural light be better?
- Where is the light falling in the scene?
- How can I get the sharpest picture?

In the lessons to follow, we address these questions by covering some of the basics of photography without using any fancy computer tricks—although I will share a few basic Photoshop techniques, which could easily be replicated in a traditional darkroom. Especially for newcomers to the world of photography, reading this section will be a wise investment in time and fun!

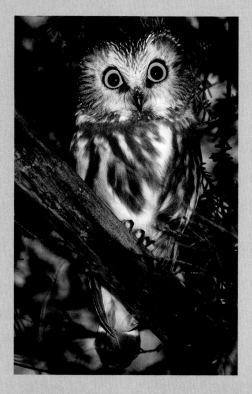

⇐ No Photoshop tricks here. This is "straight" daylight fill-in flash photo of a saw-whet owl near my home in Croton-on-Hudson, New York. I photographed this cute little animal with my Canon EOS 1D 4.15 megapixel camera and Canon 100–400 mm IS (Image Stabilizer) lens set at about 300 mm. Knowing about daylight fill-in flash, composition, and lenses helped me get the shot I wanted. Seeing and understanding the light—the natural light and the light from my flash—was also key to getting this shot.

⇓ These two pictures illustrate the big difference a change in shutter speed can make. The left-hand portrait of the Navaho boy was taken at a shutter speed of 1/125 second. The right-hand picture of the boy dancing was taken moments later at a shutter speed of 1/15 second.

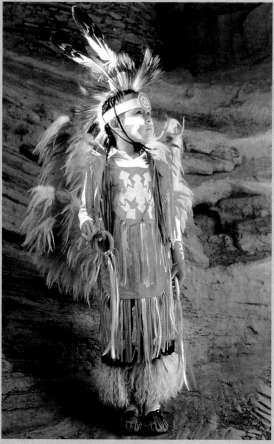

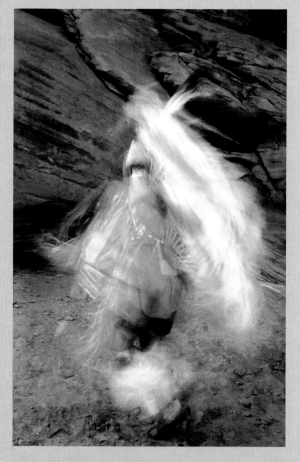

"People only see what they are prepared to see."

—RALPH WALDO EMERSON

Camera Basics

Understanding how a camera operates helps us take better pictures.

Today's cameras and lenses are sophisticated mechanical, optical, and electronic devices. Mini-computers guide many of the camera's functions at lightning speed, such as autofocusing and exposure control for natural light and flash exposures.

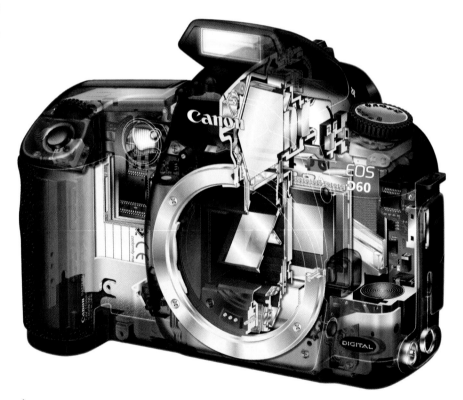

⇑ This cutaway view shows a Canon digital **SLR** (single-lens reflex) camera. The mirror in the camera's body opening creates the image we see in the viewfinder. The **digital image sensor** is behind the mirror. In SLR film cameras, the film is behind a shutter that opens and closes to expose the film to light from the lens. In a digital camera, instead of a shutter, the image sensor is turned on and off. There is no actual shutter in a digital SLR camera.

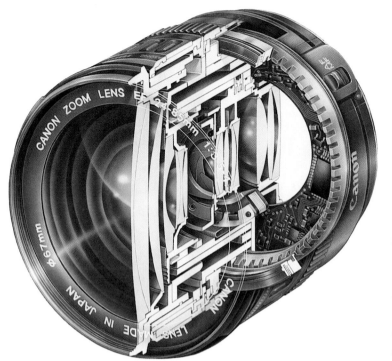

⇐ This cutaway view of a Canon SLR autofocus lens shows the complexity of SLR lenses. Note the presence of all those optical lens elements through which light passes before reaching the recording sensor. This lens attaches into the body of the camera on the previous page.

⇓ The **ZLR** (zoom-lens reflex) camera, such as this model from Minolta, is also a marvel of ingenuity that makes it easier for us to take pictures. A good ZLR camera focuses and determines the exposure setting more quickly than our eyes and fingers can. The difference between a ZLR and an SLR is that with the ZLR, the zoom lens is built in, or permanently attached, to the camera.

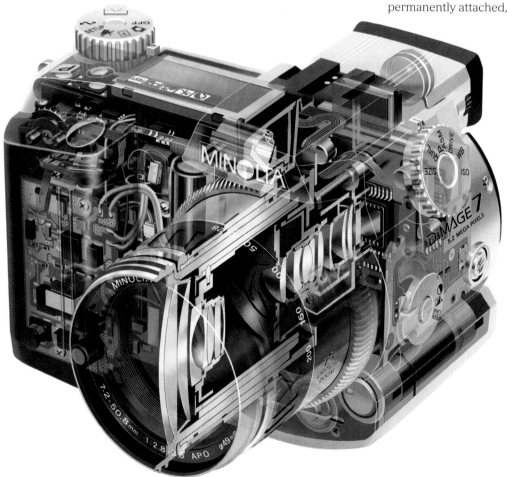

A basic understanding of how a camera operates gives us an understanding of what happens when a picture is taken. That, in turn, can help us take better pictures.

All cameras, from one-time-use models (formerly called "disposable cameras" before camera companies started their recycling programs) to high-end studio cameras, receive and record light by means of a lens, an aperture, and recording media (a digital sensor or film).

In a digital camera, the recording element is a **digital sensor**. In a film camera, it may be negative film for making positive paper prints, or positive film for making slides (technically called "transparencies"). In a Polaroid camera, a photochemical "sandwich" reproduces a positive image upon being ejected or pulled out of the camera. Polaroid P/N "peel apart" film provides both a positive image and a negative for making additional prints in a traditional darkroom.

The light that reflects off a subject back toward a camera passes first through an opening in the lens called the **aperture**. When the shutter opens, or in a digital camera when the sensor is turned on, light reaches the recording media. In film cameras, a shutter, located in front of the film, opens to let the light expose the film. In digital cameras, the digital sensor is activated whenever the "shutter release" button is pressed, and light is captured on the camera's imaging chip. As the **shutter speed** of a camera increases, the amount of light reaching the recording media decreases. For example, a shutter speed of 1/500 of a second lets in twice the amount of light as a shutter speed of 1/1000 of a second, and half the amount of a shutter speed of 1/250 of a second.

The human eye operates in a manner somewhat similar to a camera's lens. However, it is much more sophisticated, which gives us a tremendous appreciation for the gift of sight. For example, my professional Canon digital camera has a 4.15-**megapixel** (4.15 million pixels) image sensor. A human retina, consisting of rods and cones, has more than 100 million sensors (receptors) that are connected to the brain. All those image sensors are why we can "see" so much better than any consumer camera can. I say "consumer" camera because government cameras in satellites can "see" from outer space more than we can see with our eyes—perhaps even the numbers on a license plate!

The human eye is an infinitely adjustable system with true autofocus and automatic exposure. The eye's iris acts as an aperture that continually adjusts itself according to light conditions. In low light, it opens the pupil to allow more light into the eye. In bright conditions, the iris shrinks its pupil to allow less light through. What's more, the pupil can expand as much as 45 percent when looking at something exciting and pleasant. A strong emotional response can also cause our pupils to enlarge.

Both images © Richard Gicewicz, from *Perception and Imaging* by Richard Zakia.

⇈ Which picture do you prefer? Most people prefer pictures of people in which their pupils are large compared to pictures in which the pupils are small. This pair of pictures illustrates how the size of a subject's pupils affects our perception of a picture. The photos are identical except for the size of the pupils (altered by the photographer in the photo of the girl with larger pupils).

The light that the iris allows into the eye passes through the eye's lens. The lens, in turn, brings the light into focus onto the retina located at the back of the eye. To help focus the image, the eye's lens is able to change its shape, becoming slightly fatter or thinner to focus the image. No mechanical camera yet designed has a lens that will resize itself.

The retina at the back of the eyeball's interior contains two kinds of receptors, rods and cones that specialize in perceiving light and dark colors and in detecting movement. (The part of the retina on which an image is the sharpest is called the fovea. That's where the Foveon image sensor, used in the Sigma S9 camera, gets part of its name. The "eon" in Foveon stands for "electronics.")

The optic nerve is an information superhighway that connects the electronic pulses from the retina directly to the occipital lobe, a well-developed part of the brain.

Our brain makes many real-time adjustments to piece together a coherent three-dimensional image. Again, this combination of sophisticated and instantaneous functions is not yet available on any consumer film or digital camera. As a result, the human eye sees much more than any camera that you can buy. (In Lesson 7, "See the Light," we will discuss just how much more we can see.)

Enough for now about our eyes. Let's go back to the basics of a camera. Aperture diameter determines how much light from a scene reaches the lens. An opening with a wide diameter allows more light through. In low light, a wide opening lets in as much reflected light as possible so that a dimly lit subject can be recorded. In bright light, a small-diameter opening allows less light through. We measure aperture diameters as "**f-stops**," with the lower numbers indicating the largest openings—that is, f/2.8 is a larger opening than f/11, and f/11 is larger than f/22. As the aperture decreases, f/2.8 to f/3.5 to f/4.5, etc., **depth of field** (the distance in front of and beyond our focus point) increases.

A camera lens bends the light rays toward each other so they converge onto the recording medium. Otherwise we would need a recording medium the same size as the image being photographed. The **focal length** of a lens determines the distance at which light passing through the lens will be focused to converge onto the recording medium. Each lens has a different ability to refract light that passes through it.

A flat lens, such as a windowpane, bends light very slightly and keeps all of the rays parallel. Thus light passing through a window creates a image on the floor that is quite large. If we hold a magnifying glass in the light coming through the window, we can focus that light onto a single spot on the floor. We can move the magnifying glass toward or away from the floor until we create a single bright dot. In doing this, we have just created an image of the sun—and perhaps set fire to the carpet! As a kid, I used a magnifying glass to ignite leaves in my backyard, much to my mother's displeasure. In moving the lens back and forth to find the distance that creates the brightest spot, we have

used different focal points of the lens. (See Lesson 8, "A Look at Lenses," for more information.)

Before we leave this lesson and move on to the lessons on taking pictures, let's take a quick look at setting the **ISO**—the film speed in a film camera and the equivalent speed in a digital camera. We'll begin with ISO film numbers, then move on to digital ISO settings.

Films are rated with ISO numbers. Lower-number ISO films have less **grain** and are less sensitive to light than higher-number ISO films. Low-number ISO films are called "slow" films; high-number ISO films are called "fast" films. These days, Kodak Ektachrome 100 is considered a slow film, and Kodak Max 800 is considered a fast film.

Basically, if you want the finest-grain outdoor pictures on a sunny day, you'd use ISO 100 film. On a heavily overcast day, when the light level is lower, you may need a faster film, perhaps one rated at ISO 200 or even ISO 400.

To stop action, you'd use a fast film. The faster the action and the lower the light level, the faster the film you'd need. Some professional photographers who shoot indoor sports use ISO 1000 or even ISO 1600 film. Sure, the pictures are grainy, but a grainy picture is better than a blurry picture, which may result if too slow a film is used with a slow shutter speed.

Digital cameras have several built-in ISO settings, which you manually set. Low-end cameras may have only ISO 100, 200, and 400, while professional cameras may have ISO settings of 100, 200, 320, 400, 500, 640, 800, 1000, 1200, and 1600. As with film, as the ISO setting in a digital camera increases, so does the grain in a picture (technically called "**digital noise**"). Some professional digital cameras feature built-in noise reduction, which is activated manually (and which is useful on long exposures, where "noise" becomes more noticeable). When this feature is activated, it about doubles the time before you can take another picture. For example, if your exposure is five seconds, it will be about ten seconds before you can take another picture.

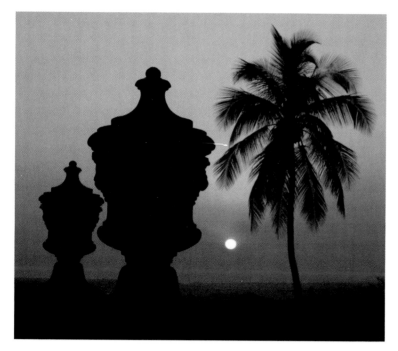

≪ Look at these two illustrations of film grain. Pictures taken with slow film and at low ISO settings have little grain or digital noise, such as in this sunset shot, taken in Trinidad, Cuba.

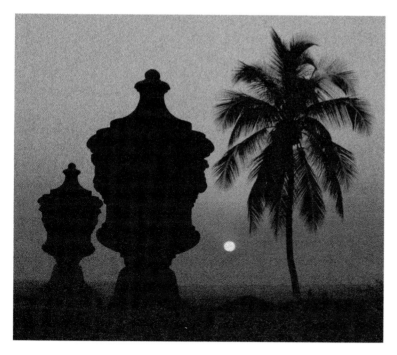

≪ Pictures taken with fast film and at high ISO digital settings look grainy, as in this shot of the same scene with a simulated higher ISO setting. In Photoshop, the Film Grain filter found in a submenu under Artistic filters can be used to add grain to an existing image.

My philosophy on ISO is this: Always try to use the lowest possible ISO setting or film rating for pictures with the most detail—unless, that is, you want grain or noise in a picture for a particular effect.

By the way, you may have noticed that I said, "for pictures with the most detail," rather than "for the sharpest possible picture." That's because grainy pictures can still look sharp, especially if there is a lot of dark-and-light **contrast** in the scene. That is especially true for black-and-white pictures with sharp detail and high contrast.

Two Basic Rules	*Here are two basic rules worth remembering.*

Shutter speed rule. To avoid a blurry picture caused by camera shake, don't use a shutter speed slower than the focal length of the lens. For example, when shooting with a 100 mm lens, don't use a shutter speed slower than 1/100 of a second.

Exposure rule. If your exposure meter fails, you can determine the approximate exposure using the "Sunny 16 rule." On a sunny day, if you are using ISO 100 film or have your digital camera set to ISO 100, the exposure setting should be 1/100 of a second at f/16. That's a starting point. If it's slightly cloudy, increase the exposure by at least one f-stop.

LESSON 7 | See the Light

Before taking a picture, observe the lighting conditions in your scene.

In Lesson 5, we covered seeing pictures. In this lesson, we will cover the importance of "seeing the light." Technically speaking, when we take a picture, we are recording light on a digital sensor or section of film. Before we take a picture, it's important to observe the lighting conditions in a scene closely.

The first step in learning how to see the light is to look for—and be aware of—highlight and shadow areas in a scene.

Let me digress slightly for a moment. Have you ever heard the term "tone-deaf" to describe a person who can't tell the difference between musical tones? In photography, we use the term "value blind" to describe an image that has very little range between light or dark. Ansel Adams used this term. Just as a tone-deaf person may not hear the difference between tones or musical notes, a value-blind viewer doesn't see the difference in light values (brightness levels) in a scene.

Fortunately, there is hope for the value-blind photographer—because we can all learn how to "see the light."

When we look for the light, we usually want our main subject to be in the highlight area. When we look at a picture, our eye is usually drawn to the brightest part of the scene first. If the main subject is hidden in the shadows or shade, someone looking at the picture may think to himself or herself, "What or where is the main subject?" That's not to say, however, that part of your subject cannot be hidden in the shadows, as in the case of dramatic movie-star portraits popular in the 1940s. That technique called for sidelighting that darkened part of the subject's face to add a sense of mystery to the image.

Recognizing a scene's highlight and shadow areas, however, is not enough. We must observe the scene's **contrast range**—that is, the difference between the scene's brightest and darkest areas. If the contrast range is beyond the recordable contrast range of the image sensor or the film, part of the scene will be overexposed or underexposed.

A digital image sensor can record about 3 stops (an **f-stop**, or aperture, is the measure of the opening in the lens that allows light to strike the image sensor or film). Negative film records 5 stops. Slide film is less forgiving, recording only about

3 stops. The human eye sees about 11 stops (which gives me a tremendous appreciation for the gift of sight), but it can also fool us into thinking that what we see in a scene is what we will capture with our cameras.

If we learn how to compress the scene's contrast range, we can shoot an evenly exposed picture. We can compress or reduce the scene's brightness range in five ways. One, recompose the scene or reposition the subject to eliminate areas that are too dark or too light. Two, use a flash to fill in some of the shadows in a scene. Three, use a **graduated filter** (dark on one half and gradually becoming clear on the other) to darken the brighter portion of a scene. Four, use a **reflector** to bounce light onto the dark area of a subject. Five, hold a light **diffuser** over a subject to soften (or even eliminate) shadows.

So the next time you look through your camera's viewfinder, think about seeing and recording the light.

Here are just a few examples of different types of natural lighting.

⇑ I took this pair of photographs of a little girl in a small village near Chitwan National Park, Nepal. As soon as I jumped off the elephant I was riding, I took a shot of the girl in bright sunlight. As you can see, the overhead sunlight cast deep shadows over her eyes, ruining the picture that I wanted. I always try to picture my subjects in the best light, so to speak.

⇑ To get a more flattering shot, I asked the girl to pose in the shade of a nearby thatched hut. The light was soft and very flattering. This picture is near the end of the third roll of film that I took of the little girl. At about the 100th exposure, I touched my nose and she touched hers. I shot and got one of my all-time favorite pictures.

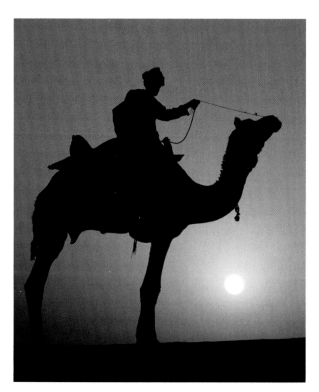

These desert pictures were taken at the same time of day of two different subjects on either side of me. They show the dramatic difference in a picture you can get simply by pointing your camera in different directions.

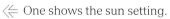 One shows the sun setting.

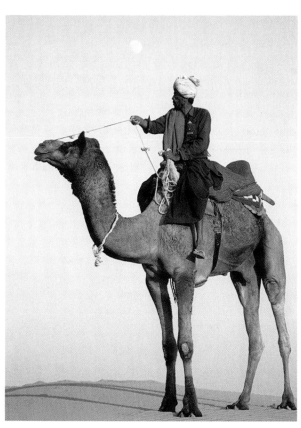

⇐ The other shows the moon rising.

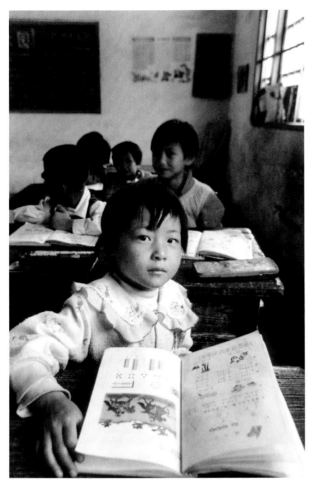

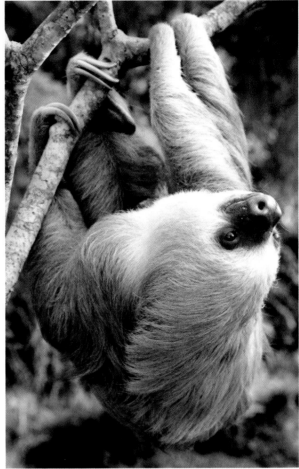

⇑ Here is a good example of seeing the highlight and shadow areas of a scene. In this classroom, which I visited on a trip to China, I wanted to photograph one of the students. The contrast range was strong, created by the strong sidelighting from a row of windows at the right side of the frame (the only light source). Because the girl's face was the main point of interest, I had her turn her head slightly toward the windows, so the window light would illuminate her face. Had she looked the other way, her face would have been in a shadow. Rembrandt, by the way, built his reputation on sidelight. You may want to try this technique for your pictures—the shadow created by window light adds a nice sense of dimension to a picture, especially a portrait.

⇑ My favorite type of light is the soft light of overcast days. I took this picture of a sloth in Costa Rica just before it rained. As you can see, nature's natural cloud "diffuser" softens the picture. I had no harsh shadows to contend with. But talk about seeing the light! I waited and waited and waited until the animal turned its head every so slightly, producing some "catch light" in its eyes. Such "catch light," or light reflecting in a subject's eyes, can make a big difference in a picture. Without it, you sometimes can't even see a subject's eyes.

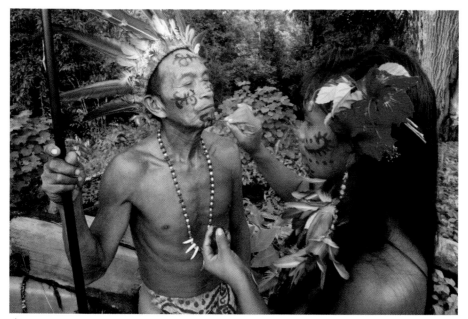

⇑ I took this picture during a face-painting ceremony of the Taraino tribe in Amazonas, Brazil. The village is almost entirely in the shade of tall trees. To get light on the chief's face, I asked him to turn his head slightly upward. That shed just a bit more light on the most important part of this picture: his face.

⇒ When you look at a scene, try to see all the different light levels. In this shot of a cowboy at Marrow Bone Springs, Texas, you can see the blue sky reflected in the window—as well as the silhouette of another cowboy. Had the sky been a little brighter, the window would have looked washed out and overexposed, and would have ruined the picture.

LESSON 8

A Look at Lenses

The lens as well as the aperture we select are of the utmost importance.

Lenses are the eyes of our cameras. They let us picture the world with our own vision at a particular moment in time.

All the pictures in this lesson were taken with my Canon EOS 1D professional digital SLR (single-lens reflex) camera. That's important to know because the effective **focal length** of a lens on a digital SLR is determined by the size of the image sensor. For example, on my camera, which has an image sensor that is smaller than that of a 35 mm film frame, the image magnification is 1.3x. So, a 100 mm lens functions as a 130 mm lens on my camera. Some digital cameras have full-size image sensors (images sensors that are the same size as a 35 mm film frame). On those cameras, a 100 mm lens functions as a 100 mm lens.

Image magnification is a plus when using a telephoto lens, because the effective focal length is extended, giving you a longer lens. Image magnification can be a disadvantage when using a wide-angle lens, because the lens will not cover as wide an area. For example, a 16 mm lens on my digital camera "becomes" a 20 mm lens. The image arrives at the sensor in magnified form, cutting off the widest edges of the original.

On most digital ZLR (zoom-lens reflex) cameras and point-and-shoot cameras with built-in zoom lenses, the focal length is often stated as a 35 mm equivalent. Even at the time of this writing, photographers are used to dealing in traditional 35 mm terms.

⇐ I hesitate starting off a lesson with a boring snapshot, but I took this one to illustrate two points. One, even in a seemingly boring setting you can find pictures. Two, when you are out taking pictures, look through your viewfinder to find pictures lurking out there!

Don't look for pictures only with your eyes. Instead, hold your camera up to your eye. You will be surprised at how many potential pictures you will see that you didn't even know were there. The more different lenses you try, the more pictures you will see. That's what I did when I was at Nathan's Famous in Coney Island, New York.

≪ While looking through my 100–400 mm zoom lens (considered a telephoto zoom) from across the eating area (to the left of where I took the boring snapshot), I saw the graphic potential in the Nathan's Famous sign and red umbrella. I set my lens at 200 mm and shot. This focal length moderately compresses foreground with background.

≪ While I was walking around with my 16–35 mm zoom (considered a wide-angle zoom) after having a great hot dog with my son, I looked through the viewfinder and saw the potential of a wide-angle shot of the Nathan's Famous sign. Getting close to the sign, tilting the camera sideways, and setting my lens to 20 mm produced this picture. This focal length pushes background subjects further away.

These two sunset pictures that I took in Provincetown, Massachusetts, show a much prettier setting than the previous one in Coney Island.

⇐ I took this shot with my 16–35 mm zoom lens set at 24 mm. With wide-angle settings, objects appear smaller than they do when a telephoto setting is used. That's why the sun looks so small in this picture.

⇐ I took this shot with my 100–400 mm zoom set at 400 mm. Although the sun has set, you get the idea that the 400 mm setting brings us much "closer" to the setting sun. With telephoto lenses, distant objects appear larger than they do with wide-angle lenses.

These two pictures, taken at the Hearst Castle in San Simeon, California, illustrate how using different lenses can affect a picture's look.

⇑ Standing only a few feet from this statue, I set my 16–35 mm zoom at about 20 mm. I chose an aperture of f/11. That combination gave me a wide-angle, in-focus view of the entire scene. Notice that even the distant background is in focus. If you want good **depth of field** and a wide view, wide-angle lenses are the way to go, especially when you are close to a subject.

⇑ For this shot, I switched to my 28–105 mm telephoto zoom, set it at 105 mm, and selected an aperture of f/5.6. As you can see, the statue is more isolated in this picture. If you want to isolate subjects in a scene, using a telephoto lens is one way to do it. I think the picture on the left is much more dramatic.

Here are a few more examples of pictures taken with wide-angle zoom lens settings and lenses. Note the good depth of field in all of the pictures on this page.

⇑ Boat builder, Brazil. 16–35 mm zoom at 20 mm.

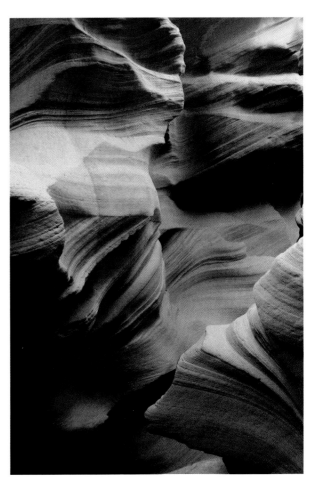

⇑ Upper Antelope Canyon near Page, Arizona. 16–35 mm zoom at 24 mm.

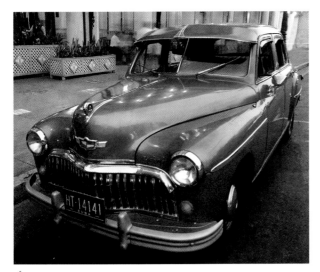

⇑ Vintage DeSoto, Old Havana, Cuba. 17–35 mm zoom (the lens I used before the 16–35 mm zoom was available) at 17 mm.

⇑ Actress Kelly Packard and woodcutter at ESPN's Great Outdoor Games, Lake Placid, New York. 16–35 mm zoom at 20 mm.

Now let's take a look at some pictures taken with telephoto zoom lenses. In these examples, note how the subjects are isolated in the picture—very little of the background shows. Also notice the relatively shallow depth of field. As the focal length increases, depth of field decreases (at the same aperture).

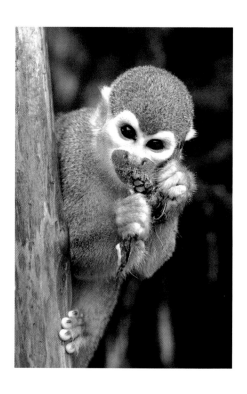

⇑ Badger, Triple D Ranch, Montana. 100–400 mm lens at 200 mm.

⇒ Monkey eating a moth, Brazil. 100–400 mm at 400 mm.

⇓ Indian chief, Dallas, Texas. 100–200 mm lens at 100 mm.

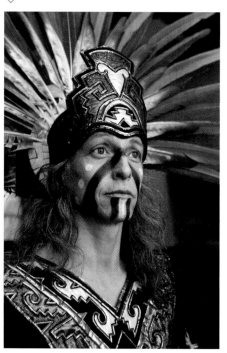

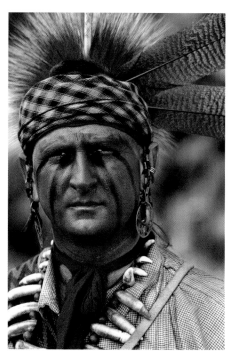

⇐ Seminole Indian, Florida. 70–200 mm lens at 200 mm with a 1.4x teleconverter.

Teleconverters, which extend the range of a lens, come in 1.4x and 2x powers. With a teleconverter, you get what you pay for. Inexpensive teleconverters usually produce slightly soft images, and all teleconverters reduce the amount of light reaching the film or digital sensor.

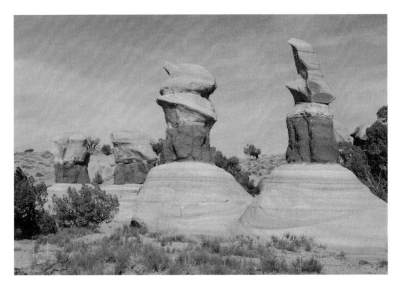

Wide or
short lens,
28 mm.

Medium lens,
50 mm.

Narrow or
long lens,
105 mm.

To further illustrate how different lenses and zoom lens settings affect our pictures, take a look at the following sets of pictures. Each photo on this page was taken from the same spot. Only the focal length on my zoom lens changed.

⇚ These landscape pictures were taken with my 28–105 mm zoom at Devil's Garden in the Escalante National Monument, Utah. I show them to illustrate the point that you can use 50 mm and 105 mm focal lengths for landscape pictures, too. (So don't get locked into thinking that you must use a wide-angle or zoom lens for landscapes.)

100 mm. 200 mm. 400 mm.

⇑ These pictures of my friend Stephanie were taken with my 100–400 mm zoom in Croton-on-Hudson. I don't really like the composition in the full-body and three-quarters pictures. I use them here to illustrate how different lenses affect a picture's look. I used a flash to brighten her face.

As I mentioned earlier in this lesson, **aperture** also plays an important role in our pictures. To see how different apertures affect a picture, compare these two pictures of a praying mantis that I photographed in my backyard. For both shots, I used a 50 mm **macro lens** so I could get a life-size picture of the creature. Macro lenses are indispensible in close-up photography.

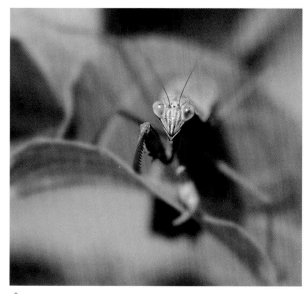 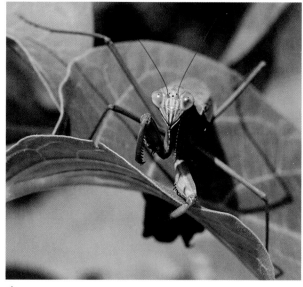

⇑ In the picture with the blurred background, I used a wide aperture, f/4.5.

⇑ In the picture with the relatively sharp background, I used a small aperture, f/16. I focused on the mantis's eyes in both pictures.

In the previous pair of mantis pictures, there was a difference of several stops between the wide and small aperture. But when choosing an aperture, it's important not to think only about choosing a wide or small aperture. It's more important to think about how just a few stops can change the impact of a picture.

For example, take a look at this series of pictures of a datura flower, which I photographed in my backyard with a 50 mm macro lens. As you can see, as the aperture becomes smaller, more and more of the background comes into focus.

Aperture set at f/2.8.

Aperture set at f/5.6.

Aperture set at f/11.

Aperture set at f/22.

One thing to watch out for when using any lens is **lens flare**. It's caused by direct light falling on the front element of a lens. That light can show up in your photograph as a strong glare.

⇊ This pair of pictures, taken on a Disney cruise ship, illustrates how lens flare affects a picture.

 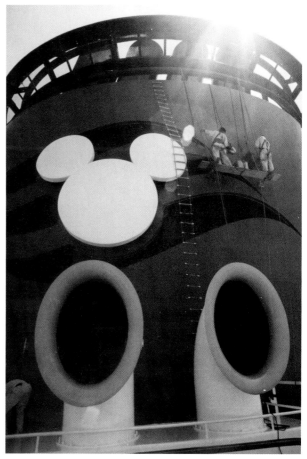

At the very least, flare can make your pictures look soft. That's why it's important to use a **lens hood**, which is designed to keep light off the front element of a lens. Sometimes, a lens hood is not good enough. In those cases, you need to shield the lens with your hand, a hat, or something else.

Lens flare is not always a bad thing in a photograph. Photoshop offers the possibility of positioning the sun, which causes lens flare, anywhere in the scene. You'll find the Lens Flare filter by going to **Filters > Render > Lens Flare**. You can also choose the intensity of the lens flare, as well as the effect you get from using different lenses.

⇑ This pair of pictures of a dead tree, taken in Devil's Garden in the Escalante National Monument, Utah, shows the before and after effect of working with Photoshop's Lens Flare filter.

Lens Tech Talk

Buzz words that may come in handy when shopping for a lens

Looking for an accessory lens or lenses to expand your creative horizons? During your shopping spree, bring up the following "tech" terms with the salesperson. They will help you narrow your focus, so to speak, to the best lens for your needs.

Apochromatic lenses. As a kid, you probably had a light prism, and you were probably amazed at how the prism dispersed the light (the white light that we see) into all these different colors of the spectrum. What was hard to see was that those different colors actually "focused" on different planes.

In photographic lenses, the different planes on which colors focus—which causes images of different sizes on the same plane—are called "chromatic aberrations." So, designers have developed apochromatic lenses (also known as "apo" lenses) to focus the different wavelengths on the same plane.

Apochromatic lens design is especially important in telephoto lenses. If you have a choice of an apo or a non-apo lens, go for the apo lens.

Aspheric lens elements. Another aid in getting light rays to focus on the film plane or image sensor are aspheric (as opposed to spheric) elements. Aspheric elements are costly and difficult to produce, so if they are in a lens (sometimes they come in zoom lenses that have a wide zoom range), it's a necessity that they are there.

Maximum aperture. The maximum aperture is exactly what it sounds like: the widest aperture in a lens, f/2.8 being the widest aperture for a 16–35 mm f/2.8 lens. Lenses with an aperture of f/2.8, f/2, or f/1.4 are called "fast" lenses, because they allow more light to pass through them. Fast lenses are useful for shooting in low-light conditions, because they let you shoot at a faster shutter speed for handheld photography than do slower, smaller-aperture lenses. Generally speaking, fast lenses cost more than slower lenses of the same focal length, because among other reasons, they use more glass (which also makes them heavier than slower lenses).

Multi-coating. Multi-coated lenses reduce the amount of light reflecting from the surface of a lens, thereby reducing the possibility of lens flare—even when photographing highly reflective subjects (which can also cause lens flare).

Number of elements. "Elements" are technically lenses within a lens that focus the light on the film plane or digital image sensor. Wide-angle lenses and fast lenses often have more elements than do telephoto lenses and slow lenses. Usually, as the number of elements increases, so does corner-to-corner sharpness. However, more elements do not always mean that you'll get a sharper picture than you would with a lens with fewer elements, because some manufacturers use better glass or have higher testing standards than others.

«Un croquis vaut mieux qu'un long discours» (A picture is worth a thousand words). —NAPOLEON

The Zoom Lens Advantage

I never leave home without my zoom lenses.

"I'll never use a zoom lens." That's what some of my professional photographer friends said when I first got into photography back in the mid-1970s. Back then, **zoom lenses** did not compare in sharpness to **fixed-focal-length lenses**. What's more, the zoom lenses of yesteryear were slow and heavy.

"I never leave home without my zoom lenses." That's what many of my professional shooter friends now say. Here's why.

Versatility. Perhaps the biggest reason zoom lenses are so popular today is that they offer photographers tremendous versatility. For example, I shoot about 90 percent of my assignments with a 16–35 mm zoom on one camera body, and a 28–70 mm zoom on another body. This two-lens setup lets me quickly and easily compose, shoot, and get out of the way, which is often important in the type of assignments I do often: photographing people in distant lands. For some wildlife, sports, and portrait sessions, I use a 100–400 mm zoom, sometimes with a 1.4x **teleconverter** (which increases the focal length of the lens by 1.4). And, of course, I pack a 50 mm **macro lens** for close-ups.

Creativity. Zoom lenses make the process of taking a picture more creative, because you can crop a scene while you are shooting and experiment with different compositions.

Sharpness. Many of today's zoom lenses rival the sharpness of fixed-focal-length lenses. Note that as the sharpness of a zoom lens increases, so does its price—usually. But one could argue that the sharpest zoom lens on the planet is not necessary to get a super-sharp print. For example, with the sharpening tools available in programs like Photoshop, and sharpening plug-ins such as nik Sharpener Pro!, soft images can be transformed into sharper images to a point with a few clicks of a mouse. Still, it's best to start with the best-quality image possible.

Speed. As far as speed goes, many manufacturers offer fast (f/2.8) zoom lenses—a feat unheard of back when I started shooting. With a "fast" zoom lens, you can use a faster shutter speed, which means you can hand-hold exposures in relatively low-light situations. (A fast lens usually has a maximum aperture of f/2.8 or wider, such as f/2 or even f/1.8. Slow lenses have a maximum aperture of f/4, f/5.6, or even f/8, as is the case with some inexpensive, very long telephoto lenses.)

Even slower zoom lenses are increasing in popularity. That's due, in part, to advancements in 35 mm film technology. In the 1970s, fast slide and negative film offering an ISO 400 setting was grainy and muddy from a professional standpoint. Today, even the ISO 800 color print films and ISO 400 slide films produce very acceptable images—as do the fast ISO settings on digital cameras. If the grain ("noise" on digital cameras) bothers you, it can be reduced in the digital darkroom by going into Photoshop's Channels menu and applying the Gaussian Blur in the Blue channel.

One note on grain here: The professional photographer David Hamilton, known for portraits of women, actually uses grain to take out some of the reality of his pictures. So grain can be a good thing.

Fast focusing. In many situations, an **autofocus** zoom lens can focus faster than you can. And if your camera has **focus tracking** or **continuous autofocusing**, you can get a sharp picture of a subject even if it is moving toward you. By the way, many of my pro friends who once said they would never use an autofocus camera are now shooting with them. I'm glad to see that we pros are so open-minded.

Compactness. I remember my first zoom lens. It was heavy and bulky. Today's zoom lenses are relatively compact and lightweight. Because they take up less space in my camera bag, I can pack more accessories.

Zoom range. Today's zoom lenses offer just about any zoom range you want, from 16–35 mm on the short side to 100–400 mm on the long side. What's more, the zoom range has been extended to a point unimaginable even a few years ago—as with Sigma's 50–500 mm lens and Tamron's 28–300 mm lens. As the late Frank Zappa would say, "Wowie zowie!"

Wide-angle. Zooms, such as the Canon 16–35 mm zoom I use, were late bloomers, so to speak—because getting sharp optics in the wide-angle range was a challenge. Today, many of these wide-angle zooms are super-sharp. For example, one picture I took with my 16–35 mm zoom was enlarged from the 35 mm film frame to 30 × 60 feet for the Kodak Colorama in New York's Times Square. Now that's sharp.

Fun. Zoom lenses make taking pictures more fun. Take it from me, a photographer who likes to have fun while shooting. Go out there and have some fun framing your scenes with a zoom lens!

P.S. We can't have a lesson on the advantages of something without mentioning the disadvantages, if you want to call them that. So here goes: Zoom lenses can be heavy. They can also have a smaller maximum aperture than a fixed-focal-length lens, which makes the scene in the viewfinder look darker and requires you to use a slower shutter speed than you would when using a faster lens.

Zoom lenses are fun to use. They let you compose and shoot quickly. When I'm shooting, I always have my 16–35 mm and 28–70 mm zoom lenses handy. For this shot, taken in Panama at an Embera village, I used my 16–35 mm set to 16 mm. I used a small aperture to get almost everything in focus.

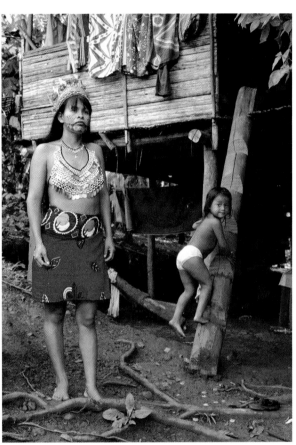

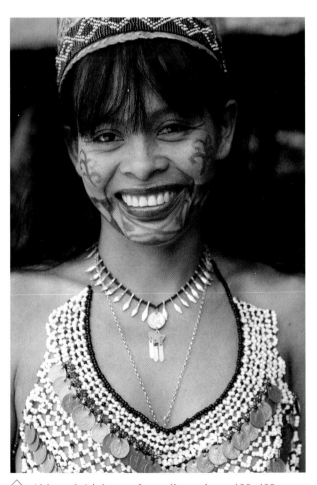

Although it's heavy, I usually pack my 100–400 mm lens for "portraits of strangers." I captured this Embera woman in Panama with my 100–400 mm lens set to 200 mm. About 10 feet from the woman, I used an aperture of f/4.5 to blur the background.

Zoom lenses let you compose and shoot quickly. While I was taking this environmental portrait, a little girl ran into the scene to climb the log ladder. I quickly zoomed my 28–70 mm lens in from 70 mm to 28 mm, recomposed, and shot. I was able to see the girl approach because I shoot with both eyes open. Hence, I can see what is happening beyond the viewfinder. Sports photographers often use this technique so that they can anticipate action. The "both eyes open" technique takes time to develop, but with it you catch images you would otherwise miss.

⇑ I like to travel light, especially when shooting in rugged conditions. The less gear, the less I have to worry about. I shot this picture of an Embera man navigating through the rapids of the Rio Chagres in Panama with my 16–35 mm lens set to about 24 mm. I used a small aperture for good depth of field.

⇑ One of the keys to successful people photography is the ability to work quickly when needed. Zoom lenses help me do that: I can compose my scene, and then "shoot and scoot." For this shot of a Kuna Yala, Panama, woman making a *mola*, I used my 16–35 mm lens set to about 20 mm. The uniform background was not distracting, so I did not try to blur it with a lower setting.

⤒ Today's zoom lenses rival the sharpness of fixed-focal-length lenses. For this picture of the Buddhist temple at the Chuang Yen Monastery in Carmel, New York, I used my 16–35 mm zoom set to 16 mm.

Here is a closing note to digital camera owners who have a **digital zoom**, in addition to an optical zoom lens, on their cameras: Use it sparingly (or not at all). Digital zooms don't really zoom in closer. They only magnify the center area of the captured frame. That results in a picture with more **digital noise** (which is the same as grain in film) and overall lower image quality. So, rather than use the digital zoom, do what I did before I owned a zoom lens: Zoom in with your feet!

"The universe is full of magical things, patiently waiting for our wits to grow sharper." —EDEN PHILLPOTTS

Shoot Sharp Pictures

A number of different factors affect the sharpness of a picture.

Most photographers strive to get the sharpest possible pictures, although some photographer-artists, including Henri Cartier-Bresson, have built their reputations on soft-focus (and grainy) images.

Several factors go into getting a sharp picture. Even more go into getting a sharp picture out of your inkjet printer, a topic covered in Lesson 42, "Printing Concepts and Tips." In this lesson, we'll take a look at the different factors that affect the sharpness of a picture.

⇑ **Lighting.** I took these two pictures of lions while on safari in Tanzania with a 400 mm lens. The horizontal picture was taken on an overcast day, when the clouds diffused the light for a soft, pleasing effect. The right-hand picture was taken late in the afternoon on a sunny day; it looks much sharper due to the strong, direct sunlight.

⇑ **Lens.** The quality of a lens can also affect the sharpness of a picture. I took this picture of a woman in Marrakech, Morocco, with an inexpensive 70–200 mm zoom lens. It's a bit soft, but I like the picture anyway.

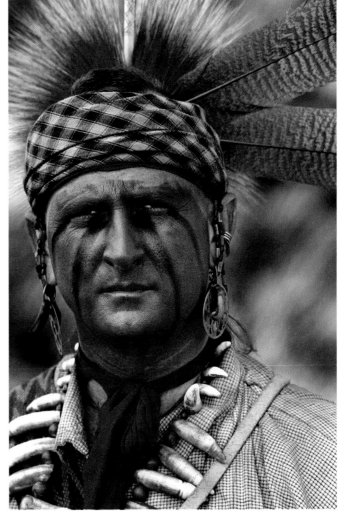

⇒ **Teleconverter. Teleconverters**, which increase the effective focal length of a lens, sometimes affect the sharpness of a picture. With some manufacturers, 2x teleconverters are not as sharp as 1.4x teleconverters, which often cost more than 2x teleconverters. Plus, expensive teleconverters often produce sharper pictures (especially around the edges of the frame) than more affordable converters. I took this picture of a Seminole Indian with a Canon 1.4x teleconverter on my Canon 100–200 mm lens set to 200 mm on my Canon EOS 1D digital SLR. Before adding the teleconverter, the effective focal length of the lens was already 130–260 mm (due to the 1.3x image magnification caused by the digital image sensor's being smaller than a 35 mm film frame). Therefore, the 1.4x teleconverter changed the effective focal length of the lens to 182–364 mm. The subject is very sharp in this picture for several reasons: I focused on the subject's eyes, plus the quality of the lens and teleconverter I chose helped.

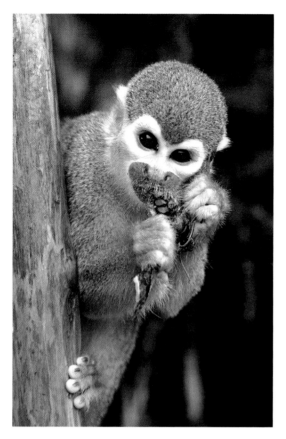

⇐ While on assignment in Brazil, I took this picture of a monkey eating a moth with my Canon 100–400 mm IS (image stabilizer) lens. It's a super-sharp lens. In my original, I can see every hair on the animal's face.

In addition to the sharpness of the lens, the **image stabilization** feature (which greatly reduces camera shake) lets the user hold the lens (as opposed to using a tripod) at relatively slow shutter speeds—much slower than is possible with non-IS lenses. For example, at the 400 mm setting on a non-IS lens, the slowest recommended hand-held shutter speed is 1/400 of a second (actually 1/500 of a second because that is the next higher shutter speed available on most cameras). That recommendation comes from one basic rule: to avoid camera shake and blur in pictures, don't use a shutter speed slower than the focal length of the lens. And exhale before you take a hand-held shot.

⇓ **Grain** in film, and **noise** in a digital image, can affect how sharp a picture looks. The higher the ISO film speed or **ISO digital setting**, the more grain or digitial noise appears in the pictures. This picture of a schoolgirl in Costa Rica was taken with my Canon EOS D30 set at ISO 1200. In the low

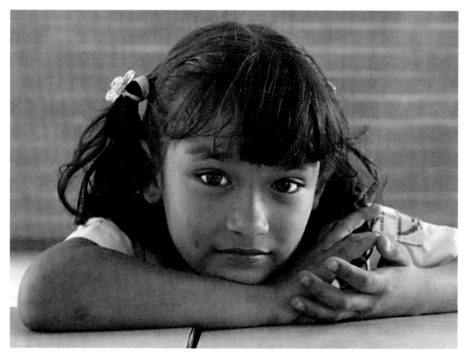

light conditions, I had to use that ISO setting to get a suitable shutter speed of 1/30 of a second that would allow me to hold my camera without getting camera shake. This picture is a bit noisy and soft, but I don't mind the noise. Plus, I remember what my dad told me about grain when I was starting out in photography: "If a picture is so boring that you notice the grain, it's not a good picture anyway."

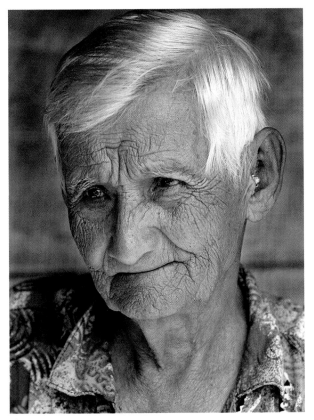

⇧ The detail in a subject also affects how sharp a picture will look. This man, Don Pablo, the owner of a farm in Costa Rica, has deep character lines on his face that add to the apparent sharpness of the picture. To make the picture look even sharper, I had an assistant hold a **reflector** to bounce light onto Don Pablo's face—thus creating shadows in his character lines, which also added to the sharpness of the picture by creating more contrast.

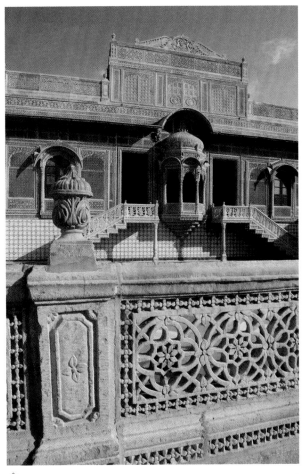

⇧ **Filters** can make the difference between sharp and soft pictures, too. Use a good (usually expensive) filter, and it will not affect picture sharpness. Buy a cheap filter, and your pictures may look soft. For this picture of a hand-carved stone palace in Rajasthan, India, I used a very expensive **polarizing filter** on my lens to darken the sky. Polarizing filters remove certain light frequencies that pass through them. In doing so, they can (but do not always) darken a blue sky, reduce reflections on water or glass, and even lessen the appearance of atmospheric haze. (See Lesson 27, "Filters for Outdoor Photography," for more information on polarizing filters.) Had I used an "el cheapo" filter, some of the detail in the intricately carved stone wall might have been lost.

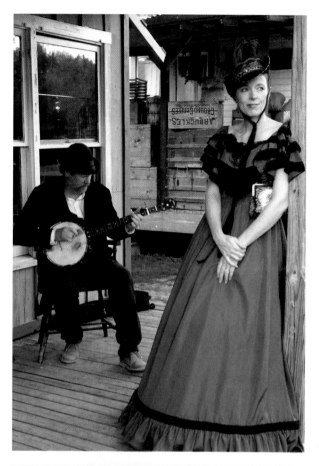

⇐ A missed focus point is another reason for a soft picture—or a soft part of a picture. At first glance, the main subject in this picture, the woman in blue, may look in focus. And actually, when I took the picture at my friend Chris's wedding in Marrow Bone Springs, Texas, I thought she was in focus, too. On my camera's **LCD screen** (shown above), the entire scene looked in focus. Because of the small size of a digital camera's LCD screen, a picture may appear sharp, even when the magnifying option on a digital camera (not available on all models) is used to "blow up" part of the frame.

⇐ But as you can see from this enlarged section of the scene, the woman is out of focus and the sign in the background is in focus. (Because I was having too much fun, I forgot to lock in my focus on the woman, reframe my shot, and then shoot.)

But that is not the only problem with this picture. It was taken late in the afternoon. Due to the low light, a slow shutter speed slightly blurred the entire scene. Again, too much fun is my excuse. Had I followed the basic shutter speed rule—*never use a shutter speed slower than the focal length of the lens*—at least the background would have been in sharp focus!

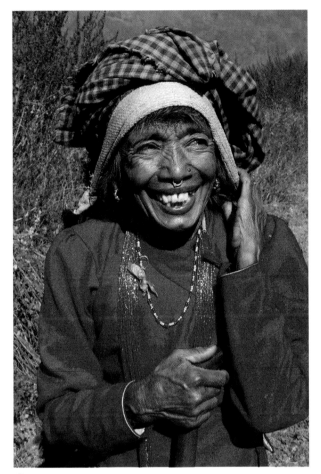

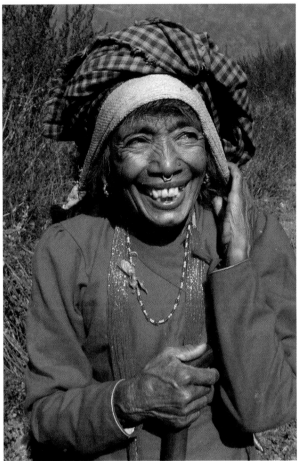

⇑ **Oversaturation** is yet another reason for a picture, or a section of a picture, to look soft. You can get an oversaturated picture by using a super-saturated film for scenes where the colors are already very saturated, as is the case in this picture of a Nepalese woman wearing a very bright red shirt. You can also get an oversaturated picture by selecting the saturated mode on a digital camera in a similar situation. And, in the digital darkroom, it's easy to get an oversaturated image simply by boosting the **saturation**. This boost may be very appealing because of the bright, vibrant colors it produces. This richer color may even look great on a computer monitor, because the monitor uses internal light to project through the colors of image. But the same image can look too dark or muddy when printed on paper, because paper uses reflected light—those supersaturated colors will absorb light and weigh the photograph down

⇑ I know I promised no Photoshop tricks in this section, and I'll keep my promise. I did not use any tricks to get this less-saturated image—which now shows more of the detail in the woman's shirt. All I did was go to **Image > Adjust Hue/Saturation** and decrease the saturation. From a distance, the corrected picture may look dull compared to the saturated image. But it is actually a more accurate rendition of how the scene looked when I took the picture.

⇐ For this sharp picture of a roadside restaurant in Chimayo, New Mexico, several of the factors that affect the sharpness of a picture came into play: using my Canon 17–35 mm lens with a high-quality (and very clean) **skylight filter**, selecting a small aperture so that everything in the scene is in focus, selecting the lowest ISO setting on my digital camera for minimal noise (grain), and holding my camera steady to avoid the blur caused by camera shake. The visual details and light-to-dark contrast of the scene also add to the picture's sharpness.

⇒ A final sharp shot to end this lesson, taken of Grosvenor Arch, Escalante National Monument, Utah. I used all the techniques mentioned above to get a sharp shot of one of the most magnificent sites in Utah.

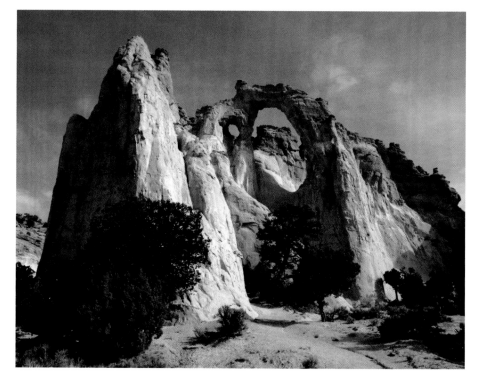

"Learn to see, and then you'll know that there is no end to the new worlds of our visions." —CARLOS CASTANEDA

Get a Good Exposure

You should always start with the very best image possible.

The #1 reason people are unhappy with their pictures is that the pictures don't look like the scenes they saw—with all that detail in the shadows and in the highlight areas. Scenes can never be recorded exactly as our eyes see them—not on slide film, nor on negative film, nor even on a digital image sensor. Our eyes see a much wider dynamic range of light than does film or a digital image sensor. Unlike film or a digital sensor, we can see detail in strong shadow areas and highlight areas at the same time.

As we explored briefly in Lesson 7, the human eye sees a dynamic range of about 11 **f-stops** from the brightest to the darkest areas in a scene. Negative film has an **exposure latitude** of about 5 f-stops, which means your exposure does not have to be "right on" in order to yield a reasonably good print. Slide film has an exposure latitude of about 3 f-stops. That means your exposure needs to be pretty close to "right on" to be accurate. Digital image sensors also have an exposure latitude of about 3 f-stops.

With today's digital imaging programs, one could argue that it is not as important to get an accurate natural light exposure for each picture. After all, digital imaging programs such as Photoshop let us "pull out" detail in shadow areas and "tone down" highlights in all types of pictures. I use these techniques often to create pictures that look more like the scenes I photographed, especially scenes that cannot be recorded as seen because of great differences between the highlight and shadow areas.

Yet it is still important to get a good exposure. You should always start with the very best image possible, for three reasons. One, it will save you time in the digital darkroom. Two, pulling out and toning down detail works only to a degree; if details are overly exposed, they are almost impossible to save, and if you try to pull up shadow areas too much, grain (digital noise) can be grossly exaggerated. And three, working on getting a good initial exposure is fun!

In this lesson we'll cover just how to get a good exposure, what exactly a "good exposure" is, how in-camera exposure meters can be fooled (and what we can do to un-fool them), how to compensate for natural exposure (the + and - settings on a camera), and how to use different types of in-camera metering systems.

The pictures in this lesson were taken with my Canon EOS 1 D 4.15 megapixel digital SLR. The advantage of digital, of course, is that you can tell (most of the time) if an area of your picture is overexposed or underexposed immediately after you take a picture. I say "most of the time" because not all the detail of a scene is revealed on the relatively small LCD screen on a digital camera.

Let's take a look at two scenes: the outdoor pool at Hearst Castle in San Simeon, California, and an indoor shot I took at the Cloisters museum in New York City. They illustrate the difference between what we see and what our cameras can record. These pictures help us realize that, in some cases, what you see is not what you get (i.e., not what your camera can record). They also illustrate that sometimes it's impossible to get a "good" in-camera exposure when there is a very wide **contrast range** in a scene.

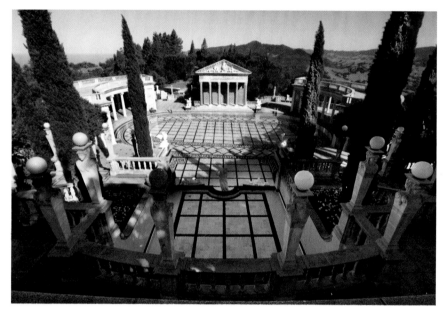

⇐ This is how the pool at the Hearst Castle looked to me when I took the picture. This image is actually a digital composite of the next two pictures. I created it in Photoshop by combining the shady part of the first shot with the sunny part of the second, darker shot.

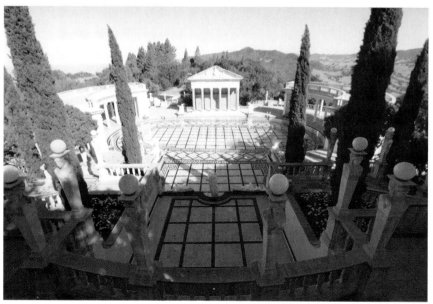

⇐ With my camera set on **Program mode** (full automatic), exposing for the foreground (shadow) area lets me see the details within the shadows, but leaves the highlights overexposed. (Program and other exposure modes offered by cameras are discussed in the next lesson.)

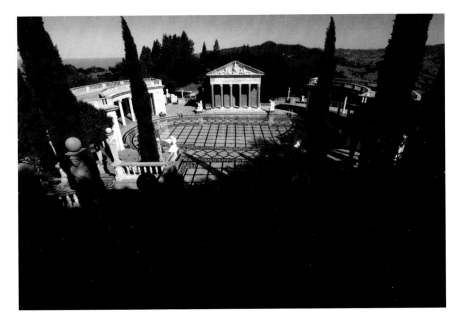

⇐ Exposing for the highlight area farther away shows that area, but now we can't see the detail in the shadows in the foreground. Had I increased the exposure just a bit for this picture (to get some detail in the foreground shadows), the highlights would have been overexposed just a bit.

If you don't use Photoshop, my Hearst Castle is a situation in which you need to wait for the right light— a low contrast range between the highlight and shadow areas—to get a good exposure. *National Geographic* photographers sometimes plan their shoots at specific times of day and year to get the light just right.

Sometimes it is just impossible to get both the highlight and shadow areas properly exposed in the same picture. Interiors like the Cloisters in New York City are another example of when it's impossible to get a good in-camera exposure of a high-contrast scene. I worked in Photoshop by combining the highlight and shadow areas of the scene to produce the desired result.

⇒ Here is what a chamber in the Cloisters looked like to my eyes. I could see the detail in the stained glass windows *and* the detail in the stone coffin in the foreground. Again, it's a composite of the two images on the next page.

⇑ With my camera set on Program, exposing for the bright, stained glass windows produced a nice exposure of the windows, but the interior of the chamber is very underexposed.

⇑ Exposing for the shadow area of the chamber let me record that area, but now the windows are overexposed and washed out.

To get a good in-camera exposure (with both areas of the chamber being properly exposed), I would have had to set up a lighting system—just as movie lighting directors do when shooting in tricky lighting situations—to reduce the overall contrast range of the scene.

Now let's look at the opposite situation—where it's relatively easy to get a good exposure with your camera set on Program (or any automatic mode).

⇐ I took this picture of an Embera boy in a remote village in Panama with my camera set on Program and my in-camera meter set to **Average metering** (which takes an average meter reading of the scene and then sets the appropriate shutter speed and aperture for a good exposure). I got a good exposure, because there was not a lot of contrast in the scene. When you don't have a wide range of shadows or highlights in a scene, try shooting with your camera's Program exposure set to Average metering.

⇓ Here is a picture I took in Trinidad, Cuba, while riding on a charcoal wagon before sunrise. As you can see, there are not a lot of highlights and shadows in the scene. So did I set my camera on Program exposure and Average metering (which took an overall reading of the scene) and shoot? Not quite. I did set my camera on Program and Average metering, but I used my camera's **Exposure Compensation** feature to step down the exposure by -1/2 stop, or, technically speaking, -1/2 EV (for exposure value). That small reduction in exposure prevented the white doors on the buildings from being overexposed. (Experience told me that the -1/2 stop Exposure Compensation was needed.) Exposure Compensation (the "+" and "-" settings on a camera) lets us reduce or add to the exposure for just this type of situation.

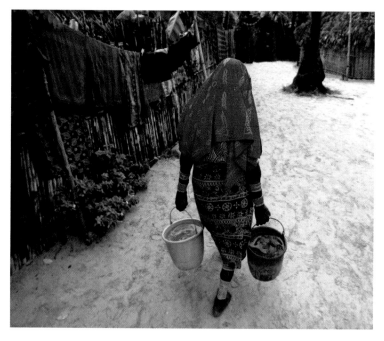

◅ Here is a common situation where an **in-camera exposure meter** can be fooled. In this shot, the setting yields a slightly underexposed picture. I photographed this woman walking on sand in Kuna Yala, Panama. The picture is slightly too dark, because the white sand fooled the in-camera exposure meter into calculating that the scene was brighter than it actually was. Therefore the camera took a slightly underexposed picture.

Before considering how to correct this situation, let's discuss why the camera's light meter was fooled. In-camera exposure meters measure the light reflecting from a scene or off a subject. So a very light subject yields a different light reading (exposure setting) than a very dark subject. Scenes with both large bright areas and large dark areas can be particularly troublesome. In-camera meters are not designed to measure extremely bright or dark areas; they are meant to give accurate readings of neutral scenes.

Today's high-end film and digital cameras have much more sophisticated in-camera light meters than older cameras and today's low-end cameras. So, with high-end cameras, the meters are fooled less frequently. But they can still be fooled. That's why some professional photographers use hand-held, available-light meters—more accurately called **incident-light meters**. These meters measure the light falling on the subject (the true light level) and are not fooled by a dark or light subject. Hand-held light meters are especially useful when shooting slide film, which has a very narrow exposure latitude.

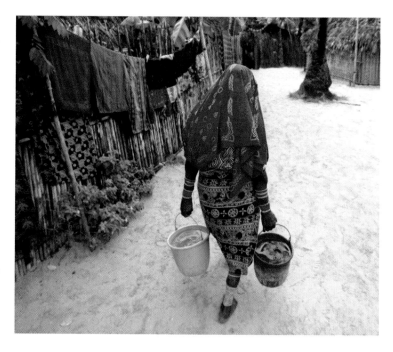

⇒ As a general rule, when you are shooting sand (and snow) scenes in an Program mode, you need to step up the exposure by about +1 stop on the Exposure Compensation dial. Notice how an Exposure Compensation of +1 stop makes my picture brighter. (Keen-eyed readers will notice that the two pictures of the Kuna Yala woman are actually the same picture. I used Photoshop to increase exposure slightly to illustrate the effect of Exposure Compensation.)

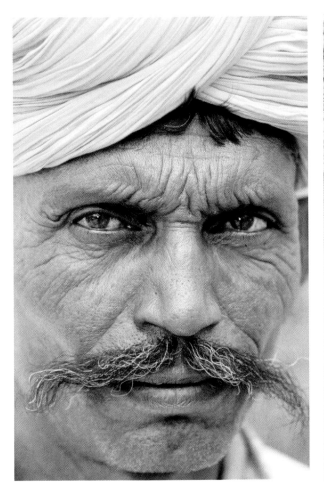
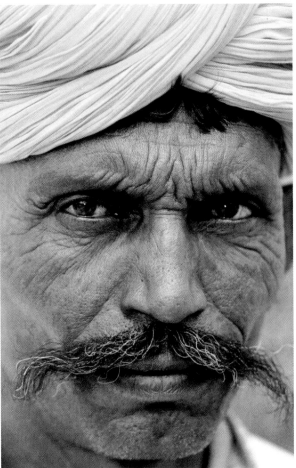

⇑ A subject that is dark can also fool an in-camera light meter into giving you an inaccurate exposure. I photographed this man in Rajasthan, India. My camera was set on **Aperture Priority**, because I wanted to control the depth of field. My in-camera meter was set to Average metering. The man's dark skin fooled the meter into thinking that the scene was darker than it actually was, and therefore increased the exposure, which resulted in a slightly overexposed picture. The man's skin is not that light. To get a more accurate exposure of the man's face, I set my Exposure Compensation to -1/2 stop (or -1/2 EV). So, when you are photographing a dark subject, remember that you should slightly decrease the Exposure Compensation setting.

Use Exposure Modes for Creative Control

Most cameras offer a number of ways to choose the proper exposure.

When I first started taking pictures, my 35 mm SLR camera had two exposure modes: **Manual mode**, which required me to set both aperture and shutter speed to get a good exposure, and **Aperture Priority mode**, which gave me the opportunity to select an aperture, while the camera automatically selected the corresponding shutter speed to obtain the correct exposure. Most of today's SLR and ZLR cameras offer Manual Program, Aperture Priority (sometimes referred to as Aperture Value [AV] on the camera controls), and Shutter Priority (sometimes called Time Value [TV] on the camera controls) exposure modes, plus a few others, depending on the camera.

Each of these different modes offers us opportunities for creative picture-taking. For this lesson, we'll travel to Panama with some example photographs I made in 2002.

Program mode is the "do everything" mode. When a camera is set to Program, or P, the **aperture** and **shutter speed** are both automatically selected based on the existing light conditions. On some high-end cameras, the camera's built-in computer also knows what lens is in use, and therefore may, for example, select a higher shutter speed with a telephoto lens to eliminate blurry pictures that might be caused by using too slow a shutter speed.

The advantage to shooting in Program mode is that you can raise your camera to your eye and just shoot, without having to think about making any camera adjustments. When I am walking around looking for pictures, I always have my cameras (I carry two cameras) set on Program. That way, if something unexpected happens I can at least get a "grab shot," after which I can take my time and perhaps get a better picture.

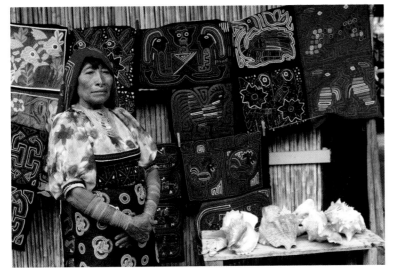

⇐ I took this picture in Kuna Yala with my camera set on Program. I knew from experience that the shutter speed and aperture that my camera selected would give me enough **depth of field** and provide a fast enough shutter speed to produce a sharp picture.

Many cameras offer an adjustable or shiftable program when set to Program mode. An **adjustable program** is one in which you can change or shift the preselected aperture and shutter speed at the touch of a button or twist of a dial. In doing so, you will still get good (actually the same) exposure value. The advantage of this approach is that you can change the shutter speed or aperture for a desired depth of field or other effect. Note that after you change the original program settings, your camera may revert to the original settings after a few seconds, when it's turned off, or when you mount a different lens.

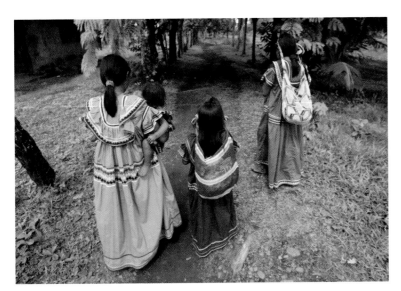

⇐ While driving in Chiriqui Province, Panama, I saw these Ngabe-Bugle women walking along the side of the road on a dirt path. With my camera still set on Program, I jumped out of the car and adjusted the program to 1/125 of a second so that a faster shutter speed would stop the action of the women walking.

Aperture Priority, however, is the mode to choose when depth of field is important. Landscape photographers usually shoot in the Aperture Priority mode and set a small aperture (f/11, f/16, or f/22) so they get as much of the scene in focus as possible. All the pictures in Lesson 26, "Landscapes and Nature," were taken in Aperture Priority mode with my camera set to a small

aperture. Portrait, glamor, and fashion photographers sometimes shoot in the Aperture Priority mode and set a wide aperture (f/2.8 or f/3.5) to get a sharp subject to "stand out" from a soft background (see Lesson 94).

The advantage to shooting in Aperture Priority mode is that even if the light level changes, the aperture remains the same (the shutter speed changes accordingly to provide the correct exposure).

As with Program mode, you can adjust the aperture in the Aperture Priority mode. You change the camera's proposed aperture and the camera automatically adjusts the shutter speed.

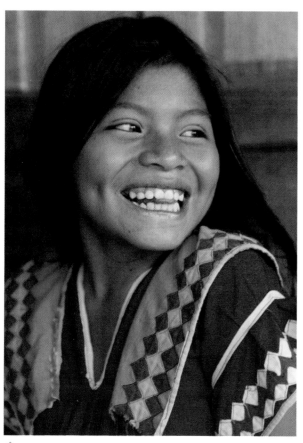

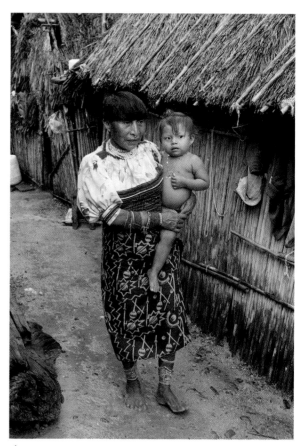

⇑ I took this picture of a Ngabe-Bugle girl with my camera set to Aperture Priority mode. I was using a 28–70 mm lens set at f/2.8. I wanted the girl in focus but the door in the background slightly out of focus. (See Lesson 8, "A Look at Lenses," for more information about depth of field.)

⇑ Here is another good example of shooting in Aperture Priority. I wanted to get a picture of a woman carrying a baby, which is a common sight in Kuna Yala. So I positioned myself on a "streetcorner," set my camera to Aperture Priority, selected a small aperture to get most of the scene in focus, and waited. After a while, a woman walked into the scene. I raised my camera and shot this picture, one of my favorites from that trip. Just about everything in the scene is in focus (due to the small aperture and greater depth of field at the 24 mm setting on my 16–35 mm lens).

Shutter Priority mode (sometimes called "Time Value," or TV) is the mode to choose when you want to stop action or blur action. A fast shutter speed stops ("freezes") action. A slower shutter speed blurs action. The benefit of shooting in Shutter Priority mode is that, even if the light level changes, the shutter speed remains the same (the aperture changes accordingly for a correct exposure).

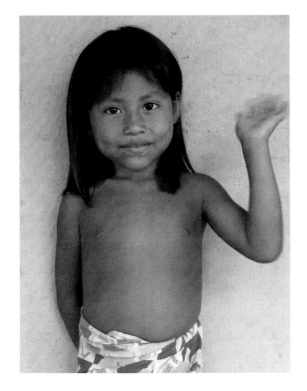

⇐ At the end of my visit to an Embera village in Cocle Province, I took this picture of a young girl who was waving good-bye. I set my camera to Shutter Priority mode and used a slow shutter speed (1/30 of a second) to capture the movement of her hand. It's a very subtle touch in the picture, but I think an effective one.

You'll find a very dramatic example of how a slow shutter speed can affect a picture of running water in Lesson 26, "Landscapes and Nature." You'll also see some effects of using slow shutter speeds in Lesson 14, "Pan to Create Motion," and Lesson 95, "Shooting the City at Night." For examples of how a fast shutter speed can stop fast-paced action, take a look at the running horses in Part IV, "Welcome to the Digital Darkroom."

When you are in the Shutter Priority mode, you can change the shutter speed for a particular effect.

⇐ **Depth mode** is an exposure mode that's available only on Canon EOS cameras. It is useful when you want good depth of field but don't want to think about f-stops and where to focus (more on this topic is covered in Lesson 15, "Focus on Autofocus"). I don't use Depth mode too often, but I did use it for this picture in a hut in an Embera village. Here is how the Depth mode works. You set your camera on the Depth mode, then you focus on a distant part of a scene that you want in focus, and lock it in by pressing the shutter button halfway. Then you focus on a near element in the scene that you want in focus, lock it in, and then shoot. Everything in between your two focus points will be in focus.

Manual mode is the mode to choose when you want to manually set aperture and shutter speed. You vary the shutter speed and aperture until an indication in the viewfinder (usually an LED or a beep) tells you that the scene is correctly exposed. (On my first camera, I lined up a needle with a viewfinder mark that indicated the proper exposure.) Personally, the only time I use the Manual mode is when I take a fill-in flash picture (see Lesson 18, "Outdoor Flash Techniques," for more information). Here are two examples.

⇐ I took this flash picture of a woman fanning a fire in a relatively dark hut in Kuna Yala. Had I shot on Program mode, the area around the woman would have been dark, because when a flash is mounted and turned on and the camera is set to Program, the shutter speed is usually boosted to 1/60 of a second, so you don't get a blurry picture. But I set my camera to Manual, chose a slower shutter speed than the camera would have chosen in Program mode, and shot. In doing so, I was able to capture some of the natural light, while the flash illuminated the subject. My flash, like most sophisticated flash/camera setups, works automatically if turned on, even when my camera is in Manual mode.

⇐ Here is another example of shooting in Manual mode. Believe it or not, it's not a posed shot! The woman was resting on a colorful boat in Kuna Yala. Here is how I got the shot, in which the bright background and the subject, who is in the shade, are both properly exposed. I set my camera to Manual and took a reading of the background, so it would be properly exposed. Then I turned on my flash and shot. The flash illuminated the woman. The natural light was also recorded, because I had set the exposure based on the manual settings.

Bulb mode, or **B**, is a setting that I rarely use. In that mode, the shutter stays open (or is activated on digital cameras) for as long as you press the shutter release button or depress the button on a cable release. You'll find an example of such a long-shutter-speed shot in Lesson 95, "Shooting the City at Night."

LESSON 13

Bracketing and Spot Metering

Bracket over and under the recommended exposure to create options.

While we are on the subject of exposures, we should discuss bracketing. **Bracketing** means taking at least three pictures of the same scene: one at the recommended exposure, one over the recommended exposure, and one under the recommended exposure. With three different exposures, we will get at least one good exposure in most cases. (And in some cases we may get three pictures that we like!) Although I did not refer to it as such, bracketing is what I did with the photos of Hearst Castle and the Cloisters that we saw in Lesson 11.

Some pros who shoot slide film bracket in 1/3 stops over and under the recommended setting, while others bracket in 1/2 stops, and still other bracket in full stops. It really all depends on the subject. Actually, some pros live by the "BLH" rule—Bracket Like Hell—taking exposures at 1/3, 1/2, and 1 stop over and under the

recommended setting. I often bracket when shooting digital just to make sure that no areas are overexposed; areas that may look okay on the camera's small **LCD screen** may not be properly exposed on the actual file. When shooting negative film, bracketing is not as important as it is when you are shooting slide film or when you are shooting with a digital camera, because negative film has a wider **exposure latitude**.

⇐ Here is a high-contrast scene on the road from Santa Fe to Taos, New Mexico. I liked the stark contrast between the bright yellow sign and the deep blue sky, but that contrast confused my in-camera

light meter! So I took exposures both over and under the recommended setting to see which one produced the best result. The -1 setting let me capture the scene to my liking.

⇐ This sunset scene, which I photographed in Trinidad, Cuba, had a lot of contrast between the bright sun and the dark silhouettes in the foreground. Plus, the light level was constantly changing. I did not want the sunset totally washed out, so I took pictures at the recommended setting, and then at -1/2, -1, -1 1/2 and -2 stops. This picture shows the effect at -2. Technically, I was not bracketing over and under the recommended exposure; I was only selecting values under the recommended setting, a good tip for high-contrast scenes.

Some mid-range and most high-end cameras have a **Spot metering** feature (which meters only a small spot in the center of the viewfinder) in addition to an **Average metering** feature. In-camera spot meters work well when you are photographing an area with mid-tones, such as green grass, a blue sky, or a test gray card (to calibrate your meter for an accurate exposure). Like Averaging meters, Spot meters can be fooled, too. (See Lesson 11 for more on Average metering.)

⇒ That's what happened when I set my camera to Spot metering for this statue at Hearst Castle in San Simeon, California. The bright, white center of the statute fooled the camera's light meter, just as had the white sand in my Kuna Yala picture in Lesson 11.

⇐ This is how the picture looked after I increased the Exposure Compensation by +1—just how the scene looked as I saw it, with more detail in the shadows.

⇓ Here is a picture that one of my photo workshop students, Andre P. Dacarie, took of me demonstrating the use of a hand-held light meter. A situation like this can also fool a camera's Averaging meter—if the girl's light face and the dark background are both in the frame—due to the huge difference in light levels. An in-camera Spot meter aimed to read only the girl's face, would give an accurate exposure of the girl's face. But to check the exposure, I used my hand-held meter to measure the light falling on the scene—which is not affected by any of the dark or light areas in the scene. I actually held the meter right in front of the girl's face for the meter reading. This shot was taken just before I took my reading.

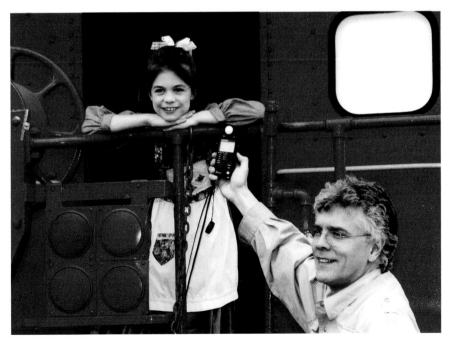

⇧ Which picture of these butterflies do you prefer: the darker or the lighter version? I simulated the lighter version in Photoshop by lightening my darker shot. Which one is a good exposure? You be the judge.

Oftentimes, you are the sole judge of what is a good exposure. Sometimes, a slightly or even very overexposed or underexposed picture can look better than the picture you'd get by following all the tips in the past three lessons. So bracket above and below the recommended range to give yourself some options.

LESSON 14	# Pan to Create Motion

Panning is moving the camera in the direction that a subject is moving.

Before the availability of Photoshop and other digital imaging programs enabled us to add a sense of motion and speed to a subject after a picture is taken (see Lesson 74, "Add Action to Still Photos"), photographers used a technique called **panning** to add a sense of motion to a still picture. Many still do. It's a simple technique of moving the camera in parallel to the direction that a subject is moving. Here is how to do it.

First, select a slow shutter speed of between 1/30 to 1/8 of a second. Then, as the subject begins to move across your field of vision, follow it in your camera's viewfinder. When the subject is directly in front of you, press the shutter release button, and keep on following the action (panning) with your camera—and your body—for a few seconds.

Sounds simple? It is. However, because the speed of moving subjects is not always the same, you need to experiment with different shutter speeds, from about 1/30 to 1/8 of a second, to find which one is appropriate for any given particular situation. Slower shutter speeds blur the background more than faster shutter speeds.

You can use the panning technique while holding your camera in your hands. However, attaching the camera to a tripod with a pan head generally produces a sharper subject.

Here are a few illustrations that show the effect of panning.

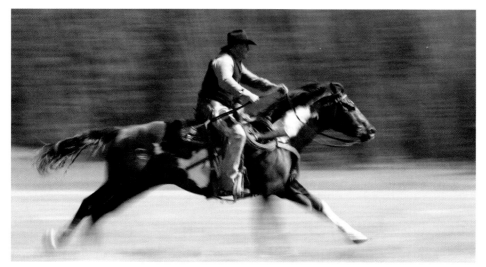

⇑ Using the panning technique, I selected a shutter speed of 1/30 of a second to photograph this rider at a ranch in Montana. This is a hand-held shot using a 100–400 mm lens at the 400 mm setting. That long focal length, combined with an aperture of f/5.6, created a shallow depth of field. Thus the background in this shot would have been out of focus even if the subject had not been moving, although it would not have produced motion streaks like we see in this picture. When composing a picture for a pan, use a wide aperture to blur the background, and experiment with several shots at different slow shutter speeds, perhaps from 1/30 of a second to 1/15 of a second.

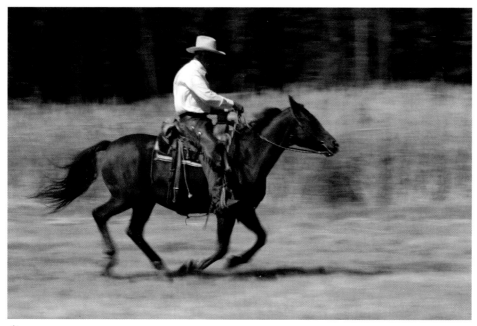

⇑ Here is an example of what I consider an unsuccessful pan. A shutter speed of 1/60 of a second makes the picture look as though it is out of focus. A slower shutter speed, perhaps 1/15 of a second, might have produced a more pleasing picture.

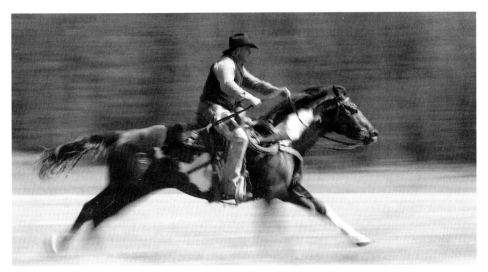

⇑ Because panning removes some reality from a picture, our mind's eye may not always accept a color panned picture as believable. If you don't immediately like your panned image, try turning your color picture into black and white. (See Lesson 56, "Work in Black and White, Photoshop Style," for more information.) Removing the color from a scene removes even more reality from the picture, which can make it more appealing.

Again, to get just one great panning effect, you'll have to experiment and take many pictures. Setting your camera's **motor drive** for a fast picture sequence (several frames per second) will give you a higher percentage of good shots.

> *"To me, photography is the simultaneous recognition, in a fraction of a second, of the significance of an event."* —Henri Cartier-Bresson

Focus on Autofocus

Autofocus cameras can focus faster than we can.

Automatic focusing for 35 mm SLR cameras was first introduced more than two decades ago. "I'll never use it," said some professional photographers. "I want to rely on my eye, and not some electromechanical device in my camera to determine what is in focus and what's not." One reason for the comments was that automatic-focusing cameras had a common problem: They could not focus quickly and accurately in all situations. This was especially true when it came to low-light and low-contrast photography, as well as when photographing fast-moving subjects.

Today, I don't know a single pro, including wildlife and sports shooters, who does not use and rely on **autofocus**. That's because today's autofocus cameras focus accurately, even at high speeds, and even in less than ideal conditions. What's more, some high-end 35 mm and digital SLR autofocus cameras even track subjects when they are moving toward the camera—a feat that was impossible for the early autofocus models.

Another reason for the new popularity of autofocus cameras among my friends is that many wear eyeglasses, and the new autofocus cameras focus more quickly and accurately than the photographer who wears glasses can.

Although autofocus has come a long, long way, too many novice photographers rely on autofocus 100 percent of the time when taking pictures. They simply point and shoot. Most autofocus cameras focus the lens on the center of the image area. Even with an autofocus SLR camera, it is possible to take an out-of-focus picture when the **autofocus sensor** is not positioned on the main subject. Indeed, we may want sometimes to take a picture in which the autofocus point the camera chooses does not represent the photographer's vision of a scene.

One example occurs when shooting portraits with a **telephoto lens**. An autofocus camera can get the focus wrong in portrait photography because, at the same **aperture** and the same shooting distance, the **depth of field** with a telephoto lens is shallower than it is with **wide-angle lenses**. The camera's autofocus sensor sees a scene differently than your brain does. Generally, you want the eyes sharp. But if the nose is closer to the camera or the ear more clearly delineated, guess where the camera may focus? What can you do in that situation? Take control of

autofocus! Use your camera's autofocus lock to choose the part of the subject you want in sharp focus. Then, recompose your picture, and shoot.

Sometimes, it's a good idea to switch off autofocus. For example, say you want a picture of your child sliding into home plate. If you were to shoot on autofocus, your camera might focus on the catcher, the umpire, or the fence in the background—if your timing or framing is a bit off, or if your camera does not focus and shoot quickly enough. Some digital cameras have a slight delay between the time you press the shutter release button and the time the picture is actually taken. That's called **shutter lag**. Here's what to do in that situation. First, use your camera's autofocus to lock the focus on the area where the action will happen: home plate. Then, switch off autofocus, recompose your picture, and wait for your kid to score.

⇒⇒ When you are looking at a scene, any scene, you need to decide on the focus point. That point that will determine what in your scene will be in focus, and what will not be in focus. For this photograph, taken in Old Havana, Cuba, I wanted the man and most of his guitar in focus. So I selected a small aperture (f/11 for good depth of field) and focused one-third of the way into the scene, near the the center of the guitar neck. Why use that focus point? Well, I was following the advice of an editor: "Many people think depth of field is distributed uniformly in front of and behind the plane of focus. In fact depth of field is about 1/3 in front of (closer to the camera) and about 2/3 behind the plane of focus. To get maximum depth of field in a landscape, for example, set the smallest practical lens aperture and then focus about 1/3 of the way into the landscape. You can verify depth of field with a depth-of-field preview button if your camera has one." Remember this "rule of thirds" as it applies to depth of field, and you'll be able to take control of the focus area of your pictures.

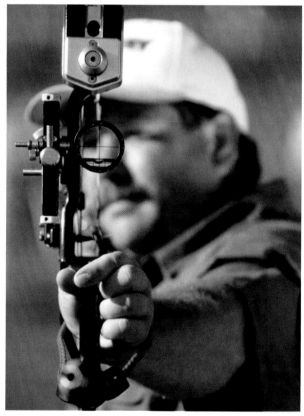

⇑ I shot this pair of pictures of an archer at ESPN's Great Outdoor Games in Lake Placid, New York, to illustrate how careful autofocusing may dramatically affect the outcome of a picture. In the left-hand picture, I locked my autofocus on the archer's eye. In the other, I focused on the bow's scope. I used a wide aperture, f/2.8, for both to limit the depth of field and to blur the background. Which picture do you prefer? I like them both.

Basic autofocus cameras offer only one autofocus mode (sometimes called "one shot"): You press the shutter release button and either a) you press harder and take the picture, or b) you hold the shutter release halfway down (locking in the focus), recompose your scene, and then take your picture. The "one shot" mode works well when nothing in the scene is moving.

More sophisticated cameras (usually 35 mm and digital SLRs) offer a "one shot" autofocus mode plus an autofocusing mode often called **Continuous autofocus**. When you set your camera on Continuous autofocus, the focus sensor actually tracks a subject as it moves toward or away from you. The Continuous autofocus mode is better suited for moving subjects, because the focus is not locked in before the shutter is released. Rather, it keeps tracking the subject right up until the time of exposure.

≪ For this picture of a jaguar, which was walking toward me in its holding area at the Belize Zoo, I used Continuous autofocusing to keep the animal in focus.

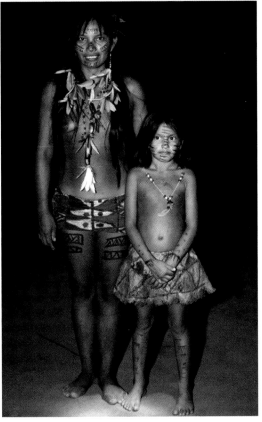

Sometimes it's a good idea to switch the autofocus off and use manual focus. In low-light situations, or when the focus-assist beam of your flash does not reach a subject, using autofocus may cause your lens to search (and search and search) for a focus point, during which time you may miss your picture. Thus focusing manually may actually be faster.

≪ For this picture of two sisters in a Taraino village in Brazil, taken in a dark hut at night, I focused manually.

"The hardest thing to see is what is in front of our eyes."

—JOHANN WOLFGANG VON GOETHE

Be Aware of the Background

The background can help or hurt your pictures.

Take a few minutes to think of all the great movies you have seen. Think about the actors. Now, think about the settings and backgrounds. The backgrounds play a major role in the storytelling of a movie. That's why movie directors and producers often pick exotic locations in which to shoot their films.

If you look very carefully at a great movie, you'll see that the actors are strategically positioned in a scene, against an appropriate background. In still photography, the background plays a "starring role," too. The background can make or break a picture—even if the subject is the #1 attraction. The background has to be interesting, but not to the point of being distracting.

As photographers, we need to pay the same close attention to the background that we do to our main subject. That's the only way we are going to help our picture "tell a story."

Our eyes and brain see a scene in three dimensions (height, width, and depth), while our cameras record only two (width and height). So, we have to learn how to see in two dimensions, in which all the elements in the scene are compressed into a flat plane. If we don't, we may take a picture in which a background object ruins our image because it appears in the same visual plane as the subject.

Compare these two pictures, amazingly similar in subject matter, to see which one is more pleasing.

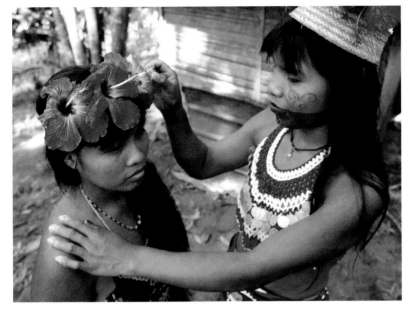

⇐ I took the picture of the Embera woman arranging hibiscus flowers in her friend's hair in Panama. The background does not add to the scene. Rather, it detracts from it. The four palm trees behind the one girl look as if they are growing out of her head. And the patch of bright sunlight on the house in the background has washed out all the detail. The next picture has a more pleasing background.

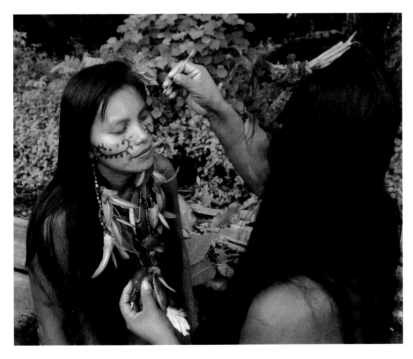

⇐ While shooting a Taraino face-painting ceremony in Brazil, I asked the women to move to a more picturesque location nearby where the background was not distracting, yet still told the story of being in the dense rain forest.

⇑ Compare these two pictures to see which one tells more of a story. Which one keeps your attention longer? These pictures are actually the same shot. I removed the boy from the background with Photoshop for illustrative purposes. This is an effective example of how watching for a background element or elements to come into a scene (and go out of a scene) can have an impact on a picture.

The two pictures on the opposite page illustrate a different background technique: selecting a background and waiting for someone or something to come into that background.

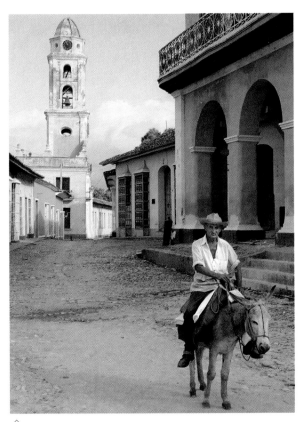

⇑ In Trinidad, Cuba, I waited at sunrise in the town square for someone to enter into the scene. In this case, the man and his mule rode in to make the shot!

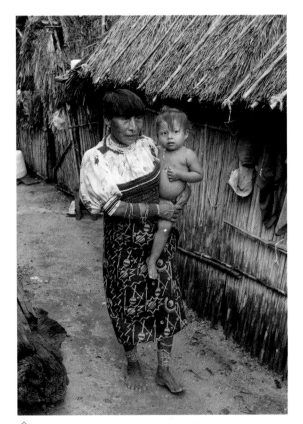

⇑ While shooting in Kuna Yala, Panama, I noticed a narrow, sandy road lined with thatched homes. It was a perfect background for a picture of Kuna life. I waited for some time until a woman started walking down the road, and then snapped my shot.

⇐ Here is a picture I took of a painter in Trinidad, Cuba. The artist was in his studio, facing out an open window. I said hello and asked if I could take his picture. The background is busy, filled with many of the artist's paintings. He shirt is busy, too, like the walls of his studio. Normally, I would say that busy backgrounds don't give the subject a chance to stand out. In this case, however, I like the dynamic patterns, because they make a statement on the artist's work. You don't have to agree. That's what photography is all about—personal likes and dislikes.

But in all cases, when you are looking through the viewfinder, be aware of the background—it can help or hurt your pictures.

LESSON 17

Indoor Photography: To Flash or Not

Experiment by taking indoor pictures with and without a flash.

Many readers are probably too young to remember the smell of a "popped" flash bulb in a professional flash unit—and how the photographer had to use a handkerchief (also now out of style) to remove the hot bulb from the bulky and heavy flash gun, which may have held four or five D-cell batteries. Flash guns and flash bulbs like the ones just described were also used underwater in the early days of underwater photography. My dad used just such a flash setup in the 1950s on his 4 × 5 Linhof camera. He got accurate flash exposures, because he followed the chart on the flash that gave the suggested f-stop for the flash-to-subject distance, given the speed of the film he was using.

These days, flash photography is much more compact, lightweight, and creative. My dad's flash unit was attached to his camera. Today we can position the flash off-camera with a **coil sync cord** for effects like sidelighting.

And flash photography is very reliable today, thanks to automatic **TTL (through-the-lens) flash-metering** systems that give us a higher percentage of good flash pictures both indoors and out. How does TTL work? You press the shutter button on your camera and the flash fires. When the light reaches the subject, it bounces back to the camera, through the lens, and the flash is turned off . . . for the correct exposure in most cases. Sure, flash-to-subject charts are still provided with flash units (on paper or on the unit's LCD panel) for manual flash control. Most professional travel and news photographers rely on TTL most of the time—but, and this is a big "but," they know how to fine-tune the TTL exposure when needed, which we will get into later in this lesson.

⇒ Let's take a look at a natural light picture of my good friend, Cuba's leader, Fidel Castro. Only kidding! As you may have guessed, the figure in this photo is a wax likeness on display at Madame Tussaud's Wax Museum in New York City. Due to the low light level in the museum, I set the ISO on my digital SLR camera to 400. And because spotlights illuminated Fidel, I set my camera's **White Balance** to Tungsten (covered in Lesson 33, "Controlling Color"). Slide shooters would use tungsten-balanced film in this situation for accurate color. Color print film shooters can use daylight-balanced film because the color can be corrected in the printing process. I shot in **Program mode**, which sets both the shutter speed and aperture for the existing lighting conditions.

If you compare this picture with the next picture, you will see the difference between a flash picture and a natural light picture, the natural light picture being, you guessed it, more natural! With the right technique, we can get a fairly natural-looking flash picture, as we will see shortly.

⇒ Notice the harsh shadow on the right side of Fidel's head. That's what may happen when you use a point-and-shoot camera with a built-in flash that is close to the lens, or if you use an SLR or ZLR camera with a hot-shoe-mounted flash and hold your camera vertically, which positions the flash off to one side.

⇊ Check out this shot. Here I am showing the wonderful photographer Annie Leibovitz (in a wax likeness) the flash system I use to reduce the harsh shadows in flash pictures. Look closely and you'll see that my flash is mounted on a bracket that lets me position the flash relatively high above the lens.

The flash is attached to the camera with a coil sync cord. The bracket swivels, so even when I am taking a vertical picture, my flash is above the lens— ensuring that the shadow from the flash always falls behind the subject, not next to it. What's more, I mount a flash **diffuser** over my accessory flash. The diffuser softens the light for a more natural effect. (See Lesson 24, "Reflect or Diffuse Natural Light," for more information about these accessories.)

⇒ Compare this picture with the previous picture without reading further, for now. See the difference? All the "hot spots" on Fidel's face are gone. I retouched them in Photoshop using the Healing Brush tool, found in the Tool Bar. When photographing a person without makeup, you may get similar "hot spots."

⇑ Here is my shot of Fidel taken with the flash setup just discussed. Because my flash is positioned above the lens, the harsh shadow is gone, and only a faint shadow falls behind the subject.

The solution is to retouch them in Photoshop or another digital imaging program. During a photo session, you can use a product called Anti-Shine that is available at cosmetic counters in department and drug stores. (I use Anti-Shine myself whenever I make a television appearance.)

In the next series of pictures we'll take a look at how to get a very natural-looking flash picture indoors.

⇑ Here is a natural light shot of my son, Marco. It was taken in our kitchen on a sunny day, so I set my camera's White Balance to Shade and my camera on Program mode. Turns out the light level was too low for a hand-held natural light picture, which is why camera shake caused a blurry picture.

⇑ When I set my digital SLR camera to Program mode and turned on my flash, my camera (as yours probably does) boosted the shutter speed so I would not get a blurry picture. Some cameras boost the shutter speed to 1/60 of a second, others to 1/90 of a second in Program mode. My f-stop and shutter-speed combination was higher than the natural light exposure. That's why the background is dark and why there is a harsh shadow under Marco's arm.

⇒ Look at how natural this picture looks. It's actually a flash picture, one that combines flash and natural light for a pleasing effect. Here is one way to do it, the easiest way for novice photographers, when you have a reasonable amount of daylight in your scene:

1) In Program mode, take an exposure reading of the scene with your flash turned off.
2) Set your camera to Manual Mode and set your exposure to the reading you got in Program mode. Make sure your shutter speed is not higher than the maximum shutter speed at which your flash will sync. (That information is in your instruction manual.) If it is higher, your picture may have a deep shadow over part of the frame. Also, if the shutter speed is relatively slow, say 1/2 second, some areas of your picture may be blurry. Therefore, you may have to switch to a higher ISO setting to get the desired shutter speed.
3) Turn on your flash and shoot. If you have a relatively new SLR or ZLR camera with TTL metering and a flash with TTL metering, you should get a good exposure, because most TTL flash units still work on TTL (automatic) even when the camera is in Manual mode.

If your subject does not fill the frame, you may have to reduce the light output of your flash (if you have a flash that lets you vary the light output with a "+/-" control) or adjust the Exposure Compensation (using the "-" control) on your camera to get a good exposure. If the subject does not fill the frame, the flash will try to light the entire scene, part of which may be behind your subject. So in trying to light the background, your flash may overexpose your subject.

You may need to experiment with the light output of your flash to get the correct exposure. If the subject is small in the frame, you may need to reduce the light output by one stop or two. On a digital camera, you can see the results immediately on the camera's LCD screen. With a film camera, take several shots at different settings.

⇒ Here is an important flash tip. For this photo, my wife, Susan, filled the frame with supermodel Elle McPherson and me during another visit to Madame Tussaud's Wax Museum. Why is the photo so dark, even though Susan filled the frame with us and shot on automatic? In flash photography, the color of the subject can also "fool" the TTL flash-metering system. In this case, all that white on Elle's body made the TTL flash-metering system think the scene was brighter than it actually was, which resulted in an underexposed picture (simulated in Photoshop to illustrate this point).

If you have the opportunity to photograph Elle McPherson in a white blouse, or anyone with a white shirt, you'll need to increase the exposure by perhaps 1 or 1 1/2 stops. It's best to experiment to get the proper exposure. Here Susan increased the exposure by +1 stop for a good exposure.

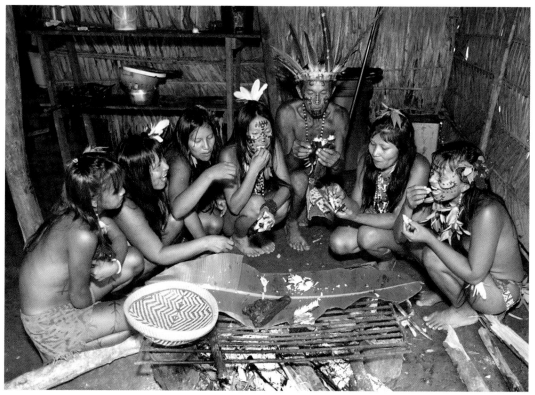

If you are serious about taking indoor flash pictures while traveling, take a backup flash unit. Had I not had a backup while shooting in a Taraino village in Amazonas, Brazil, I would have missed photographing the traditional meal—fish wrapped in a palm leaf and steamed underground. My primary flash unit had just died.

Several things can happen to a flash unit to prevent it from working properly: The batteries can leak and corrode the battery connections, the hinges of the battery compartment door can come loose, the plate that holds the flash to the **hot shoe** can become loose (or worse, break off), or the electronics can somehow get zapped (perhaps by moisture), causing an internal short, which may prevent one or more features of the flash from functioning.

Actually, if you are serious about photography it's a good idea to have backups of all your gear. In addition to a backup flash, if you use rechargeable batteries, take a backup recharger, just in case your prime charger gets zapped in a power surge (which happened to me on a boat in the Galapagos). Actually, it is a good idea to travel with a small power-surge protector; one-socket surge protectors are available at most electronics stores.

Of course, keep plenty of extra batteries on hand, so you are not "left in the dark," so to speak, when it comes to getting an indoor flash picture. And if you want to get serious about taking indoor, natural light pictures when traveling, pack a tripod. It will help steady your camera during long exposures. Also be prepared to shoot at relatively high ISO settings on your digital camera or to shoot with ISO 400 or faster film.

⇑ Here is, believe it or not, an indoor, natural light picture I took at night inside the Venetian Hotel in Las Vegas, Nevada. I set my camera to ISO 800 and mounted it on a tripod to steady my camera during the 1/15 of a second exposure. My camera's White Balance was set to Tungsten.

Red-Eye

When It Happens. What Causes It.
How to Remove It.

Red-eye sometimes happens when a flash picture is taken of a person in a dark room. The darker the room and the closer the flash is to the lens, the more pronounced the red-eye effect. Blond, blue-eyed people tend to show red-eye more than other people. To illustrate the red-eye effect, I photographed my son's friend Adrian (who has blond hair and blue eyes) in a dark room with a camera that has a flash close to the lens.

Here's what causes red-eye. In a dark room, our pupils open wide so we can see better. When the flash goes off, it is actually illuminating the blood vessels on the retina. So the red we see in red-eye pictures is actually all those tiny blood vessels.

There are several ways to reduce or eliminate the red-eye effect. In Photoshop, it's easy to get rid of red-eye. First, select the red area of the eye (using the Oval Marque tool found in the Tool Bar). Then go to **Image > Adjustments > Color Balance**. Finally, use the Saturation slider to desaturate that area of the picture. This illustration shows the results.

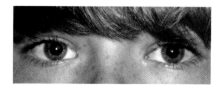

During a photo session, we can reduce or eliminate red-eye several ways: Make the room as bright as possible; have the subject stand near a light source, such as a lamp (which closes down the subject's pupils by increasing the amount of light); use a coil sync cord and position the flash off-camera; or ask the subject to look slightly away from the lens. Keep in mind that you'll get more red-eye pictures with wide-angle lenses than with telephoto lenses under the same conditions. I used several of these techniques to eliminate the red-eye effect in this picture of Adrian below, including a wardrobe change to a white shirt.

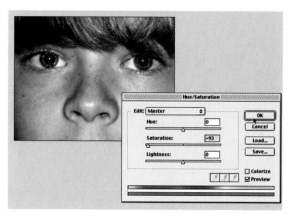

> *"There is a single light of science, and to brighten it anywhere is to brighten it everywhere."*
>
> —ISAAC ASIMOV

Outdoor Flash Techniques

Sometimes the contrast range or shadows in a scene call for daylight fill-in flash.

One of my most important outdoor photography accessories is my flash unit. Without it, and without the backup cameras, backup flash unit, and extra batteries that I always have with me, I'd miss capturing scenes with a wide contrast range between the light and dark areas. When set properly, a flash compresses the brightness range of a scene, so the light to dark range is not exceedingly wide.

In this lesson, we'll take a look at a few outdoor flash pictures—technically called **daylight fill-in flash** pictures, because the flash fills in the shadow areas of a scene. In looking at these examples, try to keep in mind situations in which you could have used—or would use—a flash for improved results.

Also keep in mind that all these pictures were taken with my digital SLR camera set on **Program mode**. When set to that mode, my camera (and most SLR and ZLR cameras) still offers **TTL flash metering** for fully automatic flash photography. In Lesson 12, we saw another example of daylight fill-in flash photography using **Manual mode** (the photo of the woman resting on the boat).

⇐ This picture of an Atlas moth is a good example of daylight fill-in flash photography. The flash, a ringlight in this case, filled in the shadows caused by harsh sunlight.

 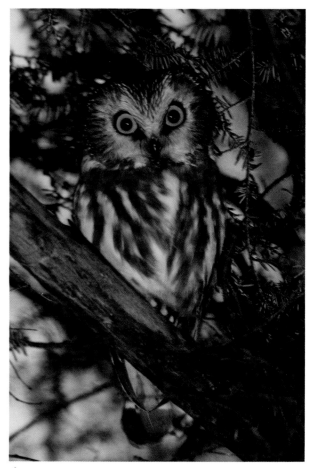

⇑ While walking through the woods near my home, I looked up (following the tip for opportunities: always look up, back, and down) and spotted this saw-whet owl sitting on a branch about 10 feet over my head. My human eyes, with their 11 or so f-stops could clearly see the owl. But my digital camera can see only about 5 f-stops. (Recall Lesson 7's discussion of what we see vs. what our cameras can record.) So, with my camera in Program mode, I got a picture in which the sky was a bit overexposed and the owl was very underexposed, because the camera's exposure meter tried to average the exposure of the entire scene. (If I had used the camera's **Spot metering mode**, the owl would have been properly exposed, but the sky would have been totally washed out, because it was many times brighter than the light falling on the front of the cute little owl.)

⇑ Then I took a flash picture of the owl. The sky is darker and the owl is brighter—but still not bright enough. That's because I did not have a super-powerful flash; the light from the flash did not reach my subject sufficiently.

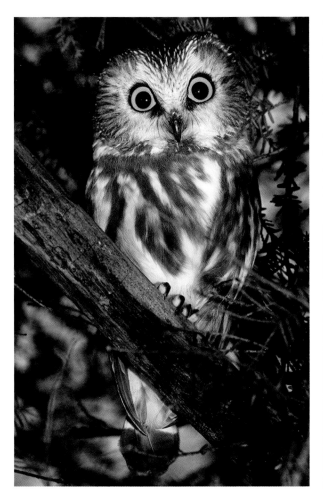

⇐ But look what happened when I used my **flash extender** (a device that attaches to the flash with Velcro) which narrows the beam of light and extends its range. My owl is now beautifully lit. I was able to shoot with the camera on Program and the flash set on TTL automatic metering, because the owl and the surrounding branches filled the frame. In Photoshop, I cropped the picture for more impact.

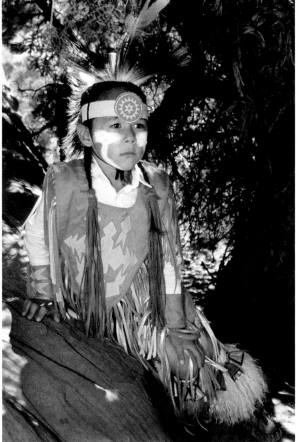

⇒ For this little Navaho boy sitting in the shade, I had to "stop down" the power output on my automatic flash by 1 1/3 stops. I could do that because I have what's called a **variable-output flash**, which lets me increase and decrease the light output up to three stops over and under the standard (automatic) setting. Had I shot at the automatic setting, the flash would have tried to fill the entire area of the scene, including the branches behind the subject. If that had happened, the boy would have been overexposed, because the light from an automatic flash does not turn off until it has bounced back from the farthest object in a scene and back into the camera. That's why in automatic, single-unit flash photography, everything has to be on the same plane to be properly exposed.

When using a variable-output flash, experiment with different settings: -1, -1 1/3, -1 1/2, and so on. If you have a digital camera, you'll be able to see the best setting immediately on the camera's LCD screen. When you use a film camera, take several exposures to get the one that's just right.

⇐ This picture, taken in a small village in South Africa, is a good example of the importance of using a flash outdoors. At first glance it does not look like a flash picture—because the light from the flash is perfectly balanced to the daylight and I used a flash diffuser over my flash to soften the light. (See Lesson 24, "Reflect or Diffuse Natural Light," for more information on flash diffusers and flash extenders.)

This is a film shot, not a digital one, so I did not know at the time which variable-flash setting (-1, -1 1/2, etc.) would produce the best result. But I did know that the contrast range in the scene—the young women's dark skin against the bright dirt—required using a daylight fill-in flash. I took almost two rolls of pictures at every setting possible to get this evenly balanced shot.

⇒ Whenever a subject's face (or eyes in this case) is hidden in a shadow created by a hat or mask, I used a daylight fill-in flash. Imagine what this picture of a masked dancer would look like if a flash had not been used. We would not be able to see the subject's eyes, one of the most important elements in this scene.

One of my favorite flash photography expressions is this: "Take the damn flash off the camera." By taking the flash off the camera—either by holding it with your hand or by having it mounted on a bracket—you can get more creative lighting effects. Of course, you'll need a coil sync cord to keep your flash connected to your camera, and your camera must have a flash connector (**hot shoe** or **flash socket**).

⇓ Here is one example of how taking the flash off the camera helped me get a good shot. This dancer is actually standing in a parking lot in Bangkok, Thailand. She welcomes guests to the hotel. Behind the dancer is the hotel wall. To "erase" the wall, I took the flash off the camera, held it higher than her head, and tilted it slightly downward. Doing that caused the light from the flash to fall directly behind her, and not on the wall—as would have happened if I had shot straight on with the flash mounted on my camera.

⇑ Had I not used a flash for this portrait of my friend Judy Nelson, taken on a hilltop on her Texas ranch, we would not be able to tell who was wearing the cowboy hat. The flash lit Judy's smiling face, and because the light from the flash was balanced to the light from the sunset in the background (again by setting my digital camera on Program mode and by experimenting with the variable-output setting on my flash), both Judy and the background are properly exposed. I was shooting with my digital camera, so I was able to instantly see my result. In this situation, the -1/3 setting on my flash produced the best result.

⟸ I took this "grab shot" of a man during my first trip to Cuba. It's not a flash shot. I include it in this section to illustrate a point: Don't get carried away with daylight fill-in flash, as great as it is. Sometimes, a natural light shot will look better than a daylight fill-in-flash shot. Sometimes, you don't want to see the person's eyes; leaving them dark can add a sense of mystery. In this case, the light from the flash would have caused all the man's piercing rings to cast myriad shadows on his face. The flash might also have reflected off the bright rings and caused annoying hot spots in the picture. So, remember this man's face—and remember that there is a time and place for all photo techniques.

"The so-called rules of composition are, in my mind, invalid, irrelevant and immaterial." —ANSEL ADAMS

Compose in Thirds

Imagine a tic-tac-toe grid over your scene.

This lesson on the rule of thirds may be one of the simplest in this entire book. It is one of the most important, however.

Imagine a tic-tac-toe grid over a scene. Place the main subject at one of the intersections where the lines of the grid meet. More often then not, you will have created an interestingly and artistically composed shot.

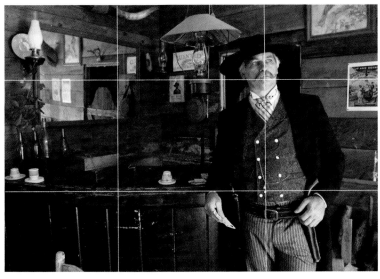

≪ That's exactly what I did for this picture I took of a gambler in Marrow Bone Springs, Texas. When we superimpose a tic-tac-toe grid on the photo, we can see that two of the lines intersect right on the gambler's face. (I drew these lines in Photoshop using the Line tool, found on the Tool Bar. I went to **View > Show > Grid**, which shows a grid over a picture, and was able to draw straight lines by following the grid.)

⇐ I also used the rule of thirds for this picture of the Official Parking Man (or "Oficial Parking Man", if we read his sign carefully) in Trinidad, Cuba.

Notice something else about the pictures of the gambler and the Cuban man. Both subjects are looking out of the frame, not into the frame nor at the camera. Many photographers prefer a shooting style that has the subject looking away toward a point beyond the frame. Consider using that technique when you are shooting.

⇑ Early one morning in Trinidad, Cuba, I jumped on a charcoal wagon (which, even in the twenty-first century, delivers charcoal to residents) and snapped this picture as we drove through the cobblestone streets. It's another example of how the rule of thirds makes your eye roam around the picture to create more interest. In Lesson 11 we saw this image as an example of underexposure by -1/2 stop.

⇐ We can use the rule of thirds for landscape pictures, too. Here I composed my picture with the bow of the boat at the point near where two of the lines of my imaginary tic-tac-toe grid intersect.

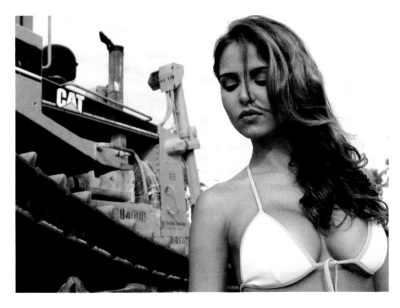

⇐ An off-center subject is more dynamic. When we compose a picture using the rule of thirds, our eyes wander the frame, making a picture more interesting.

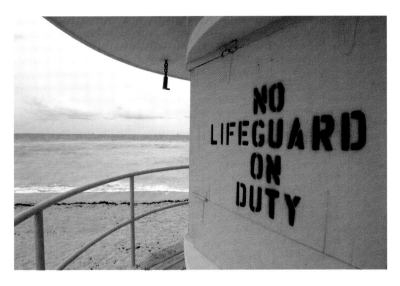

⇐ This picture of a lifeguard stand on South Beach is "cut in half" by the vertical line running down the center of the frame. The picture is also "cut in half" by the horizon line. Usually, cutting a frame in half like this is a photo taboo because it creates a static picture. I have included this picture in this lesson to illustrate an important point: We don't always have to compose in thirds. Breaking the rules is sometimes a good idea.

"Composition is the strongest way of seeing."

—Edward Weston

Compose Creatively

Don't forget to use your feet as a zoom lens.

The images in this lesson illustrate some ideas about composition—a key element in all pictures. Specifically, we'll look at how using different lenses and different elements in the scene, plus using your feet as a "zoom lens," can result in dramatically different pictures.

The first set of pictures in this lesson was taken at the Bodhnath stupa, the largest in Nepal. Stupas were originally built as shrines to house relics of the monks and holy artifacts. This ancient monument, draped with flags that carry prayers into the wind, is topped with the giant eyes of Buddha—eyes that stare down on visitors to this sacred place. (I digress from offering photo tips to share this little bit of information about Bodhnath for a reason. Learning about your subject—be it a stupa in Nepal or a sloth in the rain forest of Costa Rica—makes photography more fun. Plus, the more you know about your subject, the better you can picture it.)

When I'm shooting outdoors, I often have one camera with a 70–200 mm zoom lens on one shoulder, and one camera with a 17–35 mm zoom lens on the other. That setup lets me quickly and easily compose wide-angle and telephoto shots. The pictures of the stupa were taken with the 70–200 mm zoom near the 200 mm setting.

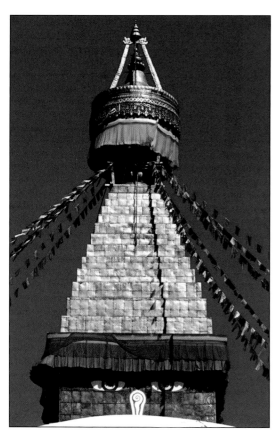

⇐ Here is a fairly boring picture of the top of the stupa. I feel it's boring because it's flat—the flat face of the structure is directly facing the camera. Plus, there are no foreground elements to give the picture a sense of depth.

⇐ When I moved just a few feet to the side, however, I was able to include some of the prayer flags in the foreground for a much more interesting picture.

⇓ Here is an even closer shot that shows the eyes of Buddha and some of the flags, but I think it's a bit too tight for the story I want to tell.

⇒ This is my favorite close-up shot of the top of the structure. I like it because the prayer flags in the foreground frame the top of the stupa. The picture has depth. And I like the way the blue sky surrounds the tower. But there is something else about this picture that is different from all the others in this lesson: it's cropped almost square, because I cropped out all the areas of the scene that did not add any interest to the picture. So don't get locked into the horizontal or vertical formats created by your camera. Think about creative cropping when you are thinking about creative composition. (The next lesson, "Crop Creatively," explores cropping ideas.)

⇑ This picture of the giant Buddha statue, surrounded by 10,000 smaller Buddha statues, at the Chuang Yen Monastery in Carmel, New York, illustrates an important composition technique: Compose to "tell the story" of a place. For this picture, I used my 16–35 mm lens set at 16 mm.

⇧ I photographed this man in Old Havana, Cuba. For me, the man's shadow on the blue wall made the idea of this picture a fuller image. So I included the man and his shadow in my shot. Notice where the man's head would be if we drew our tic-tac-toe grid over the frame.

⇧ I photographed this log-cutter at ESPN's Great Outdoor Games in Lake Placid, New York, 1999. To illustrate the power of the saw, I made the saw blade a main element in the frame to draw us in. Again, notice where the man's head would be on our tic-tac-toe grid.

"Recording images, serenity and beauty was a matter of devout observance."
—GORDON PARKS

LESSON 21 | Crop Creatively

See pictures within a picture.

When we look through the viewfinders of nearly all cameras, we see a scene that's in a rectangular format. But who wants to be limited by the shape of the frame? Not a creative photographer, that's for sure.

Take a look at the pictures in this lesson of a young woman photographed in Old Havana, Cuba, of some members of a Taraino tribe in Amazonas, Brazil, and of a snow leopard photographed at New York's Bronx Zoo. They show how the original rectangular shape can be changed by cropping to create a more interesting image.

In the pictures of the young woman, notice how the tighter cropping draws more attention

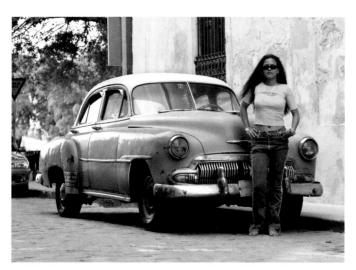

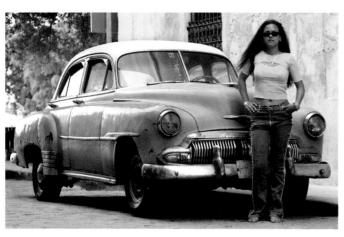

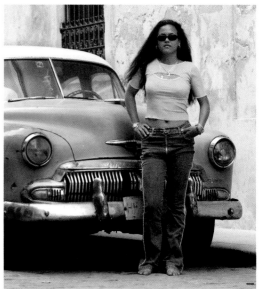

to the subject. The last, square picture in the series may be cropped too tightly, because the vintage car is an important element in the scene, yet it still shows how cropping can dramatically change a photo. Here's a bonus tip: Compare the angle at which I shot the young woman in this lesson with the angle at which I shot the girl in Lesson 56, "Work in Black and White, Photoshop Style." I took the picture in this lesson at a very low angle, and the picture in the other lesson at slightly above eye level. When you take a picture, those few feet can affect how we view a subject: the lower angle makes the subject look more dominating.

In the pictures of the Tarainos, notice how cropping actually produced two separate pictures, both of which were within the original shot.

When you are composing a scene, you should try to "cut the clutter" or "fill the frame," but keep in mind that cropping—in the digital or traditional darkroom—is an option that can produce a more creative picture or even several interesting pictures from the same frame.

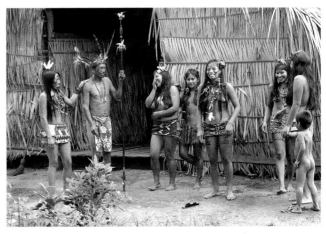

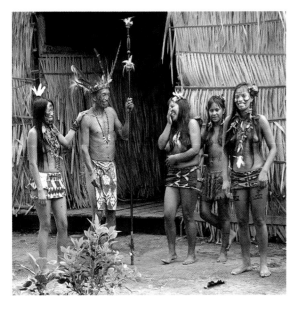

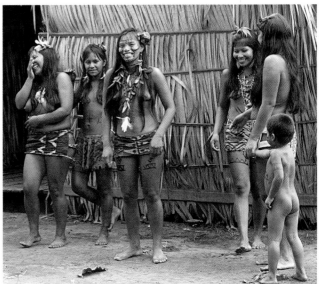

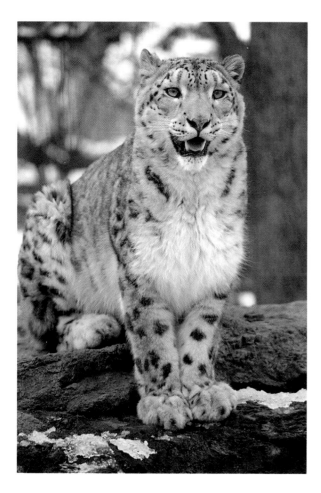

Using my Canon EOS 1D and 100–400 mm lens set to 400 mm, I took this picture of a snow leopard at New York's Bronx Zoo. I liked the magnificent animal's expression and the lighting on its body, but I found the background too distracting. Rather than trying to fix the background in the digital darkroom, I started to play around with cropping, using the Crop tool found in Photoshop's Tool Bar.

After cropping out the background almost completely, I got an image that reminded me of a bookmark. So I decided to create a bookmark for my son, Marco, an avid reader. Here's how I did it:

1) I enlarged the image area by expanding the canvas size above the cat (see Lesson 48, "Increase the Canvas Size").

2) After selecting a dark brown color (**Window > Swatches** and clicking on dark brown), I selected the area above the cat (using the Rectangular Marquee tool found on the Tool Bar) and filled it with the new foreground color (**Edit > Fill > Foreground Color**).

3) Next I added text using the Type tool (see Lesson 69, "Add Text to Your Photographs"). Notice how the color of the type matches part of the animal's fur. That's because I used the Eyedropper tool (found in the Tool Bar) to pick up a color from the fur.

4) After I was finished in the digital darkroom, I printed my image on canvas paper for an artistic look (see Lesson 41, "Pick Paper for Your Printer").

5) Finally, I used a professional paper cutter to trim the edges of my bookmark—which my son loves, by the way.

"It is not length of life, but depth of life." —Ralph Waldo Emerson

LESSON 22	# Create a Sense of Depth

Different compositions can create a sense of depth.

We see the world in three dimensions: height, width, and depth. But our cameras see only two dimensions: height and width. So, it's our job as photographers to try to create a sense of depth in our pictures.

In this lesson, we will examine a few pictures that illustrate creating a sense of depth—so our pictures don't "fall flat."

⇊ This picture of a gravesite near Taos, New Mexico, has a good sense of depth. The scene itself actually has good depth, created by a foreground element, the other gravesites in the background, and the hills in the distance. I focused my 16–35 mm lens set at 16 mm one-third of the distance into the scene's depth with a small aperture so everything beyond that point would be in focus.

⇑ Photographed straight on, without a foreground element in the scene, the St. Francis Church in Taos, New Mexico, looks flat and boring.

⇒ But look what happens when a foreground element (a statue of St. Francis) is included in the scene. The scene now has a sense of depth.

⇓ And look what happens when the foreground element becomes more prominent in the scene. The sense of depth increases. So, include that foreground element and you'll create a sense of depth. All these pictures were taken with my 16–35 mm zoom lens set between 16 mm and 20 mm.

⇐ In addition to including a foreground element in the scene, lighting has much to do with creating a sense of depth. I took this picture of the church right before sunrise, when there were no shadows in the scene. Despite the foreground element, the picture looks a bit flat due to the flat lighting. So think about including shadows when creating a sense of depth.

⇓ Speaking of shadows, look at how shadows added a sense of depth to these pictures of carvings in a temple in Khajuraho, India. The first picture, taken on an overcast day, looks a bit flat, but the picture taken in the late afternoon has a great sense of depth. The change in lighting made the difference.

 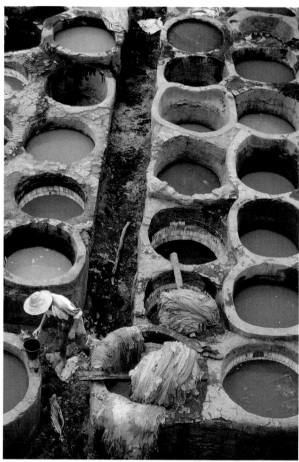

⇑ Which of these two images seem deeper? Both pictures, taken from positions just a few feet apart, show the Fez Tannery in Fez, Morocco. The left-hand picture of the vats of dye going from the top left corner to the bottom right corner has a good sense of depth. The right-hand picture of the vats of dye, basically going from the top of the frame to the bottom, has less of a sense of depth. When composing a scene, think about how different compositions can create a sense of depth.

LESSON 23 | Picture a Person in a Scene

Position the person close to your lens and ensure that the background is in focus, too.

Picturing a person in a scene is different from taking an environmental portrait of a person (see Lesson 90, "Environmental Portraits vs. Head Shots"). When you want to picture a person in scene, you are basically asking someone to position himself or herself near a building or structure, because you want a picture with both subjects.

During my travels, I see people trying to take a picture of a person in a scene all the time. Most often, the photographer makes the same mistake: he or she asks the person to stand too close to the building or structure—and too far away from the camera. The result: the building fills the frame, which is a good thing, but the person is much too small in the picture, perhaps to the point where he or she is unrecognizable.

I once saw a person standing on the steps of the U.S. Capitol while the photographer stood far enough away so that the Capitol building probably filled the frame. My guess is that person's head in the photo was about the size of a pea.

The pictures in this lesson illustrate the dos and don'ts of picturing a person in the scene. But before we get to positioning techniques, let's talk about lenses and apertures. Generally speaking, you want to use a **wide-angle lens** set at a small **aperture**. With that setup, you can get a lot in focus—from a few feet in front of your lens to infinity. Remember that as the aperture number increases (f/5.6 to f/8 to f/11, etc.), the **depth of field** increases, and as the **focal length** of the lens decreases (35 mm to 28 mm to 20 mm, etc.), the depth of field at the same aperture increases.

So why do you need all that depth of field? First, you want to position your subject relatively close to your lens, so that he or she becomes a central object in the frame—an object that is in sharp focus. Second, you want the building or structure (or even the landscape or seascape) in the background to be in focus, too. To get both elements in focus, you need the aforementioned lens-aperture setup.

The pictures in this lesson, taken in Miami Beach, were taken with a 16–35 mm zoom set at 16 mm. The aperture was set at f/11. Simply changing the subject's position and my shooting position created the different effects.

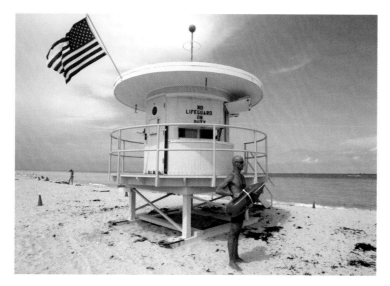

⇐ Here is an example of what happens when a person is positioned too close to a structure and too far away from the camera. The pink-and-yellow lifeguard stand looks okay, but the lifeguard is hardly recognizable. Plus, he is somewhat "lost" in the scene—that is, he is not isolated from the lifeguard stand.

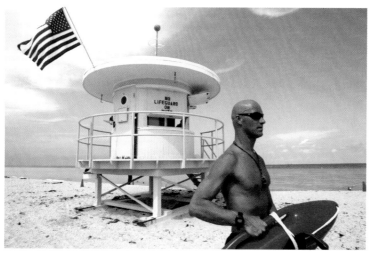

⇐ This shot is a little better. I moved a little closer to the lifeguard stand, and the lifeguard stood a bit closer to me. However, the lifeguard could still be closer. What's more, he is looking out of the scene, which, in this case, does not seem to work. Having a person (or animal) look into the scene may be more pleasing than having the subject look out of the scene. However, I've seen many fashion advertisements and music videos where the person is looking out of the scene with a pleasing effect.

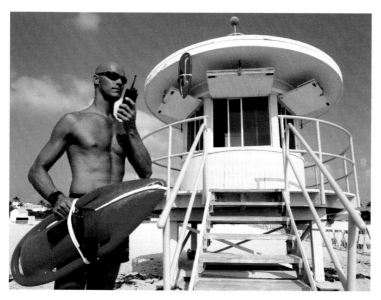

⇐ This shot shows how to picture a person in a scene to better effect. The lifeguard is close to the camera and is looking into the scene. The lifeguard stand is a strong element in the scene, because I moved much closer. Both subjects are in sharp focus and create a dynamic tension.

By the way, I know the lifeguard looks very stiff, like a statue. That's how he normally looks, each day while on duty at South Beach. His bronzed, chiseled body and shaved head add to this statue-like appearance. I thought his "look" was appropriate for this picture, which is why I did not ask him to relax during the photo shoot.

⇐ Here is a set of pictures that I took in an Embera village in Panama, that illustrates the difference between including a person in a scene and not including one. Which picture of the laundry drying on the plants do you feel is more interesting? If you chose the picture with the little child, I'd agree, and so would my editors, Dave Langford and Benny Snyder at Associated Press Travel Features, who always encourages me to include a person in a scene!

"The eyes are the windows to the soul."

—ANONYMOUS

LESSON 24

Reflect or Diffuse Natural Light

Reflectors and diffusers redirect or alter the amount and direction of existing light.

As photographers we can sometimes control the natural light that falls on a subject. We can control the color, quality, and, to some degree, the amount of light. By controlling the light, we can turn poor lighting conditions into ideal lighting.

One way to control light is to use an electronic flash, as was described in Lesson 18. A flash unit adds a bit of momentary light to the existing light. Another way to control light is to use reflectors and diffusers. These devices redirect or alter the amount and direction of existing light. Disc or oval-shaped reflectors and diffusers are available in several different sizes, from one foot to several feet in diameter. Portable, they collapse and fold so you can store and carry them easily.

Diffusers soften harsh light that passes through them for a more pleasing effect. **Reflectors**, which are available in white, gold, and silver surfaces, bounce light onto a subject to fill in shadows and can add highlights and contrast to a subject. Gold reflectors bounce a "warmer" light onto a subject, giving the subject the appearance of being photographed in the late afternoon or early morning. Silver reflectors bounce a harsher light onto a subject.

For most professionals, reflectors and diffusers are essential accessories. I never leave home without them.

⇐ A midday sun produced harsh and unflattering shadows on the face of my nephew, William.

⇐ This behind-the-scenes shot shows my son, Marco, holding a diffuser over William. As you can see, harsh shadows are everywhere, except on William.

Photo by Laura Rickett.

⇐ Look at the big difference the diffuser made. A soft and flattering light is now falling on William.

⇐ Diffusers can be used to bounce a soft light onto a subject, too. While on assignment in Kuna Yala, Panama, I encountered a Kuna woman I wanted to photograph. She was standing in the shade, where there was very soft, low-contrast lighting. To increase the contrast of the portrait, I had my guide/assistant Gilberto, hold a diffuser under and near the subject's face. He moved the diffuser around until it caught the light in such a manner that light was reflected onto the subject.

⇐ Here is the portrait of the Kuna woman. The soft light looks totally natural, because just a hint of light was added. Had I used a gold or silver reflector held that close and under the subject's face, the effect would have been what pros call "Halloween" or "Frankenstein" lighting, unflattering lighting coming from underneath the subject's face. (Stand in front of a mirror, hold a flashlight under your chin to see the "Halloween lighting" effect.)

Reflectors can also dramatically improve a portrait when the subject is in bright sunlight, but his or her face is in the shade.

In this natural-light example without a reflector, the Montana cowgirl's face, shaded by her hat, is visible, but it's a bit darker than the surrounding area. Personally, I think this picture is a flop, because we want to see the girl's face, and we have to work too hard to see it.

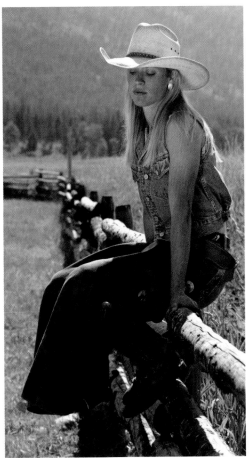

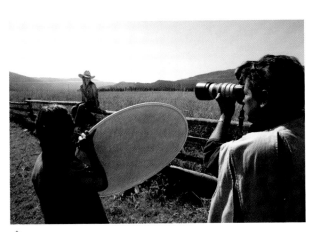

↑ Look closely at the cowgirl in this behind-the-scenes picture. Even though she is much smaller in this scene than in the previous picture, you can probably see that her face has more light on it. That's because my assistant, on the left, is holding a gold reflector that is bouncing sunlight onto her face. (The person on the right is one of my workshop students.)

↑ This tight shot of the cowgirl shows the effect a gold reflector can produce. Notice how the reflector has really livened up the portrait and added a warm glow to the woman's face and upper body. Also notice how a bit of cropping draws more interest to the picture. And see how the fence, photographed at an angle, adds a sense of depth to the scene.

⇐ Reflectors can also be used to add light and color to subjects standing in the shade—if the reflector is in the sun. Notice how the lighting is fairly flat in this portrait of the cowgirl.

⇒ Of these two close-up pictures, which one is more appealing to you? Standing off-camera, a workshop assistant held a gold reflector to bounce light onto the cowgirl's face and upper body. If you did not know the behind-the-scenes story of this picture, you might think it was taken late in the afternoon, because the light has a beautiful, warm glow. I carefully directed the cowgirl to move her chin down so that her hat hid her eyes. By not being able to see her eyes, the picture has more of a sense of mystery.

Simply holding a reflector near a subject, by the way, will not always bounce light onto that subject. For the maximum effect, the reflector needs to face the sun. When the sun is at an angle to the subject, you need to move the reflector around to get the best possible light on the subject. Reflectors can be used on overcast days, but they are much less effective under such "flat" lighting conditions.

Finally, when using a reflector on a sunny day, keep in mind that when you are working close to a subject and the sun is behind him or her, the light from the reflector can be blinding and intensely hot. Talk with your subject to achieve the best results.

"I shut my eyes in order to see."

—PAUL GAUGUIN

Create Disequilibrium

Draw attention to a picture.

If you watch music videos on television or read fashion magazines, you may have noticed that some of the images look off-balance, tilted to the left or the right. According to my good friend Dick Zakia, professor emeritus at Rochester Institute of Technology, tilting the camera to the left or right creates a sense of disequilibrium and immediately draws extra attention to a picture.

I like the disequilibrium effect. But as with all photographic techniques, it can be overused. What's more, sometimes it's definitely not a good idea to try to create a sense of disequilibrium.

Let's take a look at some pictures.

⇓ Hold the camera level, as Marco is doing here, and you get a level picture.

⇓ Tilt it to the side and you create a sense of disequilibrium in your pictures.

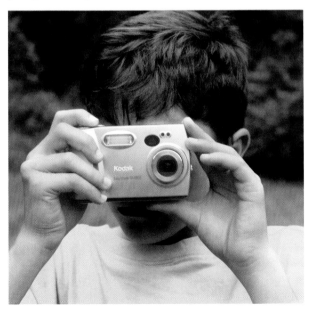

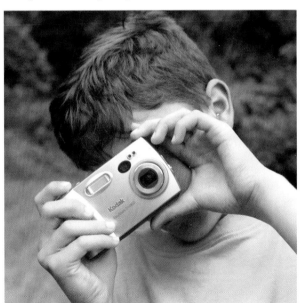

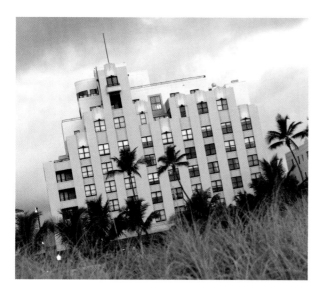

In this photograph of a hotel in the South Beach section of Miami, the disequilibrium effect does not work. I took the picture to illustrate the point that you need to be choosy about when to use the effect. Generally speaking, the disequilibrium effect does not work for pictures of entire buildings, or full-body shots of people and landscapes. The result here is less effective: the neutral grassy foreground interrupts the angled building and prevents it from anchoring itself on the edge of the photo.

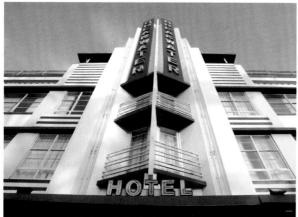

Which picture of the Breakwater Hotel in South Beach do you think is more interesting? My guess is that you like the picture with the disequilibrium effect.

I photographed this cyclist at New York's Coney Island. Once again, you can see the difference between a fairly static shot and a picture with more visual appeal.

⇑ Don't try to take a picture like this, unless you are in an inactive railyard, such as this one near Ft. Worth, Texas. It's just one more example of the disequilibrium effect—and how it can turn a snapshot into a more dramatic picture. Thanks to Mona Landers for being such a good sport.

"Look at any landscape photograph. You see the shape of things, the mountains and trees and buildings, but not the sky." —KURT KOFFKA

LESSON 26 — Landscapes and Nature

Use these tips for better nature photographs.

Before writing this book, I did not take very many landscape and nature pictures. I did, however, spend ten years taking underwater "seascape" and marine life pictures for several of my books.

⇐ Here is just one of hundreds of seascape pictures I have taken. It's a picture of a red sea fan (a colony of thousands of living animals) off the western coast of Thailand.

⇓ And if you think taking topside pictures requires a lot of gear, take a look at one of my underwater photography systems: a Canon Rebel G with a 24 mm lens in an underwater housing with two strobes

attached. That's about one-quarter of the underwater gear I take on a dive trip. The photo was taken by my friend Stella Covre while we were scuba diving in the Maldives.

Since about 1995, the focus of my topside picture-taking has been on photographing people in faraway lands. But I felt that a lesson on landscape and nature photography was necessary for this book, so, in 2002, I set out to take some illustrative pictures. Applying the basics of photography, I very much enjoyed taking the photographs for this lesson. In fact, taking the pictures in this chapter was one of the most fun parts of this project. I also enjoyed traveling around the United States, my own "backyard."

To begin, here are some basic tips that I apply to all my landscape and nature pictures.

- Use the smallest f-stop possible. To get everything in the scene in focus (as it looks to our eyes), that's usually f/11, f/16, or even f/22 if your lens has that aperture.
- Pack a tripod. Small f-stops often require the use of slow shutter speeds, and slow shutter speeds often mean that you need a tripod to steady your camera. That's good news in landscape photography for other reasons as well. A tripod helps avoid blurry pictures caused by camera shake, but it also slows you down and gives you a chance to think about making a picture, rather than just snapping the shutter.

⇐ You may not need a professional tripod, such as the one this photographer is using in Upper Antelope Canyon, Arizona, to support his 4 × 5 film camera. But having a simple, sturdy tripod is a must for serious outdoor photographers.

Even when using a tripod, it's a good idea to also use a **cable release** or a **self-timer** if your exposure is going to be longer than 1/15 of a second. Manually pressing the shutter release button during a long exposure may cause camera shake and ruin your pictures.

The next pair of pictures, taken in the rain at a small waterfall near my home in Croton-on-Hudson, New York, illustrates how a tripod can greatly improve a picture. They also show the difference between a snapshot and a photograph.

⇐ In the first photo, I set my camera on Program mode and shot without using a tripod. Several things are wrong with this image:

1) A fast shutter speed (1/1500 of a second) "froze" the moving water for an unflattering effect.
2) The focus is shallow, caused by a wide aperture (f/3.5).
3) The focus point (illustrated with a gray square in the image) is almost dead center, which does not help the depth of field, as would focusing a third of the way into the scene.

If you want a photo like this one, just set your camera on Program made and point and shoot.

⇐ Now look what happens when a few basic camera adjustments are made:

1) I set my camera on a tripod.
2) I used a slow shutter speed of 3 seconds to blur the water. (Experiment with different slow shutter speeds, perhaps from 1 second to several seconds. Each shutter speed will blur the water to a different degree.)
3) I set my aperture to f/11 for good depth of field.
4) I set my focus one-third of the way into the scene for maximum depth of field.
5) Marco held an umbrella over me to protect my camera from the rain while I was taking the picture.

So take your time when taking landscape pictures. Think about how you can use your camera controls (and accessories such as a tripod) to turn a snapshot into a great shot!

- Use the wide-angle setting on your **zoom lens**, between 16 mm and 28 mm for most of your shots. Wide-angle settings on zoom lenses and wide-angle lenses produce greater depth of field and help get as much of the scene in focus as possible. If you don't have at least a 28 mm equivalent setting on your **ZLR** digital camera, consider getting a wide-angle adapter lens (see Lesson 8).

⇐ For this picture of Grosvenor Arch, photographed in the Escalante National Monument in Utah (not far from Kodachrome Basic State Park), I set my 16–35 mm zoom lens at 16 mm and used an aperture of f/11 for good depth of field.

- **Telephoto lenses**, on the other hand, have a shallower depth of focus, but they can be useful in landscape photography, especially when you want to isolate a subject from its surroundings.

⇒ For this shot of a hoodoo (a pinnacle or odd-shaped rock left standing by the forces of erosion) in Devil's Garden in Escalante National Monument, I used the 105 mm setting on my 28–105 mm zoom lens.

- To maximize **depth of field**, I picked a focus point that is one-third of the way into the scene. (See Lesson 10.)
- Always pack **polarizing** and **neutral-density graduated filters** (see Lesson 27, "Filters for Outdoor Photography"). Sure, you can add some filter effects in the digital darkroom using Photoshop-compatible plug-ins, but why not start with the best possible image?
- Make sure that the horizon line is level in your frame. To help do this, small levels that slip onto a camera's **hot shoe** are available. Tripods and tripod heads that have built-in levels will also help you keep the horizon line straight.
- Before you take a picture, look carefully at the edges and corners of the viewfinder. Make sure that everything you want to be in your picture is showing, and make sure you can't see objects, or small parts of objects, that you don't want in your picture.

- Watch for highlights (bright areas of a scene such as reflections off water or even foliage) that can creep into a picture and potentially ruin it. In Photoshop, you can "cover up" highlights using the Clone Stamp tool (see Lesson 45, "Try Easy Tools First"). However, avoiding these problem areas, if possible, when composing a picture will save you time later in the digital darkroom.

Now let's take a look at some specific tips and how I applied them to a few of my nature and landscape photographs.

Select a main subject. When looking through our viewfinders at breathtaking scenes, we are often tempted to try to capture the entire scene within one frame. When we do that, sometimes our pictures lack a main subject.

⇐ While watching a spectacular sunset on a mountaintop in Glacier National Park, Montana, I was tempted to use the widest possible lens to capture the entire scene. However, from where I was standing, that would have produced a picture without a main subject. So, I used a zoom lens and framed two pine trees against the setting sun to produce, I think, a more dramatic picture. This picture was taken with my Canon EOS 1D digital SLR and a 100–400 mm lens set at 200 mm.

Always look up, down, and back. As we walk around in the great outdoors, most of us look only straight ahead. As simple as it sounds, if you also look up, down, and back, you will see lots more picture opportunities.

⇒ As I looked up in a forest in Glacier National Park, I envisioned this picture, the kind I had seen in magazines countless times before. This one was produced using my Canon EOS 1D digital SLR and 16–35 mm lens set at 16 mm.

Levels for a camera's hot shoe are available from companies such as Adorama (www.adorama.com).

⇐ When taking pictures toward the sun, try to avoid **lens flare**, caused by direct sunlight hitting the front element of your lens. Sometimes it's very noticeable, as in this picture. Sometimes, it's barely noticeable when looking through the viewfinder, but even a touch of lens flare can cause a picture to look soft. To avoid lens flare, use a **lens hood** or, better yet, have someone stand close by and shade your lens with a hand or hat.

Be prepared. If you are serious about outdoor photography, you need to be prepared for all types of lighting situations. That means packing a tripod, filters (see Lesson 27, "Filters for Outdoor Photography"), wide-angle lenses to take in wide scenes and telephoto lenses to isolate subjects in a scene (such as a barn in a distant landscape), and different speed films if you shoot film. Read up on background information about where you'll be and what you'll be photographing.

⇐ This is one of my favorite outdoor pictures, from Lower Antelope Canyon, Arizona. I knew ahead of time that the canyons were relatively dark, so I was prepared with a tripod to steady my camera during a five-second exposure using my Canon EOS 1D digital SLR and a 16–35 mm lens set at 16 mm. It was a good thing I packed a tripod. Heavy clouds made the canyon darker than I ever had expected.

Also note how two of the subjects, the rock in the lower left-hand part of the frame and the opening in the rock at the top right of the frame, are at two of the points where the lines of a tic-tac-toe grid would intersect (see Lesson 19). That did not happen by accident.

Create a sense of depth. We see the world in three dimensions (height, width, and depth), but our cameras see only two dimensions (height and width). To create a sense of depth in our pictures we need to include a foreground element in a scene, as we saw in Lesson 22.

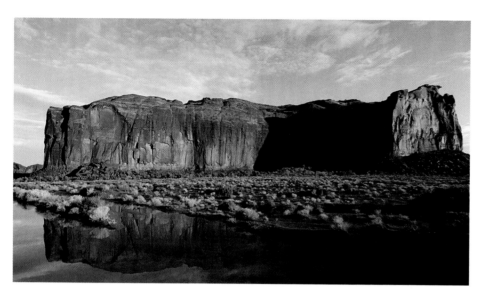

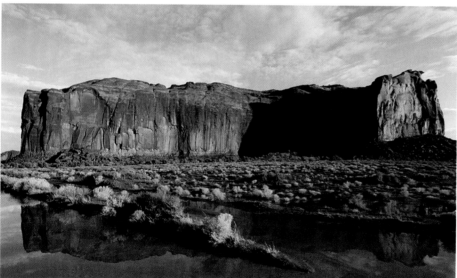

↑ Compare these two pictures, which I took a few feet apart in Monument Valley, Arizona, with my Canon EOS 1D digital SLR, and a 16–35 mm lens set at 20 mm. The bottom picture with the foreground element in the left-hand side of the frame puts us more "in the scene." However, I like the top picture with a large reflection, too. My point: Break the rules sometimes!

Vary your viewpoint. When I take landscape pictures (as well as people pictures), I take both horizontal and vertical versions of the same picture. Plus, I compose a picture so the final image can be cropped into a square. I also photograph a main subject from several different angles, usually including a foreground element to add a sense of depth to a scene. If it's possible and if it makes sense, I'll frame the main subject using natural objects that are nearby.

While on a sunset tour in Monument Valley, my guide pointed out a weathered tree that could be used as a strong foreground element and a "frame." Using the tree and varying my viewpoint, I took a picture of the Two Mittens, perhaps the most famous buttes in Monument Valley, and then a picture of just one of the Mittens. Personally, I think the picture of one of the Mittens has more impact, but the other picture shows why the buttes were given their name.

⇚ Compare the two pictures above with the tree as a strong foreground element and frame to this picture. It looks fairly flat, don't you think?

By taking both horizontal and vertical pictures, you give editors and art directors a choice if you are interested in getting your pictures published. That's what I did while photographing this arch in Devil's Garden in the Escalante National Monument, Utah. What's more, each image provides a different impression of a subject.

Trying different lenses or focal length settings on a zoom lens is also a good idea. For my Devil's Garden arch pictures, I used the 16 mm setting on my 16–35 mm zoom for the horizontal picture, and the 28 mm setting on my 28–105 mm zoom for the vertical picture.

⇑ Here is a fairly boring picture of some bear grass in Glacier National Park. I took it while teaching a workshop for *Popular Photography* magazine. Varying your viewpoint can be applied to small subjects, such as flowers, too.

⇑ Compare it with this picture. A lower angle and using the bear grass to hide the sun produced a much more dramatic image.

⇒ As always, I encourage my workshop students to vary their camera viewpoint, just as I had done for the bear grass. Here two of my students, Kathy Criss and Mark Hannum, are changing their viewpoint to produce what they hope will be a more dramatic picture.

Add a sense of scale. One way to add a sense of scale to a picture is to include a person in the scene.

⇑ No doubt, the picture of Lower Antelope Canyon without me is much more pleasing, and that's the picture I'd use in an article on the slot canyons of Arizona. But I asked my guide, K.C., to take the picture of me in the scene because I wanted to show Marco the scale of the canyon.

When you include a person in a landscape or nature picture, it's often best not to have him or her looking at the camera. Rather, have your person look off-camera, as if looking at something interesting.

Be patient. We'll end this lesson on nature and landscape photography with an important tip: Be patient!

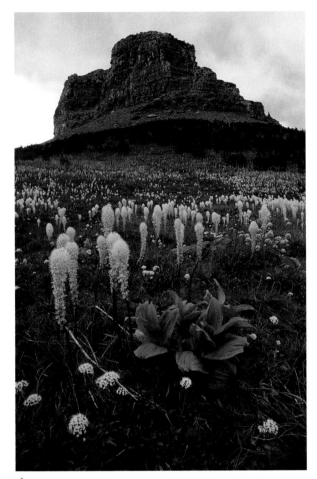 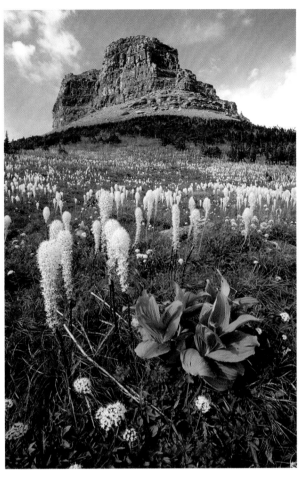

⇑ On many occasions, you may have to wait for just the right light. That's exactly what happened when I was photographing this scene in Glacier National Park. The sky had been overcast all day. But a strong wind was blowing the clouds away. I saw blue sky in the distance. After waiting for about an hour, the sky cleared and I got the photograph I wanted, one with a blue sky. So when you are outdoors, be patient. It really does pay off—some of the time. In Lesson 28 we will talk about making successful images "when the weather turns bad."

"This is not simply the past, but a prism through which the subject filters his own changing self-image." —MARC PATCHER

LESSON 27

Filters for Outdoor Photography

Filters are important accessories.

When it comes to outdoor photography, **filters** are important accessories. Without a filter, a picture can look flat and soft with muted colors and may have "hot spots" caused by glare.

Filters may be applied in the field or later in the digital darkroom. (For more on using digital filters, see Lesson 62, "Have Fun with Digital Filters.") I often use digital darkroom filters for three reasons. First, I don't have to pack a bunch of filters when traveling, which saves weight and valuable space in my camera bag. Second, digital filters save me time when working in the field; I don't have to stop, get out a filter, attach it to my lens, and so on. Third, I'd have to pack literally hundreds of filters to use all of the filter effects that are available to me in the digital darkroom.

That said, there are three types of filters I always take with me in the field: skylight, warming polarizing, and graduated.

I have a **skylight filter** on all my lenses to protect the front element of my lens from scratches and dings with no noticeable effect on my digital pictures. (A skylight filter will also reduce any blue cast in shadow areas or shade when using some slide films.)

I also pack a **warming polarizing filter** (in different diameters for my different lenses), because a major benefit of using this filter, reducing glare, can't be achieved in the digital darkroom. However, some sky-darkening effects—another feature of using polarizing filters—can be achieved with Photoshop-compatible plug-in filters such as those available in nik Color Efex Pro!

I also pack neutral-density **graduated filters**, which are dark on the top and gradually become clear on the bottom, to darken the sky in landscape and seascape photography.

When using the aforementioned filters on SLRs and ZLRs, and when composing a picture on a digital camera's LCD screen, you will be able to see the filter's effect, because you are seeing exactly what the lens sees.

Filters can be stacked to achieve different results, but stacking filters can also reduce image quality and may cause **vignetting** (darkening of the edges of a pictures) when using a wide-angle lens.

140 **Hoya, Tiffen, and B+W make a wide range of round filters that screw into the filter threads on the front of a lens.**

Let's take a closer look at my favorite outdoor lens filters.

Polarizing filters. A polarizing filter can continuously vary the amount of polarized light that passes through it. In doing so, it can (but doesn't always) darken a blue sky and make white clouds appear whiter. That effect can also be achieved in the digital darkroom by using a variety of Photoshop-compatible plug-ins.

⇑ Compare these two pictures, taken in Zion National Park, Utah. The picture on top with the darker sky and deeper color was taken with a warming polarizing filter.

A polarizing filter can also reduce reflections on water and glass (but not on metalic surfaces, such as chrome) to the point where you can see through the water or glass. That kind of effect is not possible to produce in the digital darkroom—not yet, anyway.

⇑ Compare these two pictures, taken in Glacier National Park, Montana. One was taken with a warming polarizing filter, the other was not. The top picture, taken with the warming polarizing filter, lets us see through the water, because the reflection is reduced. The picture also shows a bluer sky and a bluer band of water in the distance.

A polarizing filter can also reduce reflections on atmospheric haze and therefore make pictures appear sharper. There are two basic types of polarizing filters: linear polarizing filters (early polarizing filters that did not work well with autofocus cameras) and circular polarizing filters (designed for autofocus cameras and cameras using semitransparent mirrors in their optical path). Before purchasing a polarizing filter, read your camera manual to see what type of polarizing filter is compatible with your camera's metering system.

Cokin, Pro-Optic, and others offer square filters that slip into a holder that attaches to the lens via the filter threads.

Warming polarizing filters combine a polarizing filter with a warming filter. If you like the slightly deeper shades of yellow and red that a warming filter produces, you may want to get a warming polarizing filter. That's what I use. In addition to saving money by not having to buy a second filter, using one filter is better than using two filters. Two (or more) stacked filters may cause vignetting, a darkening of the image edges.

Yellow, green, and other types of color-polarizing filters are available for special effects. These filters add a yellow or green or whatever color tint to a picture; some provide two different colors, one at each end of the filter's rotation.

⇑ Both these pictures were taken using a warming polarizing filter, which by now you can see is my favorite filter. The picture with the large rock in the foreground was taken in Zion National Park, Utah. The picture with the bright orange rocks was taken in Red Canyon, not far from Bryce Canyon in Utah.

After attaching to your lens, polarizing filters rotate in their mount so you can dial in (select) different amounts of polarization, from maximum to minimum. When the maximum effect is achieved, the light reaching your recording media (film or digital sensor) may be reduced by up to 1 1/2 stops. When shooting in an Automatic Exposure mode with Program, Aperture Priority, or Shutter Priority, the camera automatically compensates for that difference. When shooting in Manual mode, the **TTL metering** in most modern cameras will compensate for any "filter factor." With older manual cameras you will need to make the appropriate compensation.

⇒ Polarizing filters are most effective when the sun is at a 90 degree angle to the subject. One way to determine a polarizing filer's effectiveness is to hold your index finder and thumb so your hand looks like a gun. If you point your index finger at the sun and rotate your thumb in an arc, wherever your thumb points is where a polarizing filter will be most effective. If you look in the distance in this picture, you will notice a deep blue—and deeply polarized—sky. That's the direction my thumb would be pointing if I rotated my wrist toward that direction. And yes! My index finger is pointing toward the sun!

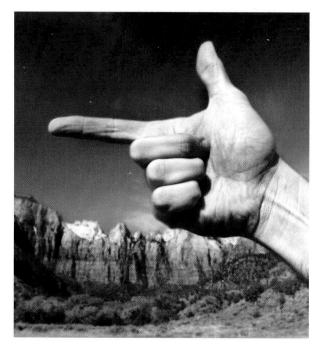

Polarizing filters are not effective at all when shooting toward or away from the sun.

One mistake that some photographers make is to overpolarize a scene. In doing so, the center of the picture becomes much darker than the edges, causing an unnatural-looking picture. I usually set the maximum amount of polarization and then dial back slightly for a more natural, yet still enhanced, look.

⇒ One more thought on polarizing filters and outdoor photography: You don't always have to use them. Although they can reduce reflections on glass (and water and vegetation), sometimes reflections are nice, as in the case of this picture taken on a ranch in Montana.

As I mentioned earlier, photographers should have a skylight filter on their lenses for protection. But when using a polarizing filter, you don't need a skylight filter, and actually should not use it. Remember, try not to stack filters.

Graduated neutral-density filters. When the sky is much brighter than the landscape, a graduated neutral-density filter can reduce the contrast range in the scene for a more even exposure. I often use graduated neutral-density filters.

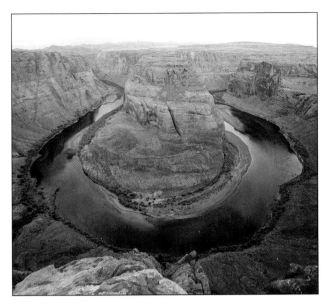

⇐ Notice how the sky in this picture of Horseshoe Bend, about 10 minutes outside of Page, Arizona, is completely washed out.

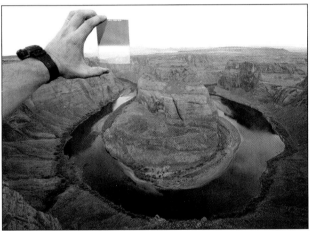

⇐ To see how a graduated neutral-density filter would darken the sky in this situation, I held the filter in front of my camera before placing it on the lens.

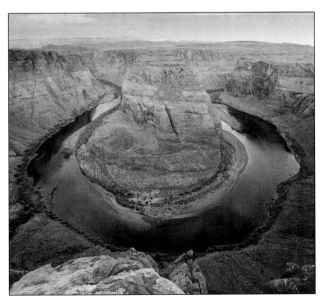

⇐ As you can see, the graduated neutral-density filter provides an even more enhanced effect.

Graduated filters are available in different degrees of gradation; on some, the delineation between the dark and light areas of the filter is very gradual, and on others it is abrupt. You'd want to use a graduated filter with a gradual change on a landscape scene and a graduated filter with an abrupt change on a seascape in which the horizon line is in the picture.

And to turn a gray sky into a blue sky, there are blue graduated filters (from light blue to dark blue). Orange, red, and other color graduated filters are also available to add color to a gray sky.

Traditional graduated filters are available in different densities (one stop, two stops, etc.) for fine-tuning the contrast range under many different lighting conditions.

A final note on traditional filters: If you want the sharpest possible pictures, keep your filters clean and fingerprint-free.

Digital graduated filters. I also use the digital graduated filters in a Photoshop **plug-in** called nik Color Efex Pro! Not only does it offer eleven different colors and densities, but also lets you create your own "user-defined" graduated-density filters. This package of filter plug-ins lets me rotate the filter's effect and shift it anywhere within the scene. (See Lesson 62, "Have Fun with Digital Filters.")

← Here is a screen shot of the pop-up window you get when you open the Graduated filters in nik Color Efex Pro! This is where you find the options for density, color shift, and rotating.

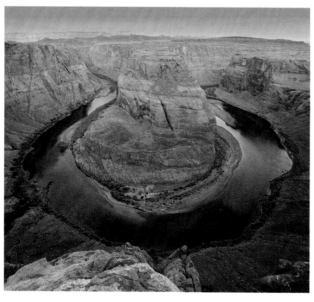

← This is how my photo with the washed-out sky looks with the nik Color Efex Pro! Deep Blue graduated filter applied.

Nik Color Efex Pro! is available from nik multimedia (www.nikmultimedia.com).

Filters for Black-and-White Film Photography

For those who like to shoot black-and-white film and then scan their images into their computer, here are a few suggested filters.

Yellow. Offers a natural tonal correction and improves contrast in landscape pictures.

Deep Yellow. Enhances landscapes to a greater degree than a yellow filter.

Green. Well suited for landscapes. More red light is absorbed than with a yellow filter, so reds are darker and greens are correspondingly lighter.

Red. Darkens a blue sky and highlights white clouds.

For digital photographers who like the look of black-and-white pictures, see Lesson 56, "Work in Black and White, Photoshop Style." There we learn to control turning a color picture into a black-and-white image using the Channels menu in Photoshop, which basically adds and subtracts colors from an image. Converting a color image to Grayscale in Photoshop is also covered in that lesson. Yet another way to convert a color picture to black and white is to use a Photoshop plug-in called Silver Oxide, which is also discussed in Lesson 56.

Mixing Filter Types *by Joe Farace*

When using modular camera filters made of optical plastic, such as those from Cokin, in combination with a polarizer, be careful that you don't position the plastic filter between the polarizer and the subject. Instead, place the plastic filter *between* the lens and the polarizer. Otherwise, the polarizing effect will be diminished or even impossible to apply.

"It doesn't matter if the weather is bad, as long as we are all together."

—Robert M. Sammon, Sr.

LESSON 28 | When the Weather Turns Bad

Make the best of the soft light and puddles.

Look at any postcard rack. You'll see pictures taken on bright, sunny days. The pictures were often taken late in the day or early in the morning, when the landscape is bursting with warm colors, contrast, and detail. Those are the kind of pictures that sell a destination, pictures that make us want to be there—and that we all want to take. And that includes me!

But sometimes Mother Nature has other plans for us. That's what happened to me on my second trip to Monument Valley, Arizona.

⇑ On my first trip in 1995, I had spectacular clear weather, as you can see by this picture of the Three Sisters near John Ford Point. I took this picture just after sunrise, when there was not a cloud in the sky.

⇑ On my 2002 trip, which I made specifically to take pictures for this book, it rained about 80 percent of the time. So my shooting time was severely reduced.

Did it get me down? A bit. Still, I wanted to get images. So, I stayed out all day looking for locations . . . and breaks in the weather. I made the best of it and actually enjoyed the challenge of trying to get good pictures, even if they were pictures that illustrated bad weather.

So if it "rains on your parade," go out there and shoot. Challenge yourself. The soft light may actually enhance some scenes. You may get lucky and get a bit of sunshine. What's more, you may actually have fun and come back with some "keepers."

⇐ This picture, taken during a break in the pouring rain, is not the most exciting picture I've ever taken.

⇐ Now look how beautiful the butte looks, from a different angle, when it is reflected in a huge puddle (which eventually washed out the road in a flash flood, as I learned later).

When you want reflections to appear in a picture, don't use a **polarizing filter**. In fact, on cloudy and rainy days, don't use a polarizing filter at all. It will have no effect on the sky and clouds and will reduce the amount of light entering your lens. That reduction in light will cause you to lose an **f-stop** or a shutter speed of exposure, which could come in handy if you want more **depth of field** or a faster shutter speed for a hand-held shot.

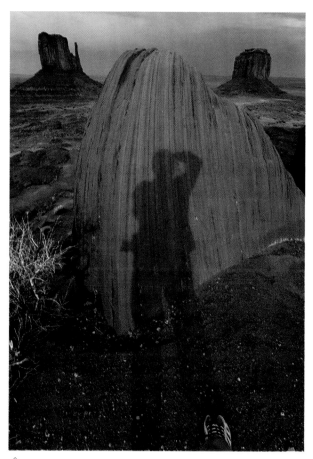

↑ Close-ups are a nice option on overcast days. The soft light provided by cloud cover eliminates harsh shadows.

↑ As long as you are having so much fun, why not take some fun shots? They will bring back fun memories of your wet-weather adventure. Looking at this picture of my shadow on the rock, with my hiking boot at the bottom of the frame, I am reminded of exactly how I felt on that particular overcast day.

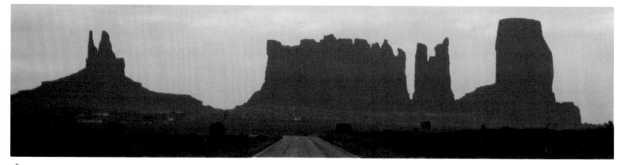

↑ Sure, the sky may be dull and the foreground may have not much detail, but that's no reason not to take a picture. Try taking one in which you plan to use only a portion of the frame—perhaps turn it into a panoramic picture. That's what I did to get this silhouette of several of the buttes. I used my 16–35 mm lens set at 35 mm, took a picture, and then cropped out the top and bottom of the frame.

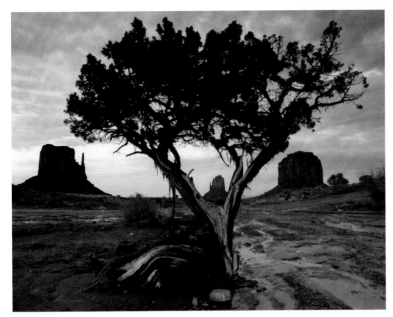

⇐ Moody scenes, created by overcast skies, make for moody pictures. I actually like this picture of several buttes and an old tree. My guide pointed out this vista. It illustrates the importance of having a good guide when traveling. For me, the picture captures the feeling of what the Navajos believe is a sacred place.

At the beginning of Part II, I said, "No Photoshop tricks in this section." I'll keep that promise, for the most part. There are, however some Photoshop techniques (not tricks) for brightening up rainy-day pictures. What's more, a skilled color printer can produce the same effects in the traditional color darkroom.

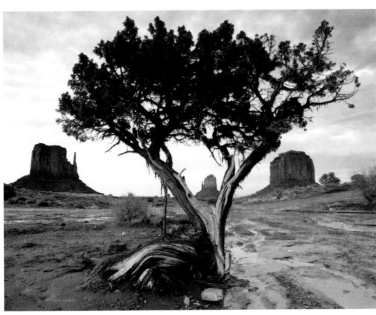

⇐ After some work in the digital darkroom, I was able to change the "weather conditions" in my moody picture. The scene is now brighter, warmer, and has more contrast.

These screen shots show how I boosted the Photo's Contrast using the **Image > Adjustments > Brightness/Contrast** control, boosted the red and yellow with the **Image > Adjustments > Color Balance** control, and lightened the overall scene by pulling down Curves in **Image > Adjustments > Curves** (for those familiar with Photoshop, pulling up Curves in RGB mode has the same effect as pulling down Curves in the CMYK mode, the mode in which I was working). In Lesson 50, "Basic Image Adjustment," we'll take a look at the various tools we can use to enhance a picture.

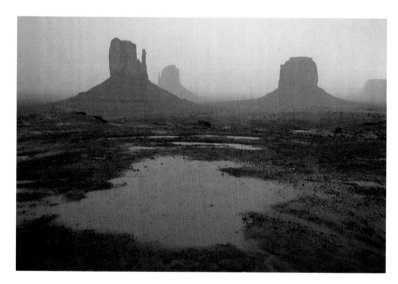

⇐ So keep in mind that wherever you go, despite the weather, good shots, and fun shots, can still be taken. For example, here is the first picture I took on my rainy, overcast, and damp trip to Monument Valley. You may say, "Yuck!" But the photo actually brings back some fun memories of joking around with my guide, K.C., in the four-wheel-drive vehicle about "You should have been here last week." What's more, it's a stock photography shot of bad weather that could sell.

Gear You'll Need for Wet-Weather Shooting

If you plan on taking advantage of the wonderful light that rainy days offer, and look forward to the challenge of shooting in adverse conditions, you may want to consider bringing along the following accessories and gear.

Fast film/ISO setting. Make sure that your digital camera has a fast ISO equivalent such as ISO 400 or 800.

Camera protector. I use a plastic sandwich bag and a shower cap from a Miami hotel to protect my camera. More serious camera covers, and flexible and watertight plastic models, are available from EWA Marine (www.rtsphoto.com).

Waterproof camera bag. I use a Lowepro backpack with a build-in "raincoat" that folds into a pocket and unfolds to cover the entire bag. Lowepro also makes shoulder bags with built in "raincoats" (www.lowepro.com).

Plastic bags for accessories. Keep memory cards and film in plastic bags for extra protection.

Camera cleaning kit. You'll need it in case your camera gets wet. On that note, if a raindrop gets on the front element of your lens or a filter, wipe it off with a lint-free cloth. A single raindrop can look like a big blob in a picture. The wider the angle of the lens, the larger the blob will appear. A lens hood will help keep the front element of your lens dry.

Rain gear. You want to be comfortable and dry in the field. Exoffico (www.exoffici.com) and Orvis (www.orvis.com) make rainwear that will keep you dry. Waterproof hiking boots are a good idea, too.

"If I could tell the story in words, I would not have to lug around a camera."

—LEWIS HINE

Basic Field Gear

Travel light but bring the essentials.

Whenever I think about camera gear, I am reminded of pictures I have seen of some *National Geographic* photographers with their gear. One was of photographer Joe McNally, standing in his driveway with at least half a dozen cases of cameras and accessories. Another photo showed underwater photographer David Doubilet surrounded, underwater, by five assistants holding a total of a dozen cameras.

If you have unlimited funds and all the time in the world to take pictures, you might want to go for all the gear and as many assistants as you can. Keep in mind, however, that all that gear and more people will slow you down. He travels fastest who travels alone.

If you are like most photographers, amateur and professional, who travel alone, have limited time, and are trying to save for their kid's college education, then you need to travel light. I do that, as do many of the pros. Another benefit of traveling light is that I can get to a location, shoot, and scoot. (My friends actually call me the shoot-and-scoot photographer.)

You don't necessarily need an arsenal of gear to take good pictures. In fact, one very famous photographer, Henri Cartier-Bresson, took many of his highly acclaimed pictures with a 35 mm camera and a 50 mm lens. No zooms. No flash. Do a Web search on this master and you'll see what can be done with a 50 mm lens.

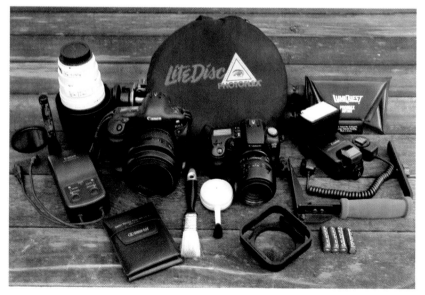

⇐ Take a look at my basic gear and why I pack it.

Gear	Use
Two SLR cameras	So I have a backup
16–35 mm lens	Street shooting and outdoor photography
100–400 mm IS (image stabilization) zoom lens	People and wildlife photography
28–105 mm zoom lens	General photography
Accessory flash	Daylight fill-in flash and indoor photography
Flash bracket and coil sync cord	Allows positioning of flash off-camera for more creative flash photography
Circular polarizing filter	Darkens a blue sky and reduces glare on water, glass, foliage, and rocks
Graduated neutral-density filter	Darkens a bright sky and compresses the contrast range in outdoor landscape pictures
Five-in-one diffuser/reflector	Diffuser softens the light falling on a subject. The reflectors (gold, silver, and white) bounce light onto a subject. The black diffuser cover reduces the amount of light that is bounced onto a subject.
Lightweight tripod	Provides camera support at night and in low-light situations.
Batteries (and battery recharger when I go digital)	Keeps me up and running
Camera cleaning kit	Keeps my gear clean, so I don't get marks on my pictures
Small flashlight	Helps me find accessories in my camera bag in dimly lit situations

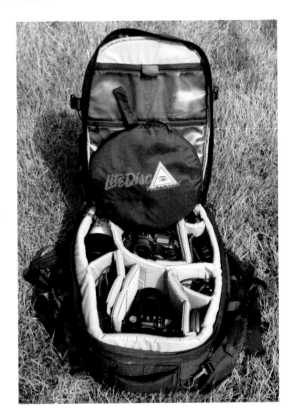

All that gear, except for my tripod, fits in my backpack. That keeps me "self-contained," so I can shoot pictures and then scoot off to the next location.

Of course, I have backup gear just in a case a lens gets damaged. In my hotel I keep a 24 mm lens for landscapes, a 28–70 mm lens for portraits, and a 70–200 mm lens for people and wildlife photography. If you are serious about photography, you must have backup gear. You just never know what challenges may present themselves in the field.

PART III
CAMERAS: THE WAY WE RECORD LIGHT

During my photography workshops, I am often asked, "What is the best digital camera?" With tongue in cheek, I reply, "Cameras don't take pictures, people do." Then I go on to say, "But having a camera is important for taking pictures."

Admittedly, choosing a camera, film or digital, can be difficult. There are dozens of models from which to choose.

Basically, cameras can be divided into three categories: consumer, prosumer (for consumers who want to shoot like pros), and professional. As you move up from consumer to professional cameras, the choices narrow and the prices increase.

In each category, different manufacturers offer models with certain bells and whistles designed to attract photographers. Ergonomics, the way a camera feels in one's hands, is important, too. You may find that one camera feels better in your hands than another, and you may prefer the layout of the camera controls in camera A to those in camera B. Actually, one of the reasons I switched to Canon cameras is because I like the way they feel in my hands. I like the feel of my camera and the easy access it offers to all the camera controls.

Nonetheless, my message that "cameras don't take pictures, people do" is an important one. I and many of my fellow professional photographer friends use different types of cameras in different situations.

⇒ When I want to travel very light, I shoot with a compact consumer digital camera with a built-in zoom lens. It's fun to use, makes photo sessions more interactive, and takes pictures that I can enlarge to 20 × 24 inches. I used that compact digicam (short for digital camera) on a trip to Nepal in 1999.

⇒ In this picture I took of a holy man in Katmandu, you can see every hair on his head. Look closely on the right side of his head (your left) and you may be able to see one hair sticking out. Pretty good for a 3MP camera.

But compact digital cameras have limitations—in zoom range, flash options, and creative control. That's where prosumer and professional cameras come in.

These days, the lines are merging between some prosumer and professional cameras, because many professionals are using full-featured prosumer cameras and are getting great results.

I use professional cameras because they offer the ultimate in creative control, accept the widest range of interchangeable lenses and flash units, and are rugged, keeping out dust and moisture. While writing this book, I shot with my 4.15-megapixel professional digital Canon EOS 1D SLR camera during a workshop in Provincetown, Massachusetts.

⇒ I used a Canon 100–400 mm zoom (known as a long zoom lens) to capture some of the spectacular sunrises on Cape Cod. (This shot of me using my zoom lens was taken by one of my workshop students, Sue Harrison.) The 400 mm setting on my lens was essential for getting the kind of pictures I wanted.

⇒ For example, in this shot, the sun appears much larger than it would have had I used a prosumer camera, even with its zoom set at the maximum setting, because prosumer zooms cameras don't have maximum optical zoom settings as long as 400 mm.

But you don't need a professional camera to get professional pictures. For example, one of my friends, John Isaac, former chief photographer for the United Nations, uses an Olympus 5-megapixel prosumer ZLR digital camera with a built-in zoom lens. He gets pictures that look super-sharp and colorful in magazines. What's more, he makes knockout inkjet prints.

The lessons in this section offer a look at the types of cameras that can help you realize your vision. You'll also learn about storage media and controlling color.

In choosing a camera, select one that meets your immediate needs but will also let you grow as a photographer. Also consider your budget. If you spend a lot of "hobby" or "business" money on the camera alone, you may not be able to get all the digital darkroom accessories you want, or need.

"The best digital cameras have 6 to 16 million pixels. Our retina, consisting of rods and cones, has over 100 million sensors."

—DR. RICHARD D. ZAKIA

| LESSON 30 | **Choose a Camera or Two** |

The camera you choose depends on the type of photography you want to practice.

Decisions, decisions, decisions! How do you choose a camera for your creative needs, as well as for family fun? In this lesson, we will take a look at just a few cameras, and their main features and benefits, in each of the main categories: consumer, prosumer, and professional.

Let's begin by comparing the benefits of film and digital cameras.

Digital	Film
Instant preview of a picture	Takes time to process film and print pictures
Excellent image quality for most applications, but not accepted by all stock photo agencies	Perhaps technically superior to a digital image, but the loss on optical processing evens the score. Slide film accepted by all stock agencies
Almost instant access to working on a picture in your computer, because of almost instant image transfer	Pictures have to be scanned or put on a CD or DVD to get them into your computer
File is digital, stored on a CD, DVD, or hard drive	Original is a slide or negative, which some photographers prefer
No dust or scratches on original image (but marks can appear if the digital sensor gets dusty)	Dust marks, dings, and scratches can happen during film processing and over time with handling
Never have to pay for film or film processing	Pay each time you shoot or process a roll of film
Several different ISO settings available in camera (ISO 100–400 in basic models; ISO 100–1600 in prosumer and professional models)	User has to pack different films for different ISO settings
Capability to store hundreds of pictures on a memory card	Hundreds of pictures on film would require many film cassettes, which take up space
No worry about airport X-rays at Security.	Film could get damaged by multiple X-rays, and certainly by CRT machines

Digital	Film
Requires lots of battery power in the field, much more than a film camera. Battery can be drained in a few hours of heavy shooting	Camera can operate for many months on a single battery charge
Comparable film camera is cheaper	Comparable digital camera is more expensive

Because most readers of this book are serious about their photography and using digital cameras, we'll begin with professional models and work our way down to the some of the most basic models.

Professional Digital SLR Cameras. Canon, Olympus, Nikon, Fuji, and Kodak offer professional digital **SLR (single-lens reflex)** cameras. Early models (which are still available) had a **CCD image sensor**, but more recent models have a **CMOS image sensor**, which seems to be the trend in some professional digital SLRs.

The CCD sensors in early models are smaller than a 35 mm film frame. So, the effective focal length of lenses becomes longer, usually by 1.3x, which is less than what's found on prosumer SLRs, which usually have a 1.5 or 1.6x magnification factor. That's an advantage at the telephoto setting, because lenses become longer. For example, a 100 mm lens on a prosumer digital camera with a 1.5x magnification factor becomes a 150 mm lens. Wide-angle lenses (in fact, all lenses) become longer, too. For example, a 24 mm lens becomes a 36 mm lens. For most pros, the loss of the wide view that results from this factor is a disadvantage, because their lenses don't "see" the same wide angle of view that they do with 35 mm cameras.

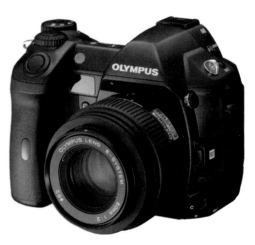

⇒ These three professional cameras from Canon, Nikon, and Olympus feature smaller-than-35-mm image sensors.

⇒⟩ Newer professional digital SLRs have larger image sensors than earlier models. On the left in this shot is an 11-megapixel image sensor, and on the right is a 6-megapixel sensor. One advantage of having a larger image sensor is that SLR lenses retain their effective focal length. Larger image sensors often produce superior images, too.

As of this writing, only Kodak and Canon have professional digital SLR cameras with full-frame image sensors. Canon offers the EOS-1Ds; Kodak offers the Pro 14n.

⇐ I took this butterfly portrait with my professional 4.15 digital SLR, which features a smaller-than-35-mm image sensor. Even though the image sensor is a whopping 6.85 million pixels short of an 11-megapixel camera, I could still make a super sharp 13 × 19-inch print of the image. So one wonders: Is an 11-megapixel camera really needed for great shots?

Below is a quick look at the main features and benefits of a professional digital SLR camera. If you are very serious about photography, and if you want to shoot a variety of subjects—indoors and out and in a variety of lighting conditions—you may want to consider a professional camera. Consider that you will need to make a sizable investment to purchase a professional camera, and an even greater investment if you are very, very serious, because you will probably want a backup if you travel.

Professional Digital SLR Cameras Feature	Benefit
Highest resolution of any digital camera	Best-quality image
Total exposure control	Offers fine-tuning of exposures in all lighting conditions
Complete white balance control	Avoids off-color shots
Through-the-lens viewing	What you see is what you get when it comes to composition
Ultra-fast autofocusing, and more accurate autofocusing in low light	Helps the photographer get more in-focus pictures
Virtually no shutter lag	Prevents pictures being missed due to delay in shutter release

Feature (continued)	Benefit
Accepts full line of accessories: lenses and flash units	Ultimate in creative control
Rugged	Can withstand use in adverse conditions
Rapid picture-taking	Needed for sports and action photography
RAW or TIFF setting in addition to JPEG	For some photographers, the best setting for capturing all of the color and detail in a scene
Custom functions for sharpening and other in-camera functions	Gives the pro creative control in the field, even without a laptop
Camera software	Used to import images into a computer, and helps in organizing pictures and data-keeping (because exposure information is recorded and viewed)

⇐ Professional digital SLRs are designed to give the working pro easy access to camera controls and menus, which allow photographers to select the specific functions they want for total creative control. This is the back of the Canon EOS 1D camera that I use.

⇐ Professional digital SLR cameras are shipped with accessories for picture-taking and camera-to-computer image transfer: a battery and recharger, camera software and basic image-enhancement software, a FireWire cable for fast data transfer, neck and wrist straps, and an AC adapter for studio shooting.

⇒ All digital cameras come with software for importing images into a computer. Professional digital SLR cameras also have software that helps you manage your images. The camera's built-in software records important exposure information, so you can see what f-stop, shutter speed, and white balance (among other settings) you used.

Prosumer Digital SLR Cameras. Canon, Nikon, Sigma, and others offer prosumer digital SLR cameras. The prosumer Canon EOS D60 features a CMOS sensor, and the Nikon D100 features a CCD sensor. Sigma's SD9 prosumer SLR features a proprietary Foveon chip that has its roots in CMOS technology.

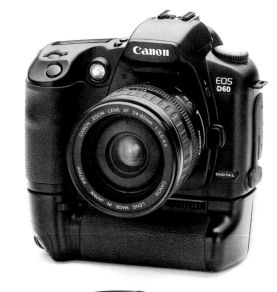

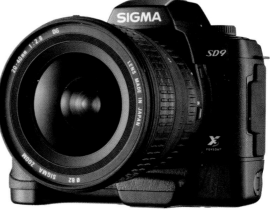

As I mentioned earlier, the image sensor in prosumer digital cameras is smaller than a 35 mm film frame. The magnification factor is typically 1.5 or 1.6x for yielding the same image area as 35 mm film frame. For example, a 17–35 mm zoom on a prosumer digital camera with a 1.6x magnification factor becomes a 27–56 mm zoom.

The following chart shows what most prosumer cameras have to offer. There is not a big difference in the image quality between professional and prosumer SLRs. That's why some pros use these cameras as their backups.

Prosumer Digital SLR Cameras Feature	Benefit
High resolution	Excellent-quality image
Exposure control	Offers fine-tuning of exposures in all lighting conditions
White balance control	Avoids off-color shots
Through-the-lens viewing	What you see is what you get when it comes to composition
Fast autofocusing and accurate autofocusing in low light	Helps the photographer get more in-focus pictures
Virtually no shutter lag	Prevents pictures being missed due to delay in shutter release
Accepts full line of accessories: lenses and flash units	Ultimate in creative control
Sturdy body, but not as rugged as a pro camera	Can withstand some knocking around
Fast picture-sequencing mode, but not as fast as a pro camera	Useful for action photography
RAW setting in addition to JPEG	For some photographers, the best setting for capturing all the color and detail in a scene
High-tech camera software	Required to import RAW images into a computer, and helps in organizing pictures and data-keeping (because exposure information is recorded)

Prosumer Digital ZLR Cameras. The main difference between a ZLR (zoom-lens reflex) and an SLR (single-lens reflex) is this: A **ZLR** is a camera with a built-in non-interchangeable zoom lens, hence its name. An SLR accepts dozens of lenses, from super-telephoto to super-wide-angle, to meet any photographic needs. Because the zoom range of many prosumer ZLRs is fairly wide, these ZLR cameras meet the needs of many picture-takers.

Canon, Olympus, Fuji, Nikon, Minolta, and Sony all offer prosumer digital ZLR cameras.

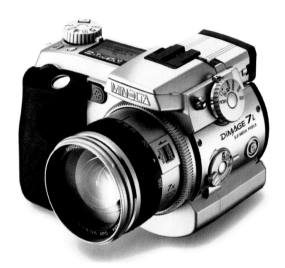

Prosumer Digital SLR Cameras Feature	Benefit
High resolution	Excellent-quality image
Exposure control	Offers adjustment of exposures in many lighting conditions
White balance control	Avoids off-color shots
Through-the-lens viewing	What you see is what you get when it comes to composition
Fairly fast autofocusing	Helps the photographer get more in-focus pictures
Perhaps some shutter lag	Could caused a missed picture of a very fast-moving subject
Camera body is not designed for rough handling	Be careful with camera handling
Medium-speed picture-sequencing mode, but not as fast as a prosumer camera	Useful for action photography
Camera software	Offers some image enhancements and offers easy camera-to-computer transfer

Consumer Digital Cameras. In the world of digital cameras, consumer-oriented point-and-shoot digital cameras outnumber all of the other cameras by far. Kodak, Canon, Nikon, Fuji, Minolta, Olympus, and Sony, to name just a few, all offer several different models of consumer digital cameras. The Kodak model below mounts on a "docking station" for picture transfer and battery charging.

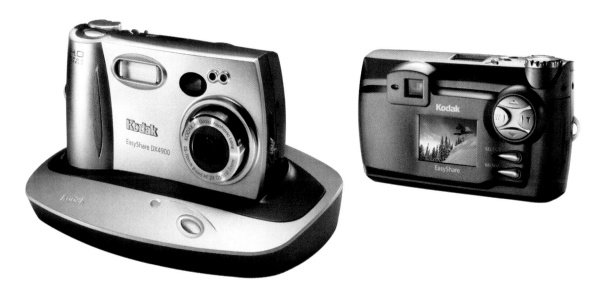

Consumer digital cameras are, first and foremost, easy to use. With around 4 megapixels, they take high-quality pictures. They are compact and lightweight and offer some creative control. One major difference between a consumer camera and the aforementioned professional and prosumer cameras, however, is that consumer cameras have a shutter lag. Short as that may be, it can cause a missed shot.

Can an advanced amateur or even a pro use them? Sure! I carry one with me at all times: a 4-megapixel model. You may want to consider a consumer camera as your backup camera or for a late-at-night, having-fun camera—for when you don't want to take your expensive digital camera out with you.

Fun Digital Cameras. At the low end of the digicam ladder are cameras of 1 megapixel or less. They are designed for people who simply want to e-mail photos to a friend. You would not want to use a fun digital camera to make a print of any size.

⇒ Two of these under-a-megapixel cameras are the StyleCam Blink from SiPix (left) and the DC1300 from BenQ (right). They are tiny, sleek digital cameras that fit in the palm of your hand.

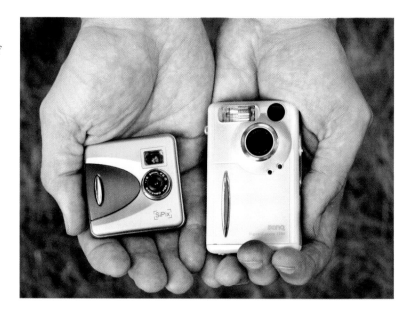

Digital Camera Phones. Over the past few years, cell phone manufacturers have developed camera-equipped phones, complete with a flash. Early models had under-a-megapixel cameras.

The next generation of phones will have 2-megapixel cameras. At 2 megapixels, a file is large enough for printing up to 5×7 inches.

We use a Sprint PCS phone for snapshots. But taking the picture is just the start of the photo fun. At the touch of a button, we can upload our pictures to the Sprint PCS Web site, where we can enhance them in a mini-digital darkroom, as well as share them via e-mail addresses. I simulated Marco's photo on the phone and on the Sprint Web site. Actual image quality is low resolution.

The Multiplication Factor on Digital SLRs *by Joe Farace*

If you put a 100 mm f/2 lens on a digital SLR that has a 1.3x magnification factor, it becomes effectively a 130 mm lens: 100 mm times 1.3. That's easy to understand. But here is something else to consider.

When computing exposure, the aperture of the lens does not actually change. According to some scientists, because the image sensor area is smaller than the standard 35 mm 24 × 36 mm frame, you can lose one stop when computing depth of field. Thus that 100 mm f/2 lens now becomes a 100 mm f/2.8 in terms of effective depth of field. That change in aperture is true at all apertures: you get the depth of field that you would if you had set your aperture one stop smaller than it is.

This is not a problem with the theoretical f/2 lens, because you can still isolate the subject from its background at f/2.8. But if you want to do the same with a camera that has a much smaller sensor chip, you may not be able to get the image (with your desired shallow depth of field) that you had in mind. In the end, you could end up needing to have a lens like a 30 mm f/0.3 to allow you to have narrow depth of field! Since the theoretical limit on lens aperture is f/0.5, you run up against some technical design problems when trying to do that.

This in one reason why, scientists and engineers speculate, many professionals will never be satisfied with cameras using smaller chips, and why some photographers at workshops that I have conducted report that photographs made with digital SLRs look "flatter" with less depth of field than images captured with their film cameras.

LESSON 31 | Pick a Picture Resolution

Always set your camera to the highest resolution for the best-quality images.

After you turn on your digital camera, perhaps the most important step is setting the picture **resolution**—that is, choosing the image quality you want. (If you are in a hurry, reading the closing thought at the end of this lesson will sum it all up.)

If you set the image quality too low, you may not be able to make high-quality enlargements, but you will probably be able to e-mail good-quality pictures. That's because the images we see on our computer monitors don't have to contain millions of pixels (**megapixels**) to look good, because computer monitors have relatively low resolutions (72 dpi for Macs and 96 dpi for Windows computers). So, even a less-than-1-megapixel image-quality setting (or a camera with a low megapixel rating) is fine if you only want to e-mail your photos.

Inkjet prints, on the other hand (as well as pictures sent to magazine and book publishers), need lots of information (millions of pixels) if they are to reproduce all of the detail found in the scene. What's more, if we don't use the high image-quality setting on our cameras, our inkjet prints may look "pixilated," that is, we may see the pixels (small digital blocks) in our prints.

High resolution.

Medium resolution.

Low resolution.

These pictures taken of a wax likeness of U.S. Secretary of State Colin Powell at Madame Tussaud's Wax Museum in New York City clearly show how image quality degrades as the resolution is lowered.

If you are making 5 × 7 prints, you may not notice a dramatic difference between the high and medium resolutions (on a professional digital camera, at least). But you will notice the difference as the size of your enlargement increases.

Image Quality	
RAW 4 MP (Uncompressed)	
✓ High/JPEG	4MP
Good/JPEG	3MP
Medium/JPEG	2MP
Low/JPEG	1MP

One important decision you need to make is which file storage format to use to save your digital photos. By far the most common format available is **JPEG**, which compresses images as they are saved, thus allowing you to take more photos on one memory card. Of course, the size of a JPEG file depends a lot on the resolution of the photo itself—high-resolution photos will produce larger JPEG files, which take up most space on your camera's memory card, than low-resolution photos do.

Some digital cameras offer you the option to save your photos in **RAW** format, which does not compress the file at all. Some cameras even let you save pictures as RAW and JPEG at the same time. RAW files take up lots more memory (space on a memory card, CD, or memory stick). RAW files also take longer to transfer from camera to computer and longer to open in Photoshop or whatever image-editing program you're using. In the process of taking pictures for this book, I set my camera to High/JPEG. That's because for the size of the images used in the book, I could see no visible difference between the JPEG and RAW images. Recently, I switched to shooting RAW almost exclusively. The main reason is that Adobe introduced a RAW plug-in that makes it easy to open RAW files. The other reason is that I am now making large prints. Accurate color management is yet another reason for shooting RAW files.

Keep in mind that as the resolution increases, so does the file size, or space the picture takes up on a camera's memory card. The following table shows how different JPEG settings use space on a memory card, which in turn affects the number of pictures that can fit on a memory card.

JPEG resolution setting on camera	Approximate number of pictures that fit on a 512 MB memory card	
	4-megapixel consumer camera	4.15-megapixel pro SLR camera*
High	412	176
Good	530	354
Medium	742	431
Low	999	N/A

* Lower number of pixels due to slightly higher megapixel sensor and a lower compression of the image

Compare those numbers with the much smaller number of pictures we'd get on a 512 MB memory card with the high-resolution RAW setting: only about 95. Again, RAW images are not compressed like JPEG images.

Digital cameras save information about image size so that you can see that information when you open the image in Photoshop.

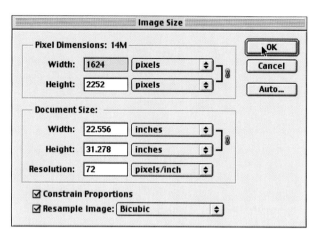

⇒ When we open a file in Photoshop, the image's default size is displayed in the Image Size dialog box: here a resolution of 72 ppi (pixels per inch), a width of 22.556 inches, and a height of 31.278 inches. Not all digital cameras save pictures with that type of indication, that is, 72 ppi with a big height and width.

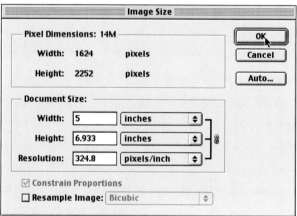

⇒ Many newer digital cameras save pictures in a more useful and friendly way. For example, the exact same size file would be denoted by some cameras as having a resolution of 324.8 ppi with a width of 5 inches and height of 6.9 inches. That's much easier to understand, because no one is going to make a 22 × 31-inch print at 72 ppi. More information on file and image size will be covered in Lesson 47, "Manage File Size and Image Size."

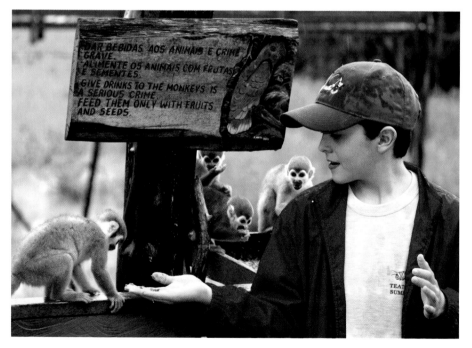

⇐ A closing thought: Always set your camera at the highest resolution. If you do, you'll capture fine details in a scene. For this picture of my son hand-feeding monkeys at Ariau Towers in Brazil, I set my pro digital SLR camera to High/JPEG. Look closely and you may be able to see a few raindrops in the scene.

"Photography does not create eternity, as art does; it embalms time, rescuing it simply from its proper corruption." — ANDRÉ BAZIN

LESSON 32 Record Your Memories

Different cameras require different ways of recording your photos.

Whether you use a digital or film camera, it has never been easier to record your memories—the sights and scenes you see—with fine detail and excellent color. But if your memories are not captured properly, they may be lost forever.

Let's start with the basics of digital media. Then we'll move on to different types of media storage.

Memory cards are the most popular form of digital storage media. They are available in different capacities and are rated in **megabytes** (MB). The more memory available on the card, the more pictures you can store on it, and the more money you'll have to spend. For most aspiring photographers, 256 MB cards are adequate. But pros need more memory, because the files from their cameras are larger than files from consumer and prosumer cameras. The pros I know shoot with 512 MB and even 1 **gigabyte** (GB) cards. But they don't save all of their pictures from a day's shoot onto one card. They use different cards, just in case one gets damaged.

Memory cards, and all removable storage media, are not really "digital film." An image is not recorded directly onto the card. Instead, it is temporarily stored in the camera in a memory buffer, and then it is transferred to the card.

The handling of memory cards is important. If you remove a memory card while a picture is being written to it, you could damage the card and lose all of your pictures (see Lesson 107, "Lost and Found").

Memory cards are not affected by airport X-rays or the newer and more powerful CRT scanning machines, but they can be affected by metal detectors, so they are actually safer going through an X-ray machine in your baggage or carry-on than in your pocket. (They would probably set off the metal-detector alarm anyway.)

Memory cards are not universal. That is, one type of memory card—say, CompactFlash—will not fit into a camera that accepts another type of card—say, SmartMedia—unless you use an adapter, but adapters are not available for all types of memory cards.

Let's take a look at the different kinds of storage media.

⇒ CompactFlash cards are currently the most popular type of removable memory. The 512 MB CompactFlash card from SanDisk shown here can store about 200 pictures at the highest JPEG resolution on a Canon EOS 1D, a professional camera. I say "about" because two things affect the total number of pictures a card can store: the camera's ISO setting and the amount of color and detail found in a scene. For example, a 512 MB card may store 200 pictures of clouds at ISO 200, but fewer pictures that include intricate patterns and other colors with the ISO set at 800.

The camera's image-quality setting also affects the number of pictures you can store. At the lowest JPEG resolution, a 512 MB card in a professional camera set at ISO 200 can store about 450 pictures. At the RAW setting, only about 95 pictures can be saved.

As of this writing, CompactFlash cards are available in two writing "speeds," standard and ultra. In some cameras, usually professional models, the ultra cards enable the digital file to be written faster if the camera can write at those faster speeds. (Not all can, so paying for the extra speed in a card may be a waste of money. Read your digital camera's instruction manual on this point.) In low-end cameras, you'll get the same file-writing speed with both types of cards

⇒ IBM Microdrives are available in 340 MB and 1 GB capacities, and were big news when they came out a couple of years ago. But with moving heads and discs (and unlike solid-state memory cards that have no moving parts), they occasionally crash when knocked around. What's more, they require more battery power than memory cards do. If you use one, be very careful when handling it and watch your battery power.

⇒ xD-Picture cards (eXtreme Digital) boast the smallest size (smaller than a postage stamp) and largest potential storage capacity (a promise of up to 8 GB as of this writing) of any memory card. Currently they are available in 188 MB capacities, with 256 MB, 512 MB, and other larger memory sizes expected by the time you read this. And with PCMCIA (Personal Computer Memory Card International Association) and CompactFlash adapters, the xD-Picture cards can be used with any CompactFlash-compatible device.

⇒ SmartMedia cards are designed for use in consumer and some prosumer cameras. They are smaller and flatter than CompactFlash cards, and their storage capacity is currently limited to a maximum of 128 MB.

⇒ SecureDigital (SD) and MultiMediaCard (MMC) cards have a similar, tiny form, and SD cards feature a switch that lets you lock the card so pictures can't be deleted by accident. Their maximum storage capacity is currently at 512 MB.

⇒ Sony cameras use memory sticks (shown) and mini-CDs. The sticks work only in Sony cameras. Some Sony cameras accept standard (80 mm) mini-CDs and floppy disks.

Some camera manufacturers, such as Olympus, offer cameras that have multiple slots, allowing both SmartMedia and CompactFlash cards to be used.

Next let's talk about 35 mm film. First, film takes up more space than a high-capacity memory card. For example, you need six rolls of 36-exposure film to take 216 pictures. On a single matchbook-sized 512 MB memory card, you can take about 200 pictures with a pro digital SLR camera set at the High JPEG setting and ISO 200.

Both professional and consumer films are available. Professional films should be kept cold, in a refrigerator or freezer, until you use them. Basically, the cold temperatures keep the colors from shifting as the film ages. That's important to pros who shoot many rolls of the same product or scene, when the color has to be consistent throughout all of the rolls.

Consumer films have a built-in shelf life, because film manufacturers know that most consumers don't immediately use all the film they buy. If the colors shift, they shift ever so slightly, to the point where most photographers would not even notice the difference.

Technically, it may be true that the film in a $10 single-use camera captures more details and color than a digital image sensor in a $5,000 professional camera in 2003. However, consider this: You lose some quality in the film's optical printing process, and your film could get scratched or "dinged" during film processing. A digital file, on the other hand, is totally clean (unless you have some dust or other particles on your camera's image sensor). What's more, although film may capture more detail, can most people tell the difference between a large inkjet print made from film and one made from a high-end digital file? Most of the pros I know would say no—but there are still a few that swear they can tell the difference.

If you want to shoot film and intend to scan your pictures, shoot negative film. Negative film contains about twice the information as slide film.

Film may get damaged by repeated exposure to X-rays and will certainly get ruined by CRT scanning machines that airports are now using for checked baggage. And speaking of getting ruined, heat also damages film.

The pros I know who shoot film do it for two reasons. One is that they like the quality, the feel, and the "look" of film. The second reason is storage: They like to have an original that they can hold in their hands. And when it comes to slides, they like having an accurate record of the color of a scene.

LESSON 33 | Controlling Color

White does not always look white.

In our cameras, digital or film, we can quickly and easily control the color of a scene. In digital cameras, we do that by using the **White Balance control.** In film cameras, the choice of film determines the color of the image.

Let's talk digital first. When we adjust White Balance, we are basically telling the camera that we want what's white in the scene to appear white in the final image. That helps all of the other colors in the same scene reproduce correctly.

But white does not always look white. Natural lighting conditions can affect the color of white objects. For example, if you wear a white shirt and stand under a tree with green leaves on a sunny day, your shirt will have a green tint. So will your hair if you have light hair.

To help us get accurate colors in different lighting situations, digital cameras have a White Balance control. Here is how changing the White Balance affected the apparent color of an antique store near my home. In looking at these examples, keep in mind that the building was in the shade on a sunny day, and that the camera's **Shade setting** produced the accurate color rendition of the building.

Before we go on, note that most pros agree that it's not a good idea to use the Auto White Balance setting. As you will see, it was not the best choice for getting accurate color for my picture of the antique store. Also check out how a "wrong" setting can produce an interesting effect, as in the case of the Incandescent setting, which makes the building look as though it were photographed at night.

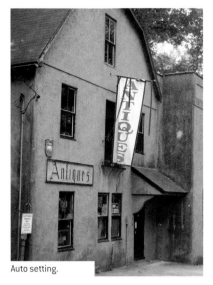
Auto setting.

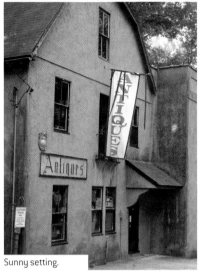
Sunny setting.

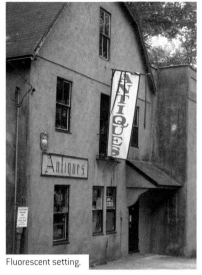
Fluorescent setting.

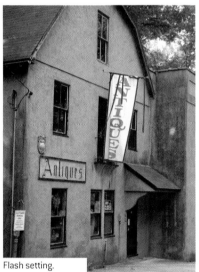
Flash setting.

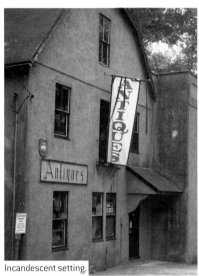
Incandescent setting.

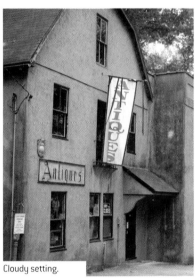
Cloudy setting.

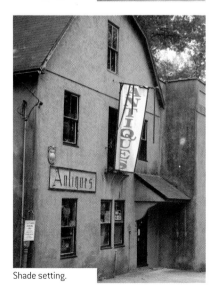
Shade setting.

Not all digital cameras have the same White Balance settings, and more sophisticated cameras usually have more White Balance options than less expensive cameras.

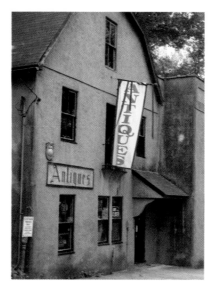

⇒⇒ In addition to White Balance controls, some digital cameras offer black-and-white and sepia modes. These settings can produce some interesting pictures. Sure, you can create the same effects in Photoshop, but it's nice to see the effects of these settings on your camera's LCD screen at the moment of exposure.

⇒⇒ Now let's talk film. Many different types of slide films are available for fine-tuning color in a scene. (Color print film is color corrected during processing, so you have little control over the final color in a print.) For example, Kodak's Extra Color slide film gives you more saturated colors. Kodak's E100S (Saturated) and E100VS (Very Saturated) films also give you saturated colors. And if you like saturated pictures with warm tones, there is Kodak's E100SW (Saturated and Warm) film. For those who prefer natural colors, there is Kodachrome 64 and Ektachrome 100. And for black-and-white lovers, there are many black-and-white films.

Following are four examples that illustrate the differences in film choice (simulated in Photoshop). I took the picture inside an ice cave in Glacier National Park, Montana.

⇐ Natural color produced by Ektachrome 100 film. The colors look very natural in this picture.

⇐ More saturated colors produced by Ektachrome E100S film.

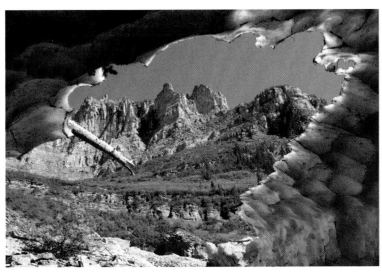

⇐ A warm and saturated image produced by using Ektachrome E100SW. The picture now looks as though it were taken later in the day.

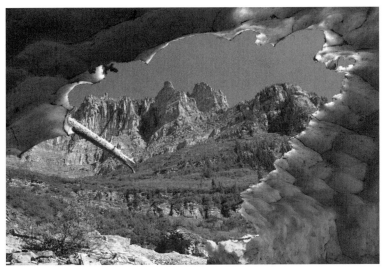

⇐ A black-and-white image produced by using Photoshop.

Of course, we can also change the color in a scene in the digital darkroom, as I did in the examples shown here. So, one could argue that it really does not matter which film you use; as long as you have Photoshop you can change the color afterward.

Here are three screen shots that show the controls we can use in Photoshop to change the color and saturation of a picture, and also how to turn a color picture into a black-and-white picture in Photoshop. We will explore these and more color control options in the lessons of Part V, "Working and Playing in Photoshop." So the next time you have your camera in hand, carefully consider how your White Balance and film choice will affect the color of your pictures.

When Auto White Balance Is a Good Choice

by Joe Farace

I agree with Rick and seldom use my digital SLR's Auto White Balance settings. However, there are some situations where it is a good choice, such as when working under mixed lighting conditions. One of the places I use Auto White Balance is at indoor auto shows in convention centers, or at any kind of indoor event held under similar conditions. In addition to the weird-colored high-intensity lights at the facility, colored spotlights illuminate each car and some—notably show cars in the "Import Scene"—are themselves bedecked with lights, including LEDS and colored fluorescents. When I enter the facility I make few a test shots using Auto White Balance, then try a few other settings and evaluate what produces the best color. In most cases this turns out to be Auto White Balance, but I always color-correct my final images prior to publication using a combination of Photoshop's **Image > Adjustments > Levels** and a color-correction plug-in such as Picto's iCorrect Professional (www.picto.com).

> *"Photography knows how to authenticate its misrepresentations."*
>
> —MASON COOLEY

Is What You See What You Get?

Cameras don't lie . . . but film and sensors don't always tell the truth!

Cameras are designed to record what we see. But is what we see with our eyes what we get with our cameras? The answer is sometimes—and that sometimes depends on several factors, including the type of image sensor or film in your camera, as well as the lighting conditions. Other factors include the selected shutter speed, f-stop, and ISO speed chosen, as well as the lens and filter in use—and, of course, how well we actually see!

For this lesson, however, I'd like to focus only on the quality of the image that film or the image sensor captures at the moment of exposure.

Digital Capture

Let's begin by talking about digital image capture. Different types of image sensors and different-sized image sensors all record light, color, and detail differently. Sensor types include CCD, CMOS, and the Foveon, which is a unique variation of the CMOS sensor offering red, green, and blue recording in every pixel, as opposed to the pixels in a CCD sensor that only capture one color in each pixel. Theoretically, you would think that an image sensor with more pixels, say 6 megapixels, would produce a higher quality image than a sensor with fewer pixels, say 4 megapixels. In reality, however, I've seen higher-quality pictures—sharper and more colorful— from a 4-megapixel SLR camera with a CCD image sensor than I have from a 6-megapixel SLR camera with a CMOS sensor, especially when the ISO of both cameras is set at or above 400. In fact, the quality of the images with the 4-megapixel camera at ISO 400, 800, and even 1000 was quite good, while the quality of the images with the 6-megapixel camera went downhill as the ISO increased after 400. This will change over time, I am sure.

Why this difference in image quality? One reason is that CCD image sensors are generally better at basic image capture than CMOS sensors, which are cheaper to produce. Again, changes are sure to come.

Another reason for the difference in my comparison was the actual size of the sensor. The more costly CCD sensor was a bit larger than the CMOS sensor—so

images from the camera with the CCD sensor did not have to be enlarged as much as images from the camera with the CMOS sensor. Sure, it was a small difference, but that difference adds up when it comes to making large prints.

Yet another reason for a difference in what we get and what we see is that our eyes can see a much wider dynamic range (or f-stop range) than a digital image sensor. One of my friends, Rudy Winston, a Canon technical adviser, offers an interesting view on the dynamic range of the image sensor. He writes, "While popular wisdom typically says digital is similar to shooting color slide film in terms of latitude, what goes unsaid is that there's tremendous detail in the shadow areas of a properly exposed digital image that at first glance may appear to be nearly black, but within Photoshop can be brought out. Of course, with a digital image, you have a definite ceiling on highlights—once it's rendered a pure white by the imager, all Photoshop can do is make a highlight area gray; it can't bring back detail that's truly washed-out (like texture on a bride's white wedding dress)."

No matter what digital camera you have, it's important not to judge the picture quality when you view that picture on your computer's monitor (which should be calibrated for the best image quality). I've opened some straight-out-of-the-camera digital images that were a bit dull, lacking in color and contrast, but I was able to turn them into the scene I saw in my "mind's eye" in the digital darkroom by adjusting the color, contrast, and brightness of the picture.

By the way, our mind "remembers" colors, so a color that we think we see may not be that actual color. I learned that while scuba diving at 80 feet, where my wife's red wetsuit looked almost black to me. But at that depth, it could not have looked red! At that depth, water filters out all red.

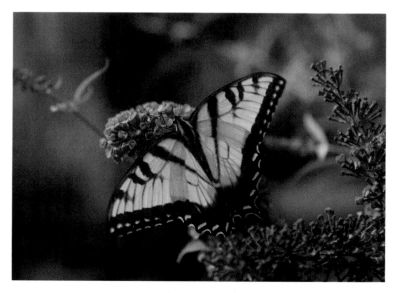

So why do I sometimes get dull digital shots? One time I had my White Balance incorrectly set to Auto (something I tell my students never to do). Another time I forgot to reset my Exposure Compensation from -.5 back to 0, so my pictures were underexposed. And other times the lighting in the scene itself was a bit flat.

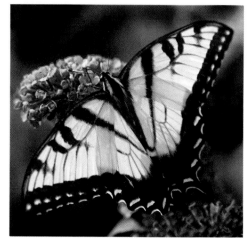

\Rightarrow Compare these two pictures of a tiger swallowtail that I photographed in my backyard with my 28–70 mm zoom set at 70 mm. If you want to photograph butterflies, plant a butterfly bush and caterpillar-attracting plants! The rectangular picture is a straight-out-of-the-camera (a $5,000 professional digital camera) shot. It lacks vibrant color, contrast, and detail, because it was taken on an overcast day, and because in my haste to photograph the butterfly, I forgot to reset the Exposure Compensation and White Balance on my camera. Now look at the cropped picture in

which I retouched out some of the annoying twigs. I was able to restore the color, contrast, and detail in Photoshop (see Lesson 50, "Basic Image Adjustment," to learn how to do that).

Before leaving digital capture, it's very important to discuss the difference between the JPEG setting (compressed) and the RAW and TIFF settings (uncompressed) that are available on some digital cameras. Briefly, I, and most of my friends who shoot for magazines, books, and newspapers and who like to make prints up to 20 × 24 inches, used to shoot at the high-resolution JPEG setting on our cameras. We didn't generally use the RAW and TIFF settings, because RAW and TIFF files took up too much space on our memory cards and took too long to download—not to mention that you needed the camera manufacturer's or a third party's special software to open and manipulate RAW files. That has changed, and we now shoot RAW images most of the time.

⇊ Here is an example of a RAW file vs. a JPEG file. Picture A was shot in the RAW mode and picture B was shot in the high JPEG mode. Can you see any difference? You might in a large print.

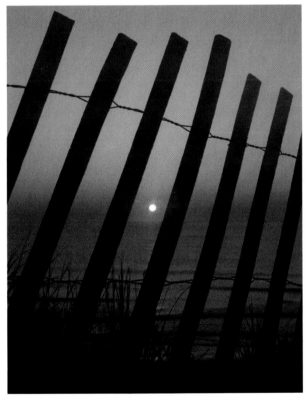

Picture A.

Picture B.

The RAW vs. JPEG discussion takes place in many photography circles. Here are some more views on the topic from some friends. Read them to make your own decision on which file format to choose.

Rob Sheppard, editor of *PCPhoto* magazine: "I know of no one who likes or uses the RAW files other than the manufacturers. They like them because they give a point of differentiation. Advantages of RAW files are few, except that they can allow better adjustment of color in certain critical situations including photos with very subtle white or black tones and where the photographer did not adjust white balance properly. I am a strong believer in avoiding the use of auto white balance except when it truly is a standard auto condition.

"Disadvantages to shooting a RAW file: they are a pain to deal with as they do not open readily with any

popular imaging program. They take longer to process and deal with; and they are not directly 'storable' because you can't use them directly in normal programs. What's more, they show no clear difference in image quality from high-quality JPEG (you have to be a real computer nerd with your nose and magnifier to the image to see any difference at all). Simply put, no one here has found any real value to shooting RAW."

Rob said that in 2002. And I agreed with him. In 2003 he writes, "I have now tempered my feelings about RAW files because I've had a chance to work with the new Adobe plug-in. While I recognized some of the benefits, I was unwilling to deal much with RAW because of the workflow, processing time issues. It just didn't seem to be worth it. However, now that ACDSee recognizes RAW and the new Adobe plug-in works very well, I am impressed."

Joe Farace, this book's technical editor and author of more than 20 books about digital imaging: "The real question is when do you shoot JPEG and when do you shoot RAW. The key is the exposure range of the scene. In a scene that has a narrow contrast/exposure range, JPEG should work fine; any lost data will be imperceptible. In a scene where there is a wide contrast/exposure range, and when you wish to retain as many of the variations in tones as possible, then you should use RAW. The question then becomes how wide should the exposure latitude be before throwing the switch to RAW; I've always told my students to shoot some tests. It works for film; it should work for digital—and it won't cost you any money for processing."

Mike McNamara, technical editor, *Popular Photography and Imaging* magazine: "Many higher-end digital SLRs are capable of capturing a 10–12 stop range of exposure values, as are several top digital point-and-shoot cameras. This range is similar to print film. But in order to capture that range, the images must be saved in RAW file format or uncompressed TIFF mode, which maintains the 12-bit-per-color data. Once files are saved as JPEG images, much of the exposure information is actually clipped (color data is reduced to 8 bits per color) and lost for good."

As I mentioned earlier, I am now a RAW shooter.

Film Capture

In the previous lesson, we talked about how different films and different digital camera White Balance settings affect the color of a picture. But contrast is another factor that affects a picture.

When it comes to slide film, you really don't want to be shooting a scene with a high contrast range, because, as we have discussed several times, slide film has a relatively narrow exposure latitude of about 3 f-stops. If you go over or under that range from the proper exposure, you'll get washed-out highlights and shadows that are too dark (although who is to say what is too dark?).

⇒ I photographed this lioness while on safari in Botswana on Ektachrome 200 slide film. I shot with my 35 mm camera and 100–400 mm Image Stabilizer zoom with a 1.4x teleconverter set at 400 mm—for an effective focal length of 560 mm. The early morning light created a harsh shadow on one side of the animal, which had just killed a waterbuck

(most kills take place in the early morning and late afternoon, when it's cooler than during the midday hours). Because our eyes have a dynamic range of about 11 f-stops, I was able to see clearly into the shadows, while also seeing the detail on the sunlit side of the animal, which did not look washed-out to my eyes. But my slide film could not fully capture the scene as I saw it. So once again, what you see is not always what you get.

⇒ I photographed this boy playing ping-pong in the shade in Hong Kong with Ektachrome 100 slide film. I shot with my 35 mm camera and 135 mm lens. Thanks to the low contrast range, I was able to get an evenly exposed picture. So when shooting slides, keep the contrast range down to a minimum.

Color negatives have a wider exposure latitude of about 5 f-stops. Another way of saying wide exposure latitude is "forgiving." So, even if the scene has some contrast, and even if your picture is a stop or two overexposed or underexposed, you can get a good print. But don't judge a picture by the negative.

⇑ Compare these two pictures of a tiger that I took at the Wild Eyes animal refuge in Montana with Kodak Royal Gold 400 color print film. The scanned negative, complete with scratches, dust marks, and fingerprints, looks flat. Now look at the retouched cropped picture. It has color, detail, and contrast—all enhanced in Photoshop. A one-hour-lab operator who knows what he or she is doing can make the same adjustments.

So when you are looking through your viewfinder, remember that what you see is not always what you will get—but you can re-create the scene (or enhance it even more) in the digital darkroom.

> *"It's a funny thing about life. If you refuse to accept anything but the best, you often get it."*
>
> —SOMERSET MAUGHAM

<table>
<tr><td>LESSON 35</td><td>

Not All Digital Cameras Think Alike

</td></tr>
</table>

Shutter lag and image-writing speed may affect the photos you take.

There are two often-overlooked features that you should consider when choosing a digital camera. Both have to do with image processing speed, or "thinking time."

One is technically called **shutter lag**. That's the time between when you press the shutter release button (although consumer digital cameras don't always have shutters in the traditional technical sense) and the time when the picture is actually taken. On low-end cameras, shutter lag can make the difference between getting a fast-moving subject in the frame—or getting nothing! On high-end consumer digital camera, shutter lag is reduced. And on professional digital cameras, shutter lag is, for all practical purposes, eliminated, which is one reason why these cameras can cost up to $5,000.

So, when looking at a digital camera, ask the salesperson about the shutter lag. If you can, take a picture with the camera. In most cases, you will be able to tell immediately whether or not the camera has a noticeable shutter lag, because most cameras make an audible "click" when the picture is taken.

⇒ These two pictures (from the same original picture to illustrate shutter lag) show what can happen when a camera with even a slight shutter lag is used to photograph a fast-moving object. The first photo captures the child zooming past the photographer. The second photo shows the child half out of the frame. If you know your camera has shutter lag, you can anticipate the moment at which you want to take your picture, and press the shutter release button slightly *before* that moment.

The other thing to consider when looking at a digital camera is the time it takes for the camera to "write" the picture to the memory card—its **image-writing speed**. Initially the photo is written to a buffer memory and when that's full is transferred to the memory card. Low-end consumer cameras don't have as large a buffer or write as fast as high-end consumer cameras, which means you could miss a shot while your last picture is being "written" to a card. In addition, low battery levels can cause an image to be written to a card more slowly than if the battery is at

For more information on image-writing speed, see SanDisk (www.sandisk.com) and Lexar (www.lexarmedia.com).

full charge. Of course, these points are moot if you shoot landscapes or the local snail race.

Not all memory cards are created equal, either. Some manufacturers, including SanDisk and Lexar, offer high-end CompactFlash cards that record digital files faster (as much as 16 times faster) than standard CompactFlash cards. The stated advantage is that you can take several high-resolution pictures in rapid succession without the camera "waiting" to write a file. Generally, higher-end cameras have large (128 MB) buffers, so the average user rarely experiences any shooting delay due to image-writing speeds.

For pros who shoot sports and action, image-writing time is very important, because they often shoot many pictures in rapid succession. For consumers, a slow writing time could mean missing an action shot when photographing action on a local playing field.

With 2- and 3-megapixel cameras, the writing speed is not that important because the files are relatively small compared to the files from a 5- or 6-megapixel camera. The larger the file, the longer the writing time.

So, if you are thinking about a digital camera, consider how fast the camera can "think."

PART IV

WELCOME TO THE DIGITAL DARKROOM

The digital darkroom has changed the way we, as photographers, take and make pictures. We see the world differently. We do what master photographer and darkroom artist Ansel Adams was so keen on: visualizing how a picture would look and how it could be enhanced, even before the picture was taken. His tool was the traditional darkroom; in our case it is the digital darkroom.

In this section we'll take a look at the basic hardware that goes into building a digital darkroom: computers, monitors, tools to get your pictures into your computer and store them when they're there, and printers to get your photos out on paper. We will also take a look at some software and hardware that can keep your computer up and running, even if the power goes out in a thunderstorm.

Reading about hardware may not be as exciting as taking and making pictures. But learning about digital darkroom components can help you work more efficiently, which may free up *your* memory to unlock some creative ideas.

The digital darkroom offers limitless possibilities—for those who simply want to make basic image adjustments and for those who want to awaken the creative artist within.

Before we get into the nuts and bolts of hardware, I'd like to share with you just a few examples of how you can turn snapshots into more creative images in the digital darkroom. To transform and create pictures like these, you really should have a computer with a fast image processor and a lot of RAM (random access memory). A good printer to show off your work is important, too.

◁ I took this picture in Montana of wild horses with a 100–400 mm lens set at 400 mm. My shutter speed was set to 1/500 of a second to "freeze" the action. I like the way the horses look in the scene, but I don't like all the "dead space" above and below the beautiful animals.

◁ Notice how a simple crop produces a much more dramatic picture. Also notice how I "warmed up" the picture by adding more yellow.

◁ This image has a soft glow, somewhat like an infrared picture. I added the glow in Photoshop using the Diffused Glow filter (see Lesson 62, "Have Fun with Digital Filters").

◁ Digital frames are easy to add in Photoshop and other digital-imaging programs. This frame was added in a Photoshop plug-in called Extensis PhotoFrame (see Lesson 82, "More Fun with Digital Frames").

⇑ Here is another shot I took of the wild horses in Montana. It's acceptable but nothing special.

⇑ This image is a more artistic version of the same picture. You, too, can create images like this. All I did was add a nik Color Efex Pro! Midnight filter and a Photoshop drop-shadow frame. Digital filters are covered in the "Have Fun with Digital Filters" and "A Tour of Plug-Ins" lessons. You'll find a drop-shadow frame under Photoshop's Actions menu, which is covered in Part VI, "Special Digital Effects and Techniques."

⇓ These two images were taken while actress Kelly Packard and I were hosting an episode of ESPN's *Canon Photo Safari* TV show in Lake Placid, New York. This shot, which is a bit overexposed, was taken by the tennis court. Check out the lines radiating from my head! In Photoshop, I transported us to nearby Mirror Lake by cutting us out of the boring photo and pasting us into a picture I had taken of that beautiful lake. Then, just for fun, I removed the color from the picture.

I share these Lake Placid images with you for a good reason: Don't believe everything you see in pictures these days. Magic is easy to create in the digital darkroom. Have fun!

> *"I think computer viruses should count as life. I think it says something about human nature that the only form of life we have created so far is purely destructive. We've created life in our own image."*
>
> —STEPHEN HAWKING

LESSON 36 Choose a Computer

Get the most out of it!

The computer system is the heart of the digital darkroom. It's where a digital picture file is opened, where you can make changes and enhancements to the file on a display, and from where the image gets printed.

Technically, that's what a computer will do for you. Personally, your computer is your workstation (or play station) for making endless variations to your pictures, and even for creating works of art. It's where you can have a lot of fun, and where you can discover the artist within.

Mac vs. Windows

Computers come in all sizes, shapes, colors, and styles. The big question when choosing a computer, however, is this: Do you want a Windows system, such as the Sony Vaio, or an Apple Macintosh system, such as the iMac?

When it comes to Macs vs. Windows computers, most of my photographer friends use Macs. They feel that it's easier to work on their pictures in the Mac environment. I agree. Windows computers, however, are becoming more and more

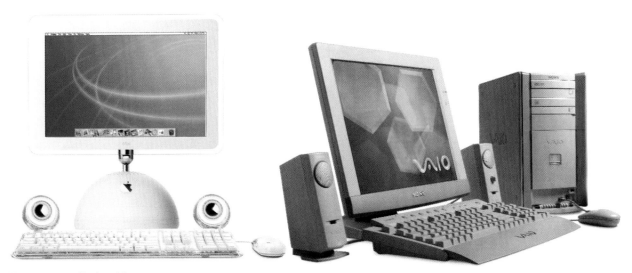

Photos courtesy of Apple and Sony.

user friendly. And one advantage to using a Windows computer is that a few more photo imaging programs and Photoshop-compatible plug-ins are available for Windows than for Macs, especially for beginners.

Don't be swayed by overall market-share differences between Macs and Windows computers. Windows has a much larger market share among all computer users. However, a 2002 study by GISTICS, Inc. (www.gistics.com), of 3,762,922 creative professionals in North America showed that 49.8 percent use Macintosh computers and 37.6 percent use Windows (all versions) as their primary system. Even that statistic may be flawed, however, because it looks only at the pros.

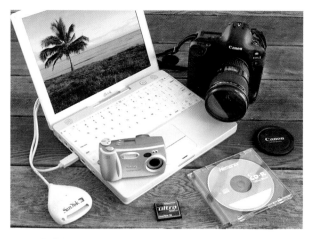

Laptop vs. Desktop

⇐ Another computer choice is between desktop and laptop models. I have both types. At home, I am glued to my desktop computer. That's where I make all of the creative adjustments to my images. On the road, I use my laptop for storing images at the end of the day, and also for burning CDs of a day's shoot. (See Lesson 103, "Travel Totally Digital," for information on traveling with a laptop computer.) If you plan to do a lot of traveling with your digital camera, you may want to consider getting a laptop computer in addition to your desktop computer system.

Photo courtesy of Apple.

Display

⇐ In any computer system, the display plays a key role. Size is important, as is image quality. For the serious photographer, a 22-inch display, such as this Cinema Display from Apple, is a popular choice. I've tried to stay away from discussing prices in this book, unless I think it's important, but the Cinema Display costs more than $2,000 as I write this.

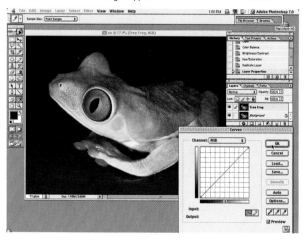

⇐ Large displays make it easier to see your photographs. What's more, large displays make it easy to view several adjustment windows (such as Layers, Curves, History, etc.) at the same time while working on an image, which saves you time when opening and closing windows. My technical editor, Joe Farace, is currently working with a 23-inch Radius LCD monitor (costing more than $4,000) that lets him have two full-size images open at the same time so he can compare his original and manipulated photographs.

Some of my friends prefer flat-panel displays, which are said to offer better brightness and contrast. Others prefer the glass CRT (cathode-ray tube) monitors that seem to display smoother gradations for subtle colors such as skin tones, which can be especially important when working on pictures of people. In choosing a display, consider the cost and image quality. At the time of this writing, I like my glass monitor, but I think flat-panel displays will be the wave of the future because they require less desktop space and generate less heat and radiation. They also use much less electricity. A P.S. here: Just before this book went to press, I got the Apple 23-inch Cinema display.

Memory

When my photo workshop students ask me what to look for in a computer, the first word out of my mouth is "Speed!" In talking about speed, I'm referring to the speed at which an image is processed. Basically, two things affect speed: the computer's **processor chip** (CPU) and the amount of **RAM** (random access memory) it has. Of the two, RAM is actually more important. So, if you have a choice of getting a computer with a 933 Hz processor and 128 MB of RAM, and a computer with an 800 Hz processor and 512 MB of RAM, go for the latter. Get that extra RAM!! I have 512 MB of RAM in my computer and sometimes that is not enough for what I want to do.

Other, lesser factors that affect the speed at which you can make image adjustments include adding Layers (which increases an image's file size), having several pictures open at the same time (which eats up RAM), and making many different kinds of adjustments to an image. You can free up some RAM by purging an image's History. In Photoshop version 7, History can be found by going to **Windows > History.** It shows the steps you made while making adjustments to an image. You purge by selecting Clear History from the History palette. **Important:** When you purge the History of an image, you erase all of the steps you took when making that image. You can't go back. So purge only when it is absolutely necessary, and when you are 100 percent satisfied with an image.

With lots of RAM, your computer will process images more quickly—or, you could say, it will "think faster." That's especially important when applying filters and special effects, which can take "forever" if you don't have a lot of RAM.

Lots of RAM is also important when using some of the basic tools in Photoshop. The Eraser tool, for example, works fast with 512 MB of RAM, but is noticeably slower with 128 MB of RAM. In Photoshop version 7, the Clone Stamp and Healing Brush tools will simply stop working if they run out of RAM.

More RAM also enables your imaging program to run faster and more efficiently in general. It helps prevent "freezes" and "bombs." And, with lots of RAM, you can have more than one program open at the same time, such as Photoshop and Microsoft Word, which is useful when, for example, writing a book or magazine article on photography, when you might need to see an image and write about it at the same time.

Lots of RAM is sometimes needed to run Photoshop along with an inkjet printer's software program to make a print. If your entire RAM is eaten up by a very large file, when you go to make a print, you could get the prompt "Sorry, Out of Memory. Can't Print."

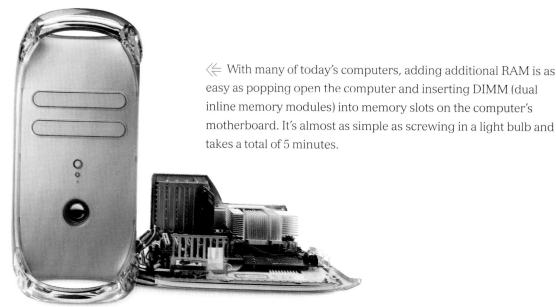

⇐ With many of today's computers, adding additional RAM is as easy as popping open the computer and inserting DIMM (dual inline memory modules) into memory slots on the computer's motherboard. It's almost as simple as screwing in a light bulb and takes a total of 5 minutes.

Photo courtesy of Apple Computer.

⇒ For Mac users, there is something else you can do to make Photoshop run faster and more efficiently. You can increase the preferred size of the memory. Here is how to do it. In the Finder, click once on the Photoshop application icon. (One click will not launch the program.) Then go to **File > Get Info > Memory** and the Memory window opens. In the Preferred Size box, increase the Preferred size. I doubled mine, but if you don't have enough RAM, that may not be possible. Technical editor Joe Farace, who has 768 MB of RAM in his Power Macintosh G4, has his preferred size set at 512 MB. That's just another reason to have as much RAM as you can afford.

Once you increase the size of the preferred memory, you will use more RAM when launching Photoshop. So you may not be able to run other programs at the same time, which might have been possible before you increased the preferred memory size.

⇒ Windows computers handle memory differently. In Photoshop, under **Edit > Preferences > Memory & Image Cache** there's a dialog box that lets you set physical memory usage as a percentage of installed RAM. On Joe Farace's Windows XP computer, which has 768 MB of RAM, he keeps physical memory usage set at 50%. The pop-up window that lets you set this has a continuously variable scale from 0 to 100%.

Ports

The number of USB and FireWire ports (on the back or front of your computer and your display) is also important. The more ports you have, the more accessories you can attach to your computer, such as a printer, slide scanner, film scanner, additional external hard drive, or Palm Pilot. My Apple 23-inch Cinema display has two USB ports, and my Mac G4 has two **USB ports** and two **FireWire ports** (which are used for ultra-fast data transfer from external hard drives and from my pro digital SLR). If you plan to have a lot of accessories, look for a system with a lot of ports. Or add a USB hub to your system.

Mouse

Now it's time to talk about the mouse and its role in helping you use Photoshop's tools to their best advantage. A mouse gives you some control, but not precise control over exactly—and I mean exactly—where you are making an adjustment, enhancement, or correction.

⇒ Enter the WACOM tablet. For serious and artistic Photoshoppers, a WACOM tablet offers the ultimate in precision. Rather than running your mouse around a pad, you gently move the WACOM pen (or cordless WACOM mouse) over a tablet, which is in effect your mouse pad with one big difference. The pen is pressure sensitive, so you don't have to adjust the opacity of the Photoshop tools (from 0 to 100) when making fine adjustments. Simply press harder for a strong effect, and press lightly for a softer effect. What's more, if you make a mistake, you can use the top of the pen as an eraser—that, too, is pressure sensitive. And, you can program the WACOM pen for certain custom functions and plug-ins, such as the nik Color Efex Pro! filters (mentioned in Lesson 63, "A Tour of Plug-ins").

⇒ WACOM tablets come in small, medium, and large sizes. One of the coolest WACOM tablets is the Cintiq. The Cintiq actually has a built-in, full-color LCD display, so you can keep your eyes on the image and your WACOM pen at the same time—just as a painter simultaneously keeps his eyes on his brush and the painting. The Cintiq will cost you more than a basic computer: $2,000 at the time of this writing.

Storage

After all your hard work and fun Photoshopping, you will need to permanently save your images. You could save them only to your hard drive, but that drive could crash and your images could be lost forever. What's more, lots of high-resolution pictures take up lots of memory and clog up your computer.

And it's not impossible that your computer could crash or freeze at any time. And it's also not impossible that after a crash or freeze, you may not be able to launch the operating system.

⟹ Two diagnostic software programs may help in the event of a disk crash: Alsoft's DiskWarrior and Micromat's TechTool Pro. I strongly recommend that you get both of these programs. TechTool Pro can be placed on your hard drive and set to run a check each time you turn on your computer. If it finds a minor problem, the TechTool Pro can fix it. For a more serious problem, you need to run a program from the CD— both TechTool and DiskWarrior have this capability.

⟹ One solution is to burn CDs or DVDs (which hold many more pictures than recordable CDs). Making two copies for "insurance" purposes is also a good idea. You never know when a CD or DVD could get damaged or misplaced.

⟹ For a much greater picture-storage capacity, you may want to consider an external hard drive. Shown here are my 20 MB and 30 MB LaCie external hard drives, which are hooked up to my computer via FireWire cables at all times. One advantage to using external hard drives over other storage options is that they transfer images much faster than your computer can burn a CD or DVD.

Power

Speaking of saving your pictures, as you can see, my two LaCie hard drives are resting by my uninterruptable power supply. It has a built-in surge suppressor, for both the power line and the phone line. If there is a power surge, my computer is protected against being zapped. And, because the phone/DSL line goes through the unit to my computer, if a phone line gets hit by lightning, my computer won't get zapped—as my previous computer did before I had this type of phone-line surge protector.

An uninterruptible power supply serves another important purpose: If the power goes off, the battery in the unit comes on for a few hours. So if there is a blackout or brownout while I am working on an image, all is not lost. Less expensive surge suppressors may offer an adequate, shorter battery backup period of ten minutes.

So the end of the story when it comes to computers is this: If you are serious, buy a computer with as much RAM as you can afford, go for a large display, and back up your images to a permanent storage place. But also leave some "fun" money for computer accessories: printer, paper, and programs.

Take the Mac vs. Windows Test *by Joe Farace*

Windows users will tell you that their graphical user interface (GUI) is the same as the Mac's, but that's only partially true. And the functionality of most cross-platform (available for both Mac OS and Windows) digital-imaging programs is almost identical, which leads some photographers to believe there is no difference between Macintosh and Windows platforms. Not true.

One of the biggest differences between these platforms is the way you navigate through the system and how each operating system performs basic digital housekeeping. If you're undecided about what system is right for you, go to a store that sells both Windows and Macintosh computers and ask a salesperson to show you how each computer handles the following operations.

1) Insert a floppy disk, CD-ROM, or Iomega Zip disk, and search its contents.
2) Show the contents of the hard drive and find a specific file.
3) Launch that file and the application that created it.
4) See what steps are required to install software onto the hard disk.
6) Ask what hardware and software are needed to install peripheral equipment and what a user must do if he or she decides to install this equipment themselves.

Seeing these operations in action will help you decide which system operates the way you do and can do much to minimize (but will never eliminate) buyer's remorse after you've bought a computer.

"The most overlooked advantage to owning a computer is that if they foul up, there's no law against whacking them around a little."

—JOE MARTIN, PORTERFIELD

| LESSON 37 | # Move Pictures into Your Computer |

We have several ways to get pictures into a computer.

In the early days of digital imaging, getting pictures into a computer required special software and took a relatively long time. Plus, those digital pictures of yesteryear did not compare in quality to the digital picture files of today. These days, we have two ways to get digital and film pictures into a computer, faster, more easily, and less expensively than ever before: card readers and camera cables.

⇊ **Card readers** are the fastest, easiest, and most popular method for getting pictures from a digital camera into a computer. There are two types of card readers: USB (shown below) and FireWire, which offers a faster picture transfer than a USB connection. As the file size of a picture increases, it takes longer to transfer. To run a card reader, we simply load the card reader's software onto our computer's hard drive from the CD-ROM included by the manufacturer, then plug the reader into a USB or FireWire port and insert our camera's memory card (CompactFlash, SmartMedia, etc.) into the reader. Using drag-and-copy techniques, all of the pictures on a card can be transferred to our computer in minutes.

Some card readers accept only one type of memory card. Others accept two or more types of cards.

Multi-format card readers that can read up to nine formats (CompactFlash types I and II, IBM Microdrive, SmartMedia, SD/MMC, Memory Stick, and MagicGate Memory Stick) are available from companies such as Belkin Corporation (www.belkin.com.).

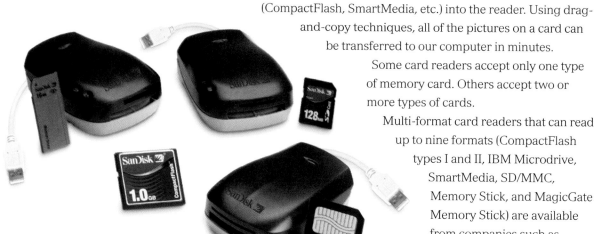

Find Belkin card readers at www.belkin.com.

Using a digital camera's software and USB or FireWire cable is the simplest but not the easiest method for getting pictures from a camera directly into a computer. First we load the appropriate software onto our hard drive from the camera's CD-ROM. Next we hook up our camera to the computer via a USB or FireWire cable. Then we run the software.

Most digital camera programs offer basic image enhancements such as cropping and color and contrast control. Others offer advanced enhancements. The more sophisticated the camera, the more sophisticated the enhancements offered will be.

The software that comes with professional digital cameras (software for Canon EOS 1D shown above) also shows exposure data, including date and time, exposure mode, shutter speed, aperture, and metering mode. That information is useful for seeing what you did right at the time of exposure, and for keeping track of all your good and poor exposure decisions for future use.

The software that comes with professional cameras lets you operate the camera remotely from a computer. It also enables you to make adjustments to camera functions from your computer.

If you travel with your digital camera, card reader, USB or FireWire cable, and your laptop, and you *must* transfer your pictures to your computer on site for e-mailing or for burning CDs, it's a good idea to pack the software for your camera and card reader, too. That way, in the unfortunate event that your computer crashes, you can reload your camera and card reader software onto another computer or onto the reformatted hard disk in your laptop. Of course, you should always travel with your system software and diagnostic software, too. (For most Mac OS and Windows systems, reloading the system software will erase all the programs on your hard drive.)

In addition to card readers, there are other methods for getting digital pictures into a computer. Some Sony Mavica digital cameras use a built-in 3-inch CD-R/CD-RW drive for recording pictures onto standard 80 mm mini-CDs. These CDs can be used in any computer with a CD or DVD drive or accessory drive with the exception of early Apple iMac models and any computer that uses a "slot" drive (much like a car CD player). (What happens is that the mini-CD goes in, but won't come out unless you disassemble the computer. Sounds like fun, doesn't it?)

Sony also makes digital cameras that record pictures on floppy disks or memory sticks. Both types of Sony cameras come with USB cables for easy camera-to-computer hook-up.

What about getting slides, negatives, and prints into your computer? Even if you are totally digital and have sold all your film cameras, there is a good reason to take a look at these options: You can work wonders on your "old" pictures in the digital darkroom, fixing them and even creating works of art out of "straight shots."

⇒ Photo CDs (as opposed to picture CDs, which offer lower-quality images) are an affordable method of film-to-digital transfer. Photo CDs are available from Canon, Kodak, and other image-processing companies. Scans of individual pictures cost between $1 and $2, and up to 100 35 mm pictures can be stored on a single photo CD disc.

Photo CDs come with color index sheets that show all the pictures on the CD in thumbnail size. These index sheets are useful for seeing what's on a CD and for marking pictures you may have used in a project, such as a photo exhibit, magazine article, or even a book like this one.

To order a Photo CD, you simply take or send your film to a lab and request a Photo CD. What's especially nice about this service is that all your pictures are placed in different folders

with different resolutions. That's useful because you can view and play with your pictures at the low-resolution setting, and then work on them at the high-resolution settings. The low-resolution photos can also be used for e-mailing and posting on Web sites. Conversely, the high-resolution pictures can be used for printing and for publication. Several pictures in this book were made from a Photo CD. Some professionals, however, find that pictures on a Photo CD, with a maximum resolution of about 1000 ppi (pixels per inch), don't have the quality they need for printing or publishing. Enter film scanners, the topic of the next lesson.

"Tain't what you do, it's the way you do it." —FATS WALLER

Scan Film and Prints

Scanners offer another way to digitize your photos.

Advanced amateur and professional 35 mm film scanners, with resolutions around 4000 ppi (pixels per inch), can, when calibrated and when in the hands of someone with a keen eye, produce high-quality digital files. The Nikon CoolScan and Polaroid SprintScan shown here each have a resolution of 4000 ppi.

Lower-resolution 35 mm film scanners, with resolutions of around 3000 ppi, can also produce acceptable results, but they may not be what a serious photographer is looking for in terms of quality.

Ppi is not the only feature to look for when choosing a film scanner. D-range, or **density range**, is important, too. D-range is the scanner's ability to capture bright highlights and deep shadows. High-end slide scanners have a D-range of 3.6 or higher. (A good flatbed scanner, which we will get to later in this lesson, has a D-range of 3.0 or higher.)

Bit-depth is important, too. Bit-depth measures the scanner's ability to capture subtle shades of gray and subtle variations in color. A high-end scanner will offer 36-bit or 48-bit color, while a low-end scanner may only offer 24-bit color, which while adequate for many applications may not achieve enough subtlety of color, texture, and shadow for critical use.

Film scanners are available with USB or FireWire connections for both Mac and Windows computers.

⟸ Film scanners are typically bundled with software that makes it easy to get your pictures into your computer. (The software shown here, LaserSoft's SilverFast AI, comes with the Polaroid SprintScan film scanner.) Once launched, a scanner's software lets you make several decisions about your scan, including size, cropping, resolution, sharpening, and color depth.

Although I am almost totally digital, I go back to my 35 mm slide file every once in a while, pick a favorite slide, and scan it. As I mentioned earlier, going back to your "old" slides and scanning them can be a lot of fun, and you could come up with a new interpretation of a picture. You may also enjoy making inkjet prints of your "old" photos.

⟹ For example, the top image is a straight scan of a spine-cheek anemonefish that I photographed on film in Papua New Guinea. I like the straight scan, but I think the softer image below, with deeper shadows created by using the Midnight filter in nik Color Efex Pro!, is more creative and artistic.

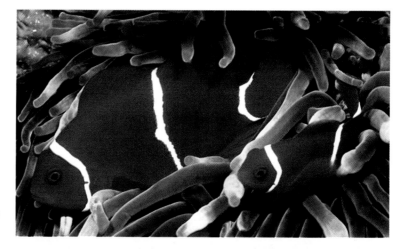

Early scanners simply scanned a slide or negative. Today, several scanners (including models from Nikon and Minolta) feature software that can save you lots of retouching and enhancing time in the digital darkroom. These programs include Digital ICE (image correction enhancement), from a company called Applied Science Fiction, that removes surface scratches and dust. Sounds great? Well, in the scanning process, the resolution is slightly lowered and scan time is increased. Even so, in choosing a scanner, you may want to consider one with Digital ICE.

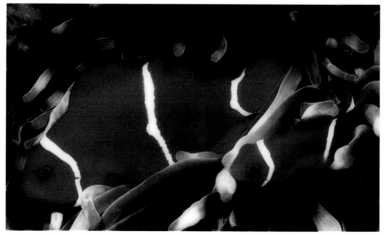

View Applied Science Fiction scan technology at www.asf.com.

Applied Science Fiction has two other programs that are built into scanners that have the ICE package and make a scanner more attractive, especially when scanning older slides and negatives: Digital ROC (reconstruction of color) for restoring faded photos, and Digital GEM (grain equalization and management) for reducing grain in pictures. Digital ROC and Digital GEM also increase scan time, but if you have grain and poor color, you may want to find the time to use a scanner with this capability. If your scanner lacks Digital ROC, it is also available from ASF as a Photoshop-compatible plug-in.

For most advanced amateur and professional photographers, 4000 ppi scanners produce files with enough detail and color for making great enlargements up to 20 × 24 inches and for producing files suitable for most publications. I used a Polaroid 4000 ppi scanner for some of the pictures in this book.

⇒ When making prints larger than 20 × 24 inches, or when larger files are needed for advertising or stock photography, a higher-resolution scan is often needed. The FlexTight Photo from Imacon, which produces a scan with 8000 ppi, meets those needs—at a cost of several times that of the most expensive Nikon or Polaroid 35 mm film scanner.

⇑ Flatbed scanners, such as this model from Canon, are designed for scanning prints but can be used for scanning any flat object, including a leaf or dried flower. As with 35 mm film scanners, resolution is important. In comparing scanners, keep in mind that the higher the resolution, the higher the price and the higher the image quality.

A flatbed scanner's resolution is typically different from a 35 mm film scanner's resolution. For example, a low-end flatbed scanner may have a resolution of 1200 × 2400 ppi, while a high-end flatbed scanner may have a resolution of 160 × 3200 ppi.

Flatbed scanners come with USB or FireWire cables, but some Windows-only scanners offer parallel port (EPP) connections. Features to look for in a flatbed scanner, in addition to resolution, include the maximum size of documents you can scan and scanning time. The availability of a transparency adapter or the ability to also scan film—slides and negatives—is a bonus. If you are serious about scanning, you may be better off getting a film scanner and a print scanner. The quality is usually better with scanners designed for a specific purpose.

⇒ Flatbed scanners come with software that even the first-time scanner can use. The software puts you in control of the final image: size, cropping, resolution, etc.

Again, I am almost totally digital. But my flatbed scanner is always attached to my computer. Every so often I go through my prints and find one I want to scan. In the process of writing this book, I found a picture of my mother and my son, Marco, when he was just one week old. The black-and-white print was a bit flat, but I knew I could enhance it in Photoshop.

⇑ This is how the original black-and-white picture looked after a scan, and how it looked after I cropped it to an oval and used the nik Color Efex Pro! Midnight filter.

Again, I share these examples with you to encourage you to go through "old" photos to see which ones can be enhanced. Some interesting ideas may be born out of necessity, as was the case with the flawed print of my mother and son.

Scanning Tips

1) Keep your scanner covered and clean. That will save you time removing spots on your images caused by dust.

2) Keep your film—slides and negatives—clean, too. Little specks of dust can end up looking like boulders.

3) Calibrate your scanner with the scanner's software (often a test slide with a film scanner). That, too, will save you time correcting color in the digital darkroom.

4) Don't use the scanner's software to sharpen the image. You can do that later in Photoshop. Sharpening a picture is easier than softening a picture, and there is such a thing as an oversharpened picture.

5) Scan to the picture size and usage. For example, if you want to make a photo-quality, 8 × 10-inch print on your inkjet printer from a 35 mm slide or negative, set the image size in your scanner's software to 8 × 10 inches and the resolution to 240 dpi. Setting your scanner at a higher dpi will not give you a better inkjet print (see the discussion on printer resolution in Lesson 40, "Choose a Printer," for an explanation). Some photographers, however, scan their slides at the highest possible resolution. That way, they can downsize their files to make a relatively small print at the time of the scan. Then, at a later date, they can make a larger print without having to re-scan their slide at a higher resolution. If you intend to send a digital file to a magazine (except perhaps *National Geographic*), you'll be fine with a 5 × 7, 300 dpi TIFF file. All the digital files for this book were made at that setting. Newspapers will accept 5 × 7 200 dpi JPEG files.

6) Before you press "Scan," crop your picture with the scanner's software. That will shorten scanning time.

7) Eliminating **moiré**: When scanning pages from books, magazine, or printed sources, you may run into strange patterns caused by the dots or lines used in printing these images. One of the best ways to eliminate these annoying patterns is to use the scanner's three-pass mode, if it has one. If that doesn't work or your scanner lacks this capability, rotate the image slightly before scanning. You can always use Photoshop to straighten it later, although some scanner software from companies such as Epson does this automatically.

8) Less expensive scanners often give the option of scanning at resolutions higher than the hardware permits, which is called **interpolated resolution**. While this sounds like "something for nothing," digitizing at twice the scanner's optical resolution *can* produce acceptable results. One way to improve interpolated scans is by using Photoshop's Unsharp Mask command, which adds edge definition and crispness. If your favorite image editing program lacks this option, nik Sharpener Pro! works with any image-editing software that accepts Photoshop-compatible plug-ins (and that's most of them).

"One photo out of focus is a mistake, ten photos out of focus are an experimentation, one hundred photos out of focus are a style."

—ANONYMOUS

<table>
<tr><td>LESSON 39</td></tr>
</table>

Save and Organize Your Photos

Using a photo-organizing program saves you time and effort when looking for a particular shot.

As you get more and more into the digital darkroom, you'll realize the importance of having your pictures (digital files) organized. If you don't, it may take you a long time to locate a favorite picture in your computer—perhaps one that took you an evening of correcting and enhancing in the digital darkroom to create. Worse still, you may not even be able to find it on your hard drive, because of mislabeling or forgetting what you named it.

Fortunately, many different photo-organizing programs are available that can help you manage your photos quickly and easily. These programs let you browse and organize thumbnail-size pictures of your files. Or, if you don't like what you see, you can delete the files on the spot (which I don't recommend because sometimes "outtakes" can become "keepers" with some enhancement in the digital darkroom).

Generally speaking, these programs are designed for photographers who transfer pictures from their camera to a computer via a memory card reader or a Kodak Photo CD or Picture CD. (Many digital camera software programs offer their own basic viewing and organizing functions.) Photo-organizing programs let you turn digital files with long, seemingly meaningless numbers into easily viewable thumbnail-size pictures, which you can name anything you like!

How do you choose a photo-organizing program? Well, if you have a relatively new computer, you probably have a photo-organizing program built in. Apple computers with OS X or later versions already installed have iPhoto, and Windows XP computers offer Photo Wizard. Adobe Photoshop 7 has a fabulous built-in File Browser that helps you preview and manage your pictures.

Both iPhoto and Photo Wizard are useful for organizing your pictures in easy-to-find folders. But for those who need more photo-organizing and photo-enhancing controls, there are stand-alone photo-organizing programs, such as ACDSee, that offer several basic and automatic image-correcting features. Before Photoshop 7, I used a stand-alone photo-organizing program called Extensis Portfolio. You'll find

other photo-organizing programs listed in the appendix section "Web Sites for Image-Makers." Most of these programs share similar basic features.

If you don't have Photoshop 7, or need more options, look for a photo-organizing program that has all the options, such as slide show, proof sheet printing, large and small thumbnail viewing, magnifying an image, renaming capabilities, and file by keyword. Whatever program you choose, I recommend using it every time you upload pictures into your computer. Sure, it takes some time, but it will save you time and effort days, weeks, months, and even years from now locating your important pictures. Personally, I file my pictures in folders by location and date.

Saving Your Pictures

After you have used your photo-organizing program to select and file your favorite pictures into a new folder, it's important to back up that folder as soon as possible. I recommend making one copy of the folder on a CD (or CDs if you have a lot of pictures) or a DVD (which has a lot more memory than a CD), and another copy on an external 20 or 30 GB hard drive that you use exclusively for your pictures. That way, you'll have your pictures saved in two places. After, and only after, your pictures are saved in more than one outside location, should you delete the pictures from your hard drive.

Also, I recommend not deleting pictures from a memory card until after your pictures are saved on a CD or accessory hard drive—and after you've checked to see that they are all there.

I never touch (and have never had to touch) the CDs . . . because I want to keep originals of my originals. I work off the pictures on my external hard drive, opening the JPEG files and immediately saving them in TIFF format on the same hard drive to prevent any loss in image quality.

⇐ With most photo-organizing programs, you simply drag a picture folder into the program's catalog window, and within a few seconds, you see thumbnail-size pictures of all files in the folder. (As the number of pictures on a card increases, so does the amount of time it takes to create thumbnails.)

⇑ Most photo-organizing programs let you preview your pictures at full-screen size. That's a useful feature when you want to see whether or not you've got the shot you're looking for.

⇑ In choosing a photo-organizing program, look for one that offers a magnifying feature. That way, you'll be able to "zoom in" on the picture and check it.

⇐ A good photo-organizing program can turn the long, seemingly meaningless JPEG numbers (shown in the long, vertical window) into thumbnail-size pictures (shown in the large window) for easy viewing. The programs make it easy to save your best shots in a new picture folder. Choose a labeling method for image folders that fits your work habits—e.g., by date, location, or subject.

*"The negative is the equivalent of the composer's score,
and the print the performance."* —ANSEL ADAMS

Choose a Printer

Photo-quality inkjet printers are widely available in a range of prices and options.

Computers and digital-imaging programs have been around for many years, but it was not until relatively recently that at-home, high-quality color printers became available and affordable for virtually everyone. The **inkjet printer** was a key element in the evolution—and revolution—of the digital darkroom.

For around $150, you can get a basic photo-quality inkjet printer. These printers lay down dots of ink on paper, virtually any type of paper. Epson makes piezoelectric inkjet printers; Canon, Lexmark, and HP all make thermal inkjet printers. Out here in the real world, when looking at the prints from both types of printers, you can't tell the difference between prints made by these different kinds of photo-quality inkjet printers. And even prints from a $150 printer may be acceptable to those just getting into at-home printing, especially if photo-quality glossy paper is used.

Serious image-makers, however, those who seek super-sharp prints with vivid colors and archival quality, need a different breed of photo-quality printer—one that produces higher-quality results and offers more creative control. Many desktop models in this category are available from various manufacturers, and are priced from $500 to $2,000.

⇐ I have made super-sharp 13 × 13-inch prints (13 × 19-inch paper) of this butterfly photograph using a Canon i9100 printer and an Epson Stylus Photo 200 printer. If you plan to make large prints, get the best printer you can afford.

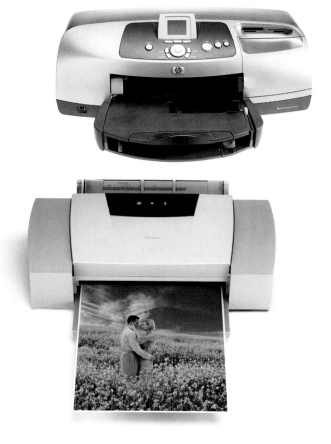

↗ Inkjet printers for serious image-makers, such as these models from Canon, Epson, and HP, are the most popular type of high-quality printer. They offer the ultimate in creative control (complete with printer software for fine-tuning an image) and can use any type of photo paper, as well as any type of specialty paper (for more, see Lesson 41, "Pick Paper for Your Printer").

⇊ **Dye-sublimation** (or dye thermal) printers, such as these models from Kodak and Olympus, fuse spots of dye onto special dye-sublimation paper (in four passes, one each for cyan, magenta, yellow, and black) for a continuous-tone image, just like a "real" photo print from a photo lab. (Some dye-sub printers use three-color ribbons, skipping the black portion and replacing it with a UV coating to protect the finished print.) But limiting yourself to the special

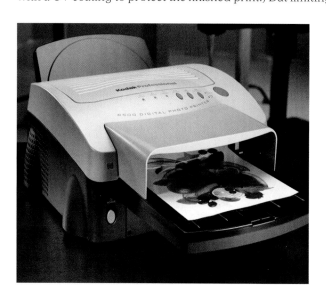

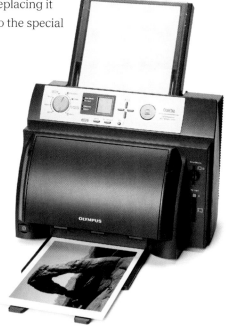

dye-sub paper, which usually comes only as large as 8 × 10 inches, limits your creative options. So although dye-sub printers produce great-looking prints, we'll limit our discussion in this lesson to inkjet printers.

Several factors determine the cost of a printer and the quality of the images it produces. In choosing a printer, consider the following features, and choose a printer based on your creative needs and budget. After all, you will need funds for ink and paper too!

Image resolution. Resolution is perhaps the most debated topic when choosing a printer. So understanding resolution is important. Serious photographers want to get the best possible prints from their desktop printer. If you are new to digital printing, you might think that if you have a printer with a maximum advertised resolution of 1440 dpi (dots per inch), you should print all your pictures at that resolution and select that resolution when scanning a picture or when determining the file size of a picture. However, you will create a huge file of many megabytes that will take an extremely long time to print and take up lots of hard drive space. Such a huge file is not necessary to get a great print. Here is why.

Printer resolutions are measured in dpi, but the dpi count in a printer is not the total number of dots placed side-by-side in an inch. Rather, it is the total number of dots that can be placed *in* an inch, often on top of one another. So, if you have a 6-color inkjet printer, it's not impossible to have 6 different colors dropped in the same spot. With a 1440 dpi printer, that would give you a real resolution of 240 dpi.

Most of my fellow professional photographer friends use that 240 dpi setting when making inkjet prints and are very pleased with their results. For example, when I make an 11 × 14-inch print, I set the image resolution in my imaging software to 240 dpi.

Ink Tanks or Cartridges

⇒ Early printers had two ink tanks: a black ink tank and a color ink tank (usually containing three colors—yellow, cyan, and magenta). Printers with this type of system are still available, and they produce good results. Today, however, the trend for serious image-makers is to choose a printer with individual ink tanks, which has long been the norm for large format shots and for printers used in the graphics arts industry.

⇒ Top-of-the-line printers have six or seven ink tanks. There are two advantages of using individual ink tanks. The first is that they give you better control over color for black-and-white prints. (If you are interested in making art-quality black-and-white prints, look for a printer that also includes a "light black" ink tank. This one extra ink tank will produce superior mid-tones and grays.) The second reason is that you don't have to replace an entire ink cartridge, wasting all the unused ink, if only one color, say blue, runs out.

Usually, as the number of ink tanks increases, so does the cost of the printer.

Types of ink. The archival quality of inkjet prints has greatly improved over the years. There are two types of ink for desktop printers: dye (not to be confused with dye-sub printers) and pigment. Printers with dye-based inks produce prints with more vivid colors and saturation. However, dyes, especially yellow and magenta, can be a bit unstable. So if and when they fade, the print can take on a cyan (blue) cast. Printers with pigment-based inks produce a print that will last longer (when displayed under the exact same conditions) than a print made with a dye-based printer. The trade-off is that prints made with pigment inks usually don't have the same vivid color quality.

In addition to the inks provided by printer manufacturers, third-party and generic inks and ink-cartridge refills are available. Printer manufacturers don't recommend these inks, because they want you to buy their inks. And most printer manufacturers say using an off-brand ink or refill will void the printer's warranty (as will using off-brand paper). You may be able to save some money by using other kinds of inks, and some may even be able to achieve a more archival quality. Before you insert an off-brand ink into your printer, however, consider all the advantages and disadvantages.

Maximum print size. Virtually all basic desktop printers produce 8 1/2 × 11-inch prints. More sophisticated printers can produce 11 × 14-inch, 13 × 19-inch, and even larger prints on flat paper. Some printers accept paper rolls, which can be used for making panoramic prints. In choosing a printer, consider the maximum size print that you think you'll ever make.

Image coverage. Some printers let you print a borderless picture—that is, a picture that is printed right to the very edge of the paper. If you like borderless prints, make sure you select a printer with that option.

Noise level. Many photo-artists like to work when it is quiet, or with soft music playing in the background. Not all creative types do. (Stephen King plays loud heavy-metal music while writing his books.) If you like to work in a quiet environment, look into the printer's noise level. Some are noticeably noisier than others.

Printing speed. For many photographers, a printer's speed is important. If you are a "type A" personality like me, be sure to compare printer speeds, too. Sometimes, but not always, speed affects image quality, especially when higher-resolution settings are selected.

⇓ **Versatility.** Most desktop printers hook up to computers via a USB or FireWire cable. Some printers, like these models from Canon and HP, also offer memory card and on-printer image controls. With this type of printer, you don't even need a computer to make a print. But if you are serious about fine-tuning the color, contrast, and brightness of a print, you really need to work on an image with your computer.

To keep up-to-date on archival tests for paper and inks, see www.wilhelm-research.com.

Portable Printers

For photographers who like to travel with a printer, portable printers are available from companies such as Canon, Olympus, and Polaroid. These mini-printers have some image controls (sharpness, brightness, etc.), and use the dye-sublimation process for making high-quality prints up to approximately 4 × 6 inches. Some of these tiny printers are battery powered, while others require AC power, but all are small enough to fit inside a camera bag. Better yet, you can make prints directly from some digital camera (such as certain Canon models) without even using a computer!

What about Paper?

The kind of paper on which you make a print *greatly* affects how a picture will look. Paper is covered in the next lesson.

One more thought on printers: If you are new to the digital darkroom, you will probably get somewhat frustrated in your first attempts to make a good print. To get a picture on your monitor to match a print from your printer, you need to calibrate your monitor and printer. You need to make test prints. And you need to experiment. Those topics will be covered in Lesson 42, "Printing Concepts and Tips."

Happy printing!

"The artist is a receptacle for the emotions that come from all over the place: from the sky, from the earth, from a scrap of paper, from a passing shape, from a spider's web."

—PABLO PICASSO

LESSON 41 Pick Paper for Your Printer

Make creative prints.

"I don't care if you make a print on a bath mat, just as long as it is a good print." That's what the late, legendary photographer Edward Weston said about making prints—many years before the invention of inkjet and bubble-jet printers. Weston had an interesting point, stressing that it's not the type of paper you use, but rather the quality of the image you are printing that counts.

Sure, image quality should be the photographer's main concern. However, the type of paper a photographer uses to make a print greatly affects the image, especially when it comes to making prints at home with inkjet printers.

Most photographers who make inkjet prints usually try to get the sharpest print possible. They use high-gloss photo paper to simulate photo-lab prints. If they are skilled in digital darkroom techniques and have a high-end photo-quality printer, their prints may indeed look as good as photo-lab prints

However, artistic digital image-makers use different kinds of paper to create more artistic prints. For example, canvas inkjet paper makes an image look as though it were printed on canvas. Canvas paper works especially well when digital painterly effects, such as watercolors and brush strokes, are applied to a picture using a Photoshop plug-in filter.

⇐ Paper specifically designed for inkjet and bubble-jet printers comes in many sizes, from 4 × 6 inches to 13 × 19 inches. Roll paper is also available for making panoramic prints.

For more information on inkjet paper, see Legion Paper, www.bogenphoto.com; Epson, www.espon.com; Hewlett-Packard,www.hp.com; Kodak, www.kodak.com; and Pictorico Ink Jet Media, www.pictorico.com.

⇒ Silk inkjet paper offers a nice result, too. A piece of Portico poly silk fabric imprinted with a picture can look like a beautiful silk handkerchief. Here I draped my silk fabric print, peeled of its backing, over a cup to illustrate just how silky the paper looks.

High-resolution matte inkjet photo paper, a step up from plain paper, is nice for making prints with a flat, matte finish. And because it's relatively less expensive than glossy, silk, and canvas paper, it's also nice for making test prints while you are learning the art of print-making.

The aforementioned papers are especially designed for inkjet printers. But they are not the only materials you can put through your printer. For artistic images, some photographers, including myself, use watercolor paper that you can buy at an art supply store. With a ruler, I tear the 3 × 4-foot watercolor into 8 × 10- and 11 × 14-inch sheets. The rough edges from the tear give my prints even more of an artistic look.

⇓ Here are two prints that show the big difference paper makes. The sharp left-hand image was printed on high-gloss photo paper. The softer image, desaturated and enhanced with a digital frame, was printed on the watercolor paper I just mentioned. At first, you may prefer the sharp picture. But think about this: Anyone could make that type of glossy print. A more artistic print takes more creative thinking.

You can also make prints on artistic writing paper and note cards that you can find at your local art store. You can make prints on ivory-colored paper and even on speckled paper. Again, prints on these art papers have a look that is more creative than prints made on high-gloss paper.

When using papers that were not specifically designed for inkjet printers, keep in mind the following two points: One, you need to experiment with the paper settings on your printer, because the nonstandard papers absorb ink differently than standard papers. And two, your prints will not last as long as prints made on archival paper.

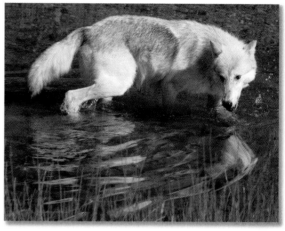

⇑ The options for paper are virtually limitless. You can even create your own. For example, this paper may look like an artistic paper. It's not. I created this "paper" by scanning a section of brown paper bag that I got at the supermarket. I like the texture and the color.

⇑ While I was looking for a picture that would look appropriate (in color and subject) on the textured paper, I came across this picture of a gray wolf that I photographed at the Triple D Ranch in Montana. When working with textured and colored papers, it's very important to pick an appropriate subject.

⇒ This image was created using Layers and Vignetting in Photoshop, which we will explore later on in this book. Compare this image with the straight print of the wolf. Which do you think is more artistic? Of course, we could ask, "Which of the pictures is more realistic?" But that is another story.

As you can see, there are many different types of paper that you can run through your printer—although I don't recommend sticking a bath mat in your paper tray.

Speaking of recommendations, most inkjet printer manufacturers don't recommend printing on other than inkjet papers. That's because some papers may be too thick or too slick or too rough for the inkjet heads, and could clog or damage the heads or the printer. What's more, some printer manufacturers say that you get the best results and the longest-lasting prints by using their paper. Epson, for example, is adamant on this point. Many pros agree.

That said, in the past five years I've had five different printers from three different manufacturers. In that time, I've used many different paper types and have never had a problem. I have, however, had lots of fun turning my "straight" photographs into more artistic images simply by using artistic papers. If you want to experiment with different papers for more creative prints, go for it, but keep the printer's warranty in mind.

"In my mind's eye, I visualize how a particular. . . sight and feeling will appear on a print. If it excites me, there is a good chance it will make a good photograph."

—ANSEL ADAMS

Printing Concepts and Tips

Software can help you get the print you want.

We'd all like to make a perfect inkjet print each and every time we click on the Print button on our printer's software. But that's not always easy. Even if we take the time to calibrate our monitor, let it warm up for half an hour each time we use it, and work under consistent lighting conditions, a print can still be off color, too light or too dark, or have too little or too much contrast. That's because a new or different type of paper, or a change in room temperature or humidity, can affect the way a print looks (as can clogged inkjet heads or low ink levels in your printer). Enter the printer's software driver. It's designed to help you get the best possible print by offering additional creative and correction controls.

⇐ In the software for one of my printers (an Epson Stylus Photo 1280), as with the software in other photo-quality printers, I can choose the correct media type (paper type), which is of the utmost importance. In this screen shot, you can see that I have chosen Premium Glossy Photo Paper because I was using Epson Premium Glossy Photo Paper. If we choose the wrong media type, we will get the wrong amount of ink on the paper. That can make a print look blotchy, too thin, and off color. It can also cause streaks, gaps, and lines in a print.

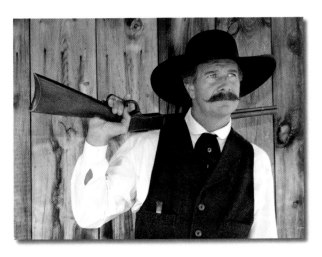

⇐ High-end printer software offers additional options for controlling print quality. The software lets you select automatic settings based on the subject in your picture. Here I chose People because I was printing a picture of my friend Dallas, a character actor from Ft. Worth, Texas. Had I been printing a landscape, I would have chosen Landscape mode. For an antique or "old photo" look, I would have chosen Sepia.

The software in most high-end printers also offers fine-tuning of the brightness, contrast, saturation, and colors in an image. I used the Contrast adjustment on a picture I took at Lower Antelope Canyon, outside of Page, Arizona.

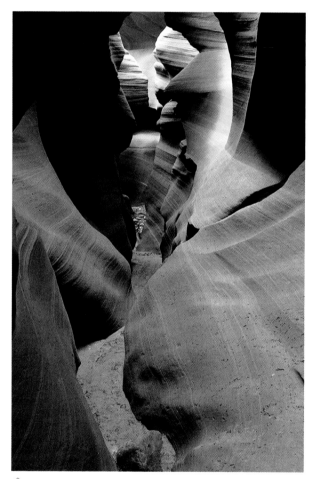

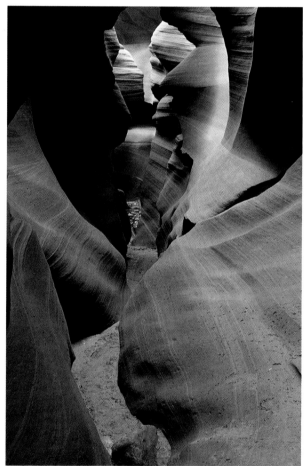

⇑ In my original picture, the background rocks near the top of the frame are slightly overexposed, because the contrast range between the rocks in the foreground and the background rocks was too great for my digital camera to handle.

⇑ By ever so slightly reducing the contrast with the printer software's Contrast control, I was able to get a print that looked more like the original scene, and a print with which I was pleased.

For more information on Test Strip, see Vivid Details, www.vividdetails.com.

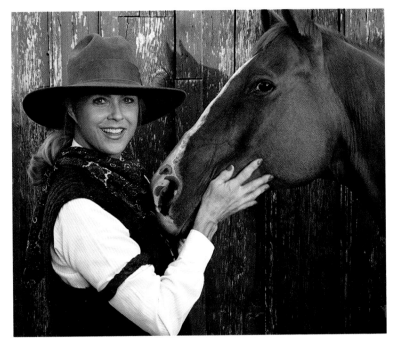

← Here is a picture of my friend Judy Nelson, another Ft. Worth "cowpoke." Judy was pleased with the inkjet print I sent her. But the print I sent was not the first print I made. To arrive at an image with which I was pleased, I used a Photoshop plug-in called Test Strip. Test Strip is based on the idea of the test strips common in the traditional wet darkroom: Different sections of a print were exposed differently to see which exposure produced the best results.

⇑ After you load Test Strip, restart Photoshop, and open Test Strip (**Filters > Vivid Details > Test Strip**), the picture on which you are working is replaced by a window that lets you adjust the color and brightness of your picture by clicking on an image that looks best to you.

⇑ After you think you have a rendition of your picture that you like, you can view larger before-and-after versions of your changes by clicking on the viewing options.

Even when you do make a print that looks great at the time of printing, it's possible that you may not be happy with it later because of **metamerism**. Metamerism affects prints made with pigment-based inks, and makes prints look very different depending on the color of the light source under which they are viewed. So a print made at night in your darkened den may look different in your sunny office or living room the next day, depending on the type of light source in each place. Newer, high-end printers and pigmented inks produce prints that have a reduced amount of metamerism. But it's still something to keep in mind when making and viewing prints.

PART V
WORKING AND PLAYING IN PHOTOSHOP

Whenever I give a Photoshop workshop, I usually begin by saying, "Every photograph you have ever taken and every photograph you will ever take can be enhanced in Photoshop." Some examples of the nearly endless possibilities include

- Creating an image that shows the shadow areas *and* the highlight areas in a scene that would not both be recordable in a single exposure with standard slide film or negative film or on a digital image sensor without special filters or accessories;
- Increasing the contrast in a picture for more impact;
- Increasing the color saturation for a richer image;
- Warming up the color of a noontime picture so it looks as though it were taken later or earlier in the day;
- Whitening the whites of a person's eyes in a picture so they are more vivid;
- Darkening the edges of a picture to create a more interesting overall photograph;
- Sharpening a picture or an area of a picture that may be a bit soft—or blurring an area of a picture for a creative effect.
- Adding an artistic touch to a straight picture;
- Removing distracting or annoying elements from a scene;
- And finally . . . fixing up my mistakes! (Pros make mistakes, too.)

Those are just a few of the possibilities that are popular with photographers. Photoshop also offers many advantages to artists and designers.

To illustrate how Photoshop can improve a poor shot, I took a boring snapshot of an antique biplane at the Old Rhinebeck Aerodrome in upstate New York and used Photoshop to make a better shot.

⇉ Even though I used a 300 mm lens, the airplane is too small in the frame. Look closely for the dust marks on the image, caused by poor film processing. There are a few scratches, too, that screamed out at me. To clean up the image, I used Photoshop's Clone Stamp tool to copy clean areas of the picture and paste them over spots and scratches.

⇉ Here's a screen shot that shows something cool we can do with Photoshop's Crop tool. Sure, most people use that tool for cropping, but when we make our crop and then move our cursor outside of the picture area, we can tilt the picture in any direction.

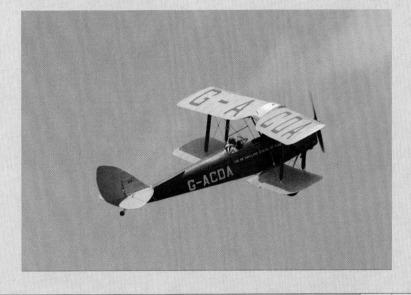

⇉ Thanks to this creative use of cropping, my plane is now soaring high—which looks much more interesting than a plane that is flying horizontally.

⇒ This screen shot shows me creating a duplicate layer (the two layers are shown in the small Layers window on the top right of the screen), adding the Motion Blur filter to the top layer, and then using the Eraser tool to erase the blurred area over a part of the picture I wanted to look sharp—the plane in this case. The window at the bottom right of the screen shot is the History window. It shows all the steps I took during the erasing process. What's cool about the History feature in Photoshop is that if you make a mistake, all you have to do is click on a previous step in History to undo it!

⇑ Voilà! My plane is soaring toward the heavens. "But hey, where did all that blue sky come from?" you are probably asking. That's easy. First, I used the Magic Wand tool to select all the areas of sky, including the parts that are showing between the wing struts. Then I went to **Image > Adjustments > Color Balance** and boosted the Blue slider until I had a deep blue sky.

Just one note: the lessons in this section are not meant to be a complete guide to Photoshop techniques. Rather, I'd just like to share with you some of the more popular Photoshop techniques for photographers who want to expand their creative horizons.

"Every artist dips his brush in his own soul, and paints his own nature into his pictures."
—HENRY WARD BEECHER

Meet the Power of Photoshop

Every picture you have ever taken or will take can be improved in Photoshop.

To illustrate my first (and most important) point, about how Photoshop can help us create an image that lets us see both the highlight and shadow areas of scene—areas that are not possible to record with standard film or a digital image sensor—we'll use a picture I took at Hearst Castle in San Simeon, California.

↖ This is how the scene looked to me. I could clearly see the highlight areas and I could see into the shadows.

↞ Here is what happened when I took an exposure reading for the highlight area—the stone structures in the distance. As you can see, they are properly exposed, but we can't see into the foreground's shadow areas.

⇐ Now look what happened when I exposed for the shadow area. We can see into them, but the highlight area is very overexposed, or "washed out." I took both of my exposures with my camera on a tripod, which was not moved between exposures.

By now, you have probably guessed that if I took the highlight area from one picture and took the shadow area from the other picture, I'd have a picture that looked like the scene I saw.

⇒⇒ In Photoshop, taking one area of a scene and combining it with another area of a scene is very easy to do using Layers (which we'll delve into more in Lesson 57, "Learn about Layers"). Basically, all I did was place one picture on top of the other, creating an image with two layers (just imagine holding two 8 × 10-inch prints one on top of the other). The top picture had the stone structures properly exposed; the bottom layer had the shadow area properly exposed. This screen shot shows the Layers window with the original layer and a copy of that layer.

⇐ The next step was to erase the dark shadow area on the top layer, to let the properly exposed shadow area from the layer below show through. This screen shot shows the area I erased. You can see the checkerboard pattern (not visible in the finished picture) because I had the bottom layer "turned off" during the erasing process. The pattern shows you what areas you have erased (or changed using another technique) on a layer.

Again, we'll talk more about Layers—a very important feature of Photoshop—in Lesson 57.

⇊ Here is one more example of how Photoshop can transform a dull and drab shot, taken in Kuna Yala, Panama, into one that is filled with color. Basically, all I did to enhance the image was to use the Sunshine filter in a Photoshop plug-in called nik Color Efex Pro! With a few clicks of the mouse, an overcast day was turned into a sunny day.

"Following the light of the sun, we left the Old World."

—CHRISTOPHER COLUMBUS

Calibrate before Opening Photoshop

What to do before you get going.

There is one important step to take before we open Photoshop. Before even entering the digital darkroom, you should calibrate your monitor for color and brightness levels to maximize the power of Photoshop.

⇓ Compare these two pictures of a woman I photographed in Bangkok, Thailand. The picture that looks good is an example of what happens when you let your monitor warm up (for about half an hour), calibrate your monitor, and keep the lighting in your workspace constant—and on the dark side. The version that looks off-color and too light is an example of what can happen if we don't let the monitor warm up, or don't calibrate the monitor, or do not keep the workspace lighting constant.

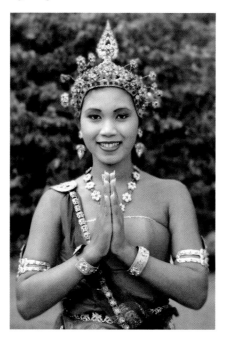

Monitors are available as CRT (cathode-ray tube) or LCD (liquid crystal display) models. While most desktop monitors are CRTs, such as the model shown, the space-saving flat-panel LCD monitors are beginning to appear on many desktops. Don't be confused by monitors labeled "flat screen." A flat screen monitor is a glass-tube CRT whose face is almost completely flat instead of the slightly rounded face found on traditional monitors. A "flat panel" is *always* an LCD screen. CRTs are inexpensive, have softer color gradations, and are easy to use for editing photographs; LCDs save space, use less power, generate less heat and radiation, but cost more and can have harsher contrasts for image editing. Both types, however, can be color managed and calibrated using the following process.

⇒ **Incorrect lighting for a digital darkroom workspace.** This is my workspace. Lighting from the window behind the computer affects how pictures look on my monitor. What's more, as the light level from the window increases or decreases during the day, pictures look different on my monitor.

And there is yet another lighting factor that affects how my picture looks: the desk lamp. Notice how the light is spilling onto the monitor. That's a "no no" when it comes to working in the digital darkroom.

⇒ **Correct lighting for a digital darkroom workspace.** This is more like it. I pulled down the black shade on my window behind the roll-up bamboo shade (plus I pulled down all the other shades in my office), and I turned off my desk lamp. Remember, the key is keep the light constant and on the relatively dark side.

⇑ After you set your room light, the next step is to use the Appearance (Mac OS) or Display (Windows) control panel to select gray as your background screen color. Because gray is a neutral color, it will not affect how any picture looks on your monitor. Blue on the new Mac screens works well, too. If you choose a bright background color, as on the left above, that color will affect how you see pictures—and therefore will affect the color and brightness changes you make to a picture.

The next step is to calibrate your monitor. Calibrating means fine-tuning your monitor to give you the best results. These three screen shots show just a few of the steps of the Photoshop calibration process called Adobe Gamma. The process (which you start by going to Adobe Gamma in your computer's Control Panel folder) takes you step by step through the process, which takes only a few minutes. At the end of the calibration process, you can see a before-and-after version of the Adobe test file.

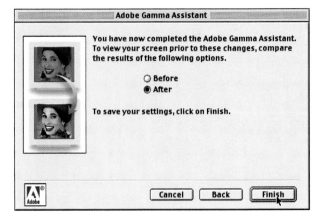

For more information on the ColorVision Spyder, see www.colorcal.com.

⇒ For finicky digital darkroom artists, there is an accessory called a ColorVision Spyder that takes the calibration process one step further (see sidebar below). You load the software into your computer, attach the Spyder to your screen, and follow the calibration process. Some pros swear by the Spyder. I'm happy with the results I get by simply following the Adobe Gamma calibration process.

If you don't think calibration is important, think about this: the reason a movie looks different on some of the monitors on an airplane (or on different televisions in a retail store) is because not all monitors are calibrated. I don't know about you, but I have never been on an airplane where the movie looked the same on all the monitors.

One more thought on calibration: because the phosphors in CRT monitors change color as they age, my friend at Adobe, Julieanne Kost, recommends that you calibrate your monitor once a month.

.

Real World Color *by Joe Farace*

Some people discover that when they set up their digital darkroom that their inkjet prints match what they see on their monitor, while others do not. If you're in the second group, keep reading: There are few problems standing in the way of obtaining an accurate color match between your monitor and your printer. The biggest difference is that when looking at a monitor you're viewing the photograph by *transmitted* light. Much as when viewing a slide on a light box, light is coming from behind that image. When looking at printed output, you are seeing the print by *reflected* light. Right away there is a difference, but these differences can be exacerbated by environmental factors, including monitor glare and ambient light color.

One of the least expensive ways to calibrate your monitor is by using ColorVision's Monitor Spyder. This is a Plexiglas and metal device that attaches to your monitor, and when used with ColorVision's software it makes your monitor relatively simple to calibrate. This combination of hardware and software can calibrate any CRT or LCD monitor and will produce ICC (International Color Consortium) profiles for Mac OS and Windows color-management systems. Depending on what software you choose and where you buy it, the Monitor Spyder can be bought for under $200.

"It is easy to dodge a spear in the daylight, but it is difficult to avoid an arrow in the dark."

—Chinese Proverb

Try Easy Tools First

Tour some basic tools.

Every artist has his or her own set of tools, each designed for a specific purpose. A tool—be it a painter's brush or a sculptor's chisel—helps the artist turn his or her vision into a work of art.

Photographers, too, have creative tools, and have had them ever since the beginning of the craft. Even back in the early days of photography, photographers could take fairly dull (thin) negatives and turn them into dramatic prints. What's more, famed landscape photographer Ansel Adams had flat negatives that he transformed into works of art. "Moonrise over Hernandez," one of his best-known pieces, was one such work.

And for years, traditional darkroom artists have used paper, chemicals, and enlarging techniques to make areas of a picture lighter or darker, and to add more contrast to a scene. They have also used what some may call "tricks" (others call them darkroom techniques) to create double exposures and montages.

Today, digital photographers can find all the tools of the digital darkroom within Adobe Photoshop's Tool Bar. This vertical bar appears on the left side of the screen whenever you open Photoshop. Many of the tools on the Tool Bar have variations that you can adjust. These tools help us fix mistakes, bring out details in the shadows areas, tone down highlight areas, and create our own works of art.

I confess: Like most artists, I don't use all the tools that are at my disposal. But this lesson looks at my favorite tools and suggests some things you can do with them. For this lesson, I chose some pictures from around Taos, New Mexico (a very nice place to photograph), one picture of a schoolgirl in Cuba, and one of a young woman in the Forbidden City in Beijing, China. Before reading about how I use Photoshop's tools, you may want to check out the Tools section of your Photoshop manual (or keep the handy Photoshop reference by your side) to refresh your memory about their location—although I'll try to help you along the way.

Also, some effects are very obvious, and some are less obvious; you may have to look twice to see an effect. That's because I, like many of my photographer friends, am fussy when it comes to my pictures. Sometimes, a slight tweaking can make the difference between a good image and a great image.

⇒ The first key to using a brush tool is selecting the size you are going to use. When you click on the little arrow near the word Brush in the Options bar at the top of your monitor, you get access to Photoshop's preset brushes in several different sizes (in the Brushes window): paint brushes with hard edges, air brushes with soft edges, and artist brushes. You can also use the Master Diameter slider to create brushes in infinitely variable sizes.

When you click on the little "fly out" arrow in the Brushes window, you get even more options for creative control. You can load new brushes (Calligraphic brushes are fun ones), rename your bushes so you can easily find your favorites, replace your bushes with custom brushes . . . and if you get lost in all the fun of Brushes, you can press Reset Brushes and start from scratch.

⇒ If you are the very creative type, you can create your own brushes. Simply click on the Brush Size icon next to the word Brush in the Options Bar at the top of the screen and get to work. You'll find several controls that let you customize each brush.

There is another very important aspect of using a brush: the pressure of the brush (called its opacity, exposure, or strength, depending on the tool you are using), which you can control by typing in a pressure (from 1% to 100%) or using the slider in the Opacity, Exposure, or Strength window at the top of the screen. You can also control the opacity, exposure, or strength with a WACOM graphics tablet and stylus (discussed in Lesson 36). In many cases, you don't want to use a brush at 100%, because that setting applies an effect too rapidly or thickly. As you'll see later in this lesson, using a lower setting is much more beneficial. Plus, it saves you from pressing Undo or going back to a previous state in your History palette to undo a mistake.

Okay, on to the tools—mostly in the order in which I use them when working on a picture. But before we get going, remember that you should *never* work on your original. To be safe, make a copy and work only on the copy. That way, if you make some terrible mistake, your original is not lost forever.

⇑ When you open a picture on your computer, look to see if the horizon line is level. If it's not, use the **Measure** tool, found by clicking once on the **Eyedropper** tool, to straighten it. Simply click on the Measure icon, and then draw a line (move the + with a ruler icon) along what is the proper horizontal in your picture, as I did on the top of this Coca-Cola sign. Once your line is drawn, go to **Image > Rotate Canvas > Arbitrary**. A window will pop up that tells you how far off level you are. Click OK and your picture will be leveled.

⇓ Simple as it sounds, cropping can make a big difference in the impact of a picture. Here I used the **Crop** tool to crop out areas of my picture that did not add interest to the scene. When you open a picture, think about how you can crop it for a more dramatic effect.

⇑ I took this photograph of the front of the St. Francis Church (made famous by Ansel Adams and Georgia O'Keeffe) just after sunrise, when part of the church and the statue of St. Francis were in the shade. To lighten the statue—a key element in the picture—I used the **Dodge** tool, starting out at a 10% opacity so I would not make the statue too light too fast. Again, when using a tool, remember that slower (lower opacity) is better. In Photoshop, the Opacity window is located at the top of your screen in the Options Bar.

⇓ The Burn tool has the opposite effect of the **Dodge** tool—it makes the areas you "paint over" darker. For this picture, taken inside a roadside restaurant in Chimayo, New Mexico, I used the Burn tool, again set at a low opacity, to gradually darken the right side of the frame, especially the lower-right corner. Compare both pictures, and see how the treated picture has less of a contrast range than my original—and see how it looks more evenly exposed.

⇧ The **Saturate/Desaturate** tool is fun to use. It's found by clicking once on the Dodge/Burn tool icon (you'll see a Sponge icon pop up along with the Dodge and Burn icons). Once selected, go to the top of your screen and choose Saturate or Desaturate from the pop-up window in the **Options** Bar. With this tool, you can saturate or desaturate specific areas of scene. For my picture of some old gas pumps, which are at a place called "Classical Gas," about an hour south of Taos, I used the Desaturate tool to take out the color around the red pump, and then used the Saturate tool to increase the saturation of the red pump. Try this technique, you'll like it.

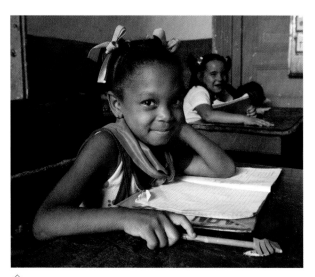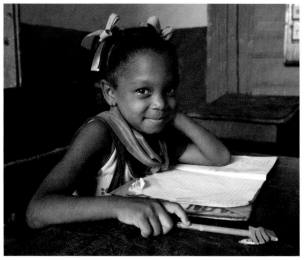

⇧ The **Clone Stamp** tool is a godsend for photographers. It lets you pick up areas of a picture and paste them over other areas. It's great for taking out dust spots and scratches (and black marks caused by dust on digital sensors) in pictures. It's also wonderful for removing objects or subjects in a scene that you don't think add

interest to a picture. In this example, I wanted to isolate the girl in the foreground from her classmate in the background. The girl in the foreground is the main and most important subject. Plus, I thought the girl in the background's white blouse was distracting, and I did not think her expression was very flattering in that moment. So, using the Clone Stamp tool, I copied areas of the door, desk, and wall and pasted them over the little girl in the background—for a picture that draws your eye directly to the little girl with the ribbons in her hair. I realize this erasure fools with reality, but the example illustrates the dramatic effects possible with the Clone Stamp tool.

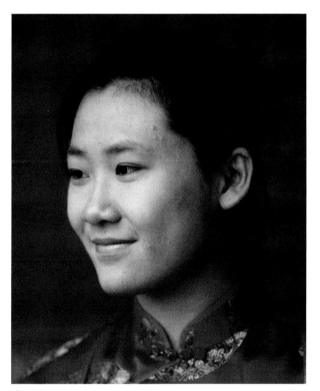 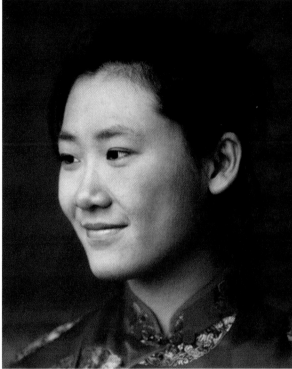

⇑ When Photoshop version 7 was introduced, it came with the new **Healing Brush** tool. The Healing Brush works like the Clone Stamp tool by letting you pick up one section of a picture and paste it over another. Moreover, the Healing Brush magically picks up a pattern or texture and places it over a blemish or mark in a picture and "heals" that spot. It is very useful for removing imperfections on a person or object. I used the Healing Brush to enhance my picture of this girl in Beijing's Forbidden City. Compare the two pictures. With a few clicks of the mouse, I used the Healing Brush to remove the girl's blemishes. I also whitened her eyes with the Dodge tool.

⇒ Photoshop offers the very useful ability to select specific areas of a scene. We may select an area using several tools, including **Lasso**, Polygonal Lasso, Magnetic Lasso, Rectangular Marquee, and Elliptical Marquee. We may also select the area outside of our selection by going to **Select > Inverse**. That's what I did in this picture of a door in a Native American pueblo in Taos. I liked the exposure of the door, but the

surrounding wall was too dark. So, I chose the Polygonal Lasso and carefully selected the door with that lasso. Then I went to **Select > Inverse** (which selects everything *except* the door) and then pulled up Curves from **Image > Adjustments > Curves**. I dragged the center of the Curve upward in RGB mode, as I usually do. That technique lightened the wall, but not the door. If I had lightened the entire scene, the door would have been overexposed, with little or no detail. The process for using the other selection tools is the same as for the Polygonal Lasso tool. The simple Lasso tool allows us to control the shape of the Lasso by the mouse movements to trace an irregularly shaped object.

⇒ Another selection tool, called the **Magic Wand**, makes a selection automatically. It does so when you bring it to a point on the image and double click. It will select an area that contains contiguous color. We control the range of colors selected by setting a Tolerance (the number of tones you want to select) in the tool's **Options** Bar. I used it to darken the sky in my picture of an old gas pump. Because there were

different tones in the sky, I needed to add to my sky selection as I went along. I added to my selection by pressing the Shift key each time I wanted to select a new area.

⇊ You'll find an entire lesson on adding type later on in this book. For now, I just want to show you the effect. You simply click on the **Type** tool and then, after selecting a color, size, and font in the **Options** Bar, you type right on your picture. The type is automatically placed on a separate transparent layer, so that once you have typed, you can move the type anywhere in the scene using the Move tool. If you don't like what you see, you can delete a type layer and start again. If you have aspirations of getting a cover shot, you may want to frame your scene with room for a magazine's name at the top of the frame.

⇑ Photoshop has a tool that lets you sample a color from within a picture, the Eyedropper tool. All you do in click on the Eyedropper icon in the Tool Bar and then click on a color in your picture. Now you can use that color in a selection. Here, after I clicked on a red area of the scene, I used the Marquee tool to make a small selection around the border of the scene. Then I went to **Select > Inverse**. To fill in the area (the small section between my selection and the edge of the frame), I went to **Edit > Fill,** then chose Foreground Color in the dialog box that popped up (a selected color becomes the new foreground color). This is a nice way to frame a print before printing.

⇒ The **Magnifier** tool is useful for checking small areas of scene to see if they are in focus or if they need retouching. For this picture of a statue of Baby Jesus at Sanctuario Chimayo near Taos, I used the Magnifier tool to see if the statue's eyes were in sharp focus. They were. I always check the eyes—of people and animals—in my pictures. If they are not in focus, I've missed the shot. (Locals believe the Christ child goes

out at night to perform miracles. With so many miracles to perform, his shoes get worn out. That's why folks bring new shoes for him to wear and leave them at the shrine.)

⇒ Photoshop lets us view pictures in different ways. We make a choice by clicking one of the three Viewing Options located near the bottom of the Tool Bar (next to the arrow below).

To view an image in the Standard Screen Mode, click the left icon. To view in the Full Screen Mode on a gray background with the Menu Bar, click the center icon. The distracting folders on the desktop disappear, replaced by gray. To really see what your picture looks like, click on the Full Screen Mode, the right icon. In any View, if we press the Tab key, Photoshop toggles off the Menu Bars and Tool Bar, leaving just your image and a ruler on the screen. This "tab" view is quite helpful for reviewing images on a black background.

> *"Choose a job you love, and you will never have to work a day in your life."*
> —CONFUCIUS

Choose a File Format: JPEG or TIFF

What's the difference anyway?

Several formats for saving files are available in Photoshop (as well as in other digital-imaging programs). The only two formats that we really need to think about are the JPEG (Joint Photographic Experts Group) and the TIFF (tagged image file format) formats. At the end of this lesson we have a note about another, more advanced format.

Note that this lesson is about saving pictures in Photoshop, and not about saving pictures in different formats with a camera. That was covered in Lesson 31, "Pick a Picture Resolution."

To save a picture in Photoshop, you go to **File > Save As** and then choose a format. Among the choices offered are JPEG and TIFF. Here's a look at the difference between those two formats, and the benefits of each.

JPEG. This format was designed to discard information the eye cannot normally see and uses compression technology that breaks an image into discrete blocks of pixels, which are then divided in half until compression ratios of from 10:1 to 100:1 are achieved. The greater the compression ratio that's produced, the greater the loss of image quality and sharpness you can expect. The JPEG format is great for sending files over the Internet and for posting pictures on Web sites, because the JPEG format compresses an image when it is closed (so it can be sent quickly), and then decompresses it automatically when it is opened (so it opens fast). Because JPEG uses lousy compression techniques, data can be lost in the process, and all that compressing and sending and decompressing can corrupt, or damage, the pixels in a picture, resulting in a loss in image quality.

The real visible damage happens to a JPEG file when it is opened, enhanced, and saved, and then reopened to begin the process once again and resaved. Do that just once, as you may do when you transfer your JPEG files from your camera to your computer, and you will not notice any difference. But do that several times and you will notice a difference in image quality. For the best possible quality, be sure to save your JPEG pictures as TIFF files immediately upon transferring them from your camera, even before rotating them.

Compare these two files, created from a picture I took in Kuna Yala, Panama. The sharp picture on top was saved as a TIFF file, and can be opened, enhanced, and saved countless times without a loss in quality. The pixilated picture on the bottom is a simulation of what can happen to a JPEG file after it is opened, worked on, and saved many times.

Another disadvantage of JPEG files is that they don't allow us to save Layers. As you will see in Lesson 57, "Learn about Layers," because individual information can be saved in different Layers, you probably want to save your Layers so you can work on them if and when you want to work on an individual Layer at a later date.

One advantage to JPEG files, though, is that they don't take up a lot of memory in your computer.

So, although, for serious photographers and Photoshoppers, saving pictures as JPEG files is not a good idea, serious photographers do send JPEG files over the Internet to editors and publishers who want to view their work. (I send my pictures to the Associated Press each week as JPEG files.) In doing so, they have four options (resolutions) for saving, and therefore sending, a JPEG file: low, medium, high, and maximum. As the resolutions go from low to maximum, the time it takes to send an image increases, but so does the quality. In other words, the larger the file size, the better the image quality but the longer it takes to transmit the file.

TIFF. TIFF is a lossless format. It allows us to open, work on, and save an image countless times without a loss in quality. When we save a TIFF file, we are saving all the Layers we may have created in Photoshop 7. So, we can go back to the image again and again and make changes to our heart's content.

TIFF files do consume more memory and hard disk space than JPEG files, so if you're serious about saving your picture files, beef up your computer's memory or get a supply of CDs or DVDs on which to store your pictures. Some extra RAM is a good idea too (see Lesson 36 for more on RAM).

Other Formats. At the beginning of this lesson, I said that there were really only two formats that photographers need to think about. If you ever get into very advanced Photoshop techniques and are working with many Layers, you may want to consider the Photoshop **PSD format**. This format supports everything Photoshop can do. Plus, it makes the program run more efficiently— including making opening and saving images faster (which you may or may not notice). Personally, I always use the TIFF format, as do my Photoshopping friends, except for one friend, Photoshop expert Barry Haynes. Barry likes to save files in the Photoshop format.

In addition, a program called Genuine Fractals lets us upsize an image without losing quality—to a point. This program requires that files be saved in the proprietary Genuine Fractals STN format, and the upsizing is done when the file is reopened. After working on the pictures in Genuine Fractals, you can save resized pictures as TIFF files.

"It's not the size of the dog in the fight, but the size of the fight in the dog." —MARK TWAIN

Manage File Size and Image Size

Large files are best for printing, and small files are best for e-mailing.

For newcomers to the digital darkroom, understanding picture size can be confusing, because we can't look at a picture as simply a 5 × 7- or 8 × 10-inch print. That's because there are several different ways to manage the size of a picture in Photoshop:

1) In pixel dimensions. These dimensions show Photoshop's calculations in pixels of the image's length and width, with file size shown as a number of kilobytes (K) or megabytes (M);

2) In actual image size (the surface area in percent, inches, centimeters, millimeters, points, picas, or columns);

3) And in canvas size—the working area of a picture, which can be larger than the actual picture area (as measured in percent, inches, centimeters, millimeters, points, picas, or columns).

In this lesson, we will examine how to manage file and image size. In the next lesson, we will examine canvas size. Before you read further, you should be sure you have read Lesson 31, "Pick a Picture Resolution," and Lesson 46, "Choose a File Format: JPEG or TIFF."

File Size Basics

Basically, we want a large file for printing and for publication, and a small file for e-mailing. Large files have more data, which is necessary for making high-quality inkjet prints. However, large files also take a long time to send over the Internet as e-mail attachments. Small files don't contain a lot of data, which makes them a poor choice for printing, but a good alternative for e-mailing.

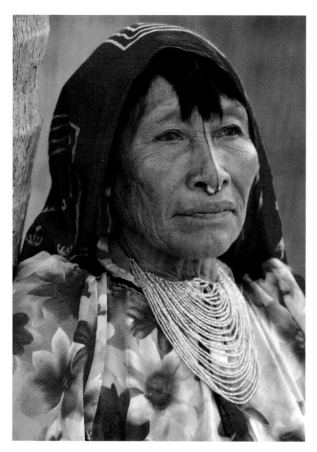

Let's start with a picture of a woman I photographed in Kuna Yala, Panama. It is a copy of the original file. I always work on a copy and I never change my original image file.

In Photoshop Version 7, as in most digital-imaging programs, when we open the Image Size window (**Image > Image Size**), we can also see the document size, which shows the width, height, and resolution of the picture.

My picture of the Kuna woman, taken at my pro SLR's high JPEG setting, has a resolution of 72 ppi (pixels per inch), a width of 22.556 inches, and a height of 31.278 inches. That's the actual default size of the picture file straight out of my high-end digital camera. (As explained in Lesson 31, not all cameras show image files at 72 ppi or with such big width and height numbers.)

The top portion of the Image Size window shows the pixel dimensions (that is, the file size). This file is 14M (14 megabytes) in size, more than large enough for printing and for publication. (Although the standard abbreviation for megabytes is MB, Photoshop abbreviates it as simply M.)

Note the Constrain Proportions box is checked. This usefully calculates a new height for any new width I enter. As for the Resample Image pop-up window, it refers to the mathematical technique used to recalculate the image when it's resized. Most users don't really need to mess around with it, so I suggest leaving it alone.

Now take a look at the document size portion of the Image Size window here. The pixel dimensions (file size) has not changed—it's still 14M. But now we have a 5 × 6.933-inch image with a resolution of 324.8 ppi, which is great for printing and for publication. I got to this point by unchecking the Resample Image box and then typing in the new width, 5 inches, that I wanted. As I changed the width of the photograph, its height changed proportionally, as indicated by that little chain

to the right that links them with Resolution. So to keep your file size large and increase the ppi resolution, you can uncheck the Resample Image box and type in a new picture width or height.

⇒ Now take a look at the document size portion of the Image Size window. I now have a 5 × 6.933-inch picture

with a resolution of only 72 ppi. That's because this time, when I changed the width and height of the picture, I left the Resample Image box checked. When the Resampling box is checked and we change the width and height of a picture, Photoshop leaves the resolution (ppi) the same. If there were space in the dialog box, I'd rename "resample" to say, "Check here if you don't want the ppi changed!"

Before we move on, take a look at the pixel dimensions at the top of the window. Now my 14M file is only 702K, which is acceptable for e-mailing but not for printing if you really care what the print looks like.

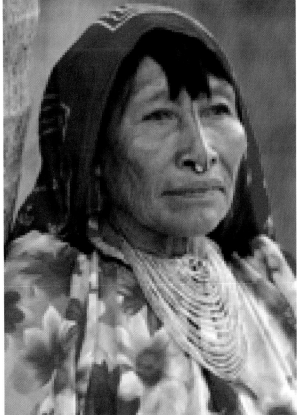

⇒ Notice all of the visible pixels that have shown up. This is about what an 8 × 10-inch print at 72 ppi would look like if printed on an inkjet printer. It shows why we should keep our file sizes high when printing a picture, and keep the Resampling box unchecked when going from a camera file to a practical working file.

The resolution of a computer monitor is 72 ppi for Macs and 96 ppi for Windows computers, so photos with higher ppis won't look any better on someone's computer.

Changing Only One Dimension of a Picture for a Special Effect

One of the interesting changes you can make to the size of your picture is changing only *one* of the dimensions, height or width. Following are two examples of this technique.

⇒ Here is a straight shot of a live-aboard boat I photographed in Amazonas, Brazil. I took the shot with my 17–35 mm zoom lens set at 24 mm.

⇓ When I opened the Image Size window for my boat shot, I unchecked Constrain Proportions, so that when I changed one dimension (height or width) the other would not change. As you can see, now the width and height dimension windows are not linked by that little chain.

⇓ Because I wanted the boat to look longer, as if I had photographed it with a much wider angle lens at a closer distance, I changed only the width of the picture—from under 5 inches to 10 inches. I chose this length after experimenting with several other lengths. As you can see, the height of the picture did not change.

⇒ This is what my boat shot looked like after I changed only the width of the picture. It now looks as though I took the picture at a closer distance with a wider-angle lens, which also would have exaggerated the length of the boat.

Now let's see what happens when you change only the height of a picture.

⇊ Here's a shot I took of a waterfall near San José, Costa Rica. I used a 28–70 mm zoom lens set at 70 mm. To create the "dreamy" effect, I used nik Color Efex Pro!'s Duplex filter (see Lesson 63, "A Tour of Plug-Ins," for more information). I used the filter because the straight shot was actually pretty boring.

⇊ When I opened my Image Size window, the width and height were locked together.

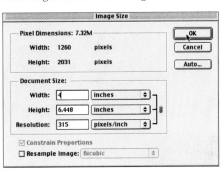

⇊ By unclicking the Constrain Proportions box, I was able to get to work creating the image I had in my "mind's eye," one of a much higher waterfall.

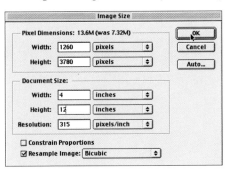

After playing around a bit, I changed the Height from about 6.4 inches to 12 inches.

⇒ Here is my new waterfall shot, a result of changing only the height of the picture.

⇚ You may want to try these techniques on your landscape, as I did on this picture of an ice cave I photographed in Montana. Play around with different width settings until you get a result you like.

Increasing Image Size for Printing

Another way to increase an image's file size so you can make really large prints is by using software that's specifically designed for this purpose.

Genuine Fractals, a program mentioned in the preceding lesson, is a Photoshop-compatible plug-in that lets you save an original image file using a special file format called STN that will allow you to print it later at any size or resolution you choose. Genuine Fractals lets you save images in two ways: The Lossless option produces a file that uses an approximate 2:1 compression and produces the highest-quality enlargements. Near Lossless encoding produces a file with 5:1 compression on average but still lets you output an image beyond 100% of the original size at high quality. A file that is originally 15–20 MB can be encoded with the Lossless option and printed in sizes up to 12.71 × 44 inches. To achieve the best-quality results with Genuine Fractals, it's a good idea to have a minimum original file size of 5 megabytes before saving it as an STN file.

See the Glossary for more detail on terms such as fractals.

"By increasing the size of the keyhole, today's playwrights are in danger of doing away with the door."

—Peter Ustinov

Increase the Canvas Size

Use Canvas Size to work outside the image area.

Canvas size has nothing to do with picture or image size. It has to do with the area you can create around your picture—in any direction or directions. Think of canvas size this way: if you made a 5 × 7-inch print on your Inkjet printer and then pasted it on a piece of 8.5 × 11-inch inkjet paper, your canvas size would be 8.5 × 11 inches. Conversely, if you just held your 5 × 7-inch print in your hand, your canvas size would be 5 × 7 inches.

Sometimes changing the canvas size (**Image > Canvas Size**) can be useful.

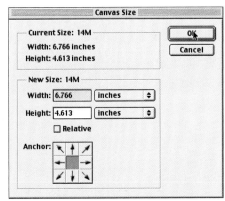

⇈ Take a look at this shot I took at the Kuna Yala airport with my 16–35 mm zoom lens set at 35 mm.

⇈ When we first open the Canvas Size window, we see a box at the bottom of the window with an anchor point shaded in gray. If we don't touch it, our canvas size—the area around a picture or part of a picture—will not be changed. If we increase the width or height (by typing in new numbers in the width and height boxes), our canvas size would be increased around the entire picture because the anchor point—again indicated by the square, gray box—is still positioned in the center of the canvas.

⇒ I wanted to increase the canvas size at the bottom of my picture, because I wanted to add more grass and some type at the bottom of the image. So, I moved the anchor point to the top of the frame (by clicking on the top, center box). You can move the anchor point to any of the nine boxes in the tic-tac-toe grid, thereby increasing the canvas size in any direction. Then, I typed in a new picture height, adding one inch to my picture's height at the bottom of the canvas.

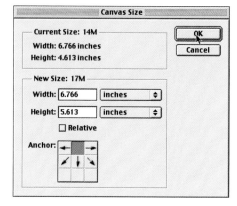

⇐ This is how my picture looked after I had increased the canvas size. (I added the black border to make the added Canvas size more prominent in the example.)

⇐ Now that I had my new, blank canvas, I got to work. I used the Clone Stamp tool to select certain grassy areas and paste them into the white area. Then I used the Type tool to type "Kuna Yala, Panama" in that area.

All you keen-eyed photographers will see that the type matches, in color, a good portion of the palm tree's trunk. That's because I used the Eyedropper tool to sample that color, which became my type color. (See Lesson 69, "Add Text to Your Photographs," for more information on that technique.)

LESSON 49 Choose a Color Mode

Working in the RGB mode is a good idea.

Unlike those involved in book and magazine publishing, photographers have several choices when it comes to which color mode we work in. We choose a color mode in Photoshop by going to **Image > Mode** and then selecting a mode. The Duotone mode requires us first to go to **Image > Mode > Grayscale** before we can select that option.

Although several color modes are provided in Photoshop, this lesson is devoted to what I call the "standard photographer modes." These modes include RGB, CMYK, Grayscale, Duotone, and Lab.

RGB. RGB, or red, green, blue, is the most popular mode for two reasons. First, computer monitors are based on red, green, and blue, so if your monitor is calibrated and if your printer is matched to your monitor, what you see on your monitor should be what you get from your printer in RGB mode. Second, all the Photoshop filters can be applied in the RGB mode, and some plug-ins work only in the RGB mode.

CMYK. Cyan, magenta, yellow, and black represent the four ink colors used in commercial printing. Book and magazine publishers use CMYK files rather than RGB files, because printers use these four "process" colors. Most of my photographer friends who send files to publishers work in the RGB mode and then convert their images to CMYK before they send off their pictures.

Because monitors are not matched to CMYK, the colors and brightness levels they show can be a bit off, but that is improving with each version of Photoshop. I edited the images for this book in RGB mode and then resaved them in CMYK mode for my publisher's production process. When I convert an RGB image to CMYK, I have to boost the contrast just a bit to get my images to look right.

Working in CMYK has one prime disadvantage, though: Not all of Photoshop's filters can be applied to an image in that mode, and not all plug-ins can be applied to a CMYK file.

Grayscale. Grayscale is a fast and easy way to convert a color picture to a black-and-white image. But as you will read in Lesson 56, "Work in Black and White, Photoshop Style," this is not the most creative way to work in black and white.

Lab. The CIELAB color system was created by the Commission Internationale de l'Eclairage to produce a color space that consists of all visible colors. The CIELAB system is sometimes shortened to Lab, which is an acronym for the channels of this image type: *l*ightness, where the brightness of the image is stored, and the "*a*" and "*b*" channels where color information is stored. Some photographers use the Lab mode to create a black-and-white image. But again, as we will see in Lesson 56, that is not the best mode for working in black and white.

Duotone. The Duotone mode (covered in detail in Lesson 55, "Discover Duotones") actually offers more options than just working in duotones (which means working with black and one of several other colors). The Duotone mode also lets you work with Tritones (which give you the option of working with black and two of several other colors) and Quadtones (black and three other colors). Duotones, Tritones, and Quadtones are used in book, magazine, poster, and postcard printing to give black-and-white images more color and more depth. But you can have some fun creating some interesting and eye-catching effects using these modes, too.

 To sum up, choosing the RGB mode is the most practical mode when working in color, but Duotone mode can help you produce creative images.

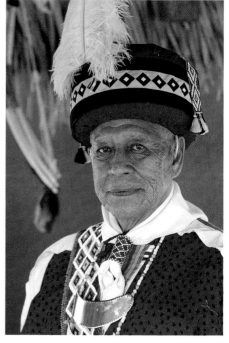

CMYK.

⇒ Because this book is printed on commercial color-process presses using CMYK files, and because there is only a slight difference between how Grayscale and Lab files look, this series of pictures illustrates only the differences between a CMYK file, a Grayscale file, and a Duotone file.

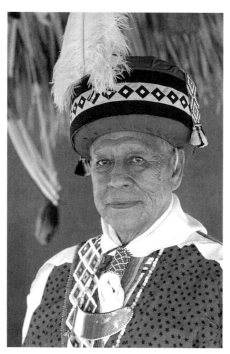

Grayscale.

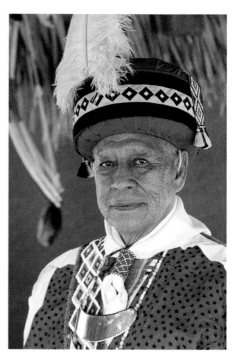

Duotone.

"It takes a lot of imagination to be a good photographer. You need less imagination to be a painter because you can invent things. But in photography everything is so ordinary; it takes a lot of looking before you learn to see the extraordinary."
— DAVID BAILEY

LESSON 50 Basic Image Adjustment

Use variations and level adjustments.

Photoshop, as well as most other photo-enhancing programs, offers several different methods for making image adjustments—or, if you prefer, corrections or enhancements. In this lesson we'll take a look at the two most popular, and most basic, image adjustments that are found in Photoshop.

In looking at the pictures in this lesson, note that the best way to make an adjustment on an image is to create an Adjustment Layer (covered in Lesson 58, "Use Adjustment Layers." For now, though, I'll make the adjustments directly on an image without the added step of creating a layer at this point.

Also note that some of my adjustments are minor—so minor in fact that you may not be able to see a big difference in the before and after examples unless you look very closely and view the pages in bright light. Limitations in printing may also affect how you see any differences between the before and after pictures.

For this lesson, I'll start off with a picture I took at the Hearst Castle in San Simeon, California. I used a 16–35 mm lens set at 16 mm on my Canon EOS 1D digital SLR.

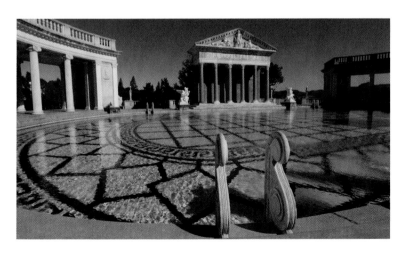

⇐ This is what my shot looked like straight out of the camera. It's a bit flat because, for one thing, I slightly underexposed the image (by 1/2 stop) to prevent the highlight areas from being washed out (overexposed). But even if I had used the recommended exposure, the picture would have looked a bit flat straight out of my camera. Most digital files can be enhanced (adjusted) to look much better.

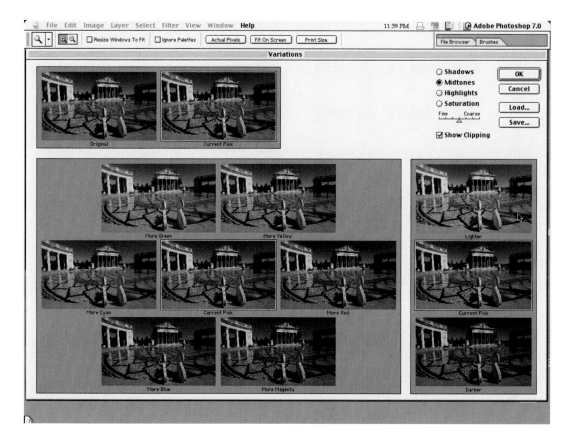

A Look at Variations

⇑ The first step I take in the image-adjustment process is to go to **Image > Adjustments > Variations**. I can see there how several possible variations in color and brightness affect my image.

When using Variations, we click on one of the thumbnails showing a variation in color and density of our original image, and that change will be applied to our image. Sounds easy, sure. But most professionals don't actually use Variations to make adjustments; they use it only to get an idea of the options that are available. Play around with Variations to see how your images might be enhanced.

Adjusting Levels

⇛ The most useful Adjustments option is Levels. Go to **Image > Adjustments > Levels**. You'll see a histogram of your image, a black mountain that illustrates the highlights (on the right side of the mountain), the shadow areas (the left side of the mountain), and the midtones (in the center of the mountain) in your picture. A histogram depicts the frequency of occurrence of pixels in each point along that continuum. A taller black column means more pixels contain that value.

As you can see from this histogram of my Hearst Castle pool shot, the mountain drops off on the right side before it reaches the edge of the histogram. That's because the picture lacks highlights, which is why it looks flat. (Had the picture lacked shadow areas, the mountain

would have fallen short on the left side of the picture.) To correct the lack of highlights, I simply used my mouse to drag the little triangle on the right side of the slider (where the little arrow is pointing) to just inside the mountain—thus telling Photoshop to boost the highlights.

⇒ This is what the corrected histogram looks like after I made the adjustments, clicked OK, and then went back to **Image > Adjustments > Levels** again. As you can see, the mountain is more evenly spread out over the slider bar. I could have played around with the midtones by moving the triangle slider in the middle of the bar left or right. But I was pleased with the way the picture looked, so I left the midtone slider alone. You, however, may want to make adjustments to the midtones in a picture just to see the effect.

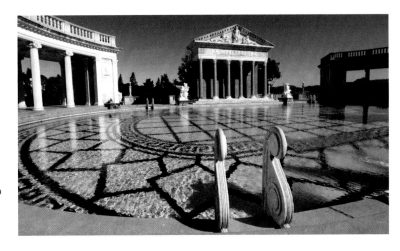

⇒ After making the aforementioned adjustments to Levels, my picture is greatly improved. It has more contrast and color and looks more like the spectacular pool at the Hearst Castle actually appears.

There are two faster ways to make Levels adjustments—faster, but perhaps not always as accurate. One method is to go to **Image > Adjustments > Levels** and then to click on **Auto**, which automatically applies what Photoshop's creators think is a good solution. You may want to try this method just to see its effect on a picture.

Another fast method for adjusting Levels is to use the little eyedroppers near the bottom right of the Levels window. The rightmost eyedropper sets a highlight, the middle one a midtone, and the leftmost one a shadow. Click on the highlight eyedropper, and then click on the brightest part of the picture. That should make the bright parts of the picture brighter by trying to match the selected tone to a pure white. Next click on the shadow eyedropper, and then click on the darkest part of your picture. That should make the shadows more prominent. Next click on the midtone eyedropper and click on a midtone in your picture, which should improve the midtones. Notice I said "should" in all of the eyedropper steps. I've found that manually adjusting Levels consistently produces better results than using the eyedroppers to set white, gray, or black points.

Before we leave Levels, note that I was working in the RGB (red, green and blue) mode (channel), which is indicated in the Levels window near the top of the frame. If you are working in CMYK, your Channel will say CMYK. In both the RGB and CMYK modes, you can adjust Levels in each of the individual channels; to do so you choose the channel you want to adjust by using the up and down arrows next to the channel indicator. That may come in handy if you really want to fine-tune an image. I have found that is not necessary for my style of photography.

LESSON 51

Curves, Brightness, and Contrast Adjustment

Try more adjustments to make your photos look livelier.

Curves is another useful Adjustment after adjusting Levels. At **Image > Adjustments > Curves**, we find the Curves window, which can be very confusing at first. Here is how it works: In the RGB mode, pull up on the curve to make a picture lighter, and pull down on the curve to make a picture darker. We pull up a curve evenly by opening the Curves dialog box, clicking on the diagonal line at the centermost point, and then moving the curve up. To pull a curve down evenly, we do the opposite. In the CMYK mode, make the opposite moves to make a picture darker or lighter.

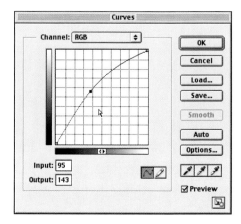

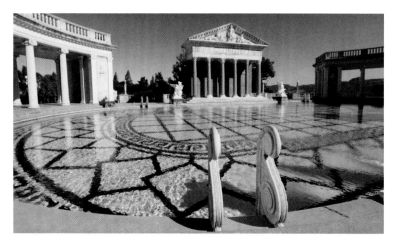

⇐ This is how my Hearst Castle pool photo from Lesson 50 looks when I simply pull up Curves. I agree it looks a bit too light. However, recall from Lesson 43, "Meet the Power of Photoshop," how you can combine a dark area of a picture with a light area from another picture of the *exact* same scene. If you don't have two pictures (one dark and one light) of the exact same scene, you can get the same effect by using Curves to "pull out" shadow

areas of one area of a picture, and then combining that area with the highlight areas of the same picture using Photoshop's Layers function.

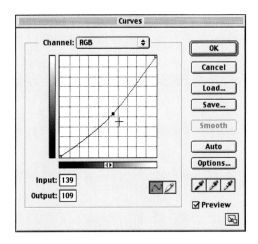

⇒ Personally, I prefer pictures—digital and film—that look a bit darker than "normal." Slightly darker pictures have more saturated and deeper colors, plus the highlight areas are not as bright. So, to make my picture darker, I pull down on the curves from the middle of the line (or pull up when I am working in the CMYK mode).

⇒ Here's how pulling down Curves affected my picture. It's slightly darker, the way I like it.

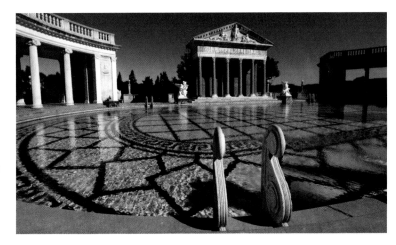

Curves offers many other potential adjustments. As with Levels, Curves offers an Auto option that is quick and easy, but not always all that accurate.

You also can use the Eyedropper tools near the bottom of the Curves window to adjust different brightness levels in your scene: just as with Levels (See Lesson 50), you click on an eyedropper (highlight, midtone, or shadow), then click on an area in your picture, and a little ball appears on the curve that indicates where that brightness level falls on the line. From there, you can pull up or pull down the curve to adjust the light values in that specific section of a picture; if you don't want to affect any other areas (brightness values) of the picture, you can place anchor points around your selected point simply by clicking along the curve line, which prevents other brightness values from being affected. You can remove any anchor point simply by dragging it out of the Curves window.

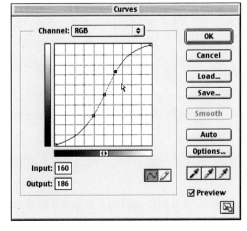

⇒ To adjust contrast in Curves make what we call in professional photography an "S curve." First, put an anchor point in the center of the curve by clicking on the center of the line. Then click on the curve at a point that's about halfway between that anchor point and the top of the Curves window. Then pull up the Curve line until it looks like the letter S. As the curve grows to look more and more like the letter S, your contrast will increase.

Again, Curves can be confusing for the beginner. The best way to become familiar with Curves is to play around with the feature when you have a lot of time.

Brightness/Contrast: The Easy Way Out

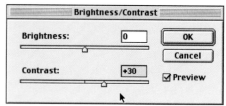

⇒ The Brightness/Contrast window is easier than the Curves window to understand and use. You simply move the sliders left or right to increase or decrease the brightness or contrast independently of each other.

I usually don't use the Brightness control. I generally make brightness adjustments using Curves, which seems to be a much better way of adjusting a picture's brightness. Using the Brightness control does make an entire picture brighter, but it may make some areas within the picture look a bit flat. Curves, on the other hand, can make a chosen area or specific tonal range within a picture look brighter.

⇒ Adjusting a picture's overall contrast in the Brightness/Contrast window, on the other hand, is much easier and more straightforward than doing so in Curves. Here is my Hearst Castle shot after I boosted the contrast in the Brightness/Contrast window. By the way, those numbers (+30 in this case) in the boxes of the Brightness/Contrast window are reference points to help you remember how much or how little you adjusted a picture.

"Balance is the enemy of art." —RICHARD EYRE

Take Control of Color

Adjust the intensity of colors.

One of the coolest and easiest things to do in the digital darkroom is to take control of color. With a few clicks of a mouse, you can do all of the following:

- Get true color, so even if your original picture is "off" in color, you can correct it.
- Increase the color saturation of a picture, giving your picture more vibrancy.
- Change colors, making a picture "warmer" and giving it the appearance of having been taken later or earlier in the day (which often makes a picture more appealing).
- Change the individual colors in a scene for creative effects.
- Reduce the color intensity of a picture for a creative effect.

In this lesson, we'll look at how to take control of color in Photoshop by using the Color Balance and Hue/Saturation controls.

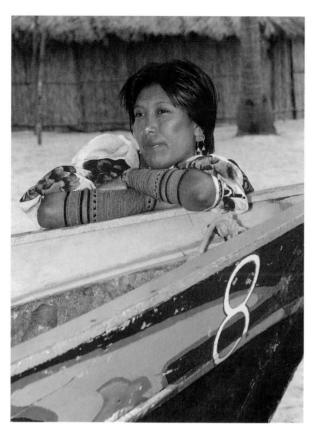

◀ Here is a daylight fill-in flash portrait I took of a woman in Kuna Yala, Panama. Because I had the White Balance on my digital camera set to Flash, the colors, especially the woman's skin tones, are fairly accurate.

⬇ However, just to see some variations of the picture, I went to **Image > Adjustments > Variations**, as I usually do, just to see if a variation would be more pleasing. Some of the Variations offer More Red, More Yellow, and Lighter or Darker. Do you prefer any of these variations to the original above?

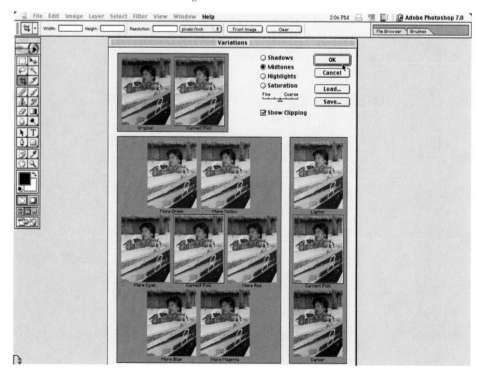

I often like saturated pictures. This picture (taken with a Canon EOS 1D) of a face-painting ceremony in Amazonas, Brazil, is an example of a saturated picture: The colors are vibrant. They were enhanced slightly in Photoshop by going to **Image > Adjustments > Hue/Saturation** and then boosting the Saturation slider.

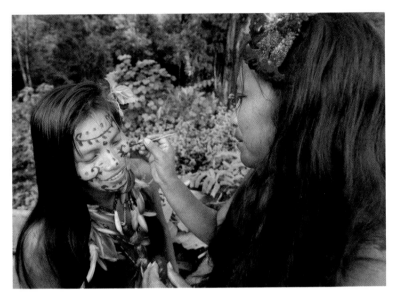

⇐ These days, supersaturated pictures are "in." That trend started with the introduction of supersaturated films such as Kodak Extra Color 100 consumer slide film and Kodak Ektachrome 100 VS professional film.

But before photographers were introduced to supersaturated film and digital effects, they were happy with natural-looking pictures, in which skin tones and colors looked normal. They shot Kodachome film (and some still do) for that very reason.

⇓ You can make a saturated picture look more natural by going to **Image > Adjustments > Hue/Saturation** and decreasing the Saturation. If you decrease it all the way, you will get a black-and-white picture. If you decrease it substantially, you will create the look of an old, faded 35 mm slide. For this picture, I decreased the saturation to a point where I simply liked the effect. So experiment with the Saturation slider. You may find you prefer a less saturated picture more than a very saturated one.

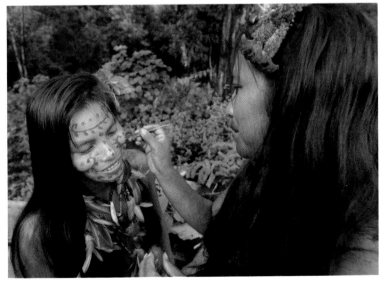

⇒ I took this picture from the top of one of the World Trade Center towers in 1998. It brings back memories—of good and sad times. As far as color goes, however the picture falls pretty flat, due mostly to a poor scan of a color print.

⇑ ⇒ But simply by boosting the saturation **(Image > Adjustments > Hue/Saturation)**, we can make the colors more vibrant. I also sharpened the picture with nik Sharpener Pro! (see Lesson 63, "A Tour of Plug-Ins").

⇑ ⇒ I took the original picture in midafternoon. To make the picture look like it was taken later in the day (colorwise, at least, because I did not want to spend hours re-creating late-afternoon shadows), I "warmed up" the picture by going to **Image > Adjustments > Color Balance** and boosting the Red and Yellow sliders, because late-afternoon scenes have deeper shades of red and yellow. With the Color Balance feature, you can adjust the intensity of all the colors in a picture.

Because I think "warming up" a picture is so useful, I'd like to give you another example of the technique, as well as of the opposite effect: making a picture look "cooler."

⇒ Here's our favorite palm tree again. I like the colors in the photograph, and they are fairly accurate.

⇑ Again, by going to **Image > Adjustments > Color Balance** and then boosting the Red and Yellow sliders, I created more of a sunset scene (again, without the usual shadows of late afternoon).

⇑ To give my palm tree picture a different "feel," one of a crisp day with a bright blue sky, I made the picture look cooler by going to **Image > Adjustments > Color Balance** and then boosting only the Blue slider.

In Photoshop, changing all the colors in a picture, as well as changing only one color, is easy to do. That's accomplished by going to **Image > Adjustments > Hue/Saturation** and adjusting the Hue slider.

What is hue? Think of hue as a continuous color wheel. Colors closer to neutral gray are located near the axis of the wheel. Colors toward the outside of the wheel are more intense. Any image contains a spectrum of hues—say gray, skin, leaves. Moving the Hue slider rotates a new color wheel onto the old spectrum, so that each original color is swapped for the color that is now on top of it. If we look at the bottom of the Hue/Saturation window, we notice two color-spectrum bars. The top spectrum represents the unadjusted image. Moving the Hue Slider to the left or the right will slide the bottom spectrum left or right, respectively, showing us which colors on the bottom will replace the original colors on the top. Note that gray will not be noticeably different after a hue change. Why? Because gray lies at the center of the color wheel and so will wind up being swapped with a very similar gray. Ditto for black, which is at the heart of the wheel. Lets see a few examples of the fun you can have with the Photoshop Hue adjustment.

⇑ I took this picture of the Leslie Hotel in Miami Beach just after sunrise. The hotel's bright yellow color makes it a landmark of the Art Deco district.

⇛ By sliding the Hue, I turned the yellow trim on the building to an aqua blue, and the blue sky to red. It's a wild image, perhaps out of a dream or from a photograph made with infrared color-slide film. As you can see in this screen shot, Master is selected (by default) in the Edit pop-up menu. When Master is selected, all the colors in a picture are changed. How do we change only one color?

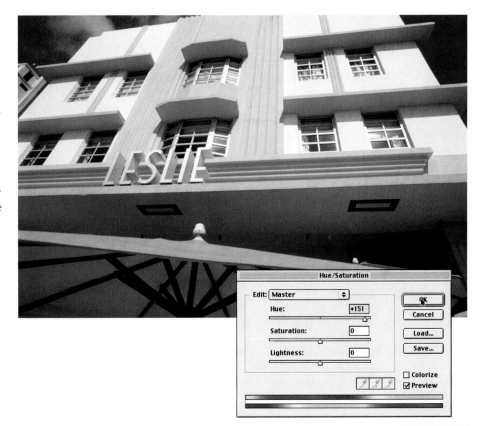

⇛ Now look at the screen shot. As you can see, I have selected Yellows from the Edit pop-up menu at the top of the Hue/Saturation window. Now, when I apply the Hue change, only the yellows in the picture will be changed. This time, the building turned green—but the sky remained its original blue.

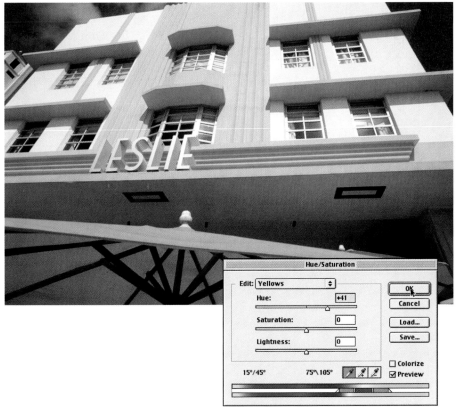

⇒ While I was in Old Havana, Cuba, I photographed this vintage car just after sunset. Like many of the cars in Cuba, it's painted light blue, almost cyan in color. (Actually, many of the buildings in Cuba are painted light blue, too. They must have a light blue paint factory.)

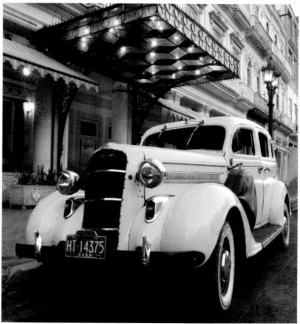

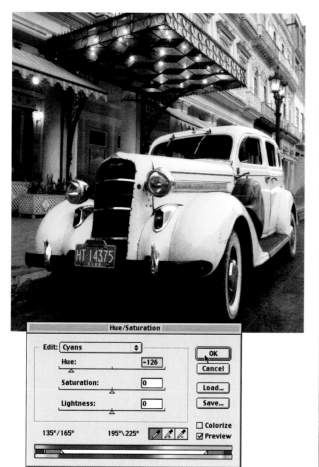

⇑ Now watch what happens. In the Hue/Saturation window, I set the Edit pop-up menu to Cyans and moved the Hue slider far to the left. The result was that the car turned yellow, and the rest of the scene remained unchanged.

⇒ Next I boosted the Hue (with Edit pop-up menu still set to Cyans) all the way to the right, and my car turned pink. Once again, the rest of the scene stays unchanged.

These are just a very few examples of how you can change—and have fun with—color. Try these techniques on your pictures.

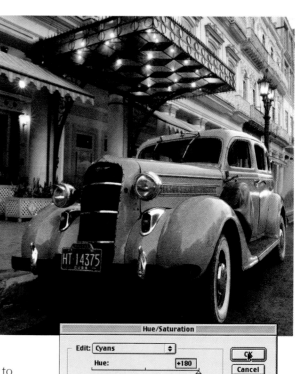

"Much of modern art is devoted to lowering the threshold of what is terrible. By getting us used to what, formerly, we could not bear to see or hear, because it was too shocking, painful, or embarrassing, art changes morals."

—SUSAN SONTAG

LESSON 53 — More on Hue and Saturation

Boost or deplete individual colors or all colors for interesting effects.

As we saw briefly in the preceding lesson, you can also adjust the Color Balance of a picture for different effects. To make my picture of the Hearst Castle pool look as though it was taken during the "golden hours" (early in the morning or late in the day when there are deeper shades of red, yellow, and orange in a scene), I went to **Image > Adjustments > Color Balance** and boosted the red tones in my picture by moving the Red slider to the right. Moving it to the left subtracts Red or adds Cyan.

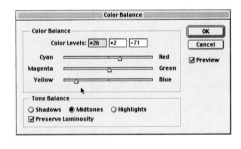

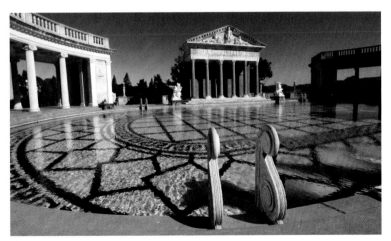

⇑ Mr. Hearst and his guests probably sat around his pool during many "golden hours," when the colors looked as they do in this digitally enhanced picture.

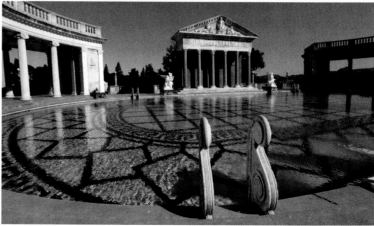

⇪ Using the Hue/Saturation in **Image > Adjustments > Hue/Saturation** and adjusting the Hue in a picture can produce interesting—and unnatural—results, as we saw in the preceding lesson. In the next picture, I adjusted the Hue all the way to -180.

⇪ I agree this is a strange rendition of my picture, perhaps somewhat like a dream scene. It's interesting, however, that all the stone structures look almost black and white, while the pool and sky have color. Strange indeed.

A few years ago, Kodak introduced several slide films that offer more saturated colors. (Saturation is the strength of a color.) Saturated films quickly became popular among photographers who wanted their pictures to pop with color.

⇪ We can approximate the effect of using such film fairly easily. Under **Image > Adjustments > Hue/Saturation**, moving the Saturation slider to the right increases the color saturation (or color strength) of a picture, so it looks as though it were taken with a super-saturated film. Moving it to the left decreases the saturation of a picture.

⇪ Here is my shot of the pool at the Hearst Castle with a moderate boost in saturation. I like the effect because it makes the colors in the picture more vivid.

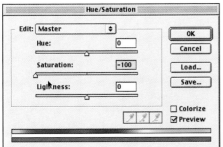

⇑ When the Hearst Castle was built, black-and-white film was standard. Here's what a black-and-white photograph taken in that era may have looked like. This one was created by fully desaturating the colors in the picture using the Saturation slider. That's easy to do in Photoshop. Simply go once again to **Image > Adjustments > Hue/Saturation** and move the Saturation slider all the way to the left. That removes the color from a scene and transforms it into a black-and-white picture. (This is not the best way to make a black-and-white picture from a color picture in Photoshop. See Lesson 56, "Work in Black and White, Photoshop Style," for a better method.)

"Fame sometimes hath created something of nothing."

—THOMAS FULLER

Use Threshold, Invert, and Posterize

Try these special effects!

In traditional photography, there is something called a high-contrast print, with only black-and-white tones made using a graphics arts film called Kodalith. In Photoshop you can create that same kind of effect by going to **Image > Adjustments > Threshold**.

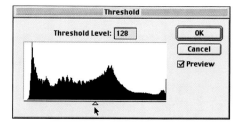

Slide the little triangle back and forth to select how many different colors will be represented in black-and-white tones alone.

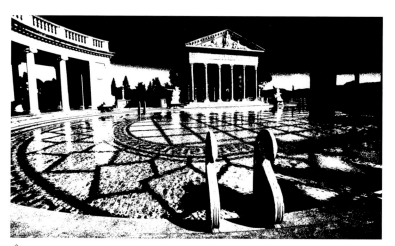

⇑ At the default Threshold setting, our picture of the swimming pool at the Hearst Castle was turned into a stark black-and-white picture.

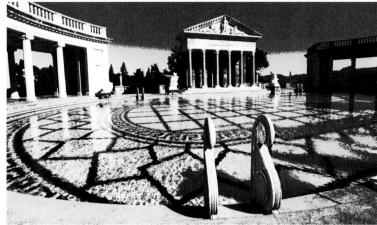

⇑ As with many of the filters and effects in Photoshop, with Threshold you have the option to fade the effect. I experiment with that fading technique every time I use an effect and recommend you try it, too. You may be pleasantly surprised with the results.

After I applied the Threshold adjustment, I went to **Edit > Fade** and faded the effect to 74% (after experimenting with a bunch of other possible settings).

⇑ I actually prefer the faded Threshold effect over the default Threshold effect. That said, if it were not for showing you the different effects you can create in Adjustments, I would not have used Threshold on this picture.

⇒ Here is a dreamlike effect that's easy to create in Photoshop. Using Invert, the colors become the opposite of the original colors. I created this effect by going to **Image > Adjustments > Invert**, which basically creates a negative image of a picture.

⇑ In the 1960s, pop artist Peter Max created interesting posters using a Posterize effect. You can create a similar effect in Photoshop by going to **Image > Adjustments > Posterize**.

⇒ Here's a posterized vision of the Hearst Castle pool that may please Peter Max. It's not my favorite, but again, it's an example of the kind of color adjustments you can make—and have fun with!

LESSON 55 | Discover Duotones

Duotones expand the tonal range of a black-and-white image.

Ansel Adams was, and still is, considered the foremost landscape photographer of all time. His exquisite use of black-and-white photography—in the field and in the traditional darkroom—set high standards for landscape photographers. Even today, his black-and-white prints sell for thousands of dollars.

So here is a question: Are Ansel Adams's posters black and white, or color? The answer may surprise you (this lesson's title is a bit of a hint). You see, many of his posters are neither black-and-white nor color images. They are **duotones**.

Technically, a duotone is an image that's made using black ink and one other color ink. In the printing process (as in printing books, posters, and magazines), duotones were developed to expand the tonal range of an image—to allow the reproduction of rich and subtle colors.

In Photoshop, you can take advantage of (and have fun with) about 150 preset "duotones" using various combinations of colors. Why the quotes around duotones? Well, the designers of Photoshop have grouped duotones, **tritones** (which use black ink and two other colors), and **quadtones** (which use black ink and three other colors) into the Duotone menu. When converting an RGB or CMYK image to a duotone, tritone, or quadtone you must first convert it to Grayscale (**Image > Mode > Grayscale**) before you can get to the Duotone menu. You'll find the Duotone menu in Photoshop version 7 by then going to **Image > Mode > Duotones**. Next you make a selection in the Duotone Options window for the number of tones that will be used in your new image—duotone, tritone, or quadtone. Then you choose the specific color or colors that you will use in addition to black.

You can load some of Photoshop's preset color combinations by clicking on the Load button in the Duotone Options window, and then selecting a specific color from a standard dialog box that opens. In Photoshop version 7, you will find the Duotone presets in the "Duotones" folder that is stored inside the "Presets" folder with the application files on both Mac OS and Windows versions of the program. Once a preset is selected, you can actually create an unlimited number of Photoshop duotones by adjusting the Curves (see Lesson 51, "Curves, Brightness, and Contrast Adjustment," for information on using Curves).

Okay, let's discover some duotones. Take a look at how they affect a picture of a man whom I photographed in Old Havana, Cuba (who charges a dollar for each picture you take), and yet another picture of the outdoor swimming pool at the Hearst Castle, built by William Randolph Hearst (who had more than a few dollars). First, we convert our color image to Grayscale, as done below.

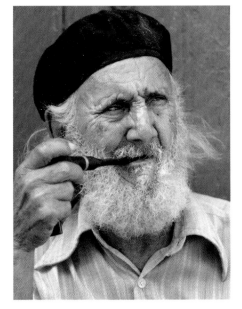

Original color images.

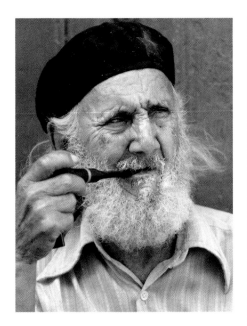

Grayscale images.

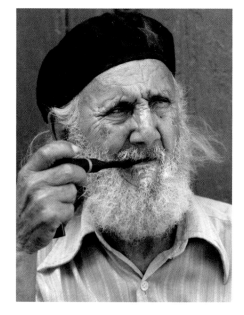

⇧ Screen shot of
Duotone Options
Window showing the
color combination for a
mauve duotone—one of
many Duotone options.

Mauve duotone images.

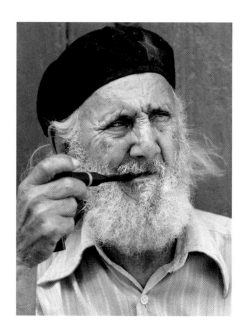

⇧ Screen shot of
Duotone Options
Window showing the
color combination for a
green tritone—one of
many Tritone options.

Green tritone images.

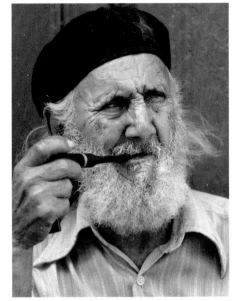

⇑ Screen shot of Duotone Options Window showing the color combination for a "cool" quadtone—one of many Quadtone options.

Cool quadtone images.

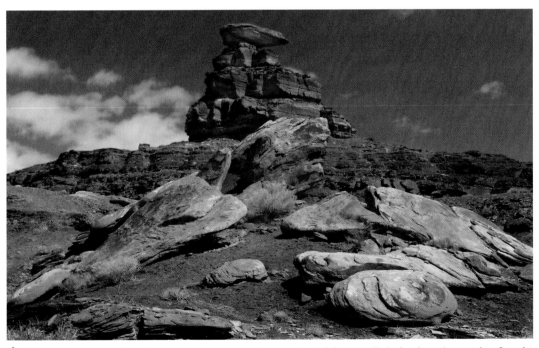

⇑ This is one of my favorite duotone images. It was created from a digital color picture that I took at Mexican Hat, several miles north of Monument Valley, Arizona.

"Any activity becomes creative when the doer cares about doing it right, or doing it better." —JOHN UPDIKE

Work in Black and White, Photoshop Style

Give three cheers for the Channel Mixer!

Take the color out of a scene, and we take away some of the reality of that scene. Take away some of the reality in a picture, and we immediately draw extra attention to that picture. That's one reason why black-and-white photography remains popular. Some photographers feel that black-and-white photography is actually more creative than color photography.

In Photoshop, there are four basic techniques for creating a black-and-white image from a color image. These techniques do not include the black-and-white images that can be created with Photoshop plug-in filters, such as nik Color Efex Pro! and Silver Oxide (see Lesson 63, "A Tour of Plug-Ins," for information on these plug-ins).

As you will see, only one of the techniques helps us create a really good black-and-white picture from a color image. Only this one technique gives us total control of an image. And this technique is lots of fun to use. But first let's look briefly at the less desirable ways to create a black-and-white image.

⇐ The Grayscale technique is used by going to **Image > Mode > Grayscale**. This technique discards all the color information at the click of a mouse.

⇐ The Hue/Saturation technique is used by going to **Image > Adjustments > Hue/Saturation**, and then moving the Saturation slider left to completely desaturate the image. The effect we get with the Hue/Saturation technique is basically the same effect we get when we use the Grayscale technique. We can also go to **Image > Adjustments > Desaturate** to turn a color image into grayscale, but I don't know any pro who does that.

Try Image > Adjustments > Channel Mixer for good results.

Simply desaturating an image, using these techniques, is not the best way to get dramatic black-and-white pictures. Simply desaturating a picture often makes it look flat, without strong highlight and shadow areas—the elements key to a good black-and-white picture. Plus, desaturating an image does not give us any control over the different tones in a picture, which is another reason that using the Grayscale, Hue/Saturation, or Desaturate techniques is not the best choice for making a black-and-white image.

⇒ The Lab color technique is used by going to **Image > Mode > Lab Color**. This technique is still not the best way to get a good black-and-white image from a color image, but it does offer a different result, which some photographers may like, or like to play with.

"Lab Color" refers to the three different channels where information is stored in this color mode: The "L" channel stores lightness information and the "a" and "b" channels the color information. We can see these different channels by going to **Window > Show Channels** or by clicking on the Channels tab in the Layers/Channels/Paths action window. By dragging the "a" and "b" channels into the trash can at the lower-right corner of the Channels action window, we are left with the lightness channel. We can now adjust the brightness and contrast for that channel by going to **Image > Adjustments > Brightness/Contrast**.

⇒ Now we get to the best way to make a black-and-white picture from a color image: the Channel Mixer technique. Go to **Image > Adjustments > Channel Mixer** and click on the Monochrome check box in the lower-left corner of the window. By adjusting the sliders for the three color channels, we control the different tones in our picture—the red, green, and blue channels. The RGB mode is the best mode to work in when using the Channel Mixer to create a black-and-white-picture. To fine-tune an image, we need to experiment with the slider much like a traditional darkroom printer experiments with different contrast papers, different exposure times, different filters, and different chemicals to achieve a desired effect.

In most cases, you will be more pleased with a black-and-white image created by using the default setting (upon opening) in the Channel Mixer window than by using the Grayscale technique. All the Channel Mixer pictures in this lesson were created at the default setting. Afterward, I boosted the contrast of each image slightly by going to **Image > Adjustments > Brightness/Contrast**. After using Channel Mixer, adjust the contrast and brightness of an image to test if it can be enhanced even further.

Here are a few examples that show the difference between the Grayscale and Channel Mixer techniques. In looking at them, and comparing them to the color shots, I would not be surprised if some readers preferred the color pictures to the black-and-white pictures.

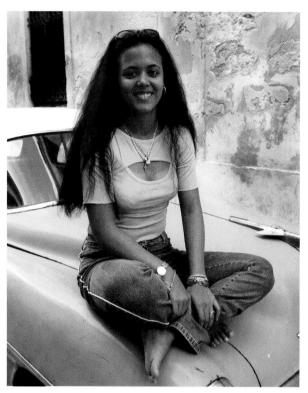

Color image of "The Sister," Old Havana, Cuba.

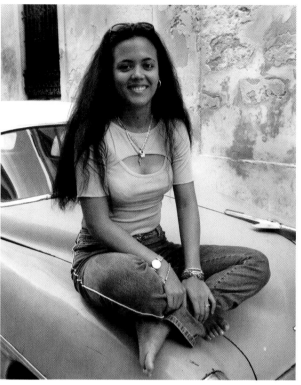

Grayscale image.

⇒⟩ Notice how the girl's clothes and the car's blue paint are much darker than they are in the Grayscale image.

Channel Mixer image.

Color image of St. Francis Church, Taos, New Mexico.

Grayscale image.

⇒ Notice that the sky is darker than it is in the Grayscale image. You'd get a similar effect by using a red filter in traditional photography.

Channel Mixer image.

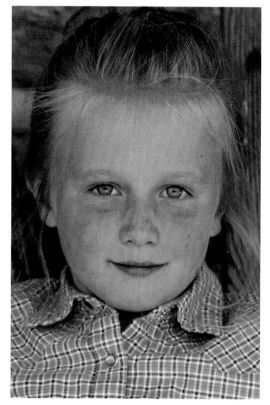

Color image.

Grayscale image.

⇒ In the previous examples, I preferred the Channel Mixer image to the Grayscale image. In some situations, especially low-contrast situations, I prefer the Grayscale version to the Channel Mixer version. The key to getting the kind of picture you like is to experiment, and play around, with all the options in Photoshop.

Channel Mixer image.

LESSON 57	# Learn about Layers

Layers helps you create montages of different scenes.

Layers is one of the most useful features in Photoshop. This function, Layers, in Photoshops's main menu, offers the ability to stack different pictures, parts of a picture, or copies of the same picture on top of one another. We vary the ability to see through a layer by adjusting the opacity. We can place layers in changeable sequences within a stack. The most important benefit of layers is that we can work with different layers without affecting other layers. When we are done, we can flatten the various layers (**Layer > Flatten Image**) to combine all of them into a final image.

Imagine holding three different prints from a Brazil vacation in your hands, one on top of the other. One picture is of a river scene, one picture is of a scarlet macaw, and one picture is of a hut. If you cut out the macaw and the hut and taped them to two different transparent pieces of paper, and then stacked them on top of the river scene picture, you'd have a composite, a three-layer image.

Because you used tape, you could easily lift off the macaw and the hut and move them to different positions. With each image on its own layer, Photoshop lets you do that cutting and pasting and stacking digitally.

Layers can be used for many different creative and corrective techniques—some of which are described in the lessons that follow, and others that are described in Part VI, "Special Digital Effects and Techniques." The possibilities, and the number of layers you can create, are virtually limitless.

To illustrate Layers with full opacity, we will combine three pictures from my trip to Amazonas, Brazil. I chose these pictures simply to show you how Layers works. The effects are easy to see here. The final picture is not my favorite, for reasons you'll see shortly. I created it to make a point.

To illustrate Layers with partial opacity, in which one layer shows through another, we will add a flower to some sheet music—just for fun.

The editing techniques I use below—cutting, pasting, resizing, and adding type—will be detailed in later Layers lessons.

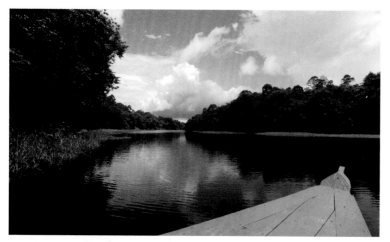

Here are my three original pictures, all taken on the same day, but at different times and in different places.

⇒ Now check out my composite of those three images. Here is how I created it.

Explore Amazonas

1) To begin my Layers process, I opened the river scene as my Background layer. The bottom layer is automatically called "Background" in Photoshop's Layers palette.

2) Next, I added the scarlet macaw on the left side of the frame, after cutting the macaw out of the sky and then resizing the bird (see Lessons 60, "Extract a Subject from Its Background," and 47, "Manage File Size and Image Size"). Because the bird was on a different layer, I could have positioned it anywhere in the frame with the Move tool.

3) Next, I added the text on a separate layer of its own, which brought me up to a total of three layers. Again, I could have slid the text anywhere in the scene using the Move tool.

4) Finally, I added the hut in the background with the same cutting and resizing method as I used for the bird. And yes, the hut, too, could have been positioned anywhere in the scene. Now we have a four-layer image.

⇒ Here is a screen shot that shows my individual layers within Photoshop's Layers palette. View the Layers palette by going to **Window > Layers**.

As you can see, I named each layer for easy reference: "Macaw," "Explore Amazonas," and "Hut." Rename a layer by double-clicking on the existing name and typing in a new name.

So, what's wrong with this picture? Well, there are a few problems. The macaw, which could have been that size in the scene, is much more color saturated than the river scene, which has soft and subdued colors. That is one reason why the macaw looks unnatural. The other reason is that the river scene was photographed when it was overcast, while the macaw was photographed when the sun was shining and when there were strong shadows on the animal that helped to create a high-contrast image. So the contrast range of the river scene and the macaw don't match.

And what about the hut? Well, at that distance in the picture, the hut would have to be much smaller than it actually is. Its size here may be okay for a fun composite, but it would drive an anthropologist nuts!

So, when working in Layers and especially when making a composite or montage, keep in mind that the pictures or parts of a picture need to "match" in the quality and direction of the light and in the degree of contrast. Of course, you can change the light and the contrast in Photoshop to a degree.

Now let's explore how we create a layer with reduced opacity, so we can see through it. For this example, I'll use a scanned sheet of music (a Bach Invention that I used to be able to play) and a picture of an artificial rose with an added drop shadow (see Lesson 78, "Create Drop Shadows").

⇒ The first step was to place the rose layer on top of the sheet music layer. I did that by copying the rose picture (**Edit > Copy**) and pasting it on the sheet music layer (**Edit > Paste**). Because the rose was on a separate layer, I could place it anywhere I wanted on the sheet music layer (using the Move tool). I chose to center it near the bottom of the frame.

⇒ This screen shot shows my two layers in the Layers palette. The rose is the top layer and the sheet music is the Background layer.

Now look closely at the Opacity box near the top of the Layers palette. I've reduced the Opacity in Layer 1 to 79%. I arrived at that percentage after playing around with various other opacities. At 100% Opacity, I could not see through the rose. At 0% Opacity, the rose would be invisible.

⇑ My finished image turned out the way I had envisioned it in my "mind's eye." The sheet music is sharp, and we can see some of it through the rose.

⇑ To put a finishing touch on my image, I added a soft, see-through edge to the overall scene called a "vignette." Vignette an image by selecting the area you want to vignette (using the Rectangular or Oval Marquee tool) and then going to **Actions > Vignette**. To activate the Action, you must press the Play arrow at the bottom of the Actions palette. In "Button Mode," at the top of the Actions palette, click the name—or button—of the action to play it. (For more on Actions, see Lesson 64, "Special Effects with Actions.)

Happy with the results, I flattened the image with **Layer > Flatten Image**.

"Perception is personal. We see what we see."

—RICHARD FAHEY

Use Adjustment Layers

Adjustment layers help you keep track of the changes you have made.

Throughout this book, you'll see that I made many image adjustments and enhancements (brightness, contrast, etc.) directly on a picture, rather than on an Adjustment layer. That's not really the best way to work, though, because you never want to work directly on an original. I did it to keep my screen shots relatively clean and to save you from looking at a lot of layers in the Layers window. Plus, the pictures were not my original images; they were copies of the originals.

Nevertheless, an Adjustment layer is the best way to enhance a picture. Why?

Because each of our adjustments will be placed on separate layer. That means we can go back to that layer again and again and fine-tune our adjustments one by one, without having to touch the original of the image on which we are working and without having to remember all the adjustments we made. And if we save our file with Layers, which is possible in the Photoshop PSD and TIFF formats, we can go back years from now and make new adjustments, leaving the original image untouched.

Start by going to **Layer > New > Adjustment Layer**. When you open the submenu for New Adjustment Layer, you'll see something interesting: The adjustments are not in alphabetical order. Rather, they go in this order: Levels, Curves, Color Balance, Brightness/Contrast, Hue/Saturation. . . . The adjustments are in that order because that is the order in which Photoshop recommends that you make your adjustments. Let's get to work.

⇐ Here is a shot I took in a Buddhist temple in Singapore. It's a poor scan of a 35 mm slide. It lacks contrast and detail.

Try Layer > New > Adjustment Layer.

⇒ When I created a Levels adjustment layer (**Layer > New > Adjustment Layer > Levels**), the histogram showed the distribution of highlights and shadows in the picture. The contrast and brightness of the image were "off"—in other words, the highlight/shadow distribution stopped short of the right and left sides of the "black mountain" of highlight and shadow areas. In a properly exposed picture, the distribution would be from edge to edge. (See Lesson 51, "Curves, Brightness, and Contrast Adjustment," for more on the histogram.)

Correcting the problem was easy. I moved the right triangle on the adjustment bar to just inside the right side of the "mountain" and the left triangle on the adjustment bar to just inside of the left side of the "mountain." That boosted the highlight and shadow areas, correcting the brightness and contrast of the scene. Totally cool, don't you think?

⇒ I proceeded to make a Curves adjustment layer (**Layer > New > Adjustment Layer > Curves**). To make the picture a bit brighter, I pulled up the Curve (in the RGB mode) from the center of the grid.

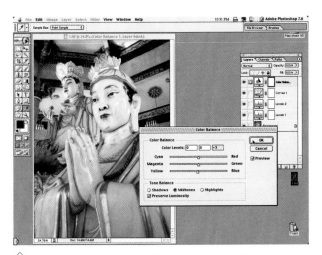

⇑ Next I created a Color Balance layer. I played around with the balance (**Layer > New > Adjustment > Color Balance**), but I actually liked the original, so I left it alone.

⇑ I was still not 100 percent happy with my image, though, so I created a Brightness/Contrast layer to boost contrast a bit (**Layer > New > Adjustment > Brightness > Contrast**).

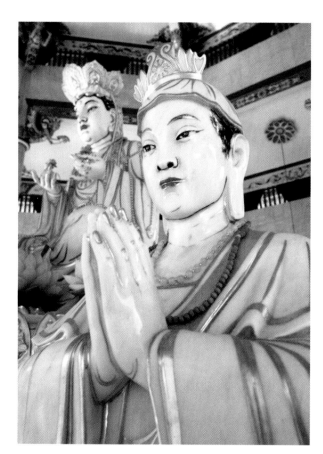

Original.

⇐ Here is my finished image, which even looks much better than my original 35 mm slide above.

"There is no audience as far as I am concerned. I am the audience."

—JOEL MEYEROWITZ

Be Selective

Often, only a specific area of a photo needs adjustment.

At my first Photoshop class, the instructor, Timothy Morrisey, said, "Selection is everything." Well, that may have been an exaggeration, but the ability to select a specific area of a picture, and then to be able to work on that area, is a major benefit of Photoshop. In this lesson, we stress the importance of selecting *only* the area that needs enhancement or correction. Many novice Photoshoppers enhance the color, brightness, contrast, and sharpness of an entire image, which is what we've been doing so far in this book. That's often not a good idea, for two reasons: One, most of the time, only a small area needs adjustment, and two, making that adjustment on the entire image area can actually make a picture look worse.

These two examples will show you when and why to be selective about your selections.

⇐ I photographed this man during Carnival in St. Martin. I used a flash so I could see the man's dark face, which was surrounded by his brightly colored costume. Still, even with a flash, his face was too dark, due to the contrast range between his face and his costume.

⇒ I wanted to make *only* the man's face more prominent in the picture. To do that, I first made a duplicate layer of the file to produce two pictures that were exactly the same, one on top of the other. Then I went to the bottom (Background) layer by clicking on it in the Layers palette (**Window > Layers**). I increased the contrast by going to **Image > Adjustments > Brightness/Contrast** and boosted the contrast on the bottom layer. So, the entire area of the bottom layer was changed to create a lighter version of the photo—including the man's face. (I'm not contradicting myself —read on!)

Then I went to the top layer (by clicking on it in the Layers palette) and used the **Eraser** tool to erase *only* the man's face. That let the bottom layer (with the man's lighter face) show through, without affecting the contrast or brightness of his costume in the top layer. If I had boosted the contrast of the entire file, the costume would have been washed out and oversaturated as it was in the bottom layer after I had adjusted it.

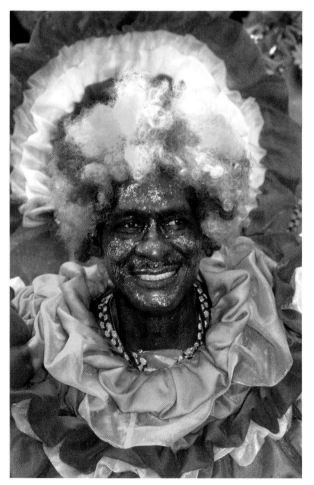

⇐ When I was pleased with my results, I flattened the two layers (**Layer > Flatten Image**) and saved my new file. The left-hand finished picture is how the man looked to my eyes when I photographed him.

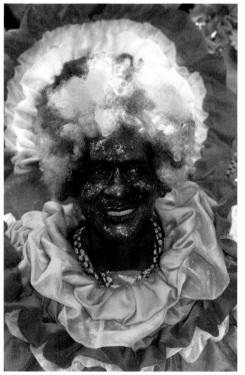

Original.

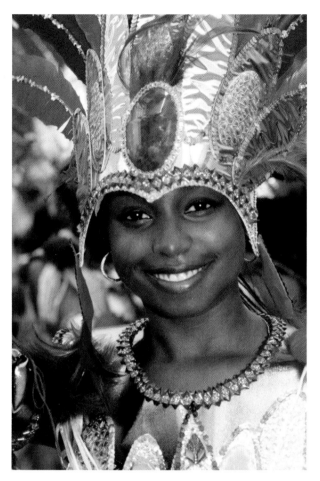

⇐ I photographed this woman at the same Carnival. This time, in addition to being too dark (again I used a flash), the dancer's face is a bit soft. Because I was dancing backward in the parade while I was shooting, my focus was slightly off.

⇑ To sharpen only the woman's face, I first selected her face using the **Lasso** tool from the Tool Bar. (If I had sharpened the entire image, her face would still have looked softer than the other areas of the scene.) Then I went to **Filter > Sharpen > Unsharp Mask** and sharpened the picture just a bit. (As I say in Lesson, 63, "A Tour of Plug-Ins," I don't usually use Unsharp Mask. I used it here just to give an example of how to use the filter.) Why is only part of the girl's smile in the Unsharp Mask window? Because when you open the **Unsharp Mask** dialog box, it reveals only part of the frame so you can more accurately check the sharpness. You can, however, view the entire frame by clicking on the "-" icon in the Unsharp Mask window. Likewise, you can enlarge your view by clicking on the "+" icon.

⇒ Next, I wanted her face to be more prominent in the scene. So, while her face was still selected, I went to **Select > Inverse**, selecting everything *except* the face. Then I went to **Image > Adjustments > Curves** and slightly pulled down the RGB curve from the center of the grid. That made everything but the face darker.

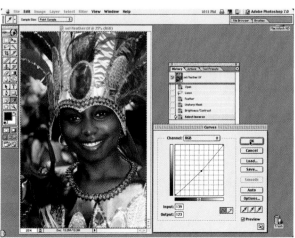

Original.

 Here is my final flattened image. The woman's face is brighter and sharper than in the original scan.

So the message of this lesson is that being selective about which area of an image to adjust can produce fantastic results.

LESSON 60	# Extract a Subject from Its Background

Lots of tools make it easy to cut out a subject.

Taking a subject out of one picture (extracting it) and placing it in another picture used to take hours of work in the traditional darkroom. But thanks to Photoshop, cutting out a subject and placing it in another scene is relatively easy.

Photoshop offers several tools for extracting a subject from a scene. The Lasso tool (found on the Tool Bar) lets us trace a subject, after which we can use **Edit > Cut** and **Edit > Paste** to cut the subject out and place it in another picture. The Lasso technique takes careful tracing and may be necessary if that subject is embedded in a diverse background.

But Photoshop offers other tools that make it easier to cut out a subject: the **Extract** tool (found under **Filters** in Photoshop version 7, under **Image** in earlier versions), the **Background Eraser** and the **Magic Eraser**, both found in the Eraser tool on the Tool Bar. These tools all work by comparing different color values. Hence, the tools work best when the background is relatively plain and when it is a different color from the subject. Knowing that, you may want to keep your background in mind when photographing a subject that you think you may want to extract later and place into another picture.

Let's use the Extract tool first, at **Filter > Extract**.

◁ Here is a picture I took of model Carolina McAllister against a black background in a photo studio.

⟹ When we select the Extract tool, a large dialog box, which includes the picture and all the Extract options, fills the screen.

To extract a subject, we trace around its edges completely with the Highlighter tool (a brush, also found on the Extract Tool Bar). You may want to magnify the part of the image that you are extracting as large as possible to make your tracing more accurate. Then we use the Fill tool (a paint bucket on the Extract Tool Bar) to fill in the traced area. It's that easy. The default colors are green for the Highlighter tool and blue for the Fill tool. (You can change these colors, as well as the size of your tracing brush.)

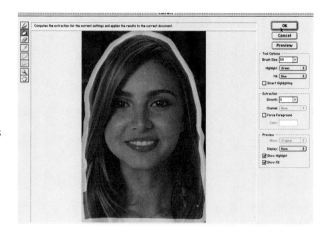

⇊ Next I clicked OK, and the background was deleted—well, almost all of it. (In earlier versions of Photoshop such as 5.5, click Preview and then click OK.) You can see that some of the background is still visible around Carolina's hair. That's no problem; I'll remove it later.

Note: When you delete (or erase) a part of a layer, as I did here, that part of the layer becomes transparent. So, when the picture is placed on top of another layer, you can see through the erased part of the top layer.

⇑ I wanted to place Carolina outdoors on a sunny day. So I looked through my files and found this stock shot of lawn, water, and sky that I took in Kuna Yala, Panama.

Try Filter > Extract.

Important: When we import one picture into another, the resolution for both pictures should be the same—that is, both pictures should have a resolution of, say, 300 dpi. If the resolutions are different, we will find out that the imported picture will be smaller or larger than we anticipated.

In addition, it's important to consider actual picture size before combining images. To use Carolina and my Kuna Yala pictures as an example, my picture of Carolina had a height of six inches, and so did my Kuna Yala picture. So I knew that Carolina would fill the frame of my Kuna Yala picture. You can use the Transform (**Edit > Transform**) tool to scale a picture up or down, but it's easier to get it right from the beginning.

⇒ To combine pictures, we open both images so each one is visible. Then we drag the extracted image of Carolina on top of the Kuna Yala stock picture. Now we see a two-layer image that looks as though it was taken outside.

What happened to the studio background that was "stuck" around Carolina's hair? I removed it by using the Eraser tool. Here's how. First, I enlarged the merged picture using the **Magnifier** tool. Then I used the Eraser (the plain eraser icon on the Tool Bar) on the top layer (Carolina) to erase all the areas of little black marks. That let the background layer (Kuna Yala) show through. I also used the Clone Stamp tool (the rubber stamp icon) to copy and paste a few strands of Carolina's hair in areas where the Extract tool had extracted too much hair.

The **Background Eraser** (the eraser icon with scissors on the Tool Bar) is another way to extract a subject. It basically works like the Extract tool. You trace around your subject with the Background Eraser, being very careful not to let the crosshairs of your brush touch your subject. If it does, some of your subject will be erased.

If too much or too little of your background is being erased with this tool, adjust the tolerance in the **Tolerance** window at the top of your screen: Decrease the Tolerance if too much of the main subject is being erased; increase the Tolerance if too little of the main subject is being erased.

⇐ Here is another shot of Carolina, this time photographed against a light background. Here, I'll use the **Magic Eraser** tool to remove the background.

⇒ Removing the background in this shot was easy with the Magic Eraser tool (the eraser icon with spray)—again, because the background was basically one color. All I did, after selecting the Magic Eraser, was to click on different areas, and the background was, you guessed it, magically erased.

⇐ Using the same stock shot from Kuna Yala, I created this image that looks as though Carolina was photographed at the beach— simply by dragging the picture of Carolina over the stock shot of Kuna Yala. As before, I made sure the resolution of both pictures was the same—300 dpi. Both pictures were six inches in height with the appropriate width, because, in this case, I wanted my full shot of Carolina to fill the background frame. I also checked to be sure that Carolina's image was not wider than the background.

To soften the edges of the new image, I used Photoshop's Vignette tool, which is found in the **Window > Actions** palette.

The lesson here is twofold. First, photograph plain scenes that you can use as backgrounds. Second, photograph subjects against uniform backgrounds when you think you may want to use them in other scenes. Portable plain backgrounds are available in many sizes for that very purpose. You can find them in professional camera stores and in mail-order catalogs.

"You know . . . that a blank wall is an appalling thing to look at. The wall of a museum—a canvas—a piece of film—or a guy sitting in front of a typewriter. Then, you start out to do something—that vague thing called creation. The beginning strikes awe within you."

—EDWARD STEICHEN

Make Your Subject Stand Out

Create a livelier shot.

Professional on-location photographers, as well as movie and music-video directors, spend a lot of time lighting their subjects. They may use reflectors, diffusers, or special lights to create a mood or effect. Frequently, they are trying to make a subject stand out from the background, which gives the scene a sense of dimension.

Lighting is so important that a lighting director credit is often given at the end of a movie.

Most photographers (like you and me) don't have the luxury (or budget) for a ton of lighting equipment, not to mention lighting experts or assistants. With Photoshop, however, we can create interesting lighting effects right in the digital darkroom.

In this lesson, I'll show you one technique for making a subject stand out from a scene. At the end of the lesson, I've included another technique for adding interest to a picture.

⇐ Here is a scanned image of a mother monkey with her young, which I photographed on the side of a road on the island of Lombok, Indonesia. It's a bit flat, due to soft lighting.

⇒ When I'm working on a picture on my computer, I often keep the original on my screen in a small window. That makes it easy for me to compare my work-in-progress with my original. However, to keep my screen shots clean and more easily understood in this lesson, I did not keep the original picture open beyond this step. Recall that I always save a copy with a different file name and then open the copy for my work on the image. That way my original remains unchanged.

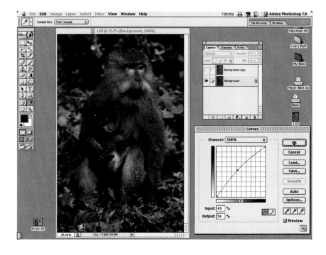

⇒ To make this monkey duo stand out in my picture, I decided to darken the background. Of course, the easiest and fastest way to do this would be to use the Burn tool, but I have found that the Burn tool can also make the "burned" areas look flat and lacking contrast. Often it is better to use Curves.

So, for this picture, the first step was to make a **duplicate layer**. Then I activated the bottom layer (by clicking on it in the Layers palette) and made the entire layer darker by pulling up the curve from the center of the grid. In the CMYK mode here, pulling the curve up makes a picture darker; in the RGB mode here, pulling the curve down makes a picture darker.

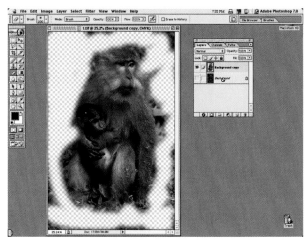

⇒ Next I clicked on the top layer in the Layers palette and used the Eraser tool to erase the area around the monkeys, which revealed the darker image below where I used the Eraser. To check the accuracy of my erasing, I turned off the bottom layer by clicking on the Eye icon appearing in the bottom layer in the Layers palette. As you can see, more erasing had to be done at this stage of my enhancing the image.

To save a copy of an original: File > Save As > type new name.

⇒ Here is what my enhanced image looked like once my erasing was done. I thought I was finished. However, I was fooled. Here is why. I was viewing the picture under different lighting conditions: My desk light was turned on, which is not how I usually work. That light affected how the picture looked on my screen. After turning off my desklamp, I explored a different type of enhancement: lightening only the monkeys' eyes.

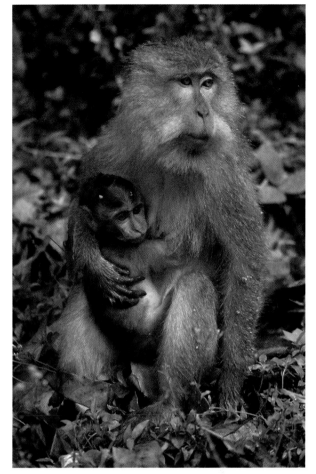

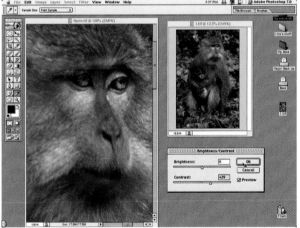

⇑ In animal photography, as well as in people photography, the eyes are the key to a good picture: They must be in focus and visible. When we look at a picture of people or animals, we look at the eyes first.

In my original photo, the eyes are too dark, because I did not use daylight fill-in flash (which would have added some "catch light" to the animal's eyes) and because the animal was in the shade. (See Lesson 18, "Outdoor Flash Techniques," for more information.)

To "lighten" the eyes, I went back into Photoshop. First I used the Elliptical Marquee tool, found on the Tool Bar, and selected all four eyes in the picture. (Add to an existing selection by holding down the Shift key or by clicking on the Add to Selection icon in the top left section of the Photoshop window.) Once the eyes were selected, I went to **Image > Adjustments > Brightness/Contrast** and increased the contrast until I liked the way the eyes looked. Note: The eyes may not look natural to you. That's because I overenhanced them here so you could easily see the effect.

⇒⇒ When this was done, I saw that my picture was still too flat. So, after deselecting the eyes, which let me work on the entire image, I went to **Image > Adjustments > Brightness/Contrast** and boosted the contrast of the entire image.

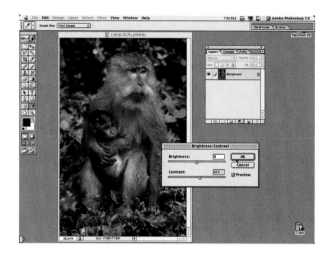

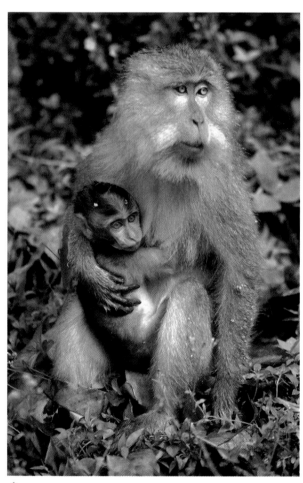

Original.

⇑ Compare my enhanced image to my original. As you see, the subjects stand out more prominently from the background—and you can see the animals' eyes.

"The art of creating is not entirely a rational and conscious one."

—SALMAN RUSHDIE

Have Fun with Digital Filters

Try fading a filter for more choices.

In "straight" photography, creative filters fit over a camera's lens and take some of the reality out of the scene. They help the photographer create an artistic image.

There are several dozen creative filters available in Photoshop, if we include all the filters in the submenus. Actually, that number greatly increases when we consider that many of the filters let us increase or decrease the degree of the filter effect by simply moving a slider. There is another control—a *very* important control—that increases the creative possibilities even further. We'll get to that in a minute.

Rather than examining the effect of a thousand combinations of filters in this lesson, we will modify two pictures to show some of the creative effects. Adobe designed many of these filters for all kinds of illustrators who are rendering and manipulating images from cartoons to fine art to photographs. This lesson will focus on some of the Filters that are most helpful for photographers. You'll find some other examples of filters in Lessons 70, "Awaken the Artist Within," 74, "Add Action to Still Photos," and 75, "Create the Magical Mirror Effect."

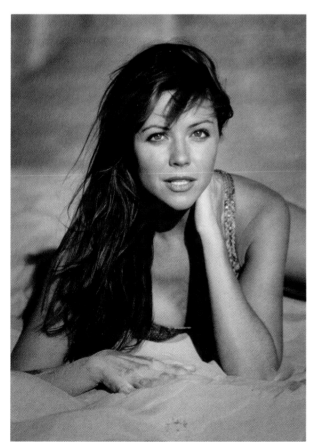

⇐ Here is a straight shot of model Karen Trella that I took on a sand dune at Lake Powell with my Canon EOS 1V and 300 mm lens. (In beach situations, be extra careful to keep sand away from your camera and camera bag. I got a bit of sand in my bag, which got into my camera and scratched several rolls of film.)

⇒ This screen shot shows the Graphic Pen filter (**Filter > Sketch > Graphic Pen**) options: Stroke Length, Light/Dark Balance, and Stroke Direction. (I told you there were lots of options!) I played around until I thought I had a nice effect. Once we choose a filter, Photoshop places the filter's name as the first item under the Filter pull-down menu—in this case, Graphic Pen. Fading the filter also becomes an option. We find Fade Graphic Pen under Edit.

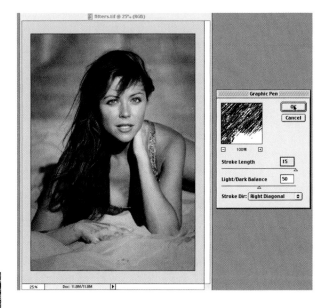

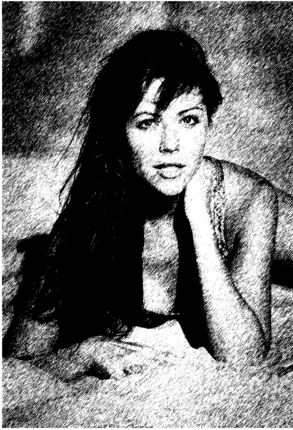

⇐ The effect turned out to be more intense than I had planned. To reduce the effects, I faded the filter.

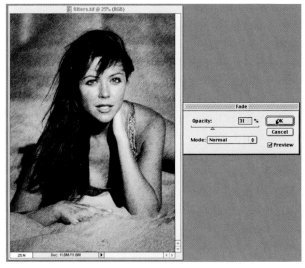

⇒ With this control, we can fade or reduce the filter's effect to get back closer to the original picture. I faded it here, but was still not satisfied.

Try Edit > Fade (name of filter) to soften an effect.

⇑ That's it! I changed my color image to a black-and-white photo by going to **Image Mode > Grayscale**. You see, you have to play around and experiment with filters. Don't settle for your first choice, as tempting as it may be. After all, you are the artist now—creating your own works of art.

⇑ Here's a dreamy effect I created by going to **Filter > Distort > Diffuse Glow**. You need to be in the RGB mode to access this filter. I like the softness of the image and the way the filter adds a glow to the highlights. The effect works well for people, wildlife pictures, and still life subjects.

Okay, all you keen-eyed photographers. You probably noticed the slight glow around Karen. If not, look again. I created the glow by using the Dodge tool to darken slightly the area around my model. I often use that technique to draw attention to my main subject.

Let's try a different creative filter.

⇒ Here's a shot of a lifeguard stand in South Beach. (If you go to Miami Beach's famous shore, get up before dawn to catch the beautiful light of sunrise.) To exaggerate the perspective of the scene, I shot close with my 16–35 mm zoom set at 16 mm, and got down on my knees in the sand and shot slightly upward. An aperture of f/11 let me get everything in focus.

I wanted to create a "yesteryear" look of the Art Deco era for which South Beach is famous. During that era, the hotels and buildings in the area were painted with pastel colors—restored during a renovation in the 1980s. I've seen postcards of the era, most of which were faded. So, I got the idea to create an image that looked like a pastel postcard. Here's how I created the effect (after much experimenting).

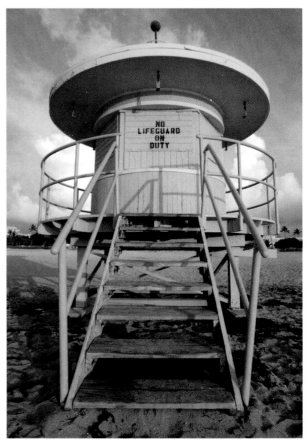

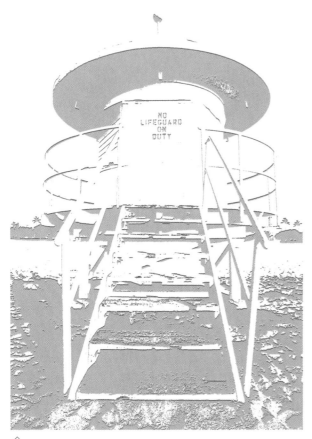

⇑ I went to **Filter > Sketch > Note Paper** to apply the Note Paper filter. The picture looked nothing like the image I had imagined.

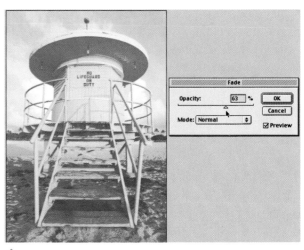

⇑ But as I mentioned earlier in this lesson, fading a filter opens up a whole new world of creativity. So I faded the filter until the picture looked like the image I had in my "mind's eye."

Try Filter > Sketch > Note Paper and then Edit > Fade Note Paper.

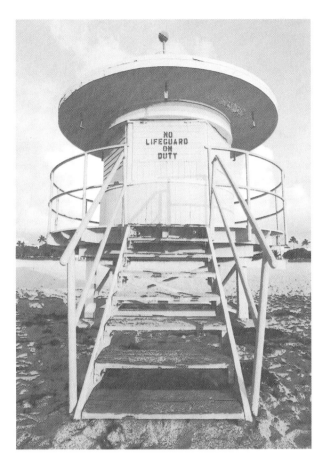

⇐ Voilà! My finished image—one that looks somewhat like a pastel postcard from the Art Deco era.

Okay. Now it is your turn to have fun with creative filters! Just remember: Fade those filters!

"The ear tends to be lazy, craves the familiar and is shocked by the unexpected; the eye, on the other hand, tends to be impatient, craves the novel and is bored by repetition."
—W. H. Auden

LESSON 63 A Tour of Plug-Ins

A plug-in expands the creative options available in Photoshop.

Photoshop plug-ins are not limited to Photoshop. They can be used with any imaging program that accepts compatible plug-ins. In Photoshop, after you load a plug-in on your computer, and the plug-in has been placed in the plug-in folder, it shows up at the bottom of the **Filter** menu (sometimes, you have to restart your computer in order to activate the plug-in).

Dozens of plug-ins are available. I use a handful recommended by the "King of the Plug-in," Joe Farace: nik Color Efex Pro!, nik Sharpener Pro!, SilverOxide, and Extensis PhotoFrame.

After you apply an effect, whether from Photoshop or a plug-in, go to **Edit > Fade** and fade the filter for many more less-dramatic effects. On the other hand, if you want an even more dramatic effect, try applying the effect more than once. To take advantage of the Fade feature, you must apply it directly after you apply the filter.

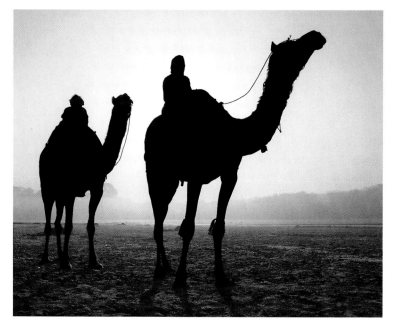

⇇ This shot of two camels offers very little color, but good contrast between the camels in the foreground and the background of soft early sunlight. I took it just after sunrise behind the Taj Mahal. At the time, I envisioned enhancing it in Photoshop with Color Efex Pro!

For more information on nik Color Efex Pro!, visit www.nikmultimedia.com.

⇒ Some of the most useful filters in Color Efex Pro! are the Graduated filters. Like graduated filters that fit over a lens, these filters gradually fade from dark to light.

With Color Efex Pro!, we can choose from an almost unlimited number of colors. What's more, we have the following controls in the filter's dialog box: Rotate Horizon (for placement of the filter's horizon line in the scene—not the horizon line in the actual scene), Filter Opacity (degree of darkness), Shift Vertical (where the dark to light area is placed in the scene), and Blend (from hard to soft).

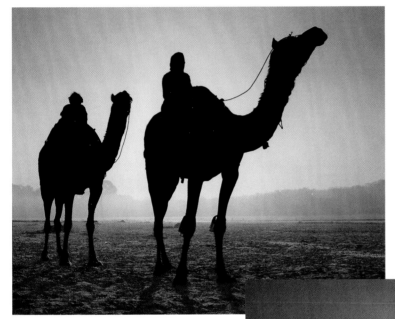

⇐ Here's the picture with a Dark Blue graduated filter applied. What other colors might look good?

⇒ How about the Tobacco filter? Its hues say "heat"—and it was hot that day!

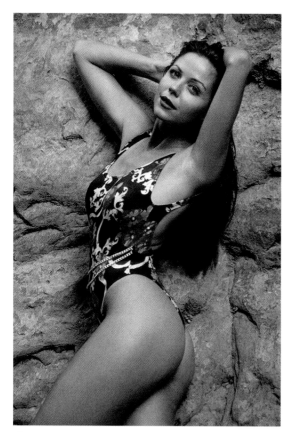

↑ Here's a shot I took of model Karen Trella during a fashion shoot at Lake Powell, Arizona. I like the picture, but I thought I'd try a few creative digital filters on the image.

↑ In Color Efex Pro!, some of my favorite filters are the Midnight filters (available in different colors). Once we select the filter, we can control the degree of color, the amount of blur, and the brightness of the scene—all of which are indicated on the filter's fly-out window. Notice also that this plug-in's action window gives us useful summary information about the image's properties. These characteristics appear at the bottom of the action window.

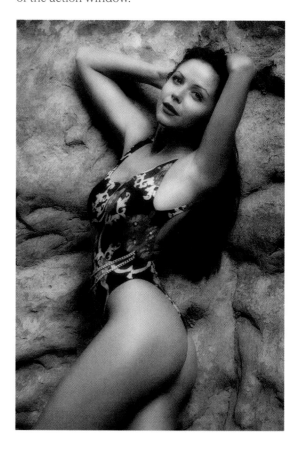

⇒ Here's the same shot of Karen with the Midnight Sepia filter applied. It's a bit dreamier and softer. To see this, compare the surface of the rock in the two versions of the image.

⇒ I shot this picture of a 1958 Ford in Trinidad, Cuba, before the sun came up. The picture looks a bit flat, because there is little contrast in the scene.

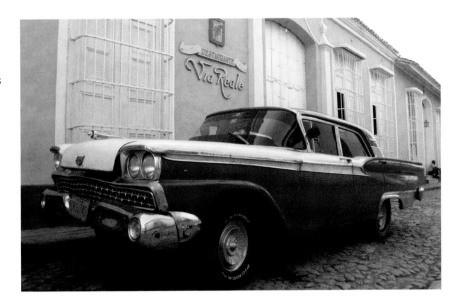

⇐ Color Efex Pro! offers a Sunshine filter that makes a low-contrast picture look as though it was taken on a sunny day. As with most of the other Color Efex Pro! filters, you have control over the effect—in this case, the intensity of the sunlight and the color-correction effect.

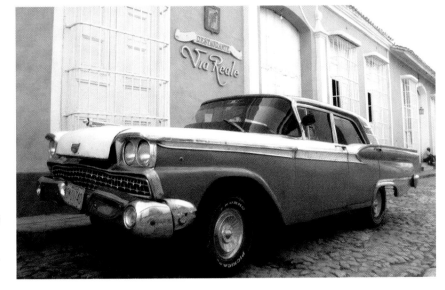

⇒ Here is the same shot of the Ford with the Sunshine filter applied. It now looks as though it were taken on a sunny day.

⇒ Profesionals get lucky too, although some don't admit it. While I was walking down a street in Trinidad, Cuba, I noticed this little girl posing in a window. I raised my camera and shot. I like the picture, but it's a bit soft. Because the subject was in the shade, soft lighting produces a picture that looks slightly out of focus.

I do not use Photoshop's built-in sharpening filter **(Filter > Sharpen > Unsharp Mask)**. It requires you to sharpen by an amount from 1% to 500%, by Radius of the region to which each pixel is compared, and by Threshold pixels that differ from surrounding pixels. If that sounds confusing to you, I agree! Even if we used Photoshop's Unsharp Mask filter, preferred by some pros over the Sharpen, Sharpen Edges, and Sharpen More options in Photoshop, what we would see on our monitor would bear little resemblance to the resulting print. The difference between the low image resolution on our monitors (72 dpi for Macs and 96 dpi for Windows) and the image's higher printed resolution on an inkjet printer may be quite noticeable. Therefore sharpening an image so it looks good on my monitor at 72 dpi may not be nearly sharp enough for printing in this book.

⇐ Instead of using Photoshop's sharpening methods, to sharpen this picture and most of the other pictures in this book, I used nik Sharpener Pro! This plug-in lets us sharpen an image according to our final use: inkjet print, laser print, Internet, or publishing in a book or magazine or on a poster. It also lets us sharpen for the actual viewing distance. Sharpening with a specific purpose in mind makes all the sense in the world to me.

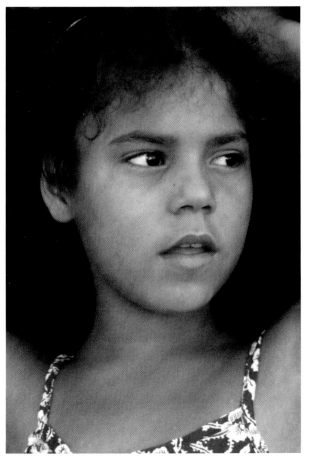

⇑ Take a close look at this enlarged portion from the initial image of the young girl's face.

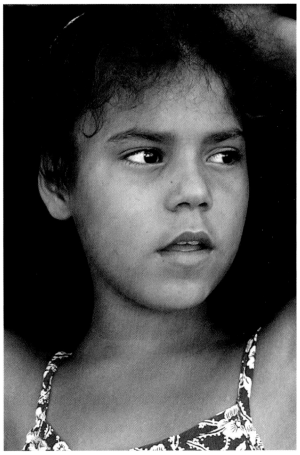

⇑ Now look at the image after I sharpened it. In the sharpened image, we can see almost every hair on her head.

⇒ When I shoot, I look for color. This shot of a roadside restaurant in Chimayo, New Mexico, has plenty of color, but I wanted to see how it would look in black and white. In Photoshop, there are several methods for creating a black-and-white picture from a color picture, which we covered already in Lesson 56, "Work in Black and White, Photoshop Style." But the SilverOxide plug-in also lets us create very good black-and-white images. To use SilverOxide, we first select the film type that we wish to mimic. Here I chose Kodak PlusX because I used to use and love that film. Then we choose which filter effect (red, yellow, green, or none) we want to apply.

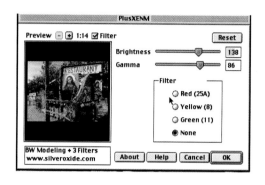

⇒ I chose not to use any filter because I liked the shot at the default setting of "none," meaning "no filters applied."

⇒ So here is my simple black-and-white conversion shot of my color picture. Notice how the bright yellow items on the left and right side of the color image call far less attention to themselves in this black-and-white version.

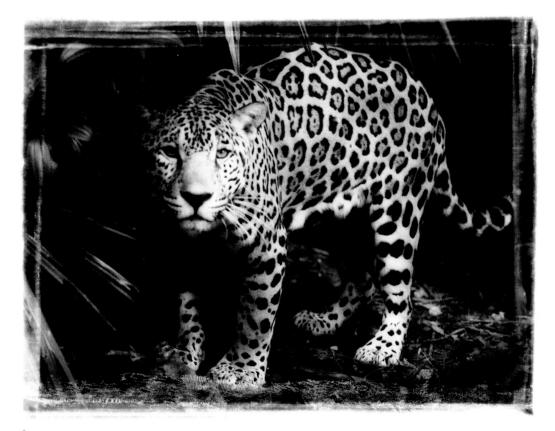

⇑ This image of a jaguar, which I took in the Belize Zoo, was created using the nik Color Efex Pro! Midnight filter. I used the Midnight filter for two reasons: One, I wanted the picture to look as though I shot it at night; and two, the picture is a bit out of focus, and the soft-focus effect created by the Midnight filter covers up my mistake (yes, pros make mistakes, too).

⇛ I used another plug-in, Extensis PhotoFrame, to make the frame. As with most plug-ins, PhotoFrame gives us many options. With small windows that work just like those in Photoshop, this plug-in allows us to manipulate Frame, Background, and Bevel actions. Each of these windows contains further tabs for more actions.

"It is imagination that gives shape to the universe."　　—BARRY LOPEZ

Special Effects with Actions

Actions is an easy way to make many changes at once.

Actions, activated in Photoshop by going to **Window > Actions**, combines several imaging tools and effects into one—you guessed it, an Action. For example, if we like the effect of using several filters on an image, and want to save that particular combination to use on future pictures, it's much easier to make an Action that can be activated at the click of a mouse.

Or say we want to tint all the pictures in a gallery show, and increase the contrast and color saturation of each image. Plus, we want to vignette all the pictures. Doing all those things to each picture takes a lot of time. With Actions, we can load all those time-consuming steps into one Action.

Creating Actions is detailed in the Photoshop user's manual. But what's not in the manual is all the fun we can have with the preset Actions, as well as with Actions we can load and activate from within Photoshop. We load Actions by pressing the small, circled triangle (called a fly-out button) at the top right of the Actions palette. Pressing that arrow opens up a fly-out menu that includes an option for loading Actions.

Because this book is about ideas and fun, I thought I'd share some of my favorite Actions.

≪ I took this picture at Wild Eyes, an animal refuge in Montana, during a blizzard. I was freezing! I used my Canon EOS 1V and 100–400 mm Image Stabilizer lens to get an up-close-and-personal shot.

⇒ Only kidding about the blizzard! As you can see from this shot, I photographed the two tigers as they stood side by side, looking at a potential meal, on an overcast day.

Only kidding again—about the two tigers standing together, that is! As you can see from the other photos in this lesson, this image is a montage I created using two separate pictures of the same tiger (I'm not kidding now). Montages are covered in Lesson 79, "Design a Montage."

To be honest, I added the snow simply by activating Photoshop's preset Blizzard Action. That's just one of the more than a dozen Actions you can use for interesting effects. Here is a look at a few more.

⇑ Here's a before-and-after pair that illustrates the Rain Action. I like the effect because it softens the picture just a little and creates a slightly different mood than the straight shot has.

In addition to special effects, more than a dozen textures are available that let us add texture to a picture. Find Textures by pressing the small arrow at the top right of the Actions palette. That opens a fly-out menu. Textures are at the bottom of that menu. Move your mouse over Textures and then release it. Now you'll see all the preset textures in your Actions palette: Parchment Paper, Obsidian, Sandpaper, and Pastel Glass Tiles are just a few. (Psychedelic Strings and Neon Rubber Bands are not as useful, but they are there.) The key is to select a texture that makes sense for the picture. In this example I selected the Obsidian texture.

Here's how to apply a texture to a photo:

1) Open the file to which you want to add a texture.
2) Create a new image file of the exact same size.
3) Working on the newly created file, click on the texture in the Actions palette you want to use.
4) After your new file is filled with the texture, drag that file over your picture. You will not be able to see your picture at this point, because it is on a layer below your texture layer.
5) Working on the texture layer, go to the Opacity window at the top of the Layers palette (activated by going to **Window > Layers**) and reduce the opacity until you are pleased with the effect. At 100%, you will see only the texture. At 0% you will see only your picture.
6) When you are pleased with the result, flatten the layers and save your file under a new name, so as not to change your original.

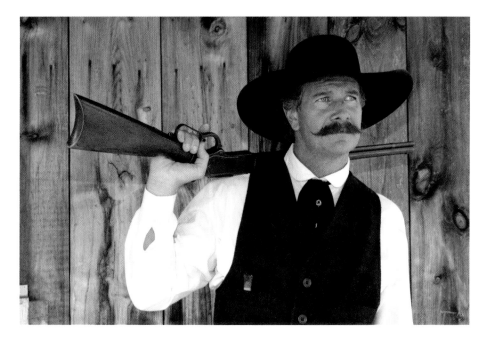

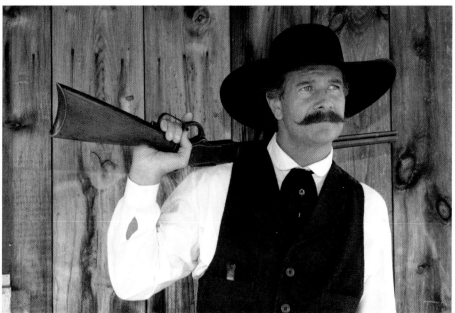

⇧ For my shot of Dallas, a character actor in Ft. Worth, Texas, taken with my Canon EOS D30 and 28–105 mm lens set to about 28 mm, I used the Sepia Toning Action to create an Old West effect.

⇑ While leading a workshop in China, I took this snapshot of the Great Wall. (Look closely and you may see a man, a sign, and a garbage can in the scene.)

To get the feeling of an ancient wall, I used the Aged Photo Action and then the Vignette Action. Before doing that, however, I used the Clone Stamp tool to remove the man, the sign, and the garbage can. See Lessons 45 and 65 for more on Clone Stamp.

I added the black border afterward just to make the picture stand out better on the page. Here's how I did it: I used the Rectangular Marquee tool to select most of the picture except a small border area near the edge of the frame. Then I went to **Select > Inverse,** which selected the area between the moving dotted lines and the edge of the picture. Then I went to **Edit > Fill** and filled the border frame with Foreground Color (the default foreground color is black) and pressed OK. Voilà!

Again, these are just a few of the Actions you'll find preset in Photoshop. Wood Frame and Photo Corners are a nice final touch to a picture. But you may want to skip Neon Lights and Lizard Skin—unless you want a very unusual photo result.

"The more sand that has escaped from the hourglass of our life, the clearer we should see through it."
—JEAN-PAUL SARTRE

Restore Old Photographs

Your old photos are not permanently faded!

"Help!" That's what my friend Bonnie Paulk said when I picked up the phone. "Rick, I have two old photos that are very precious to my family. One picture is of my husband's mother—it looks very dull. Worse still, there are ink marks on the picture all over his mother's face, including her right eye! The other picture is of my parents—it looks flat and faded. I know you are into the digital darkroom. Can you please help restore my pictures?"

Because Bonnie used the magic word, "please," I could not refuse. "Send the pictures to me ASAP," I said. "No problem."

Here's the process I used to fix up her precious photos in the digital darkroom using Photoshop.

⇑ The picture of her parents looks a few stops underexposed.

⇒ The first step was to scan the picture into Photoshop using my flatbed scanner. Because I wanted to see my improvements as I moved along, I kept the original scanned picture on my monitor (lower-right corner of this screen shot) while working on a copy that would become the final image. You may want to use that technique when you are working to check your progress.

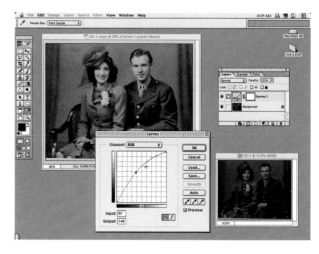

After opening the scanned picture in RGB mode, I went to **Image > Adjustments > Curves** and then pulled up the Curve from the center of the grid to brighten the picture. (Remember about Curves: In the RGB mode, pulling the film curve up lightens the picture; and pulling it down darkens the picture. In the Grayscale and CMYK modes, it works the opposite way. Also, we can use the **Image > Adjustments > Brightness/Contrast** feature to adjust the brightness, instead, but using Curves produces better results.)

Next I increased the contrast by going to **Image > Adjustments > Brighness/Contrast.** Ahhh, the picture is much improved already! Next I selected the Clone Stamp tool to eliminate the dust spots in the picture. All I did was click on a part of the picture next to a dust spot (which cloned that area) and stamped it over the dust spot. The trick here is to use the smallest size brush possible and to make the working image (screen view) area as large as possible (using the Magnifier/Zoom tool) — so you can see what you are doing in minute detail. You'll find more tips on using the Clone Stamp tool in Lesson 45, "Try Easy Tools First."

The background of the picture looked blotchy and uneven. So I selected the Blur tool and blurred the entire background area.

Then, because the subjects were soft, I used nik Sharpener Pro! to sharpen the picture for an inkjet print. (See Lesson 63, "A Tour of Plug-Ins," for more information on nik Sharpener Pro!) Finally, I used a trick I apply to many of my people pictures: I used the Dodge tool to brighten the eyes of both subjects.

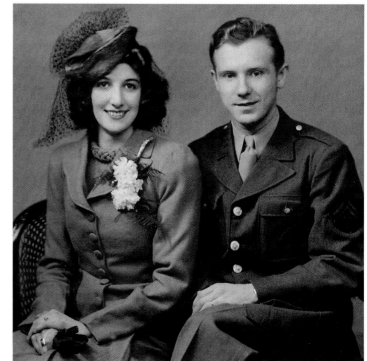

⇑ The final picture looks almost as good as new, with a bit of cropping to add more impact.

⇒ As for the other picture, what a wonderful portrait. Too bad it is ruined with those ink marks right over the eye. But that's not really a problem, thanks to the Clone Stamp tool. I chose to use the Clone Stamp tool for this lesson rather than the Healing Brush (described in Lesson 45, "Try Easy Tools First") to show you that it, too, is useful for retouching.

⇑ All I did was use the Clone Stamp tool to copy and paste good areas of the picture over the bad areas. I say "all I did" because it was relatively easy. However, it did take a fair amount of time for the retouching. I had to use a very small brush size and make very precise corrections. To make my job easier, I enlarged the area of picture (to the point where the eye filled the screen) so I could see what I was doing.

After eliminating the damage caused to the picture by someone's pen, I sharpened the picture with nik Sharpener Pro! Next, I brightened the picture using Curves. Then I increased the contrast using the Brightness/Contrast control. Then I brightened the subject's eyes using the Dodge tool.

Next, I cropped the picture using the Elliptical Marquee selection tool; I placed an oval over the area of the picture I wanted to keep. Then I went to **Select > Inverse,** which selected the area not included in the oval. Then I went to **Edit > Cut**, which removed the

entire picture rim. Finally, I filled in the resulting white area around the finished portrait with black ink by using **Edit > Fill > Foreground Color** (which by default was black).

Well, Bonnie was happy with the new and improved pictures. And, if you have any old or damaged photos in your collection, I hope these tips make your damaged pictures look almost as good as new.

P.S. You may be wondering why I did not use **Layer > New Adjustment Layer > Curves** or the Brightness/Contrast Layers to make my corrections—which I recommend in Lesson 58, "Use Adjustment Layers." Well, I worked on this picture before I got a version of Photoshop with Adjustment Layers.

"A penny saved is a penny earned." —BEN FRANKLIN

<table>
<tr><td>LESSON 66</td><td># Salvage Badly Damaged Photos</td></tr>
</table>

Remove dust and scratches with Photoshop.

Relatively speaking, the damage to my friend Bonnie's pictures in the preceding lesson was minor and easy to fix. But what can we do when we have a severely damaged picture? Let's take a look at one example.

⇩ This picture, taken of our son, Marco, when he was about one week old, was printed from a very badly damaged negative. The multiple dust and scratch marks could be repaired using the techniques described in the preceding lesson, but that would take hours. When you have multiple dust and scratch marks on an image, there is a faster way to get rid of them.

⇧ In Photoshop, you can remove dust and scratch marks by using the Dust & Scratches Filter, found by going to **Filter > Noise > Dust & Scratches**. When you select that filter, the Dust & Scratches window pops up on your screen. Here's how to use this useful tool.

Move the arrows for both the Radius and Threshold sliders all the way to the left. Then, move the Radius arrow gradually to the right until the dust and scratch marks disappear. You will notice that your entire picture will become slightly blurry. Now, move the Threshold slider, slowly, to the right until the detail is restored in your picture. You may still be able to see the larger dust and scratch marks, which you can remove manually using the Clone Stamp tool.

Your entire picture may still be a bit soft, especially if your image was badly damaged, like mine.

↥ Here's a trick. Make a duplicate layer *before* you apply the Dust & Scratches filter. Apply the Dust & Scratches filter only to the top layer, which is called "Background copy" in my screen shot. After you apply the Dust & Scratches filter and are pleased with your results, go to the top layer and use the Eraser tool to erase the most important part of the picture: the area around the eyes. By erasing those areas on the top layer, you will reveal the shaper eyes from the bottom later. If those areas are marked, enlarge them using the Magnifier tool and use the Clone Stamp tool to repair the damage.

↗ This is how my picture of Marco looked after I followed the steps I just mentioned.

⇒ Most of us always strive for the sharpest and cleanest possible picture. But here is another idea for a damaged picture, or any picture for that matter. Use a creative filter to soften the entire image for a more creative effect. Here I applied the Monday Morning Sepia filter from the Photoshop plug-in nik Color Efex Pro! (discussed more in Lesson 63, "A Tour of Plug-Ins").

"The camera is an instrument that teaches people how to see without a camera."
—DOROTHEA LANGE

Rescue Image Details

Use Layers to improve small areas of an image.

As I mentioned in Part II, "Build on the Basics," our eyes see a greater brightness range than any consumer film or digital image sensor "sees" or records. Fortunately, digital-imaging programs like Photoshop can help us restore the vision we had when we took a picture.

Just as there are many techniques for doing just about everything in Photoshop, there are many techniques for restoring detail. Here are my favorites.

⇐ I took this photograph of my cowboy friend Chris Whatley with my Canon EOS D30. As you can see, much of the detail of his hat and coat is lost because I exposed, rightly so, for his face. Had I exposed for the dark hat, Chris's face would have been overexposed. (Yes, that is a fly on Chris's chin—the camera did record that detail.)

⇓ I knew the detail was there. So I used the Magic Wand tool to select the dark areas of the scene, which are indicated by the white dotted line in this screen shot. Then I went to **Image > Adjustments > Curves** and pulled up the Curve to the point where I could see the detail in the hat and coat.

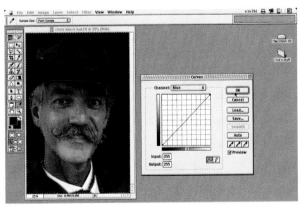

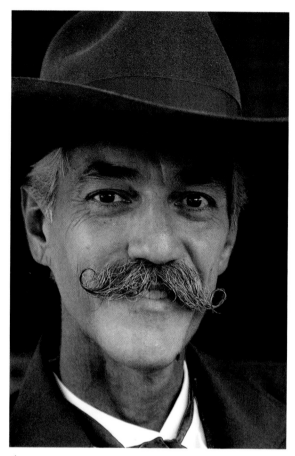

⇑ Take a close look at the picture with the rescued detail. Now you can even see that Chris's hat has a headband.

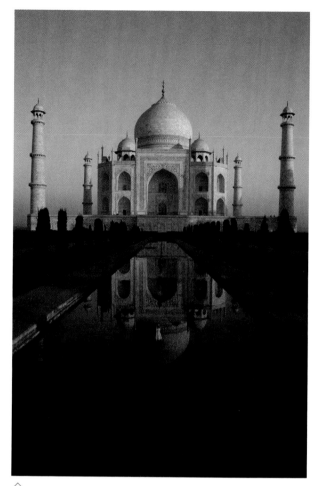

⇑ I took this picture during my first visit to the Taj Mahal. I noticed the extreme contrast range in the scene—from the white tiles on the dome of the Taj Mahal to the shadow area in the reflecting pool. Because I did not want the dome overexposed, I exposed for that area of the scene by setting the Exposure Compensation on my automatic camera at -1 from the automatic setting. In doing so, I knew the pool would wind up underexposed.

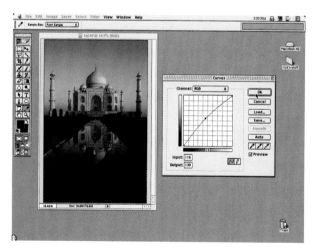

⇐ Later, in my digital darkroom, using the Polygonal Lasso found in the Tool Bar, I selected the pool area. Then, again using Curves, I pulled out some of the detail in the pool.

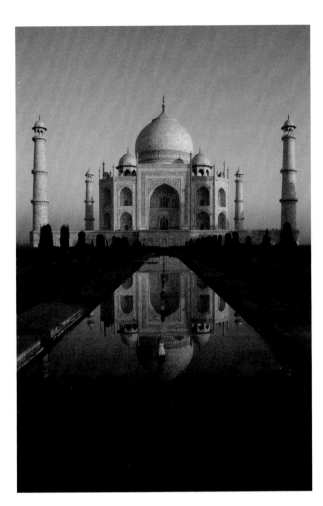

← My resulting picture is a better representation of what I saw on that beautiful, peaceful morning.

⇊ While I was photographing the Taraino tribe in Brazil, I wanted my pictures to have a "sense of place." To do that, I needed to include the background. This scene, photographed with my Canon EOS 1D and 16–35 mm zoom, created that feeling. However, because the chief and his daughter were standing in the shadow of the hut's doorway, I knew I'd have to "rescue" them in the digital darkroom.

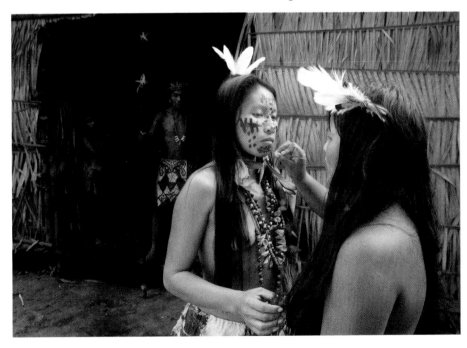

⟹ I could have used the Dodge tool to lighten those two members of the tribe, but it is less precise than Curves. I also could have selected the area and used Curves, but I wanted more flexibility. Here's what I did.

First, I made a duplicate, identical layer. I chose the lower layer, then went to Curves and pulled up the RGB Curve until I could see the chief and his daughter. We can see that the girls in the foreground are now overexposed. That's not a problem.

⟹ Next, I went back to the top layer (where the foreground girls were properly exposed) and used the Eraser tool to erase the too-dark chief, his daughter, and some of the interior of the hut. The white area of the scene is what we'll see if we turn off the lower layer (by clicking on the Eye icon for that layer in the Layers palette). This is a good technique for seeing what we have erased—and what we might have missed.

⟹ My digital darkroom fun brought out a "brighter" chief and daughter from the lower layer.

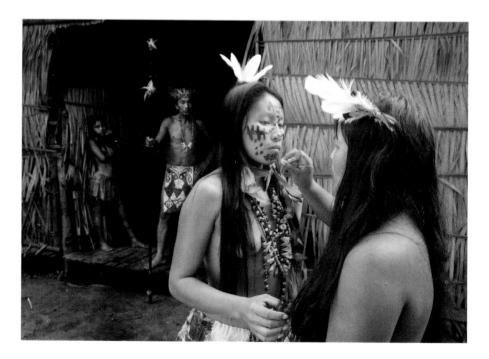

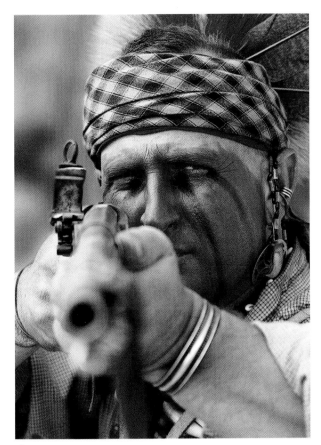

⇑ So I made a duplicate layer, then I went to the bottom layer and pulled down its RGB Curve, making the rifle and the man's hands darker. Then I went back to the top layer and began erasing the area I wanted darker: the man's hands and the rifle. Because I had turned off the bottom layer, I could see exactly what I was doing.

⇑ You can also use the Layers rescuing technique to tone down areas of a scene that are too light—the opposite of what we just did. In this picture of a Seminole Indian, taken with my Canon ESO 1D and 100–400 mm lens set at 200 mm, I like the dramatic effect of the man pointing the rifle directly at the camera, but I think the area around the rifle is too light.

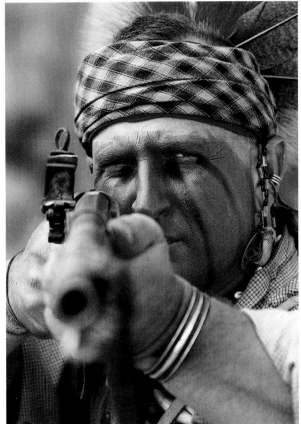

⇒ Now that the man's hands and rifle are darker, your eye goes more easily to the real subject of the picture: the man's face.

"Art is a line that makes us realize the truth."

—Pablo Picasso

Rescue Image Color

Turn bad shooting conditions around.

Rescuing (or restoring) color is relatively easy to do in Photoshop, if you know a few tricks of the trade—which I'm happy to share with you.

While teaching a photo workshop for *Popular Photography* magazine in the Ft. Worth (Texas) Stockyards, I spotted a cowboy and his horse standing in the parking lot in front of a setting sun. Interestingly, most of the workshop participants had headed for the restaurant, because they did not see the possibilities that this scene offered; only a few stayed with me for the shoot.

Here's what I did to get the shot:

⇊ In situations like this, simply shooting on automatic may result in a sunset picture in which the sky is too light. I put my camera on Program mode but took exposures at -1 and -2 stops under the recommended exposure setting. That way, the sky would not be overexposed. (By the way, that's standard advice for photographing sunsets: shoot on automatic and underexpose a stop or two.)

I was teaching, so I had to shoot quickly, because I also wanted my students to get the shot. Well, as you can see, my picture looks rather boring, not to mention all the "dead space" on the left side of the frame.

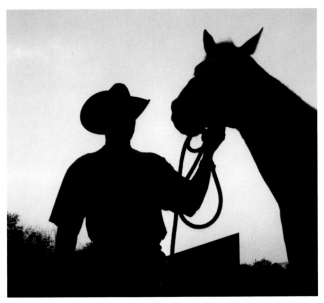

⇑ Cropping may enhance a picture. Look how it helped in this case.

⇑ To "pull out" the color, I went to **Image > Adjustments > Curves** and pulled the RGB Curve down until I was happy with the darker color.

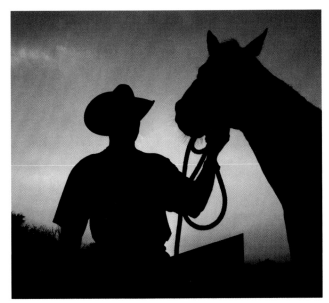

⇑ Here is the greatly improved image that resulted.

⇑ But I wanted more—more color. So, I went to **Image > Adjustments > Color Balance** and boosted the blues by moving the Blue slider to the right.

⇑ Compare the resulting image to my original. The difference is quite vivid, and the whole process took only a few minutes.

⇑ I made two final changes. I did not like the weird shape of the barn in the background. It looked too modern. So, I drew a triangle next to the roof with the Polygonal Lasso and filled it in with black by going to **Edit > Fill** and using the Foreground Color black. Instantly, a new roof line. Finally, I cropped the image to a square shape.

⇐ I'm sure you've heard the expression "Necessity is the mother of invention." Well, after I took this picture of a macaw in Brazil, I needed help to rescue the color. I saw the bird when I had just come out of my air-conditioned room. I quickly raised my Canon EOS 1D and set my 100–400 mm lens to 400 mm. Because the humidity was near 100 percent, my lens fogged. I shot anyway, figuring I could fix up the shot back at home in my digital darkroom.

 The fogging caused a loss in detail and contrast. So I went to **Image > Adjustments > Brightness/Contrast** and boosted the contrast until the picture looked good. As a final modification, I sharpened the picture using nik Sharpener Pro! (discussed in Lesson 63, "A Tour of Plug-Ins").

⇑ Ah, that's much better. Keep this defogging trick in mind the next time you go on a tropical vacation.

"If an army of monkeys were strumming on typewriters, they might write all the books in the British Museum." —Sir Arthur Eddington

LESSON 69

Add Text to Your Photographs

The creative possibilities with text are limitless.

We can have lots of fun in Photoshop using the Type tool to add words to our pictures. We can make dummy magazine covers (as I did for this chapter), personal greeting cards, or flyers and posters.

As with other Photoshop tools, the creative possibilities are limitless. Type can be almost any font, size, color, and shape. We can place it anywhere in the picture. If we don't like what we see, that's not a problem. Type is placed automatically on an individual layer so we can go back and make changes to everything about the type on that layer! However, once we flatten the layers, the text is permanently embedded in the picture.

Before working with type in the digital darkroom, remember this very important tip: Never work with your original. If you do, you may make a mistake on a precious picture. To avoid that, work only with a copy of your original. I can't stress that enough.

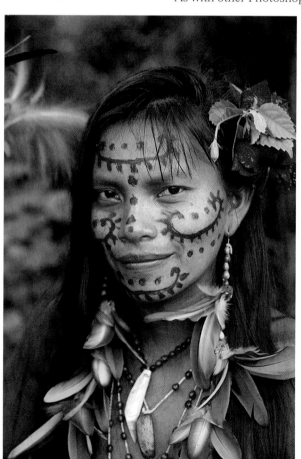

⇐ For my "cover" shot, I started with a copy of a picture that I had taken with a magazine cover in mind—which is why I had left the extra space at the top of the frame in the first place. (Leaving room for a publication's banner is a good idea, if you are interested in getting your work published.)

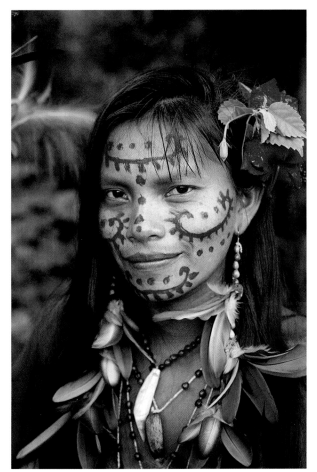

⇐ Look closely at the woman's face in this picture. It seems to glow more so that it does in the first photograph. That's an illusion. Actually, the edges of the frame are darker. I made them darker with the Burn tool for two reasons. First, the bottom of the frame had to be darker if I wanted my type to stand out against the bright areas of the picture (the light-colored feathers). See how much darker that area is? Second, most pictures look better when the edges are darkened, which makes the main subject in the center stand out.

⇑ Now it is time to add the type. After clicking on the Type tool in the Tool Bar, I moved my cursor over the picture and typed "FACE to FACE." Simply typing in Photoshop automatically creates a new layer.

I chose Times as my font from the Type menus in the Options bar, and played around with the font size until I found a good size. White was the default color, indicated by the color white in the Default Foreground and Background Colors box on the Tool Bar.

I then typed "Brazil" in the lower-right corner of the frame. Another new layer was created.

As you can see by looking at the Layers palette (which I activated by going to **Window > Layers**), I now had three layers (the picture layer and two type layers). Using the Move tool, I fine-tuned the position of each layer of type in the frame after clicking on the respective layers in which the type was created.

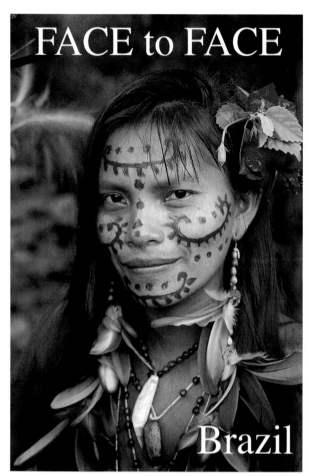

⇑ Here is my finished cover image, complete with type. My cover, however, was not as finished as I thought.

⇒ Next, using the Rectangular Marquee option on the Marquee tool, I selected the actual picture area. Then I went to **Select > Inverse**, which selected the area outside of my picture (the white area). Next I clicked on the Eyedropper tool on the Tool Bar and then clicked on a light area of the woman's face, which made that color my foreground (selected) color. Lastly, I went to **Edit > Fill** and chose the Foreground Color, which filled the white area with the color I had selected. Finally, I thought, my cover was finished! Well, not quite.

⇑ Using **Image > Canvas Size**, I increased the canvas size by 1/2 inch around the entire picture. You increase the canvas size by typing in new numbers in the New Size windows within the Canvas dialog box (see Lesson 48, "Increase the Canvas Size").

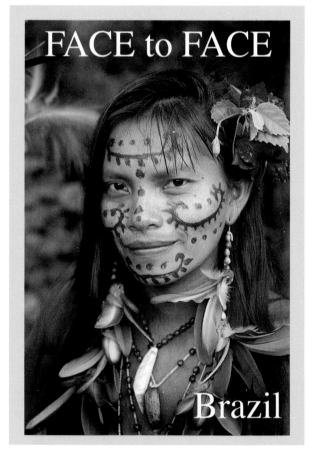

In Photoshop, we are never really finished, because, as I said, the possibilities are endless. So, I thought about changing the type—not only the color, but the words. So I started over, removing the border and type layers. (Things like this happen as we get more and more into the digital darkroom.) After I typed in my new words, I went to the Options bar at the very top of my screen. That gave me more options for color, size, alignment (left, right, centered), etc. I thought green type would be appropriate for this rain forest image, so I selected a shade of green from the Color Picker menu.

Here's the image I like most after trying many different colors and fonts and on and on! When I was done, I saved my picture as a new file called "Final Cover."

Now it's your turn! Have fun typing!

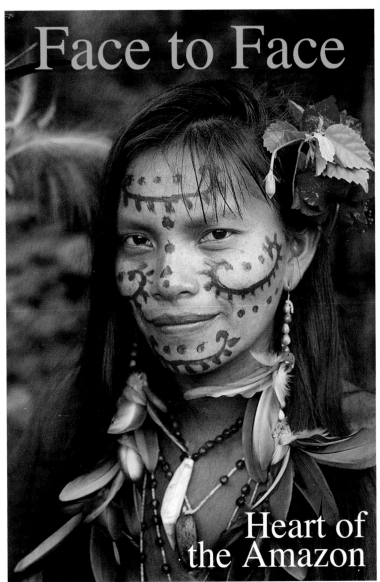

"With all art expression, when something is seen, it is a vivid experience, sudden, compelling and inevitable." —ANSEL ADAMS

LESSON 70 Awaken the Artist Within

. . . while sitting at your computer and using Photoshop.

With the development of the camera, people like me who cannot draw or paint could become artists. Back then, the little black box with film inside made it possible for anyone to express his or her creativity.

Today, Photoshop and other digital-imaging programs offer endless creative possibilities for photographers to expand their visions further than ever before with a few clicks of a mouse and, of course, time.

This lesson is not a step-by-step like many of the others in this book. It is just designed to share some ideas—the most important of which is that you can awaken the artist within you while sitting at your computer and using Photoshop.

Now, I would not be surprised if every reader of this book does not like all the effects in this lesson. And, I'm sure there will be some who don't even like the subject matter in the photograph I choose. But that's what art is all about—liking what you like, and creating images that please *you*.

So here are some variations on a theme, if you will. The scene is a small hotel in Miami Beach. The model is a friend from Brazil.

⇐ Straight shot in very low light. Canon EOS 1D, ISO 400, 16–35 mm zoom lens set at 24 mm.

⇐ By slightly desaturating the image (**Image > Adjustments > Hue/Saturation**), I made the scene look a bit softer.

⇒ To create this grainy, glowing effect, I applied Photoshop's Diffuse Glow filter (**Filter > Distort > Diffuse Glow**).

⇐ Jill Enfield has inspired me with her beautiful and often moving infrared pictures. In Photoshop, we can create a similar effect by changing a color picture into black and white (**Image > Mode > Grayscale**) and then applying the Diffused Glow filter.

⇒ The painting on the wall reminded me of a fresco, so I tried the Fresco filter (**Filter > Artistic > Fresco**) and liked the effect.

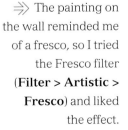

This is one effect that is not my favorite, but I'm showing it to you anyway. This stark black-and-white image was created by using the Threshold effect (**Image > Adjustments > Threshold**). Try this effect on pictures that have distinct highlight and shadow areas and you may get an image that looks like a black-and-white drawing.

I encourage all Photoshop users to try fading (**Edit > Fade**) a filter or effect to produce even more effects—virtually a limitless number. To create this dreamy scene, I faded the Threshold effect (**Edit > Fade > Fade Threshold**) after I had applied the Threshold effect. As a final touch to this image, I applied Vignette which is available in Photoshop's Actions palette.

Here is a close-up of my friend. I desaturated the image almost to the point where it became a black-and-white image. Then I put a frame around the image with a Photoshop-compatible plug-in called Extensis PhotoFrame (see Lesson 63, "A Tour of Plug-Ins").

See the Extensis PhotoFrame samples on the enclosed CD-ROM.

LESSON 71 | Simple Artistic Techniques

Add an artistic flair to your pictures.

In the previous lesson, we looked at a few ways to awaken the artist within, which I do believe lives in each of us. In this lesson, I'd like to share just few more simple techniques that can add an artistic flair to your pictures.

⇐ I took this simple picture on the sand dunes on Cape Cod, Massachusetts. It's not terribly exciting, but I took it with a more artistic image in mind. (Photoshop has changed the way I, and many of my photographer friends, take pictures.)

⇑ To create a more artistic image, one with a softer touch and a lot more grain, I applied the Monday Morning Sepia filter in the nik Color Efex Pro! Photoshop plug-in (see Lesson 63, "A Tour of Plug-Ins").

⇑ While I was on Cape Cod, I admired the pictures of a local artist who used a pinhole camera to document the landscapes. With some pinhole cameras, the edges of photos come out darker than the center area of the picture. To create that effect in Photoshop, I used the **Burn** tool, found on the Tool Bar, to darken the border of my picture. The darkened edges, combined with the soft-focus effect of the Monday Morning filter and added grain, is pretty close to the effect you'd get with some pinhole cameras.

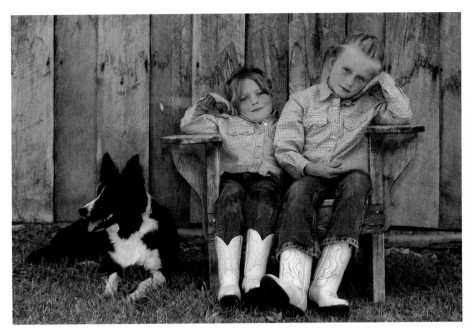

⇑ This is a set-up shot, taken on a ranch in Montana. It was set up in that I asked the girls to sit together in the chair, which I moved from the bright sunlight into the shade for a more pleasing lighting effect. I took more than 50 pictures of these girls to capture just the expressions I wanted.

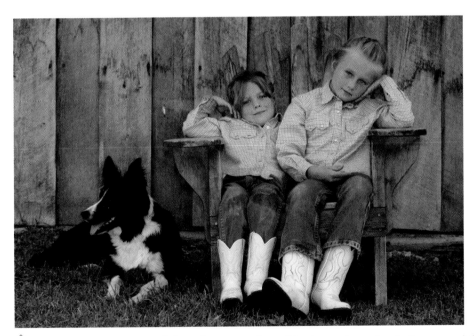

⇑ In this version, I reduced the color saturation of the image by going to **Image > Adjustments > Hue/Saturation** and then using the Saturation slider to slightly desaturate the image. I used the same technique earlier in this book, but I share it again here because I like to stress to all my photo workshop students that less is sometimes better than more (more saturation in this case). With less color saturation, the picture takes on a more artistic quality.

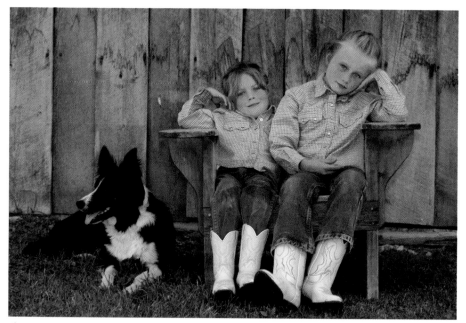

⇑ This next version illustrates an artistic technique that has become popular in recent years: removing the color from the area that is surrounding the main subject.

⇒ In Photoshop, an easy way to do that is to use the **Sponge** tool, found on the Tool Bar in the same box with the Dodge and Burn tools. When you activate the Sponge tool, you have the option to Saturate or Desaturate the area you "sponge over," using your mouse or WACOM table pen as a paintbrush. You make that selection at the top of the screen in the Mode window. Next to the Mode window is the Flow window. That's where you control the pressure of the tool in use—the Sponge in this case. At 100%, the tool is used to its maximum potential. At say 10%, the tool's effectiveness is greatly reduced. So, if you want to quickly desaturate part of an image, you'd set the Flow to 100%—which is what I did, because I wanted to remove all the color from the surrounding area.

Experiment with Flow for different creative effects. It's fun and, naturally, creative.

> *"Satisfaction lies in the effort, not the attainment. Full effort is full victory."*
> —MAHATMA GANDHI

LESSON 72

Frame with Photoshop Actions

A frame should complement your photo in some way.

In Lesson 63, we saw how you can add digital frames to your pictures using Photoshop plug-ins. But there are also frames available in Photoshop's Actions (found by going to **Window > Actions**).

Actions, as we saw in Lesson 64, are a series of steps that are automatically activated at the click or a few clicks of a mouse. (Some Actions require that you click the OK button as you go through individual steps.) They can save use a lot of time when creating special effects.

To "play" an Action, we first need to click on it. Then we click on the Play icon at the bottom of the Actions palette, indicated by a yellow arrow in the first screen shot for this lesson. If we place the Actions palette in Button Mode (select **Actions > Button Mode** from the palette's own menu), all we need to do to play it is click on that Action's button.

⇐ For this lesson, I'll use a picture of a macaw that I photographed deep within the rain forest of Costa Rica. Well, not really. The macaw was photographed in the lobby of a hotel in Costa Rica. Luckily, upon checking in late at night, I had my camera. (Always have your camera handy and be ready to shoot. You never know when a good picture opportunity will arise.)

⇒ When you go to Actions, you'll see a list of **Default Actions**, which I have highlighted in red for easy identification. (You will not see red on your screen.) Under Default Actions, you'll find a Wood Frame, which I have highlighted in yellow. For more frames, like those highlighted in light red, you need to use other Actions that come with Photoshop 7, but are not preloaded.

⇑ Loading Actions is easy. Click on the little arrow at the top right of the Actions palette, shown by my yellow arrow in this screen shot. After you click on the arrow, click on Load Actions. That will load your selected Actions. Once this is done you will see Frames among other newly loaded Actions.

⇐ Here is what my macaw picture looks like with a Brushed Aluminum Frame, automatically added with Actions.

⇑ Check out this screen shot of the History palette from the just-completed Action. As you will see, it took 19 individual steps for Photoshop to create the Brushed Aluminum Frame. Imagine how long it would take us to do that manually.

Here are two more examples of Photoshop's Action frames.

Have fun framing your photos! Keep in mind that the frame should complement your picture in some way.

Photo Corners.

Wood Frame.

"If you chase two rabbits, both will escape."
—CHINESE PROVERB

LESSON 73 | Too Much of a Good Thing?

Don't overdo it. When working in Photoshop or any digital-imaging program, it's easy to become enamored of special effects and use too many, or use an effect that is too intense or too dramatic.

Less is sometimes best. Notice I said "sometimes." Sure, I go wild with effects, too, when I think they are appropriate or to demonstrate a particular technique. In other words, subtle changes and softer enhancements are often the best way to improve a picture, as you have seen throughout the preceding lessons. Here are just two examples of how a more subtle effect is more pleasing than a very dramatic effect.

⇐ I took this shot of a silhouetted palm tree with Kodak's Kodachrome 64 while walking on the beach one morning in Fiji.

⇑ Here is a posterized image of the Fiji beach scene, created by going to **Image > Adjustments > Posterize**. Sure it looks cool, but in my opinion, the effect is too intense and too unnatural.

⇒ Here are two softer versions of my palm tree scene. Both were created by going to **Filter > Sketch > Note Paper**. The black-and-white picture was created with the default colors selected in Photoshop. The aqua-and-white picture was created by going to **Window > Swatches** and choosing that specific color from the Swatches palette. The tip here is to play around with different colors when using the Note Paper filter, as well as other filters where color makes a difference.

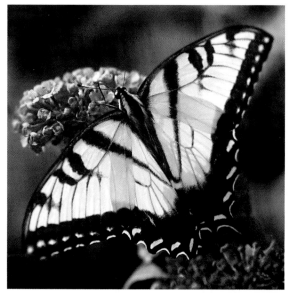

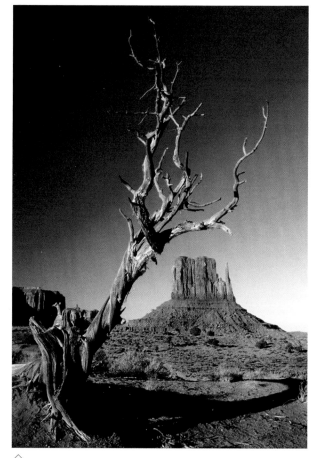

⇑ I shot this tiger swallowtail butterfly in my backyard with my 4-megapixel pro digital SLR. I like the straight shot. Look what happens when the Pop Art filter in nik Color Efex Pro! is applied. Too far out for me! And now, for something complete different, as the writers of the 1970s television show *Monty Python's Flying Circus* would say, I applied the Pop Art filter only to the butterfly. Again, pretty far out, but I am using these images to illustrate a point—less is more.

⇑ I shot this scene with Kodak's Kodachrome 64 while on a trip to Monument Valley, Arizona.

⇐ Maybe this scene would look nice if I had been on Mars, but, the nik Color Efex Pro! Infrared filter is a bit too much for this nice landscape scene.

⇒ Of all the filters and effects I experimented with on my Monument Valley picture, I like the Old Photo filter in nik Color Efex Pro! the best.

So please keep in mind: You can have too much of a good thing. Don't overdo it!

Now that we have covered basic Photoshop editing, in the next section, Part VI, we will cover special effects and techniques.

PART VI

SPECIAL DIGITAL EFFECTS AND TECHNIQUES

This section includes, as the title implies, some totally cool effects you can create in Photoshop. Check them out. Have fun. Try them with your own pictures.

Some of the effects may change the way you take pictures. They have for me: I now take pictures that I would not have taken before Photoshop.

⇐ For example, I took this documentary picture of a "Red Devil" bus in Panama, knowing that I would transform the picture in Photoshop using the Motion Blur filter (covered in Lesson 74, "Add Action to Still Photos").

⇑ To give the picture even more impact, I used the Crop tool and rotated the image, as discussed in the introduction to Part V, "Working and Playing in Photoshop."

"Never mistake motion for action." —ERNEST HEMINGWAY

Add Action to Still Photos

Convey movement in your still pictures.

I shoot still pictures. Sure, video is cool, but I like to capture individual frozen moments in time. However, I often like to convey the action and the grace of a moving subject in my still pictures.

Before the advent of fast computers and digital image-enhancement programs, I used several techniques to simulate the feeling of motion in a scene. These included panning during an exposure (see Lesson 14, "Pan to Create Motion") and shooting at a slow shutter speed when using a flash. Both techniques still work very well.

But today, I seldom use these techniques. Why? Because achieving similar results in the digital darkroom is easier: I don't have to make any calculations in the field, especially when it comes to mixing daylight with the light from my flash. What's more, I have complete control of how the picture turns out!

Want to see just how easy it is to create a sense of speed in your pictures? Read on!

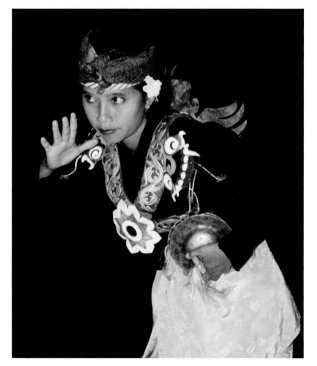

⇐ I photographed this dancer in Lombok, Indonesia, during a nighttime performance at a hotel. I set my film camera to Program mode and shot. I got a good exposure because I followed the rule of "filling the frame with the subject" when shooting on flash pictures on Program or any automatic mode. The expression "the name of the game is to fill the frame" will help you remember this technique. If you don't fill the frame, the flash system may try to light the background, too! That results in an overexposed subject.

After scanning the original slide into Photoshop, I made a duplicate layer by going to **Layer > Duplicate Layer**. Now I had two identical images, one on top of the other.

⇒ Next I applied the **Motion Blur** filter to the top layer by going to **Filter > Blur > Motion Blur**. Using this filter we can control the angle and intensity or number of pixels affected by the blur. As you can see, the top layer is now totally blurred; the bottom layer (hidden in this image because it is underneath the top layer) is still sharp.

⇑ Using the Eraser tool on the top layer (the blurred image) I began to erase the blurred area on the dancer's body—starting at the center and working toward the edges of her body. To create a smooth transition from a sharp middle to blurred edges, I adjusted the pressure (opacity) of the Eraser tool as I moved from the center of the subject outward. In the center of the subject, for example, I set the Eraser at 100% opacity—because I wanted her most important features to be a 100% sharp. By the time I got to the edges of her body, my Eraser was set to

5% opacity. Had I left the Eraser at 100% opacity, the transition from sharp to blur would have been too stark and would not have looked natural.

To ensure that I erased the blur effect on all of the parts of the dancer that I wanted sharp, I switched off the bottom (sharp) layer by clicking off the Eye icon on that particular layer in my Layers palette. With only the top layer active (visible), it was easy to see what parts of the image I was missing, and what parts of the frame needed more erasing.

⇒ To enhance the scene even more, and to take up some of the "dead space" in the photograph, I used the **Lens Flare** filter (found in **Filter > Render > Lens Flare**, which, when the point of light is placed in a dark area, can produce a spotlight effect.

Have a keen eye? Look closely at the final image and you'll see that I brightened the whites of the dancer's eyes just a bit using the **Dodge** tool. Fashion

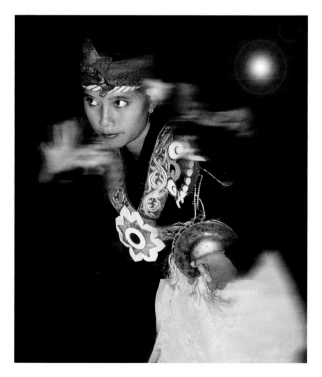

photographers often use this technique to give their models a more youthful look. Also, you may notice that this picture looks slightly sharper than my original. That's because I sharpened it using nik Sharpener Pro!, a Photoshop plug-in that is much easier to use than using the Sharpen filters found in Photoshop at **Filter > Sharpen**. That's because Sharpener Pro! allows us to sharpen for specific media (inkjet or laser printer, printing in a book or magazine, or publishing on the Web) and for actual viewing distance.

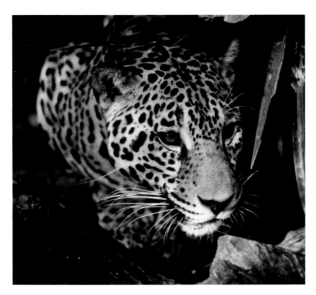

We can also create a sense of speed and motion in wildlife pictures. I used the same effect as above on a photo I took of a jaguar at the Belize Zoo. Applying the speed effect produced a more dramatic picture. In the screen shot you can see how I selected the angle (from about 10 o'clock to 4 o'clock on the circular dial) as well as the intensity of the blur (pixel distance).

Look closely at the eyes in both images. The eyes in my enhanced image are brighter and sharper. I selected the eyes using the **Elliptical Marquee** tool, then used **Image > Adjustments > Curves** to lighten the eyes, and **Image > Adjustments > Brightness/Contrast** to make the eyes more vibrant in the image.

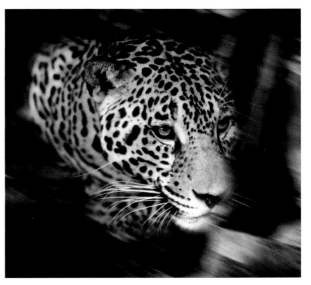

You may wonder why the screen background is blue in the screen shot of the dancer and gray in the screen shot of the jaguar. The reason: I created the dancer image early in my Photoshopping days—before I found out that the best way to work in Photoshop is with a gray screen. Screen color affects how you see a picture on your monitor. Neutral gray is better as a background.

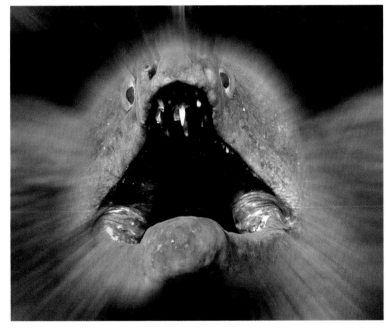

← Let's take a look at another way to add action and excitement to a photograph. Go to **Filter > Blur > Radial Blur** and click the Zoom button in the dialog box that opens. We can move the focal point of the zoom with our mouse. This filter simulates a technique that photographers used before Photoshop was invented: zooming out during a long exposure when a camera is mounted on a tripod.

Following the same layering and erasing technique that was used on the dancer and the jaguar, I used the Radial Blur filter to create a picture I call "Attack!" Don't worry, green moray eels are relatively harmless; they just look threatening because they are always opening and closing their mouth—something they have to do to breathe because their gills are located in their throats.

Okay, get moving—with your pictures, anyway!

Create the Magical Mirror Effect

LESSON 75

. . . for beautiful reflections or "lucky" nature shots.

"It's all done with mirrors" is a popular saying among professional magicians. Well, these days, digital photography artists are using mirrors, of sorts, to create magical effects on their computer monitors. Basically, a mirror image is one in which one side of a frame is perfectly mirrored (reflected) on the opposite side of the frame—side to side or top to bottom. Here's how to do it.

STOP! If you are reading this article while sipping coffee at the kitchen table or relaxing on the couch, stop! You really need to follow these steps while sitting at your computer.

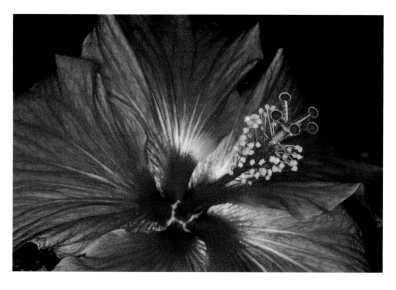

⇐ Start with a picture. Actually, you have to start with a vision—an idea of how a picture or section of a picture will look mirrored against itself. I started with a close-up photo of a hibiscus, taken with my 50 mm macro lens and a ringlight (a flash unit that fits over a lens specifically designed for close-up photography). I admit it's not the most artistic picture, but I pulled it from my stock file just for this lesson.

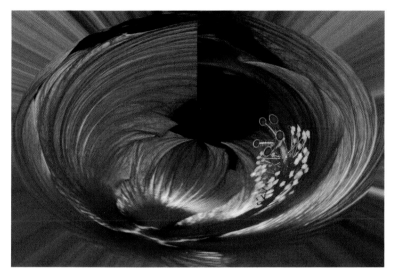

⇐ You can skip this step. I'm including it just to show you a unique Photoshop filter. To create this image from my hibiscus photo, I used Photoshop's Rectangular to Polar filter (**Filter > Distort > Polar Coordinates > Rectangular to Polar**). The filter bends and distorts a picture in an unusual way. I used this distortion filter because I wanted a circular flower to crop and mirror below.

⇒ Select the area of the picture to be mirrored or copied and reversed. I chose only half the frame of my polar coordinates pictures, but you can use the entire image area, too. I selected an area using the Marquee tool, which is located on the Tool Bar.

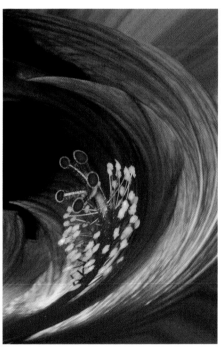

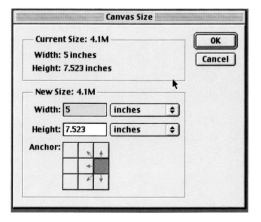

⇐ The next step is to increase canvas size, which will become the new working area. We can increase the canvas area in any direction by clicking on the different "direction" boxes in the tic-tac-toe grid. (See Lesson 48, "Increase the Canvas Size.") For this exercise, we need to double our original image area in order to create the mirror effect. In this example, I chose the middle right box and doubled my image width by typing the new size in the Width window. My canvas was now doubled to the left of my selection.

The entire canvas area is now shown: My picture is on the right and the empty area of the canvas (white area) is on the left. Now, copy the existing picture area by selecting it (using the **Marquee** tool on the Tool Bar). Then click on **Edit > Copy**. Go to **File > New**, and we'll see that a new document is created that's *exactly* the size of our copied image. Now click **Edit > Paste**. Go to **Image > Rotate Canvas > Flip Canvas Horizontal**. We now have a reversed image of our original. Cool, don't you think?

⟹ We are getting close! Use the **Move** tool (on the Tool Bar) and drag our new flipped image into the blank area of our expanded canvas. (If that does not work, it means our layer is locked and can't be moved. In that case, we need to rename the layer. To do that, double-click on the *highlighted* Background Layer Window in the Layers palette. Another window will pop up that lets us rename the layer.) Carefully align the images so they look perfectly mirrored. That's it!

Keen-eyed readers will see that I used the Clone Stamp tool, found on the Tool Bar, to fill in two small black areas of the image, which, for some reason, I thought detracted from the impact of my mirror image.

⟹ Here is another example of the magical mirror effect. I photographed this lone butterfly at Butterfly World in Coconut Creek, Florida, again using a macro lens and ringlight. To create the mirror effect, I followed the steps outlined above. I call it, "Where Butterflies Go at Night." I created the "moon" near the top of the frame by selecting one of the "eyes" on the butterfly's wing (using the Elliptical

Marquee tool), copying it (**Edit > Copy**), and then pasting it into the image (**Edit > Paste**). Pasting the "eye" automatically created a new layer. Using the Move tool, I can position the "eye" anywhere I want in the scene.

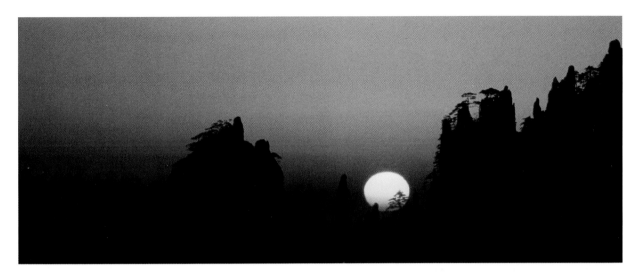

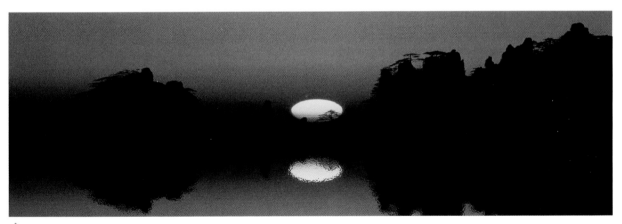

⇑ We can also use the magical mirror effect to create beautiful reflections. Rather than increase the canvas size horizontally, I simply increased it vertically to make space for a reflection. Here's what I did with a photograph I took at sunrise in a remote area of China (where there was no lake). I used my 70–200 mm zoom set at 200 mm. In Photoshop, I cropped the photo. Then I copied the photo and flipped it vertically (**Image > Rotate Canvas > Flip Canvas Vertical**). Because I knew I wanted to create a ripple in the imaginary lake, I add the Ocean Ripple filter (**Filter > Distort > Ocean Ripple**). Then I increased the canvas size vertically (**Image > Canvas Size**). Finally, I dragged my flipped image into my original file and lined up the two images.

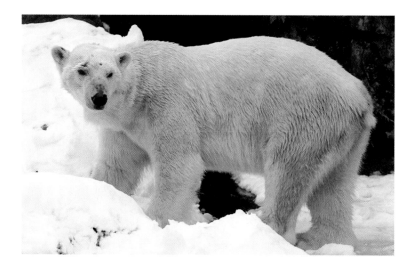

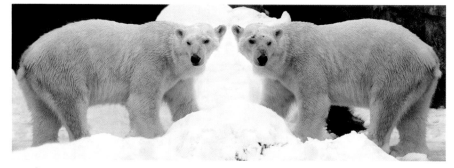

⇑ I photographed this polar bear at New York's Bronx Zoo with my Canon EOS 1D and 100–400 mm IS lens set at about 300 mm. After creating a traditional mirror effect using the aforementioned techniques, I wanted to see if I could create an image that did not look like a perfect mirror image—one that would look like a lucky wildlife photo (knowing that I would never try to pass it off as a straight shot).

Here are the changes I made to create the "non-mirror" animal on the left:

1) I cloned areas of snow to hide some of the water and the background (see Lesson 45, "Try Easy Tools First");
2) I cloned clean areas of fur on the animal's face and used them to cover some of the dark spots;
3) I used the Liquify tool (see Lesson 76, "Liquify Reality") on the animal's back and stomach to make the animal on the left look skinnier than the animal on the right;
4) I also used the Liquify tool on the left-hand animal's face, making it look thinner.

Okay, your turn. Have fun with mirrors!

⇑ Here, my favorite model, Karen Trella, is standing on what looks like a rock in the middle of a lake. Actually, when I photographed her, she was surrounded by sand.

LESSON 76 Liquify Reality

Create surrealistic images.

Salvador Dali was known for creating fanciful paintings in which the objects in a scene looked distorted or stretched or even melted. In Photoshop, the Liquify tool can help you create images with a Dali-esque, surrealistic touch.

⟪ To show you the before-and-after effect, I'll use a picture I took of a lifeguard stand in Miami Beach.

⟪ When we open an image and choose **Filter > Liquify**, the Liquify dialog box opens. Here we will find several tools to manipulate a picture, but we can have fun and be creative even with just one——the **Warp** brush. It is immediately available as the default tool when you open the filter, and is a good one to start with. We select the brush size on the right side of the screen and then start "painting" over our picture. As we move

the Warp brush over an area, it starts to melt, or distort. Let your mind run free. Don't be locked in to conventional ideas. Have fun! When you are satisfied with your image, click OK and your artistry will be applied to your picture.

⇒ Here is the result of my playing around with the Liquify tool. I wonder if Salvador Dali would like it?

Here's an idea: Turn this page upside down. If I had not distorted the image so grossly, the image might look like a reflection. You may want to keep that in mind when thinking about creating images with reflections, as we learned to do in Lesson 75.

The Liquify tool can be used to alter reality in very subtle ways, too. Here is one example, using a technique that fashion photography retouchers have used for years, but which is much easier to accomplish with Photoshop. I learned this technique from my friend Julieanne Kost.

⇒ Here is a straight shot of my friend Kirsten, photographed in the warm light of late afternoon. We were both watching my son's lacrosse game. I mention that to illustrate that it's important to always carry a camera. You never know when you might get a nice picture.

In Liquify, I made Kirsten's waist and her arms ever so slightly thinner. Compare the upper parts of her arms in both pictures. I moved the brush inward on her waist and the lower parts of her arms.

Here is the retouched picture. You may have to look closely to see the difference, but Kirsten spotted the results immediately. She was very good-natured about my Photoshop fun.

> *"Vertical columns, such as those found in Greek and Roman temples, look parallel from the ground because they are wider at the top than at the bottom."*
>
> —JOANNE KEMP

LESSON 77 Control Perspective

Fix perspective problems the cheap and easy way.

It's a fact: When we take a picture of a tall building with a wide-angle lens from a relatively close distance, the building will look like it is falling over backward. To avoid this, for about $1,500 we can buy what's called a Perspective Control (PC) lens that helps correct that effect in the camera. We could also spend a few thousand dollars on a nice view camera, which uses tilts and swings to correct the "falling over backward" effect.

But save your money! With the Transform tool in Photoshop, we can correct the problem in a few minutes with a few clicks of the mouse and have some extra cash to buy more ink and paper and other digital darkroom supplies.

⇐ I used this technique on a picture I took of a church in Ponce, Puerto Rico, with my 24 mm lens.

| **Try Edit > Transform > Perspective.**

◀━ After opening my picture, I used the Rectangular Marquee tool to select the entire image. Then I went to **Edit > Transform > Perspective** and pulled the top anchor point (the little square boxes that appear when Transform is selected) at the left side of the frame outward. (I could have pulled the anchor point at the opposite side of the frame with the same effect.) I played around with how much I pulled out the frame to get just the degree of adjustment I wanted.

⟹ As you can see, the church here is not falling over backward as much as it was in my original. I agree that it's not a perfect adjustment, but it is greatly improved.

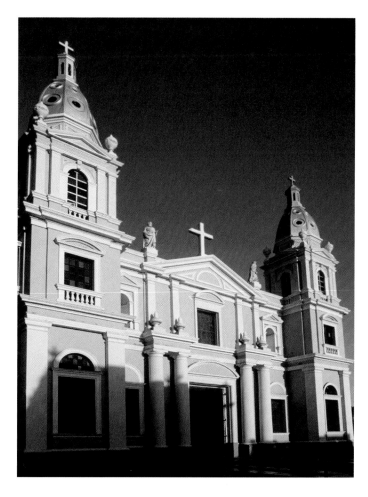

Before going on to the next paragraph, take a minute and look closely at the repaired image. I made some other adjustments. You may not see them at first, but take a close look. Can you see what I did? The stained-glass windows on the second floor of the church are now brighter and more colorful. That's because I selected them (using the **Magic Wand** tool) and boosted the contrast using **Image > Adjustments > Brightness/Contrast**. Then I made the windows more colorful by going to **Image > Adjustments > Hue/Saturation** and increasing the color saturation using the Saturation slider. This is a good example of the color, contrast, brightness, and saturation control you have over individuals areas in a scene.

⇐ I did not like all the empty sky as "dead space" above the church, so I went to **Filter > Render > Lens Flare** and added a "sun" in the sky, adjusting the intensity of the flare and its position to my liking.

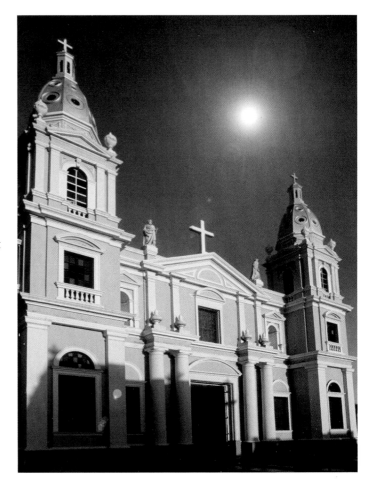

⇒ My final picture looks good, right? Well, when working in the digital darkroom, "It's not nice to fool Mother Nature." Given the shadows in the scene, the sun could not possibly be in that position. I included the sun just to illustrate that very point.

If you plan to use the perspective control technique, remember this tip: Don't shoot a building so tight that the edges of the building are butting up against the edge of the frame (as they are in my picture). Having extra room around your building will leave you more room to correct your picture.

*"Everything that is visible hides something
that is invisible."*
—RENÉ MAGRITTE

Create Drop Shadows

**Simple shadows
can greatly
enhance the image
of an object.**

Shadows add a sense of depth to pictures. Without shadows, the subject or subjects in a scene may look flat. One of the popular effects in Photoshop is to add a "drop shadow" to an object that's included in a montage of one or more image layers. (You can see an example of how I used this layering technique in Lesson 57, "Learn about Layers.") We can also use the drop-shadow effect to add a shadow to an isolated object in an image, which is what we will do in this lesson.

Here's the quickest way to create a drop shadow in Photoshop.

⇩ Start with an object that you can easily isolate. This silk rose (with fake water droplets) has already been "cut out" of its background. (See Lesson 60, "Extract a Subject from Its Background," for how to cut objects from their backgrounds.)

⇩ Open the file containing the object (the rose in this example). Then open the target file (the file filled with the solid color in this example). The target file is the file containing the picture in which you want to place your object with an added drop shadow. To make it easy for

you to see the drop shadow, I created a target file with a solid color. This screen shot shows both files open.

⇒ Next, select (cut out) *only* your object. In this example, I cut out the rose by selecting the white area using the **Magic Wand** tool, and then by going to **Select > Inverse**. Now only the rose in my file was selected. Then I went to **Edit > Cut**.

↘ Next, activate your target file by clicking anywhere in its frame. Then go to **Edit > Paste** Now your object is pasted into the new file, onto a new layer on top of the target file. (We could have also clicked and dragged the rose onto the colored background, which would have automatically created a new layer.)

⇓ Here comes the magic. Go to **Layer > Layer Style > Drop Shadow**. The Drop Shadow dialog box will pop up. You will see several controls for creating a perfectly matched drop shadow, including opacity, distance from the object, and size and spread of the shadow. Play around with these controls and then click OK. If you like what you see, save your picture. If you don't, experiment with the controls more until you are happy with the shadow created.

⇒ Here is what my rose looks like with a drop shadow added. Compare it to the rose in the screen shot against the plain background. The simple shadow greatly enhances the image.

Try Layer > Layer Style > Drop Shadow.

"Be careful what you pretend to be because you are what you pretend to be."
—KURT VONNEGUT

Design a Montage

A great place to use the Extract feature.

As a child, I liked to make **montages**—two or more images combined in one new picture. I used scissors to cut out subjects from pictures and glued them onto a "background" picture. You may be familiar with the work of Jerry Uelsmann, a master of black-and-white montages; his stunning images of elements of nature and people blend seamlessly with one another.

As a teenager, I made montages in the wet darkroom by exposing parts of different negatives onto one sheet of photographic paper. As an adult, I still like to make montages. Now I work in the digital darkroom, where it's easier and the creative possibilities are virtually limitless.

In this lesson I'd like to share with you two of my favorite digital photomontages. I'll take you through the process step by step.

But first, I have to tell you that Photoshop has changed the way I shoot. I often look for subjects and scenes for my montages that may not look that exciting by themselves, but that would be useful in a montage as a background or foreground.

Second, I like to have images of a subject against plain backgrounds so they can be easily isolated for pasting into a montage. Photographing common objects is the key here.

⇐ Such was the case with the two pictures—a calm sea and a lone fisherman walking on the beach—that I used to create this montage of the fisherman walking into the parted waves, which I call "Last Catch."

371

As always, I create my background first. In this case, it was a calm sea with a cloud-filled sky. Using the **Mirror** effect (described in Lesson 75, "Create the Magical Mirror Effect") I created an image that included a reflection (mirror) of the entire scene, because I wanted more water in the foreground. Then I cropped the clouds out of the lower portion of the scene. Next, I went to **Filter > Distort > Twirl** to stir up the waves. To be honest, I stumbled onto this effect; as you can see, it works well on these waves.

After I was pleased with the degree of twirl, I cropped out the left side of the picture. Then I used the mirror technique again, which resulted in an image in which the sea looks like it's parting. I added the "sun" to the picture by going to **Filter > Render > Lens Flare**, which lets you place the "flare" anywhere in the scene.

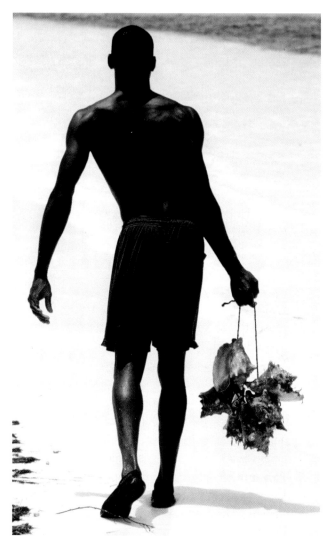

Now it was time to add my main subject: the fisherman, whom I had photographed in Barbados. First I needed to cut him out of his beach scene.

To see Jerry Uelsmann's montages, visit www.uelsmann.net.

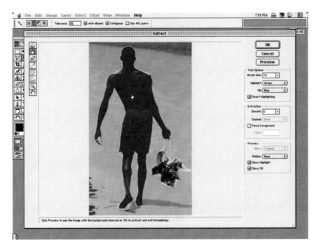

I could have selected him using other selection tools, such as the Magic Wand or a Lasso but that would have taken too much time. (When I work, I am often eager for speed!) Because there was a lot of contrast and color difference between the fisherman and the sea and sand, I used the **Extract** function, found under **Filter > Extract**. Basically, I traced the fisherman and his conch shells with the Edge Highlighter and filled my selection with the Fill tool.

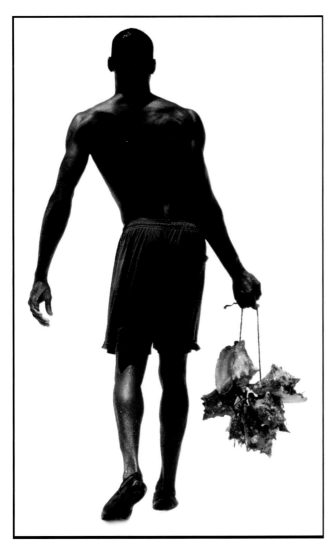

When I clicked OK, my fisherman was almost perfectly cut out. I did have to use the Eraser tool to "rub out" some of the sand areas closest to the fisherman's skin for a "clean cut." Then I used the Move tool to position the fisherman amid the waves.

Keen-eyed photographers will notice a difference between my original fisherman and my inserted fisherman. Look at him carefully. Did you see it? I used the Paintbrush tool to redraw the rope that the fisherman is using to hold the conchs together. The rope was lost when I made my selection.

⇑ Here is my second-favorite montage, which I call "Sky Diving." I combined color pictures I had taken of clouds, a whale shark (the largest fish in the sea), and a manta ray into a black-and-white image. Why black and white? I simply prefer it over the color version. I often view a color picture in grayscale to see which I prefer.

You'll notice that it actually looks as if the animals (placed on two seperate layers on top of the cloud [background] layer) are passing in front of and behind some of the clouds as they "swim" through the sky. After flattening the image I created that effect by using the Clone Stamp tool, setting the opacity at 30–40% and stamping over the animals with sections of neighboring clouds.

Play with the Opacity feature. It will give you an "X-ray" vision of sorts, enabling you to see through one layer into another.

"Not every light is true light. To the wise, the light of truth is light itself."

—TIRUVALLUVAR

Lighting Effects

Change the color, direction, and quality of light in the digital darkroom.

In Photoshop, we can change the quality and direction of light in a picture. We do that by going to **Filter > Render > Lighting Effects**.

Let's take a look.

⇓ I took this picture of a datura flower in my backyard on an overcast day. (While traveling in Nepal, I learned that some Nepalese consider this flower to have magical powers.) The light from an overcast sky produced an evenly exposed, soft picture.

⇓ When we open the **Lighting Effects** window, we see that there are many options for controlling light: Style (15 different types of lighting effects in addition to the Default Spotlight setting, the one selected for this illustration), Light Type, Properties, and Texture. We find even more options in the Preview window in the left-hand side of the window. That's where we can

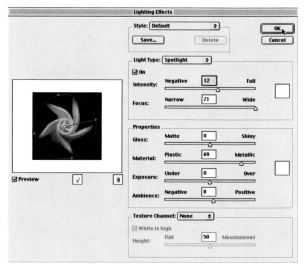

control the direction and intensity of the light by using the "handles" (in graphics programs, the little square boxes we can move around) on the oval or circle, depending on the type of light source we choose. Each handle point can be moved around or used to stretch the light source in the window.

An important word about the Lighting Effects window. This window and all its choices can be intimidating and confusing at first. So, even though it's tempting to take control of the light in one of your pictures, set aside a block of time to familiarize yourself with all of this filter's functions. Don't expect to master it on your first try, or even on your second or third. It may be one of the more complex features of Photoshop, but it is well worth the effort of learning how to use it. So, rather than actually working on a picture, you may just want to play around with all of the controls to see what they do.

Okay, back to work.

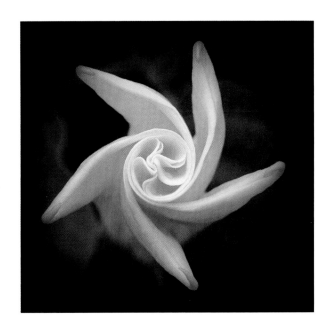

⇒ Because I chose Spotlight to light the flower from above, the background near the edge of the frame became much darker. That let the flower stand out more in the frame. (Ansel Adams used this technique of darkening the edges in many of his prints, although not to this degree. So did Renaissance painters.)

Lighting Effects also lets us change the color of the light.

⇒ By clicking on the Color box (indicated by the black arrow in this screen shot) we can select a color from the Color Picker window that pops up. I chose an ivory color.

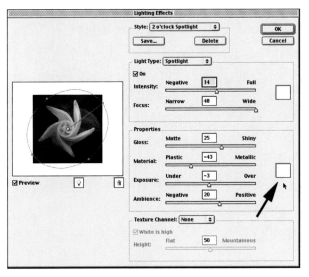

You'll see that I made another change as well. I changed the direction of light by choosing the 2 o'clock Spotlight, which is now showing in the Style pop-up menu at the top of the window. Again, we can control the exact direction of light using the five-pointed light controller. (The number of points, not necessarily handles, will vary based on the lighting style selected.)

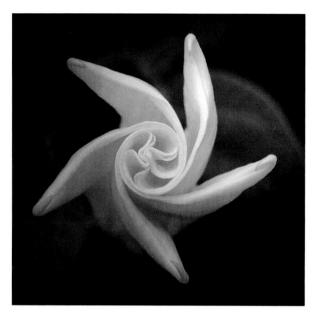

⇑ This image, the result of using the 2 o'clock spotlight and an ivory color, is my favorite in the series. But I'd like to show you a few more creative effects.

⇑ Here's what my datura flower picture looked like after I applied the Blue Omni Spotlight. To me, it looks like hand-blown blue glass illuminated from within.

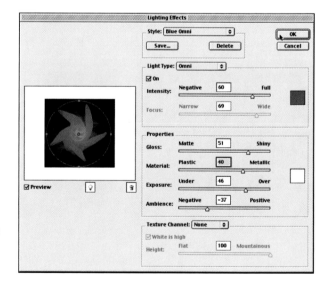

⇒ This screen shot shows the settings I used to create the dark-blue image of the datura.

The Xenofex plug-in is available from Alien Skin Software (www.alienskin.com).

⇚ As I always tell my workshop students, after you apply a filter or effect, try fading it by going to **Edit > Fade** to see if it improves the photograph. That's what I did to create this image, producing a brighter blue flower.

⇚ Always looking for other creative options, I played around a bit more with my soft blue datura picture. Here I applied the **Crumple** filter from a set of Photoshop plug-ins called Xenofex. As its name implies, the **Crumple** filter produces the look of a crumpled piece of paper. Even the edges of the frame are crumpled.

So when you take a picture, keep in mind that you can actually change the color, direction, and quality of light in the digital darkroom, and have a lot of fun doing it!

"Creative minds have always been known to survive
any kind of bad training."
— ANNA FREUD

LESSON 81 | Create Flyers and Posters

**It works
and it's fun!**

If you want to get your pictures published, one of your first steps is to get the attention of an art director or editor, who probably receives dozens of submissions from photographers each week.

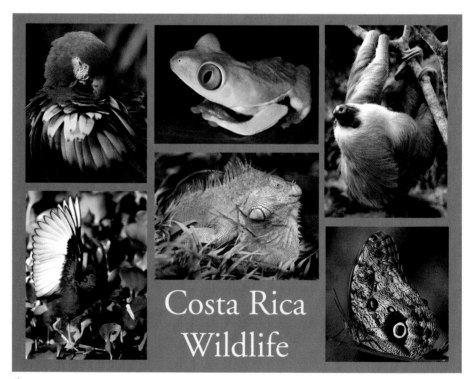

⇑ One way to draw extra attention to your work is to create a flyer or poster of your best pictures, and then submit it to the editor or art director with a professional cover letter. I've done that for years, and I still do, because it works and it's fun!

Creating flyers and posters is easy to do in Photoshop—or any program with Layers. Here is a step-by-step guide.

⇐ Start with your best pictures. For this lesson, I'll use six pictures I took in Costa Rica. This illustration shows my pictures on a contact sheet. (Creating contact sheets is covered in Lesson 100, "Automate Contact Sheets.")

⇒ The next step is to set up a new document that is the same size as your final flyer or poster. For this lesson, I chose to set up a document for an 8.5 × 11-inch flyer at 300 ppi (pixels per inch).

The ppi you select is *very* important. All the pictures used *must* be the same ppi in order to maintain proper image size. For example, if we place a 300 ppi, 3 × 3-inch picture in a 300 ppi, 8.5 × 11-inch document, it will take up 3 × 3 inches of space, because the resolution of both images is the same. However, if we place a 150 ppi, 3 × 3-inch picture in a 300 ppi, 8.5 × 11-inch document, it will be only 1.5 × 1.5 inches, because each pixel at 300 ppi (1/300 inch) is only half as large as a 150 ppi pixel (1/150 inch).

You can change resolution of your photos, as I had to do, by going to **Image > Image Size** and adjusting the ppi to match the desired output. (See Lesson 47, "Manage File Size and Image Size," for more information on changing picture size.)

Speaking of image size, as you move along in the process of creating your flyer or poster, you most likely will have to crop some of your pictures, as I had to. Do that before you place a picture in your flyer or poster, because cropping it with the Crop tool on the flyer or poster will crop out all of the surrounding area as well.

⇒⇒ We can also change image size (a photo's dimensions) by using the Transform tool. First, use the Rectangular Marquee tool and select your entire image. Then go to **Edit > Transform > Scale**. Then pick a corner anchor point; I picked the top left one. Move that point toward the opposite anchor point. This move will scale down your picture, as shown in this screen shot. To scale up a picture, you first have to increase the canvas size (see Lesson 48, "Increase the Canvas Size"), then you increase the image size using a corner anchor point.

⇒⇒ Next we need to create a new file—a background for our flyer or poster. I chose a dark green background to bring to mind the colors of the rain forest. I created the green background by going to **Window > Swatches** and then clicking on a dark green. Then I went to **Edit > Fill**, chose Fill with Foreground Color, and clicked OK. Now my document was filled with green.

⇒⇒ Now we are ready to drag and drop our pictures into the new green 8.5 × 11-inch document. If we cannot drag and drop a layer, that layer is locked, as indicated by a little lock next to the layer in the Layers palette. To unlock it, double-click on the layer in the Layers palette. A "New Layer" box appears. Rename the layer.

⇑ You can have fun placing your pictures in different areas of the document. You may need to flip some of them using **Image > Rotate Canvas > Flip Canvas Horizontal**. As you can see, I flipped my pictures of the sloth, butterfly, and macaw for this flyer, so that the subjects are not looking out of the document.

⇑ It does take some time to get all your pictures in the right position, with the right cropping. Try to use the Zen philosophy: Enjoy the process. To help you line up your images, go to **View > Show > Grid**. A grid will appear on your document that will help you align your pictures. You can turn off the grid again by going to **View > Show > Grid** again. This grid will not print with your image, even if it still shows on your screen.

If you want to add type to your flyer or poster, be sure to leave room for words. (For more on type, see Lesson 69, "Add Text to Your Photographs.")

⇐ Here is a screen shot that shows the layers that were automatically created as I dragged my images into my flyer document. The beauty of Layers is that you can make adjustments to each layer as you go along, or even after you have finished and saved your document.

Oh, that reminds me: Don't forget to save your flyer! Saving documents in the Photoshop (PSD) format preserves Layers, as does the TIFF format, but saving a document in the JPEG format flattens all images into one layer. I save a final version of my flyer as a TIFF, however, in case I want to change a layer later. Manually flatten an image by going to **Layer > Flatten Image**. I do that when I send a picture off to be published. When flattening an image, we also reduce the file size.

"To see an object in space means to see it in context."

—RUDOLF ARNHEIM

LESSON 82

More Fun with Digital Frames

Solve problems, add variety, and have fun by adding frames to your photos.

In our homes, a frame "dresses up" and puts a finishing touch on a photograph, painting, drawing, or poster. A frame's color, texture, and width can enhance the image that is within its borders. Likewise, if a frame or mat is too gaudy or too brightly colored, it can distract from the presentation of the picture. These are some of the reasons why framing shops charge big bucks to properly, frame, mat, and mount images.

For those working in the digital darkroom, putting a frame, creative edge, or border around a picture is easy—and everyone seems to be using them, in both advertising and editorial applications. Even *National Geographic* ran a story in March 2001 in which all the pictures were enhanced with digital photo frames. The article was on naturalist William Barton's work in Florida and the Carolinas. It was shot by Annie Griffith Belt on infrared film. Jill Enfield hand-colored the photos.

I learned a great deal more about digital photo frames after co-teaching a workshop with digital guru Joe Farace. In the workshop, Joe outlined five good reasons for using digital frames and edges:

1) Photographs with irregular edges add variety to your portfolio images by providing visual relief from straight-edged rectangular shapes.
2) The edges of images with white or light-colored corners tend to disappear from the final print. A creative frame adds a decorative border to the photograph while giving the finished image a clearly defined edge.
3) Instead of cropping to clean up distracting elements, you can use creative edges to hide minor compositional flaws while adding panache at the same time.
4) Creative edges can add an artistic touch to an image that might otherwise appear too literal.
5) Playing with creative edge effects is fun and, gathering from viewer reactions, many other people like them as well.

For more on PhotoFrame by Extensis, see www.extensis.com; on Splat! by Alien Skin Software, see www.alienskin.com.

One of the easiest digital photo-framing programs is PhotoFrame by Extensis. It's a Photoshop plug-in, which means we can use it with any Photoshop plug-in compatible program. Auto FX Corporation also offers a digital photo-framing program, PhotoGraphic Edges 5.0, which can be used as a Photoshop plug-in or as a stand-alone application. Splat! by Alien Skin Software is another Photoshop-compatible plug-in that includes digital photo frames. Each is fun to use!

Once we open PhotoFrame, we actually have a limitless choice of frames, because of the number of framing options (built into the program or downloaded from the Extensis Web site) and because we can "tweak" the color, shape, style, angle, and size of each frame.

As with traditional picture frames, a digital photo frame should complement the photograph. For example, you would not want to put a high-tech frame around a wildlife picture, but it may be appropriate for a fashion photograph. In addition, digital photo frames can be overused if they make all your pictures look too much alike.

Here are a few before-and-after illustrations of how a digital photo frame can "dress up" a picture. I used PhotoFrame to enhance the pictures of the jaguar and model Carolina McAllister, and PhotoGraphic Edges for the sunset picture of the cowboy and his horse.

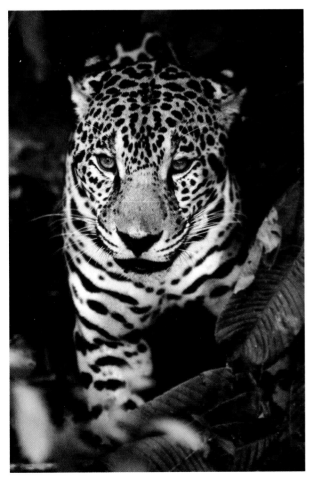

⇐ Straight shot of a jaguar, photographed at the Belize Zoo.

⇑ As you can see from this screen shot, with PhotoFrame we have a nearly limitless number of creative options for using, creating, and editing digital photo frames.

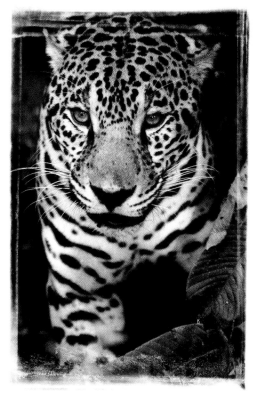

⇈ We can add an artistic frame around a picture, such as this "Camera" frame that is available in PhotoFrame.

⇈ I liked the standard Camera frame, but look how choosing green as the frame color changed the look of the frame and the picture.

⇐ Not all frames have to be rectangular or square. An oval frame can work, too—if it's appropriate for the subject. Here I used the "Charcoal" frame in PhotoFrame.

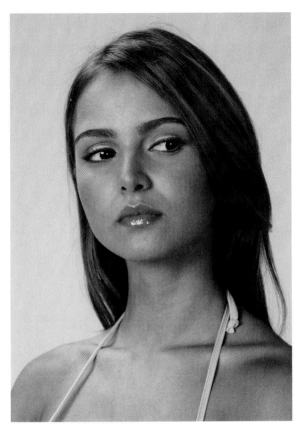

⇑ Model Carolina McAllister looking as lovely as ever in a straight studio portrait.

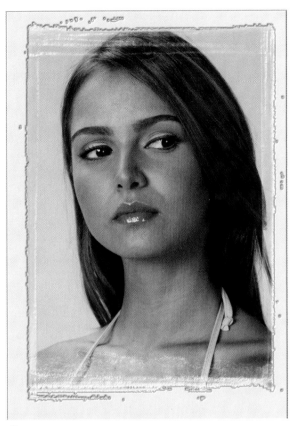

⇑ Carolina's "hot" look required a "cool" frame, such as the Outer Bevel frame with a cool-gray color in PhotoFrame.

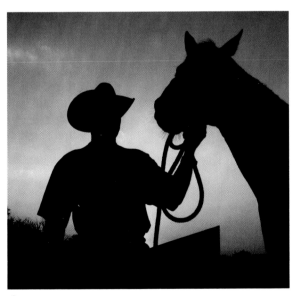

⇑ We met this cowboy and his horse in Lesson 68.

⇑ Here I used an older, no-longer-available version of PhotoGraphic Edges. I flipped the picture horizontally (**Image > Rotate Canvas > Flip Canvas Horizontal**) to fill the image area of the digital photo frame.

"Painting is the most beautiful of all arts." —PAUL GAUGUIN

LESSON 83

Paint with the Art History Brush

Transform your photos into paintings.

One of the artistic tools in Photoshop is called the Art History brush. It's in the Tool Bar grouped with the History brush.

The **Art History** brush can help bring out the artist in us—perhaps more so than other digital filters because we actually use our mouse or the pen with a WACOM tablet to paint over our pictures. We use it as we would an actual paintbrush (which artists do when they hand-color a picture). That means you have to cover every pixel with your brush, because you have to "paint" the entire frame. You can't rush through this process, which can be a good thing: It can help you relax, as it did for me (someone who is totally hyper).

There are almost limitless options in brush style, opacity, pixel diameter, and tolerance for creating an artistic brush. When you activate the Art History brush, the choices are shown in the **Brush** menu (**Window > Show Brushes**) and at the top

of your monitor. Combine these choices and you can spend hours in the digital artistic studio creating your own works of art with a custom brush.

That's exactly what I did for this lesson! I spent more time on the pictures here than in any other lesson, because I kept changing my mind about which effect I really liked. Here's how it started and ended.

⇐ I began by looking for a picture that I thought could be transformed into one that looked like an artistic painting. I searched my landscape files and came up with this sunset shot from Trinidad, Cuba.

← The effect of the standard Airbrush tool is pretty nice. It blurs the area you paint and makes it look somewhat like a watercolor painting.

⇒ Here's another landscape photograph. I shot this one in Tahiti—where more than a few artists go for inspiration.

⇒ To create this artistic image, I loaded the Calligraphic Brushes and selected a Flat brush stroke. Then I painted over the image—which took about 15 minutes.

⇒ This is the result I achieved using a Spatter brush. It's softer and dreamier than the effect you get with a Flat brush.

⇒ To ensure that you paint the entire frame, use the Navigator (**Window > Navigator**). Then enlarge the window and scroll around the entire frame. You may be surprised to see what you missed while having so much fun!

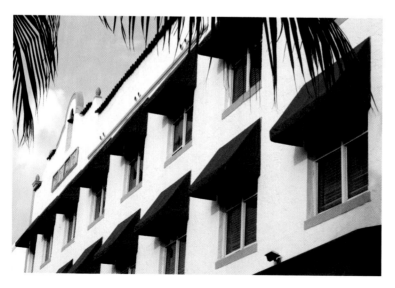

⇐ While teaching a photo workshop in Miami Beach, I met a photographer, Barry Wolfe, who was manipulating Polaroid pictures of the Art Deco buildings with a wooden, pen-like instrument. The effect was wonderful. I said I'd like to try to create the same effect in Photoshop. His tip: Make sure you have plenty of contrast in the scene.

⇐ So I went out and shot some pictures specifically to try to imitate Barry's technique. I used a Flat Calligraphic brush and "painted" over the entire image. The process took about half an hour. It does not match Barry's technique exactly, but I think it comes close. Either way, it was fun!

Here are a few more general tips to follow when using the Art History brush:

- If you get a prompt that you can't use the Art History brush, don't panic! That happens when you crop a picture after you open it. So, if you want to use the brush on a cropped image, crop it, save it, close it, and then reopen it before using the brush.
- Use a small brush for more control. Large brushes affect a larger area of the picture.
- Experiment with several different brush styles and sizes.
- At first, work with small files as trials—for example, 5 × 7 inches at 100 dpi. As with all effects in Photoshop, the larger the file, the longer it takes to create the effect.
- For an even more artistic image, try printing your picture on textured watercolor or canvas paper.

PART VII	**MORE PHOTOGRAPHY TIPS**

We are nearing the end of the book, but that does not mean that your photo learning or photo fun has to end. So far we have covered the basics of photography, picture-taking, printing, and Photoshopping. In this section, I'd like to share with you several more photo and digital darkroom techniques, from the simple to the sublime.

⇐ For starters, take a look at this photograph, which I took at Horseshoe Bend near Page, Arizona. The picture illustrates an important point in landscape photography, as well as one for general composition.

The picture is appealing because of the S shape of the river in the scene. People seem to like pictures where a river, stream, road, snowdrift, line of objects—or a figure study of the human body— forms an S in a picture. Perhaps the S curve adds a sense of movement to a still picture (which a straight line does not do) by causing our eyes to move around the picture. Or, as my friend Dick Zakia says in his lectures, "From a Jungian point of view an S shape is serpentine, and serpents play a very important role in our psyche. We are imprinted to respond to such shapes for they are archetypal. We may unconsciously experience the S shape of a

meandering river as a gigantic serpent making its way across the land and being protected or hidden by trees, bushes, grass, and the like. The shape of the S is sensual—the reason why female figures are more interesting than male figures." Whatever the reason, try to keep the S shape in mind when looking through your viewfinder.

In this section we'll explore tips on going freelance (as I did after my 9-to-5, suit-and-tie job in an advertising and public relations agency), creating digital slide shows, and even perhaps publishing your own electronic book. We'll also go a bit more into my personal photo philosophy.

And for those of you who like creating your own photo fantasies in the digital darkroom, we'll take a look at one of my favorite photo-imaging programs, one that lets you create lifelike 3-D images.

⇓ Here is one that I created using the software program Bryce. I call it "The Return of Predation on Planet Bryce." Here I used pictures of a jaguar and a butterfly to create my photo fantasy.

Okay, let's have some more photo fun!

"Photography is truth. The cinema is truth twenty-four times per second."
—JEAN-LUC GODARD

LESSON 84 | Taking vs. Making a Picture

Take all the pictures you can, but make some too.

"What's the difference between taking a picture and making a picture?" Well, that's easy. Taking a picture means just pointing your camera at a subject and clicking the shutter (although some digital cameras don't actually have a shutter). Making a picture, on the other hand, means looking at a subject or scene very carefully, and then thinking about which elements you want in or out of the picture to tell the story you want to tell . . . and then looking for a creative composition . . . then thinking about the lighting . . . and then, finally, clicking the shutter.

As for myself, I do both. I take pictures, especially when I'm traveling, when I see a scene that will be gone in a split second. However, when I have the opportunity, I make pictures, setting up a scene before I snap the shutter for a more creative image.

In this lesson I'd like to share with you some of the pictures that I've made, in the hope of showing you how important it is to *make* pictures (in camera) whenever you can. Making a picture can turn a snapshot into a great shot.

All the pictures in this lesson were taken with my digital SRL cameras.

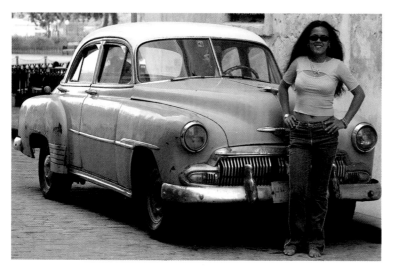

⇐ While I was walking down a street in Old Havana, Cuba, I saw this girl dressed in blue and this blue car. They were on opposite sides of the street. To make this picture, I asked the girl to stand by the car. I also asked her to take off her shoes, which added to the relaxed feeling of the picture. I used my 70–200 mm lens at 200 mm to isolate the subjects from their surroundings.

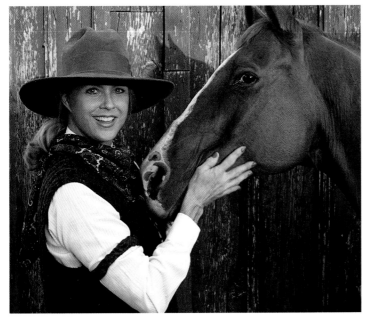

◄ Here's another shot in Cuba. While driving down a country road with my friend Gerry Oar, I spotted a building with a bright blue wall. Up ahead, I saw a man with a 1957 Chevy parked in the street. Ah, the making of a good picture. We stopped and asked the man to pull his car into the parking lot and pose for my picture. Notice the colors complement each other and the door in the background frames the man's head. To get everything in focus, I used my 17–35 mm lens set at 24 mm and used a small f-stop.

◄ I took this picture at Miss Molly's Bed and Breakfast in Ft. Worth, Texas. Walking inside, I felt as if I were in a nineteenth-century brothel. Obviously, this is a "made" picture that illustrates how photographers can be art directors while shooting. The large mirror with an intricate frame caught my eye. What a prop! So I posed Miss Molly in front of the mirror and then asked a cowpoke to pose in the doorway. The picture has a sense of mystery—something that is always nice to capture. I chose a small f-stop on my 17–35 mm lens set at 17 mm to get Miss Molly, her reflection, and the cowpoke's silhouette all in focus.

◄ This picture of my friend Judy Nelson and her horse looks very natural. Actually, just a few minutes before, I was photographing Judy on the other side of her barn in the shade—where there was soft, flattering light. But before the sun set, I asked Judy to pose with her horse on the opposite side of the barn, which was bathed with strong, warm light. We made the picture together, working as a team to get the picture. I used my 28–105 mm lens at 105 mm—a nice setting for head-and-shoulder portraits.

⇒ While shooing in the Ft. Worth stockyards, I encountered this cowboy, Chester Stidham. There were lots of people around, and the streets were busy with traffic. To make this portrait of Chester, I positioned him in front of his horse and framed my shot so the saddle was in the background. I used my 70–200 mm lens at 200 mm for an extremely tight shot, blurring the saddle just enough so you can still tell it is a saddle.

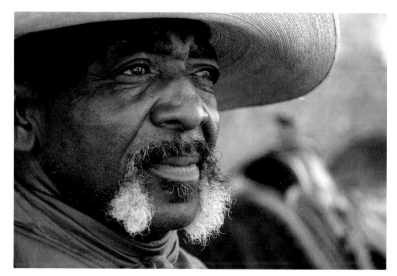

⇒ This shot of Peace Corps volunteer Gina Castinidos and shopkeeper Reinaldo Quiroz was fun to compose. Before I made the shot, Gina was trying on a sombrero in a corner of Reinaldo's shop, Artesanians Quiroz, about an hour west of Panama City. In that corner, with little light and contrast, Gina was holding a very small mirror. To make the shot, I asked Gina and Reinaldo to move closer to the shop's window, where there was more light. Then I asked for a larger mirror for Gina to hold. Then I had my assistant, Gilberto Alemancia,

hold a gold light reflector to Gina's left, which bounced some window light onto Reinaldo's face. The shoot took about 10 minutes to organize. But the subjects enjoyed themselves, as you can see from their faces. My lens? My favorite, of course: 16–35 mm zoom set at about 20 mm.

So take all the pictures you can . . . but make some, too.

*"The more one looks, the more one sees. And the more one sees,
the better one knows where to look."* —ANONYMOUS

LESSON 85 | Tell the Whole Story

Communicate your experience to others through your pictures.

Each October, hot-air balloonists from around the world travel to New Mexico for the annual Albuquerque International Balloon Fiesta. The event also draws thousands of spectators interested in seeing and photographing hundreds of balloons flying in the clear New Mexico sky. It's estimated that one million pictures are taken at the action-packed festival each year. I've taken most of them. Only kidding! I have, however, photographed the event four times, and each time I seem to take more and more pictures.

One of my main goals at the Fiesta, in addition to getting a breakfast burrito at 5 A.M. when I arrive at the field, is to "tell the whole story" of the festival. That means taking as many different kinds of pictures as possible. "Telling the whole story" is a useful technique to use when you travel to a destination. It helps you to think about communicating your experience to others through your pictures. It also helps you get pictures for a slide show—digital or 35 mm.

Here's a look at just a few of the pictures—and techniques—I've used to tell the story of the ABF (as it's known to balloon pilots) for my slide presentations.

⇐ One of the most dramatic—and photogenic—moments happens before the launch. When the balloons are about halfway filled with air (by huge fans), pilots pull the burners and big bursts of flames rush into the balloons. These moments make for great shots, but the timing must be "right on" to capture the flames, which last only a few seconds. I set my ISO to 400 and my 17–35 mm lens to 24 mm. I took several pictures in sequence so I'd have a good chance of capturing the drama of the moment.

⇑ Right before liftoff, dozens of inflated hot air balloons are tethered to the ground. It's a beautiful sight, but the balloons block out much of the sky and much of the light. To capture the action on the ground before and during liftoff, I set my ISO to 400 and shot with my 17–35 mm lens, which gives me a number of creative composition options from a single shooting position.

⇓ The balloons usually lift off shortly after sunrise, when the air currents are perfect for ballooning. For brightly lit scenes like this, I use an ISO 100 digital setting or film, because slower digital settings and films have less noise or grain (respectively) than higher settings or films. This picture is cropped from the 35 mm format for more impact—there was too much dead space at the top and bottom of the 35 mm frame.

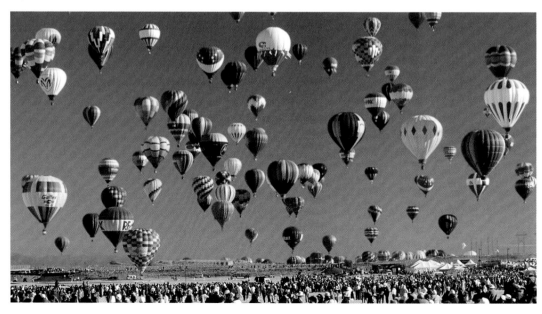

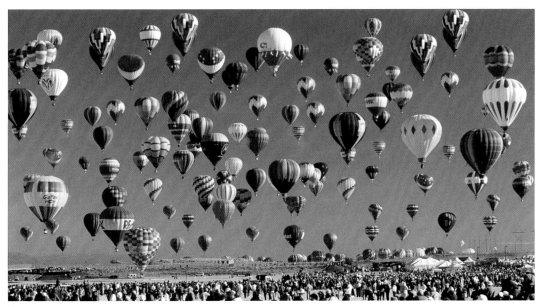

⇑ Sure, we all want to tell the story, but we don't want our story to be fiction, unless we are playing around with Photoshop. I created this image by cloning (copying) several balloons and pasting them into open-sky areas of the picture. (For more on the Clone Stamp tool see Lesson 45, "Try Easy Tools First.") If you manipulate a picture, it's a good idea to tell people that your picture is enhanced. One very famous wildlife photographer told a bit of a white lie, and got in a bit of trouble for doing so. And *National Geographic* magazine moved one of the pyramids in Egypt on one of their covers—something people criticized. Remember, when it comes to photography, as in life, "honesty is the best policy."

⇒ Here is a shot that is part of almost every ballooning story. I asked a pilot (most are very friendly and accommodating) if I could walk around inside his balloon (in my socks) while it was being inflated, well in advance of the time he pulled the burners. I used my 17–35 mm wide-angle zoom set to 17 mm and shot toward the top side of the balloon, which was perpendicular to the ground at that moment. Look closely and you can see the very small shadows of some people outside the balloon on the left side of the picture.

⇒ People are part of so many photo stories. When I'm shooting, I'm always looking for an interesting person (or character) who will complement my story. This man, with a balloon reflected in his sunglasses, was a perfect subject. For this shot, I set my 17–35 mm lens at 35 mm and used ISO 100 film.

⇓ The glow from inside the colorful balloons is simply spectacular at the evening "balloon glow" event. To capture the light, I used an ISO setting of 400.

The Albuquerque Balloon Fiesta is one of many hot-air balloon shows held throughout the United States. Most events are listed on the Web site of the Balloon Federation of America. Hey, maybe you'll see me at one—with my cameras hanging around my neck. We can "tell stories" together.

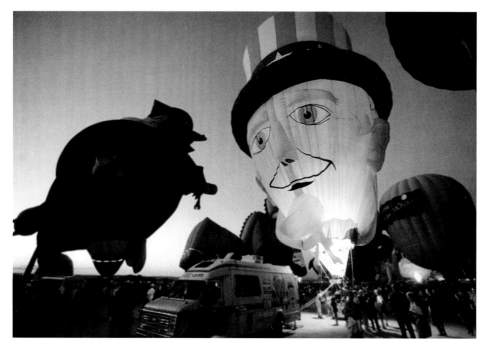

See www.bfa.org for more on ballooning events.

> *"Photography records the gamut of feelings written on the human face, the beauty of the earth and skies that man has inherited and the wealth and confusion man has created."*
>
> —EDWARD STEICHEN

Take a Lot of Pictures

Always keep your camera handy.

Marilyn Monroe was one of the most photographed women in the world—for one reason, she was very photogenic. One of her favorite photographers was Milton Greene. It's said that he used an interesting technique during some of his photo sessions with her that most people don't know about—a technique that even Monroe was not aware of at the time. For the first few hundred "pictures," Greene did not have film in his camera. You see, he wanted Monroe to feel comfortable and relaxed in front of the camera before he actually started shooting. And when he did start shooting with film, he took hundreds of pictures to get one great shot, because he knew that facial expressions can change in a split second, making the difference between a picture that captures the essence of the person and an unflattering picture in which the person's eyes are half-closed.

Most professional photographers in the fields of fashion, sports, and news take dozens of pictures to get one great shot. (One *National Geographic* photographer, Jim Brandenburg, challenged himself for a project and took only one picture a day for a month—and the pictures were stunning!) I shoot a lot of pictures (sometimes 40 or 50) of a subject that I simply must capture. With that many pictures from which to choose, I'm pretty sure I will have at least one keeper.

So you may think the message of this lesson is simply to set your camera on motor drive (rapid picture advance) and shoot away at everything in sight. Not so! Using that approach, which I call the "machine-gun technique," may yield some nice pictures. But it's a waste of time if you are not careful about subject selection, as well as the basic techniques that go into the making of a good picture. A more effective method is to use the "sharpshooter's technique," carefully selecting a subject and using all your skills to get some good shots.

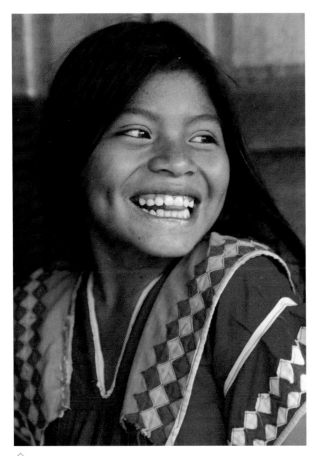 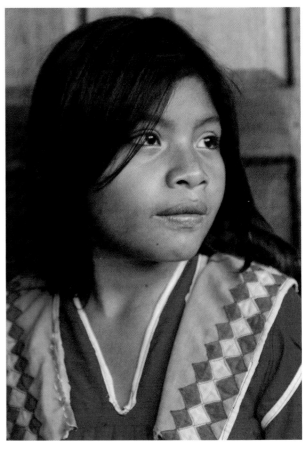

⇑ These pictures are my two favorites from my photo session with a Ngabe-Bugle girl in a small village in Panama. One captures the girl bursting with energy and happiness, the other captures a more serious side of the girl.

⇒ The remaining pictures in this series are outtakes—acceptable, but not my personal favorites. You may, however, like one or more of these pictures better than my favorites. That's cool. That's what photography is all about.

Along with taking lots of pictures is always having your camera handy and always having enough film frames or digital memory left to capture moments that can come and go in the blink of an eye. Here is just one example of what I mean.

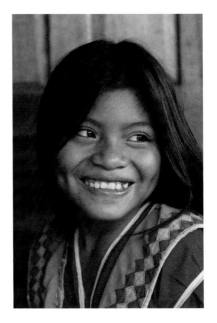 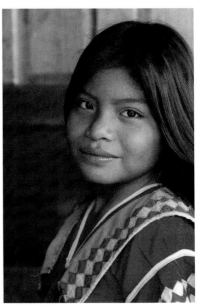

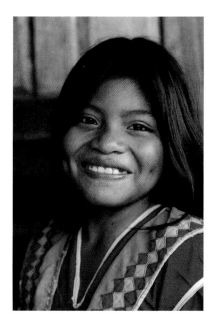
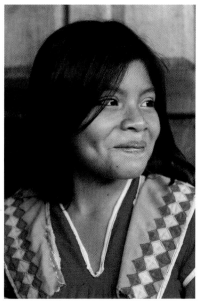
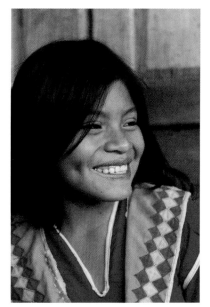

⇒ In 1995, while riding along a remote, dirt road in Papua New Guinea, our truck was stopped by some fierce-looking Huli clansmen who were pointing homemade weapons—bows and arrows and shotguns—at our truck. I was a bit nervous, knowing that the Hulis are in constant battles with neighboring clans—battles in which lives can be lost. Still, I raised my camera and shot the scene through a dirty window of the truck (which is why these pictures look a bit soft). I was going to put down my camera, but I kept shooting. I'm glad I did! As you can see, these Huli men were only kidding around. Had I not had a fresh roll of film in my camera, which I keep handy all the time, I would have missed the shots, which bring back a great memory.

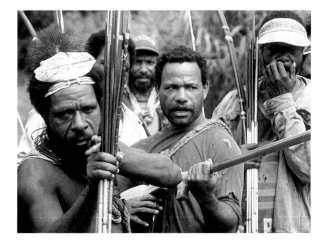

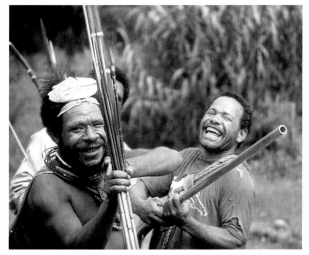

"God is in the details." —LUDWIG MIES VAN DER ROHE

<table>
<tr><td>LESSON 87</td><td></td></tr>
</table>

LESSON 87 | **Look for the Details**

Move in and zoom in on interesting details.

I find people the most fascinating subjects. I like people's faces, their eyes, and their soft complexions or hard character lines. I generally take both head shots and pictures of people in their environments. But I also take another kind of picture, something I picked up from reading *National Geographic:* I zoom in or move in to capture specific details of a subject. Without a face in the picture, details can have a strong impact—so strong, in fact, that my guess is you will remember at least one of the pictures in this lesson more than others in this book.

This lesson will share with you a few detail shots of people. Keep the "moving in and zooming in" technique in mind the next time you see an interesting detail in a subject. A detail may help you tell more of the story.

Navaho headdress, Monument Valley, Arizona.

Dancer's speckled back, St. Maarten.

Dancer's beaded costume, Barbados.

Kuna woman's hands and
beaded arms, Kuna Yala,
Panama.

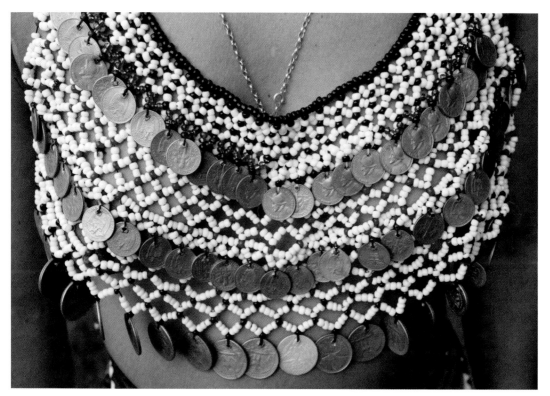

Embera woman's necklace, Panama.

Back scarring, Papua New Guinea.

"We can only recognize what we know." —E. H. GOMBRICH

Get to Know Your Subject

. . . for a better chance of getting the shot you want.

Aspiring photographers often ask, "What's the most important aspect of photographing people?" "The answer is simple," I say. "Getting to know your subject, and getting your subject to accept you." After that, you can think about the photographic basics, such as which lens to use, how to compose your picture, what you want your picture to "say."

When I travel to foreign lands, I spend a fair amount of time getting to know my subjects before I start shooting. I ask questions about their life and lifestyle. Before I leave home, I research a culture, so I am at least a little familiar with the region that I will be visiting. I also check out the climate and political situation to reduce the number of surprises when I arrive.

I share aspects of my own life, which my subjects usually find interesting. I also share some family photos that I carry in my wallet. In places where there are no one-hour photo labs or Internet cafes, such as the highlands of Papua New Guinea or the Zulu lands in South Africa, my family photos are a hit!

My most effective technique for getting a subject to feel comfortable with me is to spend some time doing simple magic tricks. I buy these at Tannen's Magic in New York City, which sells just about every trick or plans for every trick you have ever seen. Even the simplest tricks can be fun ice-breakers.

Promising to send a picture, and following through, is another good way to get a subject to like you. If you promise to mail a photo and don't follow through, you may ruin it for the photographers who follow you—including me!

So when you see a subject you want to photograph, you will have a much better chance of getting the kind of photograph you want if you spend some time getting to know your subject before you start clicking away

↓ Joking around with these Huli clansmen in Papua New Guinea helped me get the shots I wanted for my books and magazine articles (two of those pictures are in Lesson 5, "Seeing Pictures"). My scuba-diving buddy Pam Rewers took this photo.

⇐ My portrait of these two women in a South African village is in Lesson 18, "Outdoor Flash Techniques." I got the women to like, or at least accept, me by sharing a photo of my son Marco, who was only one year old at the time.

⟹ In Palau, Micronesia, I participated in a tribal dance on the beach to show the people that I was interested in learning from them and in having fun with them!

⇊ Sharing digital pictures with a subject makes an encounter with a stranger more fun—for the stranger and the photographer. As you can see from the expression on the face of this holy man, whom I photographed in Katmandu, Nepal, he is enjoying the photo session as much as I am.

Photograph by Susan Sammon.

⇊ While teaching a photo workshop for *Popular Photography* magazine in Ft. Worth, Texas, I got into the act by participating in a gunfight. I lost the "gunfight," after which I took some winning pictures.

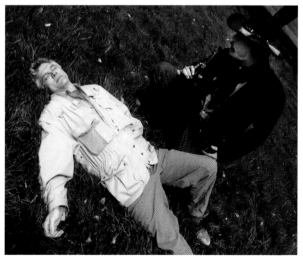

Photograph by my friend and assistant John Costello.

"Between the photographer and the subject there has to be a distance. The camera may intrude, trespass, distort, exploit." —SUSAN SONTAG

Respect Your Subject

Your subject will sense the respect you have.

Throughout this book are many pictures of people—strangers, mostly—whom I've photographed in strange lands around the world.

Having good equipment helped me get the photographs. But the real key was following some advice I was given early on in my career by a friend, *National Geographic* photographer Sarah Leen. "Respect your subjects, and they will respect you."

I follow Sarah's advice and encourage you do to the same. If you do, your subject will sense the respect you have. If you don't, that feeling will come through, too, and you probably will not get the kind of photograph you envisioned before you snapped the shutter.

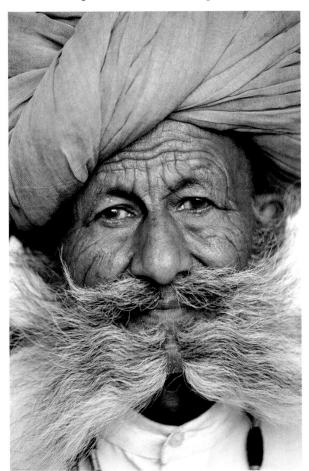

Bearded stranger, Rajasthan, India.

Carolina McAllister, South Beach.

Woman, Ganges River, India.

"We're lost, but we're making good time." — Yᴏɢɪ Bᴇʀʀᴀ

Environmental Portraits vs. Head Shots

Shoot a subject as many ways as you can.

When I'm photographing people, I try to take a head shot and an environmental portrait—that is, a picture that shows the person in his or her environment. Such images have more of a sense of place.

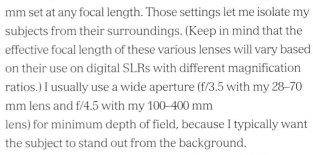

For my head shots, I use either my 28–70 mm lens set around 70 mm, or my 100–400 mm set at any focal length. Those settings let me isolate my subjects from their surroundings. (Keep in mind that the effective focal length of these various lenses will vary based on their use on digital SLRs with different magnification ratios.) I usually use a wide aperture (f/3.5 with my 28–70 mm lens and f/4.5 with my 100–400 mm lens) for minimum depth of field, because I typically want the subject to stand out from the background.

For my environmental portraits, I use my 16–35 mm lens set at a small aperture, around f/8 or smaller, so I get as much in focus as possible.

In most cases, I like to work as close as possible to a subject. A close shooting distance, I believe, makes it easier for a subject to "connect" with me, and vice versa.

With these two types of pictures, head shots and environmental portraits, I can give editors and art directors a choice when they need a picture. But more important, I have fun taking both types of pictures—and I think you will, too.

⇐ Boring! That's that I call this shot of a man I photographed on the side of a road near Panama City, Panama. I'm leading off this lesson with this photo to illustrate a point: Maybe sometimes it's not worth it to take an environmental portrait.

⇒ Here is a much closer view. Not a head shot, but a tighter environmental portrait that shows the man sitting on a horse. I include it to illustrate another point: Sometimes maybe even a tight head shot is not the best possible shot.

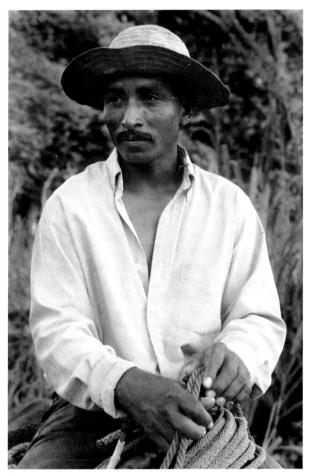

⇑ Notice how the man stands out from the background more than he does in the previous picture? That's because I used Photoshop's Burn tool to darken the background. Try that technique with some of your portraits. I think you'll like it.

⇒ Here's an image (intentionally poorly cropped in Photoshop) that illustrates a common mistake: not looking at the bottom of the viewfinder when you take a picture. As you can see, the man's hands are cut out of the frame. My point: Check out the bottom of your viewfinder before you shoot. Please!

The same picture illustrates another important point: Don't "cut off body parts." In other words, don't crop a picture at a person's joints: wrists, ankles, or elbows.

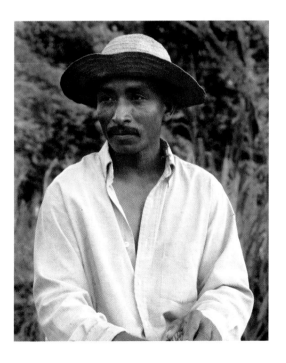

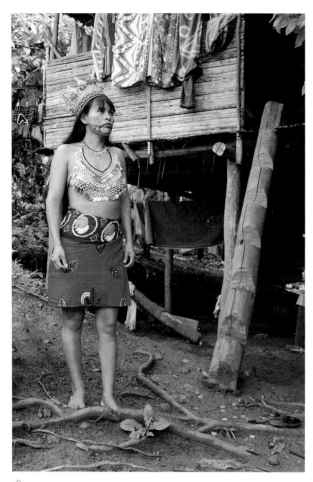
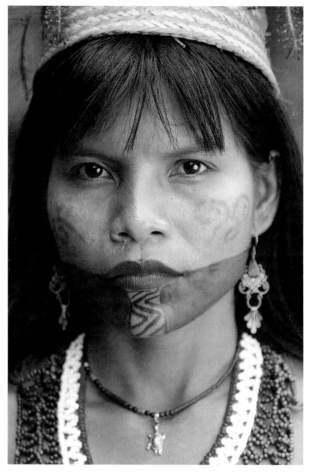

⇑ These two pictures of an Embera woman in Panama are good examples of an environmental portrait and a headshot. To get each one of these shots took more than a dozen pictures. When photographing people, you have to take a lot of pictures to get a shot you really like—and one that is flattering to your subject.

Notice how in this environmental portrait the woman is off-center in the frame, and how the background tells the story of the location. Also, see how almost everything is in focus, because I used a small f-stop, which is important in environmental portraits.

⇒ This next series of pictures illustrates the evolution of a portrait session.

I took the first shot of this Embera girl after I positioned her in a doorway of her school, where she goes to get breakfast, as do many children. After she began to trust me, she pulled out a pair of sunglasses and put them on. Because I am always ready to shoot, I caught her in the act, so to speak.

Next, she had the idea to pose like a fashion model. That surprised me, because this Embera village is a one-hour car ride and one-hour motorized dugout canoe ride from Panama City, far from the fashion world. Anyway, I took more than 50 pictures of her—environmental portraits, three-quarter shots and head shots. I think the picture that tells the best story is the environmental shot of the girl on the stairs. It shows that the buildings are built off the ground by a few feet to keep hungry animals away.

So shoot a subject as many ways as you can.

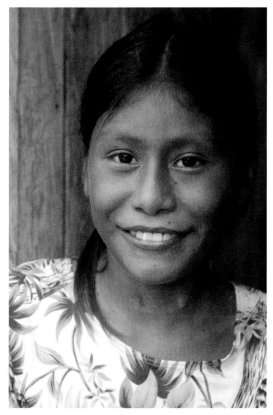

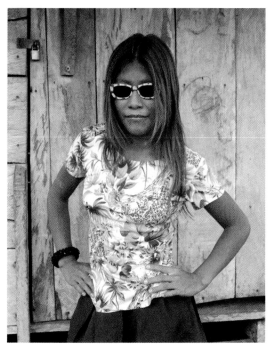
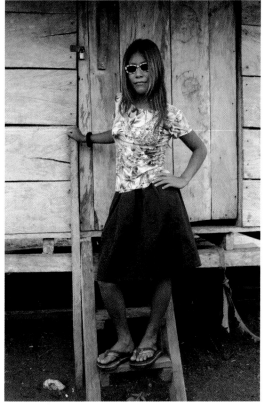

"Dictators ride to and fro upon tigers on which they dare not dismount. And the tigers are getting hungry." —WINSTON CHURCHILL

Adventures in Wildlife Photography

Photographing wildlife can be very moving.

Wildlife photography can be very rewarding. Once we import a wildlife picture into the digital darkroom, we can enhance our experience even more by fixing mistakes to get an image back to how it looked in our "mind's eye," before the recording limitations of film or a digital image sensor came into play.

I've used some of these wildlife photographs in other lessons to illustrate various techniques. But now we are talking specifically about photographing wildlife—which can, at times, be a very moving experience.

⇐ On that point, here is a picture I took of a lion kill in Botswana while filming a *Canon Photo Safari* television program. Because the lion was mostly in the shade, I used ISO 400 film. I had my 100–400 mm zoom set at 400 mm.

Earlier in the day, we had seen a newborn giraffe walking around with its mother. The animals were in a mix of shade and sunlight, and the background of trees and twigs was distracting. I took a few snapshots, and then we went on in search of better opportunities. Upon returning to the lodge, we passed the same area. A pride of lions had killed the baby giraffe. As a photographer, I wanted to get the shot, but I could not help but feel sorry for the

baby giraffe's mother, which looked on from a distance of about 100 feet. The scene brought home the meaning of the term "the circle of life."

I kept shooting from a safe distance, but I did not like several things about the scene: The contrast range was too great for my film to handle, so areas would be washed out; the twigs in the background were distracting; I could not get close enough to fill the frame; and the colors in the shade were dull.

⇒ If I were working on an article for *National Geographic,* I would not include this digitally enhanced picture, because the magazine seeks to portray life as it is. I'm including this enhanced version here to show what can be done in the digital darkroom. I created a scene that more closely resembles what the scene actually looked like, because our eyes have a greater contrast range than film or a digital sensor, and because even wearing sunglasses can make a scene look better.

To enhance the scene, I did the following in Photoshop:

- Cropped it tighter.
- Used the Clone Stamp tool to copy and paste dark areas of the twigs in the background over the light areas.
- Darkened the background and foreground areas with the Burn tool.
- Softened the background with the Blur tool.
- Darkened the giraffe with the Burn tool.
- Increased the color saturation using the **Image > Adjustments > Hue/Saturation** control.
- Boosted the red and yellow tones by going to **Image > Adjustments > Color/Balance**.

When I was finished, I had a picture that looked much more pleasing yet could have looked that way naturally. If you use these techniques and get a picture published, it's smart to tell readers that the picture was enhanced.

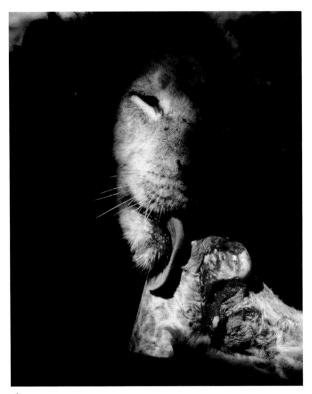
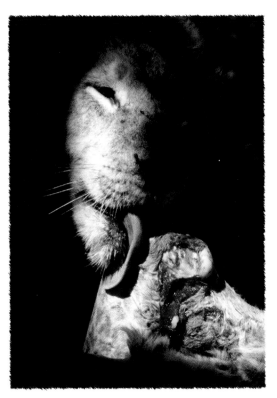

⇑ Frankly, the blood and guts of the natural lion kill are too much for some people to see in a picture. Even our television producer retreated to the back of the safari vehicle to cry. People have turned away from my original color shot. To take out some of the reality of the scene, I used Photoshop's Sepia Action at **Window > Actions > Sepia Toning (layers).** With a few clicks of my mouse, my color shot was transformed into a sepia-tone shot. To create the frame, I used the Stroke Frame that's also found in Actions.

⇐ The #1 thing to remember in wildlife photography is that the subject's eyes must be in focus. Miss the focus and you miss the shot. When using telephoto lenses and telephoto zooms, which offer a relatively shallow depth of field, especially at wide apertures, it is especially important to focus so that eyes are sharp.

I thought about that when framing this iguana, which was sitting in the grass on the side of a road in Costa Rica. Before taking this shot with my 100–400 mm lens set at 400 mm, I locked the focus on the animal's eye

Use the "lock and shoot" technique.

(using the focus lock feature on my camera), and then recomposed my picture by moving my lens slightly to the side. Use the "lock and shoot" technique and you'll have a good chance of getting an animal's eye in focus—if it is standing still. I knew I had a nice shot, because I could see it on my Canon D30's LCD screen.

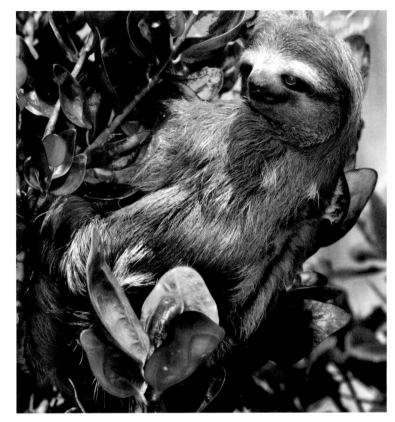

⇒ By now you know that telephoto lenses are important for wildlife photography. For this shot, however, of Buttercup, a three-toed sloth at Aviarios del Caribe in Costa Rica, I used my 16–35 mm zoom set at 35 mm. I was able to use a "short zoom" because Buttercup was resting in a bush at eye level. Buttercup, an orphaned sloth taken in by Luis and Judy Arroyo, the owners of Aviarios del Caribe, is one of several sloths they care for in their wildlife sanctuary.

When you set out to take wildlife photographs, take all your lenses, not just your telephoto lenses. You never know which lens you may need.

Also pack your flash. As you can see, there is a sparkle in Buttercup's eye. That's because I used daylight fill-in flash (see Lesson 18, "Outdoor Flash Techniques," for more on how to do this).

⇒ I'd like to tell you that I photographed this red-eyed tree frog deep in the rain forest of Costa Rica, but I actually photographed it in a tree by the swimming pool during a trip to that wonderful country. For close-up wildlife photography, I use a 50 mm macro lens set to a small aperture, usually around f/16 or f/22, so I get as much of the subject in focus as possible. (At close distances, macro lenses have a very shallow depth of field, as do telephoto lenses.)

To get even lighting, I used a ringlight on my lens. If you don't have a ring light

for macro photography, you need a coil sync cord, which lets you hold the flash off-camera. If you took a shot like this with your flash mounted on top of your camera, the light from the flash might illuminate only the top of the animal.

I like the lighting that the ringlight produced, but it also produced two white marks—reflections of the flash tubes—on each side of the animal's eye. I was able to remove them in Photoshop using the Clone Stamp tool, picking up clean areas of the red-eye and pasting them over the reflections.

⇈ I took this picture at Wild Eyes animal refuge in Montana, the same place I photographed the tigers in Lesson 64, "Special Effects with Actions." It's a fun shot that shows you what I go through to get a picture. The blur on the bottom right side of the picture is bear saliva on the lens. I escaped the encounter, and actually plan to return to Wild Eyes someday for more photo fun!

Not far from Wild Eyes in Montana is another wildlife center, the Triple D Ranch. That's where I took the following pictures of a bear, gray wolf, and badger while teaching a photo workshop. The Triple D Ranch is a great place to shoot—perhaps you will make it there someday.

⬈ This shot of a grizzly was the result of planning, timing, luck, technique, and having the right gear. Those elements are needed for good wildlife pictures. Let me explain.

Planning. I knew that the Triple D Ranch had a big, relatively tame grizzly. So, my Popular Photography workshop participants and I made special arrangements to photograph early in the day during a private photo session.

Timing. We arrived just as cloud cover had cleared, and the early morning sun bathed the animal in a beautiful, warm light. In addition, strong sidelighting added a sense of depth to the scene.

Luck. The grizzly was in a good mood and "showed off" for the photographers. More important, as you can see in this shot, the animal's face was beautifully illuminated by the sunlight—for a brief period of time. That was lucky for us!

Technique. With wildlife photography, as with people photography, the background plays a key role. So, one technique I always stress is to keep an eye on the background. In this picture, the unobtrusive background lets the animal stand out clearly in the frame.

Gear. We all had telephoto lenses. I shot with my Canon 100–400 mm IS zoom (which reduces the effect of camera shake) set at 400 mm. At that setting, I was able to fill the frame with the magnificent animal. Because the bear was moving, I set my shutter speed to 1/500 of a second to "freeze" the animal's movements. And, as always in wildlife photography, I set my camera's autofocus indicator on the animal's eye.

If you don't think luck played an important role in my grizzly bear picture, look at these next two pictures.

⇑ In this shot, the bear moved in front of a tree, which looks as through it is sticking out of the animal's head.

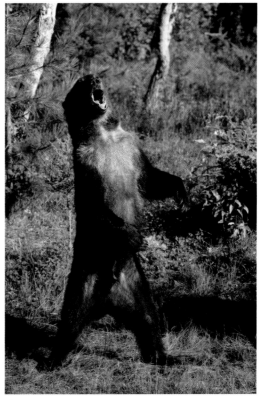

⇑ Here, the bear's face is hidden in a shadow. Another "outtake," as we say in the world of professional photography.

In Lesson 90, "Environmental Portraits vs. Head Shots," I talk about the importance of taking both types of pictures. In wildlife photography, the same principle applies. This picture was also taken with my 100–400 mm lens set at 400 mm. The animal was much closer than in the previous pictures.

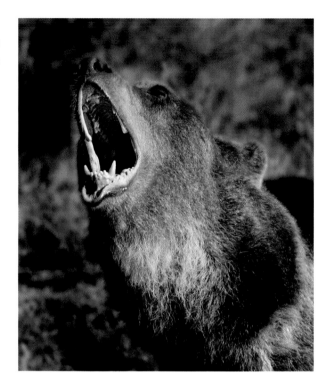

When an animal is near or in the water, I try to compose a picture so that the animal's reflection is in the frame; the calmer the water, the clearer the reflection. When you are trying to capture an animal's reflection, don't use a polarizing filter. It can reduce reflections on water.

⇒ "The name of the game is to fill the frame" means that when we compose a picture, fill the width or the height of the frame with the subject, as in this picture of a badger. Crop out the dead space. That's good advice if you want a photo with impact—usually.

⇑ Here is a shot I took with a magazine cover in mind. For this, rather than "filling the frame," I "composed for a cover," leaving some dead space around the subject to accommodate type.

⇑ As you can see, the "compose for a cover" technique makes it easy for an editor or art director to place type in a picture for a magazine cover. Try it the next time you are framing a shot.

Before we leave Montana, I'd like to share one more technique with you.

⇒ Here is a nice shot from Glacier National Park of a mountain goat surrounded by bear grass. Notice all the space on the left side of the frame. That gives the animal space to "breathe" in the scene.

⇒ Look what happens when a picture is framed in such a way that the animal's face and nose are butting up against the side of the frame. The animal has no room to breathe!

Good luck with your wildlife photography.

"A photograph is a secret about a secret. The more it tells you the less you know."
 —DIANE ARBUS

Close-Up Picture-Taking vs. Picture-Making

Close-ups pose special challenges to photographers.

I'd like to lead off this lesson on close-up photography by sharing an example of how we can turn a dull and drab shot into a much more dramatic image in the digital darkroom. After all, we are digital image-makers, right?

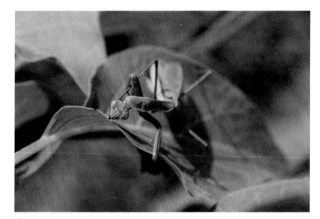

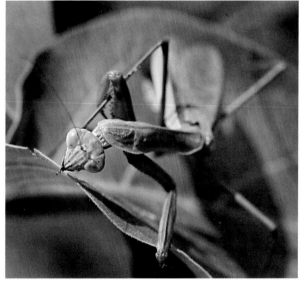

⇑ Here is my original image, taken in my backyard with my Canon EOS 1D and 50 mm macro lens. Personally, I think the praying mantis is too small in the frame. What s more, the colors and contrast are bit flat.

⇛ But look what happened when I cropped the image tighter, sharpened it slightly, increased the contrast, "warmed up" the picture by boosting reds and yellows, and darkened the leaves around the subject—all techniques that are covered in Part V, "Working and Playing in Photoshop."

So when you open a wildlife picture on your computer monitor, think about how it can be enhanced while you are having fun playing in the digital darkroom.

Close-up photographs are visually appealing because they often show a subject larger than life, as is the case when you make an 11 × 14-inch print of a butterfly. Although it may look relatively easy, close-up photography actually presents a special set of challenges, which can be met by using some special equipment and techniques.

Lenses

Macro lenses, as opposed to zoom lenses with macro settings, are the choice of most pros for close-up photography. Macro lenses let us shoot much closer than macro zoom lenses, which do not offer a true macro mode.

Zoom lenses with a macro mode are also slower than true macro lenses—meaning that less light reaches the film or imaging sensor. For example, many macro lenses have a large maximum aperture of f/2.8, while a zoom macro lens may have a large maximum aperture of only f/3.5–4.5. Plus, the maximum aperture on some zoom lenses diminishes as you zoom to a longer focal length. Less light means two things: One, the image in the view finder will look darker, which may affect focusing and composition; and two, we will need to use a slower shutter speed, which may cause a blurry picture due to camera shake. Macro lenses have yet another advantage over zoom macro lenses: They are often sharper. Major camera and lens manufactures offer 50 mm, 60 mm, and 100 mm macro lenses. I have a Canon 50 mm macro lens.

Shorter macro lenses let you get closer to a subject than longer macro lenses, and they offer more depth of field at the same shooting distance and the same aperture. You'd use a longer macro lens when you can't get as close to a subject as you want—say, when you want to photograph a butterfly that may be frightened away if you get too close.

Another option for close-up photography is a screw-on close-up lens kit. Kits usually include +1, +2, and +3 close-up lenses that screw into the filter ring of SLR and built-in lenses (usually 35 mm to 100 mm). Close-up lenses can be stacked for even greater magnification. For example, you can use a +2 with a +3 lens for a +6 magnification. Although perhaps not as sharp as a macro lens or a zoom macro lens, close-up lenses do provide an opportunity to take nice close-up pictures without having to invest in a macro lens or a zoom macro lens.

Sharpness

In close-up shooting, camera shake is exaggerated, so you have a good chance of getting a blurry picture if you are not using a tripod or a flash. Second, depth of field is often very shallow; even at small apertures, depth of field may be only a fraction of an inch when shooting extremely close to a subject. Therefore, your first concern, after selecting a subject that is, is getting the main subject in your picture in sharp focus.

For sharp close-up pictures, your best bet is to use the smallest aperture—f/22 if possible. Again, that's because depth of field is very limited with macro lenses. (Cameras with a depth-of-field preview button, which lets you view the scene at the selected aperture, and digital cameras with a magnification feature, which lets you zoom in on part of the frame, are great for checking to see if your subject is in focus.) Of course, if you want to isolate a subject in a scene and blur the background, use a wider aperture, but be very careful about your focusing.

A tripod can help steady the camera for a sharp picture. But even when a camera is mounted on a tripod, the picture can be blurry if you press down too hard or too quickly on the shutter release button— especially during long natural-light exposures. To remedy that problem, follow the "hands-off" technique: use a cable release or your camera's self-timer.

The ISO setting on a digital camera or a film's ISO can affect the apparent sharpness of a picture. Slower ISO settings and films have less digital "noise" or grain than faster ISO settings and films, which is why close-up photographers like them.

Check out Lesson 10, "Shoot Sharp Pictures," for other factors that affect sharpness.

Lighting

A flash will make a close-up picture look sharper than a natural light picture by adding contrast. But using a

flash can create challenges, too. A built-in flash, over or next to the lens, will light your subject with strong top or sidelight, respectively. A hot-shoe mounted flash will do the same thing, depending on which way you hold your camera.

So what's a photographer to do who wants to use a flash? Well, you have two main choices, if you don't want to spend time setting up a complex lighting system that costs lots of money. First, if your camera has a flash connector, you can buy an extension (coil) cord and hold your flash off-camera, aiming it at the subject. That technique is okay, but you will probably get harsh shadows in some part of the scene, because the light will be coming from only one direction.

For serious close-up photographers, a better option is to use a **ringlight**, which fits around the lens and produces even lighting or slightly directional lighting, depending on the model you choose. Ringlights with more than one flash tube also offer ratio lighting, in which you can reduce the light from one or more of the flash tubes to create top, side, or bottom lighting.

Contrast, created by shadows and highlight areas, can also be a challenge in close-up photography, for both natural-light and flash pictures. A wide contrast range can be reduced with several different techniques: using a flash to fill in shadows, using a diffuser or reflector to even out the lighting conditions, and, of course, burning and dodging in the digital darkroom.

The close-up shots that follow illustrate some close-up picture techniques.

⇐ A ringlight can produce shadowless lighting, as this picture of a butterfly illustrates. I used my 50 mm macro lens set at f/22 for this picture of a posing butterfly at Butterfly World in Coconut Creek, Florida. All the tubes in my ratio-lighting ringlight were turned on.

⇒ I photographed this blue morpho butterfly at Butterfly World with my 50 mm macro lens and a ringlight. Notice that the butterfly's antennae are in sharp focus, but the background is slightly out of focus. Had I used a smaller aperture, the butterfly and more of the background would have been in focus. See what I mean about macro lenses offering a very shallow depth of field?

⇒ Look what happened when I used the Burn tool in Photoshop to darken the area around the butterfly. Using that technique draws more attention to the butterfly. It also reduces the contrast range of the scene and reduces the highlight areas.

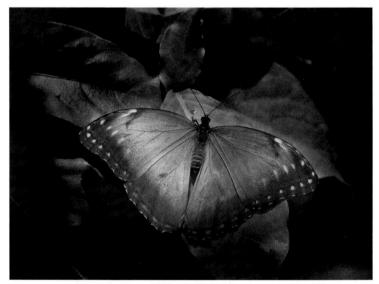

⇒ Butterflies are works of art created by Mother Nature. So to frame this work of art, I chose an appropriate digital frame in Extensis PhotoFrame.

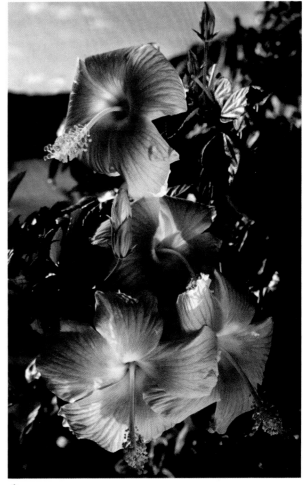

⇑ Here are two pictures that illustrate the difference between a snapshot and a more creative shot. The almost full-frame shot of the hibiscus, taken with a 50 mm macro lens, shows the flower in all its glory, but it's a fairly standard shot, and a bit boring.

⇑ This next picture of several hibiscus blooms was taken with a 17–35 mm zoom set at 24 mm. Look at all that depth of field. And notice how the background enhances the overall picture. The flowers look as if they are glowing because my wife held a gold reflector to bounce light onto the flowers.

⇐ Beauty in nature is easily found in flowers. The soft, natural light in a greenhouse made this picture of a cyclamen look more like a painting than a photograph. To create this effect, look for natural light, and use your eyes to seek out artistic compositions.

Why not try out some of these techniques by taking a few flower pictures at a local arboretum? You'll discover the wonderful world of close-up photography, and you may discover a new world of creativity at the same time.

In photography, the adage "Practice makes perfect" rings true. "Testing, testing, testing" also applies, especially when embarking on a new type of photography, such as macro photography.

Before I took a trip to Butterfly World, I practiced with my macro lens and ringlight in my kitchen. I experimented with f-stops and shutter speeds, shooting angles, backgrounds, and lighting. After several practice sessions, my camera adjustments became almost second nature, giving me freedom at Butterfly World to compose my photographs in my viewfinder quickly and then shoot. The picture of the newborn butterfly, surrounded by several chrysalides, is the result of my "homework." The other two photographs are kitchen shots.

"I don't know what you could say about a day in which you have seen four beautiful sunsets."
—JOHN GLENN

Shoot Spectacular Sunrises and Sunsets

Be prepared— and enjoy the moment!

Have you ever been disappointed with your sunrise and sunset photos? Do they lack color, drama, or impact? If so, here are quick tips for turning sunset snapshots into great shots!

But first, a word about safety. Never look at the sun for a long period of time. You can damage your eyes. Extended exposure to bright, direct sunlight may damage a digital sensor, especially the sensors in some consumer point-and-shoot digital cameras. Therefore, envision your picture, shoot, and then turn your camera away from the scene.

Timing. We see some spectacular colors just as the sun kisses the horizon and after it has finished its kiss. Great shots are available before and after those magic moments, but watch for that quick change in colors that produces such wonderful photo opportunities. And, always be prepared with plenty of film or memory on your memory cards. You'll also need some time because you want to capture the ever-changing colors in the sky, which can vary from second to second.

⇐ For example, look at this picture I took in Glacier National Park, Montana, about ten minutes before sunset. I composed my picture so that the sun was out of the frame. The beautiful layer effect is caused by the combination of mountains in the scene and the mist in the air. (Canon EOS 1D, 100–400 mm lens set at 400 mm.)

Composition. There is an old saying: "Dead center is deadly." In sunset photography, this means don't put the sun in the dead center of the frame. Rather, try placing it off-center. That technique, effective for most subjects, draws the viewer into the scene by forcing him or her to look around the frame. (But remember, rules are made to be broken.) Also, try not to place the horizon line in the dead center of the frame. Place it low in the frame when the sky has lots of color, and high in the frame when the foreground is interesting, as is often the case when photographing sunsets over water.

⟹ This picture from Glacier Park illustrates those two composition techniques. Recall the rule of thirds from Lesson 19, "Compose in Thirds." (Canon EOS 1D digital SLR, 100–400mm lens set at 200 mm.)

Foreground elements. A sky filled with spectacular colors is a great photographic subject. But place a dramatic foreground element in the scene, and your photo will gain a sense of depth. Trees, plants, fences, and buildings are great sunset foreground elements, as are people and animals.

⟹ Look at these scenes, taken just few feet from each other in Provincetown, Massachusetts, to see the difference a foreground element can make. Which one has more of a "sense of place," as well as a sense of depth? (Canon EOS 1D digital SLR, 16–35 mm lens set at 16 mm.)

Be careful! When including a foreground element that is close to your lens in a scene, use a wide-angle lens and a small f-stop, around f/11 or even f/22. This combination will give you good depth of field, so that the entire scene will be in focus. To illustrate this point, above is a sunrise shot taken with my zoom lens set to 35 mm and an aperture of f/2.8. The foreground is too blurry, for my taste anyway. Compare this picture with the picture on the right with the sharply focused fence in the foreground. For the fence picture, I set my zoom lens to 16 mm and the aperture to f/22. And of course, I used a tripod.

Lenses. Photograph a sunset with a 24 mm or 35 mm lens and the sun will look like a small red or yellow dot in your picture. That may be okay, if the sky and foreground are interesting. Use a telephoto lens in the 300 mm to 600 mm range and the sun will look like a huge ball of fire in your picture. A dramatic effect, indeed.

Don't forget a tripod. A tripod will come in handy after the sun has set, when you want to get low-light shots of a pastel-colored sky—pictures that require shooting at slow shutter speeds.

Shooting Tips

- Underexpose the scene by at least one stop. Underexposing intensifies and saturates the colors. You can set you camera on Program mode and your exposure compensation to -1 (or even -2). If your camera does not have an exposure compensation mode, you can double the ISO setting for the same effect (ISO 100 becomes ISO 200, ISO 200 becomes ISO 400, etc.).

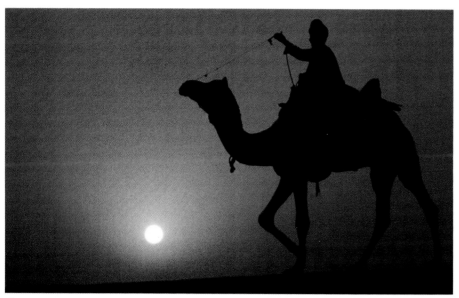

⇧ This sunset shot from Rajasthan, India, brings back great memories of a magical moment. I composed the picture so the camel was walking into the scene, shot using Program mode, and underexposed by two stops. (Canon EOS 1V, 70–200 mm lens set at 200 mm, Kodak Extra Color 100 film.)

- We can also use several options in Photoshop to create a more saturated picture from our original: We can go to **Image > Adjustments > Hue/Saturation** and increase the saturation. We can also pull down the Curves in RBG mode, or push up Curves in CMYK mode until we get the desired effect at **Image > Adjustments > Curves**. We can also go to **Image > Adjustments > Color Balance** and boost the reds and yellows, two colors that make sunsets look spectacular.

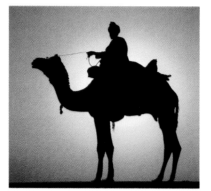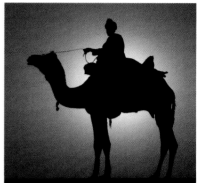

⇧ Here's a look. In the first shot, the colors are fairly dull. In the second image, I boosted the saturation. A big improvement, don't you think? In the last shot, I pulled down Curves, which increased the color saturation and made the entire image darker.

⇒ Here is another example of how to make a sunset picture more colorful. The dull shot was taken in Big Sur, California, with my camera set on Program mode. To enhance the scene, I opened the picture in Photoshop, went to **Image > Adjustments > Color Balance** and boosted the red and yellow sliders are far as they could go. (Canon EOS 1D, 28–70 mm lens set at 70 mm.)

- Red, yellow, and orange filters can help make dull sunsets and even colorful sunsets look more dramatic. However, they "color" the entire scene, which can look too artificial at times, especially when there is white sand in the foreground. So I don't really recommend them.

- **Graduated filters**, on the other hand, can help improve sunset photos. These filters are dark on the top and clear on the bottom, and they smooth out the contrast range between a bright sky and a dark foreground. Graduated filters are available in several densities, allowing you to modify the bright and dark areas of a scene for picture-perfect results. They also come in different colors (red, yellow, blue, and so on), so you add color only to the sky.

- If you don't have lens filters, try using the nik Color Efex Pro! **graduated filters** mentioned in Lesson 63, "A Tour of Plug-Ins." These filters can darken and color the sky for a much more dramatic picture.

⇒ I like to start shooting sunsets well before the sun actually sets—because I love being outside and taking pictures at that time of day. I took this shot at Big Sur about two hours before the sun dipped below the horizon. At that time, the dramatic colors of sunset had not yet begun to appear. I like the shot anyway, because the stark contrast of the scene creates a mood. Shoot during these hours and you may get some pleasing and dramatic effects.

⇒ Rather that trying to add the usually red, yellow, and orange colors that are associated with most sunsets, I thought I'd play on the natural colors of this moody seascape. This picture has a midnight mood. It was easy to create with the Midnight filter in Color Efex Pro! This filter seems to work well with a fair amount of contrast in the scene.

⇒ Continuing to play on my mood theme, I applied the Color Efex Pro! Monday Morning filter to my moody seascape. The grain, color, and softness of the filter remove some of the reality from the scene, and when you remove the reality, you immediately draw attention to an image.

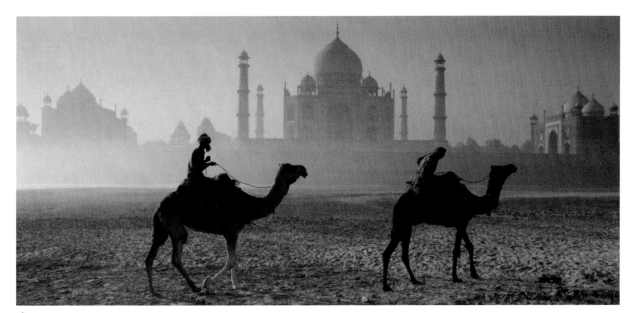

⇑ Timing plays an important role in sunrise and sunset photography—actually, in all photography. For this photograph, taken at sunrise behind the Taj Mahal, I asked the camel owners to ride back and forth about four times. I took dozens of pictures in an effort to get the camels in just the right postion in the scene.

Final tips: Don't get too caught up in the technical aspects of sunset shooting. After all, you're there to have fun! So enjoy the moment. And if your shot does not turn out the way you saw it in your "mind's eye," remember that you can enhance the colors, contrast, and exposure of your scene in Photoshop. Try to shoot sunrises or sunsets several days in a row. Each will be different and will offer quick learning opportunities.

"Don't you love it when some incredibly beautiful woman like Linda Evans or Cindy Crawford tells you that the real beauty secret is finding your inner light? No shit."
—MARIANNE WILLIAMSON

LESSON 94 — Glamour Photography

Communicate and have fun!

I'm not a professional glamour photographer. Rather than photographing beautiful men and women in fancy clothes with an art director by my side suggesting this shot and that shot, I choose to be a travel photographer capturing people in their home or work environments.

That said, I have enjoyed my few glamour shoots. One of my favorites was at a workshop in Lake Powell, Arizona, with model Karen Trella. Another was in Miami (indoors at Giovanni Studios and outdoors at South Beach) with Carolina McAllister. This lesson will use some shots from those shoots to illustrate some basic fashion photography shooting tips.

⇐ Take a look at these two photos. Both are pleasing, but notice how a more interesting pose makes for a more interesting picture. When you are working with models, explore a variety of poses. Make suggestions to your models, and take suggestions from them, too.

Both pictures were taken with a 70–200 mm zoom lens set at 200 mm with an aperture of f/5.6. With that setup, I was able to slightly blur the background behind the model.

Notice that beautiful lighting. Two assistants holding large gold reflectors on each side of Karen bounced light onto her body. **Reflectors** are essential

Reflectors and diffusers are essential.

accessories in fashion photography, as are **diffusers**, which soften harsh lighting that's falling on a subject for a more flattering effect. If you are serious about fashion photography, invest in reflectors and diffusers or in a combination reflector/diffuser kit. I have a five-in-one kit that includes a circular diffuser with zip-over black, white, silver, and gold covers that folds neatly into my camera bag and has an unfolded radius of about three feet. I use it often for my people photography.

As with all the other pictures in this lesson, I talked to my model during the entire shooting session, making posing and expression suggestions and giving positive feedback on the shoot. If you stop communicating with your subject, that will come through in the pictures.

In real estate, it's all about "location, location, location." In fashion photography, that's often the case, too. That's why we went to Lake Powell—for the fabulous scenery that made for a fantastic background. We also chose that location for the beautiful quality of light in the early morning and late afternoon.

⇑ For this picture I used a 300 mm lens. (Today I'd use my 100–400 mm lens.) Telephoto lenses and telephoto zooms are popular with fashion shooters because, when shooting at wide apertures and relatively close to the subject, the background blurs—drawing all the attention to the subject. I also shot at eye level while I was kneeling in the sand. Shooting "eye-to-eye" is also an effective technique for fashion photography. Finally, I applied nik Color Efex Pro! Midnight Blue filter to make the picture more effective.

⇐ This picture is a duotone (see Lesson 55, "Discover Duotones"). I chose to turn my color image into a duotone for the simple reason that I like experimenting in the digital darkroom. A duotone picture seemed natural in this case, For this shot, I used a 300 mm lens with an aperture of f/2.8. Because I was working very close to Carolina, the background became totally blurred.

← Fashion photography is indeed a glamorous profession. This photograph illustrates just how "glamorous" it can be!

⇊ In this behind-the-scenes shot, an assistant is blasting hot air onto Karen's face with a powerful and noisy leaf blower to get Karen's hair to look like it is blowing in the breeze. Talk about fun! To create the quality of light we wanted, another assistant is using a reflector to bounce light onto Karen's body. In addition to reflecting light, reflectors reflect heat—more fun for our model!

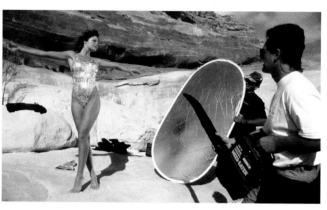

← Much of glamour photography is shot in studios, where controlling light is easier. This is one of the first pictures I took of Carolina McAllister at Giovanni Studios. I shot Carolina with my 28–70 mm lens set at 70 mm. The beautiful lighting was created with about $10,000 worth of lighting equipment. Powerful strobes inside "soft boxes" softened the light. A main light was positioned to my left, and a fill light was positioned to my right. If you don't want to invest $10,000 in studio lighting, check out Lesson 102, "Turn Your Den into a Studio." You'll see you can create some nice effects for about $600.

⇒ If you take a close look at Carolina's lips, you'll see the reflections of the lights caused by her glossy lipstick. Personally, I did not like seeing these "hot spots."

⇒ To remove the reflections, I used the Healing brush in Photoshop. After selecting the Healing brush, I clicked

on a non-glossy area of Carolina's lips while holding down the Option key on my Mac (the Alt key on Windows computers). Then I moved my brush over the hot spots and painted over them with the non-glossy area that the Healing brush picked up. (Previously I tried the Clone Stamp tool to do this, but found that the Healing brush works much better. If you don't have the Healing brush, go for the Clone tool, but be very careful about the areas you select.)

⇐ Now the hot spots are gone from Carolina's lips. You'll also notice that the picture is cropped a bit tighter, which draws us more to the model's eyes. So, play around with cropping—it may give you a result you prefer.

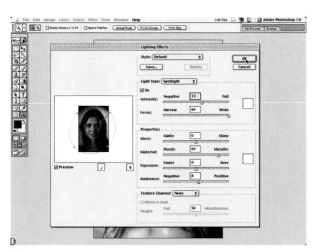

⇑ Although the lighting was wonderful in the studio, I thought I'd play around with lighting in the digital darkroom. So, I went to **Filter > Render > Lighting Effects** and selected Spotlight, one of several different lighting effects, each of which has controls for direction, intensity, etc. I liked the Spotlight effect and applied it.

⇑ Here is how the uncropped picture of Carolina looked after I applied the Spotlight effect. When you play around with the lighting effects, give yourself plenty of time to get to know how best to apply each effect.

⇒ When you work with a model, communication is very important. Most models may be great at body language, but they may not necessarily be great mind readers—any more than you may be. For this shot, I asked Carolina to lean forward just a bit, pull her hair to one side, and smile. It was her idea to put her hands in her belt loops. If you look closely, you'll see that I was actually shooting at about the same level as Carolina's belly button. Shooting from lower than eye level creates an entirely different feeling from shooting at eye level—one of superiority of the subject in this case—but avoid taking "up the nostrils" shots.

⇓ Props and backgrounds play an important role in glamour photography. Most of the time, I look for pretty props and backgrounds. But when I saw this ugly bulldozer on the beach, I knew that it would make a perfect prop—sort of like "Beauty and the Beast." I shot this picture with my 28–70 mm lens set at about 35 mm.

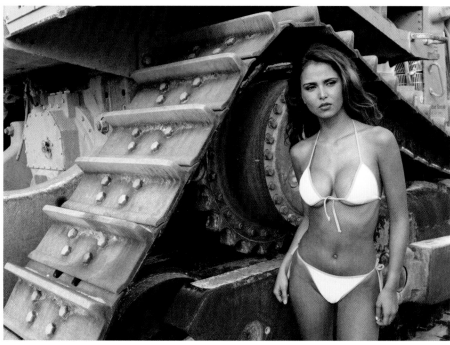

"The magic of photography is metaphysical. What you see in the photograph isn't what you saw at the time. The real skill of photography is organized visual lying." —TERENCE DONOVAN

Shooting the City at Night

Nighttime is the right time for fun and creative pictures.

Shooting a cityscape at night is vastly different from shooting the same scene during the day. Neon signs, building lights, street lamps, and the lights from passing cars—with a darker background and foreground of sky, buildings, and street—create beautiful, colorful, and magical scenes. But they are high-contrast scenes, containing extreme ranges of brightness to darkness, and require certain shooting techniques.

Here's a look at shooting the city at night. I hope these tips and techniques help you capture not only the scene you see in your camera's viewfinder, but also the exciting feeling of the original experience. After all, if a picture conveys an emotion, it's a successful photograph.

The pictures in this lesson were all taken in the South Beach neighborhood of Miami Beach, Florida, with my digital SLR and a 16–35 mm zoom lens. I set my white balance to Daylight because I like the resulting warm colors that this setting produces. If you shoot film, I recommend using daylight-balanced film. For after-sunset shots with my digital camera, I set my ISO to 400 and use a tripod to steady my camera during long exposures. To determine the correct exposure, I set my camera to the automatic Time Value mode to control shutter speeds under these conditions. I often set my Exposure Compensation to -1 because the dark areas of a scene can fool a camera's exposure meter into "thinking" that the scene is darker than it actually is, resulting in the bright lights' being overexposed. I check my exposures on my camera's LCD preview screen, which displays an overexposure warning when certain areas are overexposed.

High-end digital cameras have a noise reduction feature that removes some of the grain associated with long shutter speeds on digital cameras. Noise in a digital image is equivalent to grain in a film picture.

⇒ When I plan on taking nighttime pictures in a city, I scope out the city during the day for scenes that may make nice nighttime scenes. Spending some time during the day helps me become familiar with the city. It also lets me pick safe shooting locations, such as curbs or traffic islands in roadways.

Follow your mother's important safety advice. Always wear white at night. You want passing cars, bicycles, and skateboarders to see you when you are shooting.

This picture of the Waldorf Towers Hotel is a hand-held shot, taken shortly after sunrise with my camera set at a shutter speed of 1/25 second, and an aperture of f/11.

⇒ A good time to take nighttime pictures is actually not at night. If you shoot shortly after the sun sets, you'll get some daylight in your pictures. Daylight does two things. First, it softly illuminates the buildings so you don't have just bright lights in your pictures. Second, it adds a soft glow to the sky so you don't have a totally black sky in your pictures, as is the case well after nightfall. This picture was taken about 20 minutes after sunset with my camera set at ISO 400, shutter speed at 1/30 second, and an aperture of f/8.

Shoot in twilight to get some daylight in your image.

⇒ Here are two examples, taken around midnight, that illustrate the difference between a snapshot and a more creative shot. This first picture has very little "movement" or action, because it was taken at a shutter speed of 1/125 of a second, which can stop the action of some moving objects. But action is what South Beach is all about, and that's what I wanted to capture! The picture is also a bit too dark.

⇒ Now check out this picture, taken with a shutter speed of about 20 seconds to capture the red taillights streaking through the frame. It shouts "action!" A tripod is necessary when taking such long exposures, and I used a small aperture, f/11, to boost the depth of field.

Notice that there are no white headlights in this picture, which would have been created had any cars been heading toward my camera. That is no accident. I waited and waited and waited until no cars were coming toward me, because I wanted only red taillights in the scene. In addition, I took almost 25

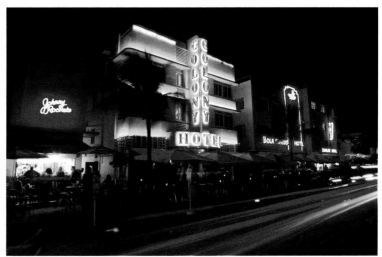

shots, at different slow shutter speeds, to find one with the effect I wanted—just the right amount of light and the right amount of streaking—the cars were moving at different speeds and the number of cars in the scene was constantly changing. This picture is also brighter than my snapshot of the same scene. That's because I lightened it by pulling up Curves from the center of the Curves grid in the RBG mode (**Image > Adjustments > Curves**).

⇒ Speaking of streaking, look at how the bright red and yellow lights in this scene stop (or start) in the middle of the scene. It looks rather strange, don't you think? For successful streaking photos, most of the lights should streak through the entire frame. Again, to get that kind of result, you need to have patience, take a lot of pictures, and watch the lights. This picture, however, does illustrate the benefit of shooting shortly after the sun has set, when there is still some light in the sky.

⇓ Here is an interesting technique. Try composing a picture so that a building is reflected in the hood or trunk of a car. Keep in mind that black cars reflect light more dramatically than white cars. For this picture of the famous Pelican Hotel, my exposure was about 20 seconds. To get everything in focus, I used an aperture of f/11. Again, I took many shots to get one I was pleased with.

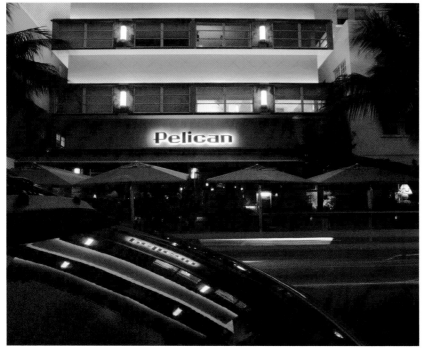

So the next time you are in a city, remember: Nighttime is the right time for fun—and creative—pictures. And remember to wear white for safety!

LESSON 96	# Shoot in the Snow

Capturing snow scenes presents its own challenges.

Winter is a wonderful time of year for outdoor sports and activities. During the winter months, children of all ages bundle up to go skiing, snowboarding, ice skating, and sleigh riding. The winter months are also a wonderful opportunity to explore and enjoy the great outdoors with your camera, especially when Mother Nature lays down a blanket of soft, white, glistening snow.

A beautiful backdrop of snow offers us interesting and creative photo opportunities, especially early and late in the day, when strong shadows add to dramatic "snowscapes." Capturing the action and beauty of snow scenes, however, presents its own set of challenges. In this lesson, we'll take at look at a few of those challenges, and how we can deal with them.

First, it's very important to keep your camera warm for as long as possible, perhaps tucked under your coat. Cold temperatures can drain a camera's battery rapidly, just as they do a car's battery. Naturally, don't leave home without a fully charged battery or two.

Next, when it's snowing, keep a plastic bag handy to protect your camera. I use a large plastic sandwich bag with an opening cut for my lens. It's a lot cheaper than professional camera protectors and it works very well.

Now to some tech talk.

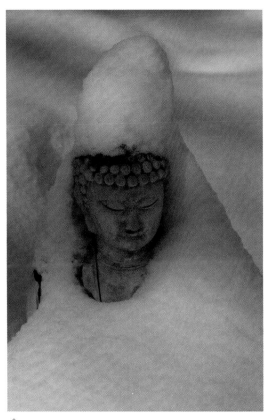
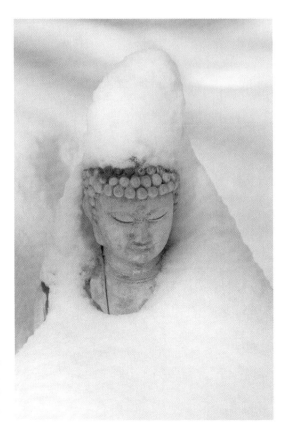

⇑ Bright snow can fool a camera's exposure meter into thinking that the scene is brighter than it actually is. That often results in an underexposed picture if you shoot in an automatic exposure mode, as I did when photographing this statue of Buddha in my yard.

↗ To compensate for the bright snow, set your camera's Exposure Compensation to +1, and bracket around that setting (see Lesson 13, "Bracketing and Spot Metering"). *Increasing* the exposure may sound backward, but that's actually what you need to do, especially when shooting slide film, which is not as forgiving of incorrect exposure as print film or a digital image sensor. For this picture I set my Exposure Compensation to + 1 1/2.

⇒ On sunny days, most snow pictures have a blue tint, because the sky acts as a giant reflector and bounces the blue color of the sky onto the snow. When using film, especially slide film, a skylight filter will reduce that blue tint. In Photoshop, you can reduce the blue tint by going to **Image > Adjustments > Color Balance** and moving the yellow/blue slider toward yellow. That's what I did on this image to get accurate color.

≫ Speaking of filters, a polarizing filter can reduce strong reflections on snow and ice; it is most effective when the sun is at a 90-degree angle to the direction in which you are pointing your lens. I used a polarizing filter to reduce the glare on this ice patch on Lake Baikal, Siberia. (See Lesson 27, "Filters for Outdoor Photography," for more information.)

⇊ When you are photographing action, such as kids zooming down a snow-covered slope, experiment with shutter speeds. Use a fast film (ISO 400), or a high ISO setting on your digital camera, to stop the action. A shutter speed of 1/500 of a second should "freeze" most action. That's the setting I used to take this shot of Marco.

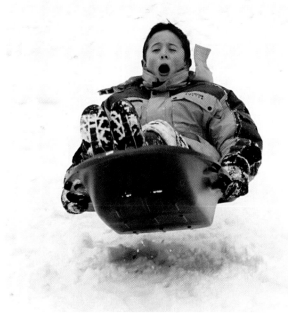

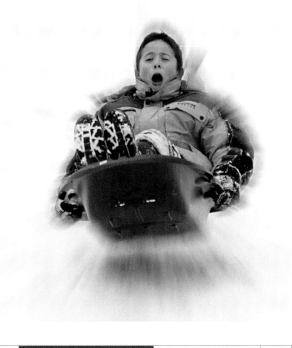

≫ To increase the action and impact of a shot, try using Photoshop's Radial Zoom Blur filter, found at **Filter > Blur > Radial Blur** and then clicking on Zoom. (See Lesson 74, "Add Action to Still Photos.") The opposite of "freezing" action is blurring action. Check out Lesson 14, "Pan to Create Motion," to learn about this technique.

Getting sharply focused pictures of fast-moving subjects can be a bit difficult. Many professional and some advanced amateur cameras offer a continuous autofocus feature that actually tracks a fast-moving subject, even when it is moving directly toward you. Before my session with Marco sledding, I set my digital SLR to AI Servo (which is what Continuous autofocus is called in Canon cameras). If your camera does not have Continuous autofocus, set your camera to manual focus, pre-focus on a predetermined area, wait for your subject to come into the frame, and shoot.

Setting your camera to motor drive and selecting a small aperture will help ensure the shot you want. For my shot of Marco airborne, I set my aperture to f/11 and took ten shots in rapid succession.

As with most of our pictures, taking them is just beginning of the photo fun. The fun (and work) continues in the digital darkroom. Here's a fun idea: Turn a sunny-day photo into a snow scene. It's easy to do in Photoshop. Here's how.

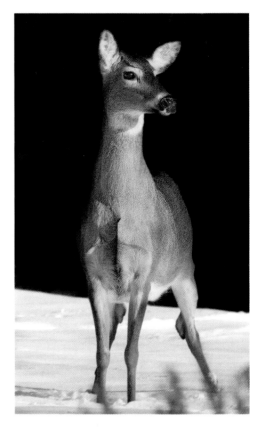

⇒ I shot this white-tailed deer in my backyard early one sunny morning with my digital SLR and 100–400 mm zoom set at 400 mm. The "warm" color of the animal and the long shadows tell us that this the photo was taken when the sun was low in the sky. (By the way, I darkened the background, which was filled with distracting branches, in Photoshop using the Burn tool, found in the Tool Bar.)

⇒ For this "snowy day" shot, I worked some Photoshop magic. First I removed the shadows using the Clone Stamp tool, found in the Tool Bar. Next I changed the tone of the picture by going to **Image > Adjustments > Color Balance** and moving the yellow/blue slider toward blue. That made the picture "cool" in color, the opposite of the "warm" colors we see on a sunny day. Next I went to **Window > Actions** and selected Blizzard. (See Lesson 64, "Special Effects with Actions," for more information.)

⇒ Take a look at some of the enhancements I made to this picture that I took of a church near my home with my Canon EOS 1D and a 17–35 mm lens set at about 24 mm.

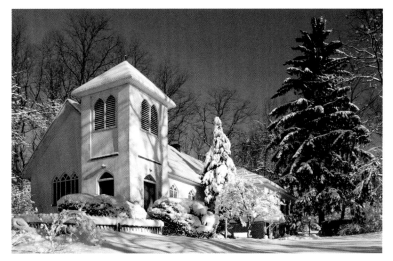

⇒ I created this black-and-white image by going to **Image > Mode > Grayscale.** That's the easiest way to get a black-and-white picture, but see Lesson 56, "Work in Black and White, Photoshop Style," for more tips on creating black-and-white images. Grayscale works well here because the scene has good contrast range.

⇒ Working with my original color image, I applied Photoshop's Stamp filter (**Filter > Sketch > Stamp**) to create this image that looks like an artist's sketch. But I was not done.

⇑ As always, I like to play around with the Fade filter after I apply a filter—I faded the Stamp filter 45%.

⇒ This image shows the result. As you can see, some of the original color is now back in the scene.

⇒ When we use the Stamp filter, we can add a tone (or tint) to a picture by selecting a new foreground color. We do that by clicking once on the Set Foreground Color box, located near the bottom of the Tool Bar, opening the Color Picker window. We then pick a color by moving the arrows on the vertical color scale up or down and then picking a color in the large, square color window. (I added the yellow arrows. You will not see them on your computer screen.)

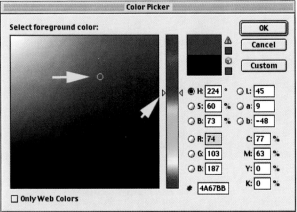

⇒ I picked a light blue color for my snowy church scene. To soften the picture, I vignetted it by selecting an area near the edge of the frame (using the Rectangular Marquee tool found in the Tool Bar) and then going to **Window > Actions > Vignette Selection > Play** (you must click the Play button at the bottom of the Actions palette in order to activate an Action).

Try some of these tricks out on your snow shots. Use your imagination to create your own unique images. Have fun, and don't forget to dress yourself and your camera warmly!

"Fun has a scared dimension." —ADRIAN DIAZ

Take the Fun Shots, Too!

Bring back memories of good times with loved ones.

This lesson is not actually a lesson, but some advice that originally came from my wife, Susan. "Take the fun shots, too," she'd say to me during our jaunts around the world.

What had I been doing? I was so focused on getting pictures for my books and newspaper and magazine articles that I wasn't bothering to take the fun shots. Now I am sorry that we don't have a file folder of snapshots from our early travels— pictures just for our own memories of what we did and saw.

These days, I take lots of fun shots—because, after all, my family matters most. What's more, I think the pictures I take of my son will be important to him in future years (see the Acknowledgments for a 45-year-old snapshot that is still important to me). Don't get caught up, as I did, in getting the best and most creative shot possible. Have fun with your photography—and with your family and friends! In years to come, you will be glad you did.

Here are few fun shots of Marco and Susan. They may not be your favorite pictures in this book, but they are some of mine.

⇐ I photographed Marco driving a go-kart at Coney Island, New York, with my 100–400 mm lens set at 400 mm. Because I set my camera to Continuous autofocus, the camera tracked Marco right up until the moment of exposure, ensuring a sharp shot.

← Several lessons in this book include pictures of Taraino Indians whom I photographed on a trip to Amazonas, Brazil. Here's a fun shot I took of Marco on the same trip. Who says you can't have family fun while on assignment?

⇑ Here's a shot I took of Susan at the Hearst Castle in San Simeon, California—or more accurately, in front of a painting of the Hearst Castle that visitors stand in front of for (you guessed it) fun shots!

⇑ Fun shots are fun to take. They bring back memories of fun times together with loved ones.

LESSON 98	# Try 3-D

Use your standard pictures in unique and unusual ways.

For creative digital photographers and artists, there are many stand-alone graphics programs that can expand one's photographic horizons. In contrast to the plug-ins for Photoshop, such as those covered in Lesson 63, stand-alone graphics programs must be launched separately. Once we open them, we import our pictures into them and get to work.

An entire book could be written on these photo-enhancement programs. I like a few, including Extensis PhotoFrame, which I used earlier to create the fancy frame around my butterfly picture in Lesson 92. But my favorite stand-alone program is Corel's Bryce 5 (originally called Bryce 3-D), because it allows us to use our pictures in 3-D landscapes, seascapes, or skyscapes that we can customize to our own vision. I chose this program to share with you for two reasons. One, I think you might like to experiment with it. Also, the program allows you to use some of your standard pictures in unique and unusual ways.

⇐ For the image I call "Predation on Planet Bryce," I created my seascape in Bryce, choosing the color and texture of the sky, clouds, and island.

Then I created the sphere in Bryce by choosing one of the program's many sphere options. All these items can be moved—in what looks like three dimensions—anywhere in the scene. The controls in the screen shot (top and left side of the screen) let you move the objects in any direction.

Next, I opened two of my pictures in Photoshop and used Photoshop's Magic Eraser to cut out the moray eel and raccoon butterfly fish. Then I imported them into Bryce where I changed their size and position about a thousand times until I found a combination I liked.

\Rightarrow Here is my final image. Those beautiful reflections you see are automatically created. Look closely and you'll see some of the island reflected in the bubble in which the butterfly fish is swimming.

To 3-D or not to 3-D, that is the question. The choice is yours.

<table>
<tr><td>LESSON 99</td><td></td></tr>
</table>

LESSON 99 | Play with Print With Preview

Dress up your prints

Photoshop's Print With Preview feature **(File > Print With Preview)** shows us how a picture will look on a sheet of paper *before* we make an inkjet print. What's more, Print With Preview offers several creative printing options.

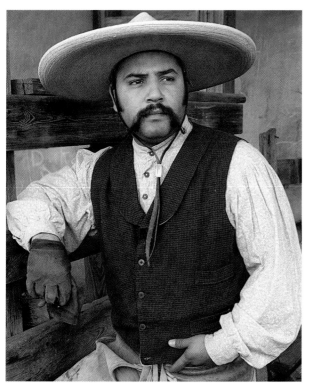

⇐ Let's take a look at some of these printing options, using a photo of a cowhand at the Ft. Worth stockyards in Ft. Worth, Texas.

⇑ In the Print With Preview window, the first thing to do is to click on **Show More Options**, indicated by the red arrow that I have added to this screen shot. If we don't do that, our only options, which are quite limited, are those that you see next to the previewed picture.

⇧ One option is to change the size (larger or smaller) of the image on the paper. We can do that by grabbing one of the "handles" at the corners of our picture and dragging it outward or inward. If you compare this image with the previous one, you can see that I enlarged the image to fill more of the page.

⇧ If we don't use Print With Preview and simply go directly to the Print option, our picture will be printed without a border. If a picture has white or light tones near the edges, it can blend in with the color of the paper, if the paper is white. In Print With Preview, we can fix that by adding a border around the image. After we click on Border, we can add a border from 1 to 10 points in size. The thin border that I added may be hard to see in this screen shot, but on an inkjet print, it makes a big difference.

⇧ Another option in Print With Preview is adding a background that fills the area surrounding our picture. When we click on Background, the Color Picker window pops up. There we can choose any color we like as our background color. (Keep in mind that color backgrounds use a lot of inkjet ink.)

⇧ After we select a background color, the area around our picture is filled in with that color, for a perhaps more creative print.

Play around with the other options in Print With Preview. They provide a nice way to "dress up" your prints.

"No one really listens to anyone else, and if you try, you'll see why."

—MIGNON MCLAUGHLIN

LESSON 100 — Automate Contact Sheets

The simple process is quite helpful.

Contact sheets, usually 8.5 × 11-inch sheets of paper on which smaller versions of pictures are printed, are useful to professional and advanced amateur photographers for several reasons. Contact sheets are an easy way to keep track of sets of pictures, especially when a sequence number and shooting data (location, date, etc.) accompany each picture. They can also be used as proof sheets when submitting work to potential photo buyers, offering a quick look at a photographer's work. And contact sheets can be used by authors who submit sets of pictures for lessons in a book, thereby making the editor's job of keeping track of the pictures easier. That's what I did for every lesson in this book. Originally, contact sheets were made by placing negatives in contact with photographic paper in the wet darkroom, exposing them to light, and processing them in several chemical baths. These days, we can produce contact reference sheets in the digital darkroom. To find the automated contact sheet feature in Photoshop, we go to **File > Automate > Contact Sheet II.**

Before the advent of automated contact sheets, there was (and still is) a digital option for making a contact sheet of sorts. After we open a picture folder on our desktop, we go to **Print > Print Window.** After clicking on the Print or OK button, we get a print with thumbnail-size (almost literally) pictures of the photos in the folder. But who would want to squint to look at those tiny pictures? Not me!

⇒ Here is a look at the Contact Sheet II window in Photoshop. I have marked four of the most important choices there with big red numbers:

1) First we need to choose the picture folder from which we want to make our contact sheet. When we click on Choose, a window (not shown) pops up that shows us the files on our computer. After we locate the appropriate folder, just as we would select any folder in our computer, we click once, and only once, on that folder to select it. If we click twice on the folder, it will open, and we will not be able to select the entire folder.

2) Next we need to set the image resolution. When e-mailing a contact sheet, set the resolution to around 80 dpi (dots per inch). For high-quality inkjet prints, use 240 dpi. For draft-quality contact sheets, set the dpi to around 150.

3) Now we can choose how we want to arrange our pictures on the contact sheet. I have set my selection at two columns in three rows. We can set the columns and rows according to the number of pictures in our picture folder in order to get them all on one sheet of paper.

4) We have a choice of including or not including file name information. We make that choice by checking or unchecking the Use Filename as Caption box. Here I have not checked the box.

⇒ Here are two examples of contact sheets, with and without file names under the pictures. As you can see, the pictures are slightly larger when a file name is not included.

After we have made all our choices, we click OK to make our contact sheet. We can then save, e-mail, and print our contact sheets. The process is really quite simple!

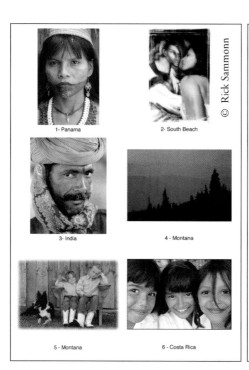

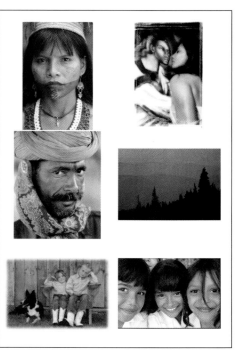

Use Photoshop's Type tool to add labels to a contact sheet.

"If the viewer does not get it, you have failed to communicate."

—ELLIOTT ERWIN

LESSON 101 | Automate Picture Packages

Produce multiple copies for friends, neighbors, and clients.

Remember when you were a kid and had your school photo taken? When the proofs were sent home, your parents had a choice of several picture packages: one 8 × 10 and two 5 × 7s, one 8 × 10 and four 4 × 5s, wallet sizes, and so on. Well, in Photoshop we can create our own picture packages, with many picture size choices, with just a few clicks of the mouse. Here is how.

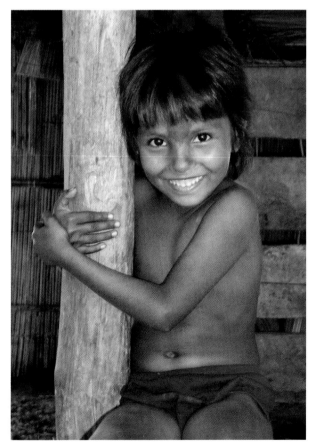

⇐ For this lesson, I'll use a shot of a little girl in a small village in Chitwan National Park, Nepal.

⇓ We get to Picture Package by going to **File > Automate > Picture Package.** Once the window opens, we have several options that are very self-explanatory. Check them out to see what each one does.

⇒ Our first choice, marked by the red arrow I have added, is Layout. This is where we choose the number of pictures we want on a page. By clicking on the up and down arrows at the end of the Layout bar, we see all the available printing options. Here I have selected two 5 × 7-inch prints on a piece of paper.

⇒ In this screen shot, you can see that I changed the Layout to four 4 × 5-inch prints.

After we have chosen our Layout and other options, including the all-important resolution (240 to 300 dpi for high-quality inkjet printing), all we have to do is click OK and our picture package is created in a matter of seconds.

Having an automated picture package with two or more pictures on the page is great. But now what do we do; cut the pictures apart with scissors? Well, we could do that. But a better method is to use a paper cutter (available in an art supply store), which provides a nice, clean straight cut. If you plan to make a lot of picture packages, I'd suggest investing in a paper cutter. And if you plan on getting into the portrait business, even as a hobby, plan to offer picture packages. They are easy to produce and will be welcomed by your friends, neighbors, or clients.

And for best results, use photo-quality inkjet paper, glossy or matte.

"Light is my inspiration, my paint and brush. It is as vital as the model herself. Profoundly significant, it caresses the essential superlative curves and lines. Light I acknowledge as the energy upon which all life on this planet depends."

—RUTH BERNHARD

Turn Your Den into a Studio

. . . and then take your studio on the road.

When we take a picture, we are recording light on a piece of film or on a digital sensor. Logically, therefore, capturing the quality of light we see is of paramount importance when we click the shutter.

But as we have seen throughout this book, light and lighting can be tricky. It can be too harsh or too soft. It can be the wrong color due to temperature, making subjects look like they are from another planet, with reddish or even greenish skin. Or light can be coming from the wrong direction, causing unflattering shadows on a subject's face or making a subject look older than he or she actually is. And, of course, there can be too little or even no light at all.

Those are a few reasons why professional portrait photographers have photo studios in which they can control light and create flattering pictures—their unique works of art.

Most photo enthusiasts who aspire to be professional photographers don't have the sophisticated lighting equipment—light source; light domes, umbrellas, and reflectors; stands, and so on—that they *think* they need for professional quality portraits. Some photographers are intimidated by the thought of setting up a complicated lighting system—not to mention the cost. Not me: I use a very basic system that I can set up in a few minutes. What's more, it's affordable, and can be set up in a relatively small space.

I use a medium Photoflex SilverDome Starlite Lighting Kit. I also use a few accessories: a Photoflex white/gold Litedisc reflector, a 4 × 8-foot piece of lightweight black or ivory-colored fabric that I buy at the local fabric store for $5, and four pushpins to attach my fabric to the top of my bookshelf.

The medium Photoflex Starlite Lighting Kit, like the other Photoflex kits, includes gear for beautifully lighted portraits: a Starlite 3200 power head, which produces continuous lighting at a color temperature of 3200K; a 500-watt lamp (a 1,000-watt lamp is also available); a silver dome with a built-in diffuser that produces a soft and pleasing effect; a Starlite connector that lets you rotate the dome 360 degrees for creative positioning; and a light stand with casters, which lets you easily roll the light source into position.

After rearranging the furniture in my den, I usually begin by setting up the power head/dome/stand to the right side of my subject. I set up the Litedisc gold reflector on a Litedisc holder and stand to the left of my subject to bounce the continuous light source onto the other side of my subject. That setup produces fairly even lighting, because light is reaching my subject from the left and the right.

For my backdrop, I attach my piece of black or ivory fabric to the top of my bookcase with pushpins. The entire setup takes about 15 minutes.

The beauty of the SilverDome Kit and all hot-light kits, in addition to the beautiful quality of light they produce, is that the light shines continuously, unlike a flash. As we move the light source around and before we take a picture, we can see the shadows and highlights on a subject's face. That's unlike a strobe system, which requires you to take a picture to see the results (if the strobe system does not have a built-in modeling light).

I used my basic system to photograph fashion designer Brooke Campbell. I photographed her with my Canon EOS D30 set to the Tungsten white balance because of the 3200K light. (If you still shoot film, I recommend using one of Kodak's tungsten-balanced films.) I set my 28–105 mm zoom lens to 105 mm, which gave me a comfortable shooting distance (about 8 feet) from Brooke.

Because Brooke was not moving around, I mounted my camera on a sturdy Bogen tripod and framed her in my viewfinder. That gave me the ability to watch her expression closely without having to squint through the camera's viewfinder during the photo session.

Our portrait session lasted about an hour. Afterward, I popped the CompactFlash card out of my camera and into my USB card reader, which was attached to my Power Macintosh G4. Brooke and I reviewed the pictures on my Mac's 20-inch monitor. Brooke picked her favorite pictures, which I printed on my inkjet printer. I also made a CD for her using Roxio Toast, the program I like best for burning CDs.

The moral of this lesson: You don't need a large photo studio filled with "tons" of expensive lighting equipment to get professional-quality results. You don't have to be a millionaire, and you don't need to live in a mansion.

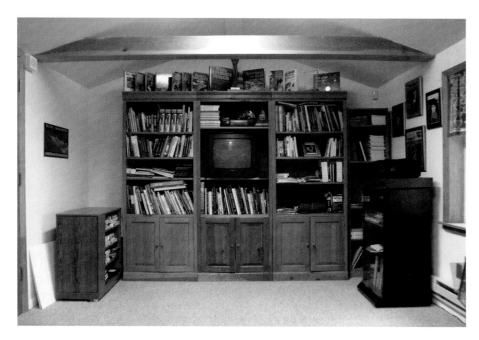

⇐ Here's how my den looked after a few chairs were moved out of the way.

For more on reflectors, see www.photoflex.com.

⇒ My Photoflex lighting system—SilverDome Starlite Lighting Kit power head (right) and gold Litedisc reflector on the Litedisc holder and stand (left)—took about 15 minutes to set up. Brooke, my subject, is doubling as my assistant. She is holding a Sekonic light meter to take an exposure reading. My goal was to get fairly even and soft illumination on both sides of Brooke's face. The reflector on the left side of the picture helped with that.

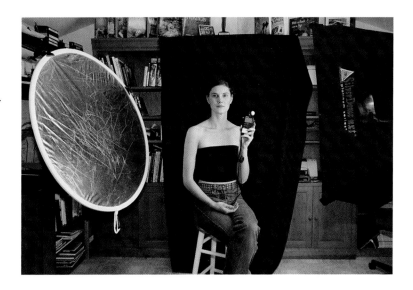

⇓ I took about 50 pictures of Brooke in the Mardi Gras mask. After each exposure, I checked the result on the camera's LCD screen. As with all my people shots, I focused on Brooke's eyes, the most important element in people pictures. This shot is my favorite. It's pretty much a straight shot. I did brighten slightly the whites of her eyes using the Dodge tool in Photoshop.

⇑ Just for fun, I photographed Brooke without the mask. Notice the fairly even—and professional—lighting my simple setup produced. Her mother loves this shot. But her hair is somewhat "lost" in the background. That's why I switched to my ivory-colored background for the next series of shots.

These next pictures illustrate the effect of shooting with only one light and without a reflector—and how moving that light just a few feet can dramatically affect a portrait. In looking at these portraits of Brooke, all taken against an ivory-colored background, notice how the background becomes darker as I move my light in an arc

from close to the camera to a position that produces sidelighting. But more important, notice the shadows on Brooke's face, and how they add a sense of depth to the pictures.

⇐ Although Brooke looks nice in this shot, the portrait falls pretty flat when it comes to lighting. That's the result of front lighting, where the light was positioned next to my camera (at about a 5 o'clock position).

⇙ Now that's more like it! Moving my light closer to Brooke's side (at about a 4 o'clock position) created **ratio lighting**, in which one side of Brooke's face is darker than the other. That type of lighting creates a more dramatic picture, with shadows and a sense of depth.

⇓ This is a digitally enhanced version of the previous photo. It's my personal favorite from Brooke's photo session, because it looks the most artistic. I created the soft and dreamy effect in Photoshop using the Midnight filter in a plug-in called nik Color Efex Pro! You can create soft-focus effects, which are nice for portraits, by using a soft-focus filter.

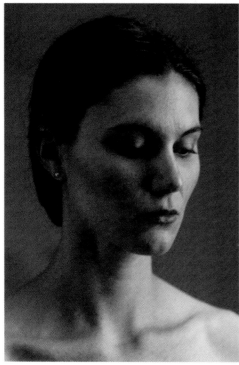
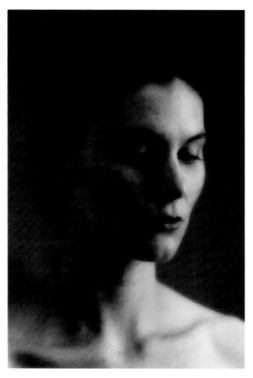

As always, I talk to my subject during the entire photo shoot— giving some direction, but mostly talking about other stuff. My goal is to make my subject feel relaxed; I don't want him or her to focus too much on the photo session.

⇑ I also take my complete Photoflex lighting kit on the road. It fits in a soft golf bag case. (I hand-carry the bulb for safekeeping.) I used the kit for this photo session at a bed and breakfast in Ft. Worth, Texas. My assistant John Costello snapped this shot of me shooting during that photo session. My other assistant, Robbie Freeman, held a gold Litedisc reflector to even out the lighting in the scene.

⇒ My lighting setup was simple for this portrait of a cowboy: main light on the left, reflector on the right. To add to the "Old West" feel of the picture, I turned my color picture into a sepia-tone picture using the Sepia Tone feature in Photoshop's Actions (**Window > Actions**).

> *"The man who goes alone can start today; but he who travels with another must wait till the other is ready, and it may be a long time before they get off."*
>
> —HENRY DAVID THOREAU

<table>
</table>

LESSON 103	**Travel Totally Digital**

What you can do if you want to go filmless on a trip.

When I have a travel assignment for Associated Press Special Features, I go totally digital, leaving my film cameras at home.

⇐ My Associated Press travel features are fun to shoot and write. The articles, which usually run in the travel sections of Sunday newspapers, are picked up all over the world. This is one "clip" of my Brazil AP article. You'll find other pictures from my Brazil and Panama "totally digital" AP trips sprinkled throughout this book.

I share this clip with you because I actually got started in photography by pitching an article on one of my trips (to Lake Baikal, Siberia) to the lifestyle editor at my local newspaper. If you go someplace interesting and get some good pictures (and of course an interesting and accurate story), why not pitch a story to your local paper? Remember: Editors need to fill up space, and they are usually interested in promoting local residents.

⇒ Here are just a few items that I carry in my traveling digital photo kit: my Macintosh iBook, my Canon EOS 1D digital SLR, my Kodak DX4900 digital point-and-shoot camera, my SanDisk USB memory card reader, and writable Memorex CD-R discs. Other items in my kit that are not shown include several SLR zoom lenses, camera and flash batteries, all of the CDs for my imaging and computer software, diagnostic CDs, my camera battery's recharger, additional 512MB camera-memory cards, a surge suppressor, and a camera cleaning kit.

Even if you don't have a professional digital camera like this 4.15-megapixel Canon EOS 1D, remember, cameras don't take pictures, people do! You can use my tips and techniques no matter what kind of digital camera you have. In fact, I pack my compact digital camera for my fun shots (and actually had some pictures taken with that camera published by the Associated Press). What's more, you don't have to go to an exotic location like Panama to test out my travel tips. Use the tips in this book anywhere you visit or even in your own town.

So let's get started. Here's how I go totally digital.

Packing Up

Going digital for the first time can be a bit scary. To reduce the "fear factor," make a checklist of all the essential items you'll want in your gear bag:

Digital camera. If you *must* come back with great shots, take along a backup digital camera. And test all of your cameras before you leave home, so you are familiar with all their controls and won't have questions about camera operation once on site. However, do take the instruction book along just in case you forget a particular camera function.

Memory cards, sticks, or CDs. Take more memory than you think you will need, even if you plan to download your pictures onto a storage device or your laptop computer each night. You never know when you'll find yourself in a situation when you want to take a "ton" of pictures.

I pack several 512MB memory cards. At the largest JPEG setting (the setting I always use) on my Canon EOS 1D, a 512MB card can hold about 200 pictures at the ISO 200 setting. (As the ISO for each image increases, the amount of memory taken up by each shot increases.)

Extra batteries and battery recharger. You may find yourself in a location where there are no convenience stores to buy batteries or no electrical outlets to plug in a recharger. Therefore, you must be self-powered, so to speak. Also, if you rely on a recharger, take a backup recharger just in case a power surge zaps your primary recharger. Of course, taking a mini surge suppressor is a good idea, too. One-socket surge suppressors are available at Radio Shack and other electronics stores.

Accessory lenses. When I travel, I like to travel light. My basic in-the-field lenses for my SLR digital are a 16–35 mm zoom, a 28–70 mm zoom, and a 70–200 mm zoom. With those three lenses, I am prepared for just about all situations.

⇒ Here's is just one shot from my AP travel feature on Brazil. That's our resort down below. I was shooting out an open window of a helicopter with my 16–35 mm zoom set at around 24 mm. (I shot at a shutter speed of 1/250 of a second to prevent blurry pictures caused by the vibration of the helicopter.) When you can't change lenses quickly, zoom lenses are the way to go!

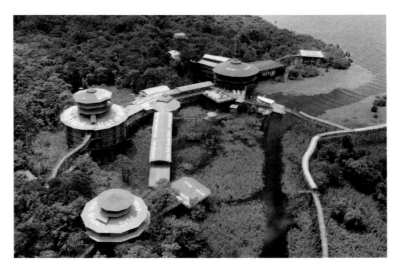

If you are shooting with a built-in zoom lens that has a limited range, add-on wide-angle and telephoto lenses will help expand your photographic horizons—not to mention the focal length range. An accessory telephoto lens will, in most cases, give you a sharper picture than a digital zoom, because the digital zoom only zooms in on part of the image captured on the camera's image sensor. So when you make a print, the pixels in your image will be larger, which makes a picture look grainy and soft. For that reason, I never use the digital zoom feature. Rather, I crop my picture in the digital darkroom, and then use a program called Genuine Fractals to increase the size of my image before printing.

Storage device. I travel with a Macintosh iBook laptop computer loaded with Adobe Photoshop. One note of caution: Pack all your computer's original software, your imaging software, and some computer diagnostic software such as Alsoft's Disk Warrior or Micromat's TechTool Pro. I've had to use all of the above on trips when my computer crashed. If you do take a laptop computer, the fastest and easiest way to get your pictures from your camera to the computer is by using a card reader with a USB or FireWire cable.

⇒ If you take a laptop computer, you may want to look into getting a hard case for protection, such as the briefcase-style cases offered by Pelican Products. If your computer gets a hard knock to its top cover, or if too much pressure is applied to the top cover, your screen could crack—as mine did when I was on assignment in China. If you open your computer and power it up, and your screen looks like this, you will know your screen is cracked. I hope you never see a scene like this!

If you don't want to lug a laptop, the Minds@Work Digital Wallet is a great

 For small storage devices, see Minds@Work Digital Wallet at www.mindsatwork.com.

way to store pictures on-line. But even if you do that, I'd recommend keeping your files on your memory card—just in case something happens to the Digital Wallet. You always want your picture files in at least two places.

Camera bag. I use Lowepro AW (all-weather) camera bags that keep my gear safe and dry, even when it's pouring rain in Panama. Choose a bag that will protect your gear and give you easy access to your camera and accessories.

Camera cleaning kit. Clean cameras give clean pictures. A lintless cloth is your best choice for cleaning your lens. And a blower brush is essential for cleaning dust and specks off the image sensor in an SLR digital camera. If you're brave, pack a digital-imaging chip cleaning kit (Sensor Swabs and Eclipse lens cleaner).

Portable printer. Canon and Olympus make small portable printers that are great for travel. If you want to make some prints on site for your subject, you may want to pack a compact printer.

Shooting On Site

Shooting with a digital camera on vacation (or assignment) has several advantages over shooting film. Mainly, you can check your camera's LCD screen to see if you've "got the shot." But those little images can be deceiving. They don't really tell you that an image is in super-sharp focus or if there is a bit of camera shake. What's more, if your LCD screen does not have a magnifying feature, you may not be able to tell if a subject's eyes are open or closed. So be sure to take some "insurance" shots of scenes you really like.

The corollary to taking "insurance" shots is to refrain from deleting pictures that you think are flops. In many cases, slightly over- or underexposed pictures can be saved in the digital darkroom. And, even if a picture is out of focus or whatever, you may be able to add a creative digital filter to salvage an image that might otherwise be lost.

When you are actually taking pictures, you have a few decisions to make about your camera settings. Here is what I recommend.

- Shoot at the highest JPEG setting (unless you shoot RAW). Keep in mind that RAW and TIFF files take much longer to write to a memory card. Even if you have a high-speed memory card, it gives you a higher writing speed only if your camera has that capability. Those extra seconds may cause you to miss a shot. Also, when you want to review a shot on your camera's LCD screen, it takes longer for RAW or TIFF files to open. Transfer time from camera to computer is also longer for those files.
- Set your white balance to match existing light conditions. Sure, you can adjust color later in the digital darkroom. But why not start with the best possible image?
- Use the LCD preview screen for composing only when necessary, as in close-up photography. The LCD screen eats up lots of battery power, so use it sparingly even to review your pictures in the field.
- Think about the ISO setting. The higher the ISO, the more noise (the digital version of film grain) you'll get in your pictures. But don't let the possibility of a lot of noise stop you from taking a picture. After all, a noisy picture is better than no picture at all. Digital noise can be reduced later by using a Photoshop-compatible plug-in such as Noise Reduction Pro in the digital darkroom.
- Make sure that your camera will not die in the field. Keep more batteries with you than you think you'll need. You just never know what picture opportunities may arise, or if you will stay out longer than anticipated.

Saving your files. Every night I download all of the day's image files via my SanDisk USB card reader to my Mac iBook, and then I burn CDs of those images. Before the sun rises the next day, I have my files saved in two places—in folders on my hard drive and on CDs, just in case my laptop quits.

After I download my images, I open some of them—among other reasons, to see if a tiny speck of dust or lint or stuff has landed on my camera's image sensor and needs to be removed before my next day of shooting. I've had to clean my camera's digital sensor on more than one occasion. You don't have to worry about cleaning the image sensor if you have a built-in zoom that can't be removed. Specks of stuff can only get onto the image sensor in digital cameras with interchangeable lenses.

I do not make any image adjustments on site. Pictures look very different on my laptop than they do on my calibrated home monitor. Hotel-room light may not be constant, as it is in my digital darkroom at home, and it dramatically affects how a picture looks.

When You Get Home

When you are back home and comfortably seated at your computer, it's time to transfer your files to your hard drive. My advice is to open each image, save it as a TIFF file (for lossless image quality) immediately, and then copy your files to another storage device. I save my trip pictures on CDs and on an external hard drive (see Lesson 36, "Choose a Computer"). Again, my pictures are saved in two places.

After my "originals" are saved. I get to work on image editing (on my color-calibrated home-computer system), never touching my originals. I usually crop and then selectively sharpen and adjust the color, contrast, and brightness of every image. By selectively, I mean adjusting only those parts of the image that need adjusting. A big mistake novice digital image-makers make is to apply adjustments to the entire image. (See Lesson 59, "Be Selective.")

Safe travels!

⇓ **P.S.** I photograph almost everything—because even the worst shot can sometimes be turned into a creative or fun shot in Photoshop. Here is a cropped section of the picture I took of my cracked screen, late at night in my hotel room in China. In Photoshop I applied the Weird Dreams filter in nik Color Efex Pro! Had I not shared my screen-cracking experience, some readers might see this photo and think that I photographed an amoeba with some type of special scientific photographic equipment. My point: Save all of your images. At a later date, you just may think of some way to turn a dull or disastrous shot into an interesting one. I took my cracked computer screen shot two years before I came upon the idea of creating my "amoeba" photo.

"A picture is worth a thousand words; a slide show is both."

—ANONYMOUS

LESSON 104 Digital Slide Shows

Create picture-perfect presentations.

I fondly remember my father's 35 mm slide shows. First, my dad would hold the pictures up to a ceiling lamp, trying to see what the heck was on the small slides so he could put them in some kind of order. Next, he would drop the slides into a tray, hoping they would all drop in place during his show—which did not always happen. Then, I'd help him set up the projector and bulky screen. Finally, he would ask me to turn off all the room lights. Seconds later, my family was transported to Venice or Istanbul, or back in time to a fun family vacation.

Some of dad's slides, inevitably, had dust spots on them; others were accidentally placed in backward. Occasionally, one or two slides would be upside down. The shows, technically speaking, were not perfect. Still, seeing the pictures on the big screen was fun—magic, back in 1962.

Slide shows have come a long way since I was a teenager. They too have gone digital—which means you can, indeed, create a picture-perfect slide show.

Several software programs are available for Mac and Windows computers that let you create slide shows on your home or portable computer. Kai's Power Show, for example, is a basic, easy-to-use program that offers more than a dozen fun transitions between slides to add pizzazz to your slide presentations. Microsoft's PowerPoint is at the other end of the spectrum. A professional presentation program packaged with Microsoft Office or sold separately, PowerPoint offers more control over how your images are presented on the screen. You can make multi-image slides (several images on one slide), complete with text and different backgrounds and color borders. Those borders and backgrounds make a big difference in how a picture stands out on the screen. I always use a black background. I select either a white border around a picture, or sometimes I use a border color complementary to the picture.

Creating clean transitions between slides in **PowerPoint** are a snap at **Slide Show > Slide Transitions.** I like to use Box Out for my transitions: the next slide appears as a tiny box in the center of the frame and gradually expands to full size.

The first step in making a computer-generated slide presentation is to get your pictures into your computer. That's easy with a transfer from a digital camera, a film

or flatbed scanner, a Picture CD, or through an on-line photofinisher (see Lesson 37, "Move Pictures into Your Computer," for more details). You don't need high-resolution images for a successful slide show. I use 7 × 10 images at 100 dpi (dots per inch).

Once you have your pictures on your hard drive, you can use a computer-imaging program, such as Photoshop, to clean up your images if they have dust spots, and turn them right side up if they were scanned upside down.

With both the slide program, such as PowerPoint, and the folder that contains your images open, the next step is to move your slide images into your slide program. With many programs, that is a drag-and-drop procedure. With others, putting slides in order is done with a few clicks of a mouse.

One of the big benefits of digital slide shows is that you can view your show in a Slide Sorter mode, much like viewing your pictures on a contact sheet. In PowerPoint, this sort mode is found at **View > Slide Sorter,** and makes it very easy to insert new pictures and delete old ones. With traditional 35 mm slides in a tray, removing or adding a single slide meant shifting every other slide by hand.

Once your slide show is completed, it can and should be saved—and shared—on a CD, DVD, accessory hard drive, or Zip disk.

Slide presentations, if done correctly, look cool on a computer monitor or even on a television set. Picture-takers who are serious about giving slide shows, however, go one step further. They present their slide shows with a digital projector, which hooks up easily to a home or portable computer. Most of my professional photographer friends show their work digitally by means of a projector connected directly to their laptop computer.

Digital projectors do not come cheap. Good ones cost anywhere from about $2,000 to $6,000—many times more than 35 mm projectors, which still do a great job projecting slides. As the brightness of the projector (measured in ANSI lumens) increases and the resolution increases, the cost increases. For example, a 1000 ANSI lumens/800 x 600 ppi projector will cost less than and not be as bright and sharp as a 2000 ANSI lumens/1024 x 768 ppi projector.

One final tip on creating digital slide shows: start and end with a black slide. That will prevent the slide projector manufacturer's logo from popping up on the screen.

In writing this lesson, I wonder what my own son, Marco, will say a few decades from now, when he looks back on the digital slide shows I'm currently producing. At that time, slide shows will probably be projected holograms from handheld organizers that double as cameras—and even that camera technology is already here.

⇐ Kai's Power Show makes it fun and easy to create a slide show. The program features a "slide strip" that shows you the order of your slides. For each slide, you can choose a different in-and-out slide effect (dissolve, wipe, etc.).

⟪ Microsoft's PowerPoint lets us create professional-looking presentations. PowerPoint lets us view pictures in several different ways, including Slide Sorter, which makes it easy to see the entire presentation at a glance and add or delete slides.

⟪ One of my goals is not to distract the audience with fancy dissolves and ever-changing backgrounds. I pick a black background and one type of dissolve (e.g., Box Out), and I use a border to make my pictures stand out against the background. Without a border, a picture, especially one with dark edges, can "get lost" in the background.

"If being an egomaniac means I believe in what I do and in my art or music, then in that respect you can call me that. . . . I believe in what I do, and I'll say it."

—JOHN LENNON

Going Freelance

Break out on your own as a freelance photographer.

I have been a full-time freelance photographer and writer since 1990. Before that, I freelanced after work, but I did not share that information with my bosses at the advertising agency at which I worked! Like my other freelancer friends, I take my job very seriously. However, I will start this article with three jokes.

Question: What's the difference between a U.S. savings bond and a freelance photographer?
Answer: A U.S. savings bond eventually matures and makes money.

Question: How does a freelancer spend his or her time?
Answer: A freelancer spends 50 percent of the time looking for work, 25 percent of the time trying to get paid, and 25 percent of the time actually working.

Question: What's the most important thing a freelance photographer needs?
Answer: A working spouse!

All three jokes ring true to a certain degree, especially for the freelancer who is starting out. As far as maturing goes, I, and most of my freelance photographer friends, are kids at heart, probably because we are always excited about what we do.

What about making money? Well, in the beginning, it was tough. But hard work pays off, and now the bills are being paid.

But enough about me! You want to know how *you* can get started as a freelancer, taking pictures, making money, and, perhaps most important, having lots of fun doing what you do!

Read. Many people ask me for recommendations for books on freelancing. Although there are great books, such as *The Photographer's Market* and *The Writer's Market,* that are filled with hundreds of listings of potential publishers (magazines, newspapers, books, stock photo agencies), I recommend a book that truly helped me. It's Wayne Dyer's book *Real Magic.* In this self-help book, one of many by Dr. Dyer, he talks about how people can create the life they want to live. Sounds wacky!

Well, I read the book and it helped me. Tremendously. It helped me get out of my suit-and-tie New York City 9-to-5 job. I believe it can help you, too.

Have a "cush." Before you leave your day job, you need what my accountant calls a "cush," or a cash cushion. If you don't have a cush, you'll be struggling to make it big right away. With a cush, you'll have more time to be creative and to market yourself creatively. I was fortunate enough to have saved a two-year cushion. Plus, I had a working spouse. Good thing, too!

Get started. Getting started is the hardest part, almost as hard as it is to stay there, because the competition is strong. I got started by sending my pictures to photography and travel magazines listed in *The Writer's Market* and *The Photographer's Market*. I got tons of rejections, but I followed the "never give up" philosophy and eventually got my work into print.

Then, I tried to get a book contract using those tear sheets. More rejections. But I stuck to it and eventually got a book contract, and another and another.

Here's my best rejection story; I share it to give you some encouragement. I had an idea for a series of six children's 3-D books on the subject of nature. I took the idea to *National Geographic*— I actually drove down from New York City to see the editor of the book division in Washington, D.C. He said, "No thank you." The next week, I took the series idea to the Nature Company. They said, "Yes, thank you . . . for bringing the idea to us." These six books were among my best-selling books.

⇒ Yes, that's me wearing a pair of the 3-D glasses that came with my 3-D children's books, co-authored with my wife, Susan. All the other books in the picture were rejected by one or more publishers before I eventually got a contract. The moral of the story: Never give up.

Assist. Many pros hire assistants to help them in the field and in the studio. The pay is not great, but consider becoming an assistant. You may even feel like you should be paying the pro, because you'll learn so much. You can contact well-known pros through their Web sites, which you can find by doing a search on google (www.google.com) or yahoo (www.yahoo.com). Locally, check out the yellow pages.

Be a good businessperson. All successful freelancers I know are excellent businesspeople. When you send out your work, it has to look as professional as possible. If you have QuarkXPress or Adobe PageMaker (desktop-publishing software programs), you can make your own letterhead and envelopes. If not, work with a printer and designer on your "look." It says a lot about who and what you are.

When it comes to getting paid, be professional in that area, too. I've found the key is to be patient. Also, when it comes to payment, some magazines have fixed rates. Others let you

negotiate. I've found that trying to establish a long-term relationship is more profitable in the end than going for the "quick bang for the buck."

Make yourself famous. This sounds funny, I know. But it is possible. Believe me, I know! One way to make yourself famous is to have big photo posters made that have your name on them. Sure, posters are expensive, but you may be able to get them for free! I did. Several years ago, I went to a printing show, met a printer, and asked if he wanted to do a trade-off: He could use a few of my photos for free if he made me 1,000 posters. He liked my pictures. Three months later, I had 1,000 Rick Sammon posters of three different varieties. In the beginning, when I sent my photographs and article ideas to magazines, I sent a poster, too. I think some of the editors figured that anyone with a poster had to know what he was doing.

⇒ I created this poster in Photoshop (the typeface is Sand). You can create your own posters and flyers as outlined in Lesson 81, "Create Flyers and Posters." Sending a publisher, editor, or art director a professional-looking poster or calling card along with your work makes a good impression.

Another way to make yourself famous is to promote yourself to as many publications as possible. The more people who see your name and the more you are published, the more "famous" you become. I do like to keep in mind, however, the sign I have on my desk: "Don't Believe Your Own PR."

Keep up with technology. Hard as it may be, you must keep up with technology. If you don't know about the latest and greatest photo gear and digital darkroom tools (and techniques), you may be left in the dust by your competition. I hope this book has helped you in that area, as well as giving you some confidence in yourself.

Make contact and get input. Each year, top pros from around the country participate in an event in Delray Beach, Florida, called FotoFusion. These pros, including myself, give seminars on freelancing and the business side of photography, as well as on the technical and aesthetic aspects of imaging. What's more, they critique portfolios of would-be freelancers.

Participate in a workshop. Photo workshops are a wonderful way to learn photo techniques. You get to rub shoulders with professionals who love to teach, and you get to see how they work. You also get to meet like-minded people—so you'll surely have a blast. I've taught workshops for *Popular Photography* and *Shutterbug* magazines and at the Maine Photographic Workshops. I've had as much fun as the students. "The teacher learns from the student" is often the case at these workshops.

You can find a workshop that is right for you by doing a Web search and typing "photo workshop" in the search window.

Take good photographs. What makes a good photograph? Well, think about what Duke Ellington said about music: "If it sounds good, it is good." The same could be said for a picture: If it looks good, it is good.

⇒ Usually, a good picture is a result of having an interest in your subject. As you can tell from the majority of pictures in this book, I enjoy photographing people. Having good pictures is the biggest key to getting published.

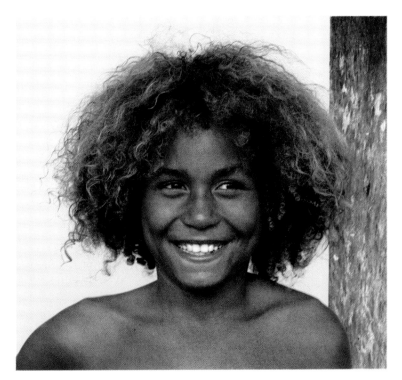

Photograph what you like and you'll like your pictures. You may want to specialize in travel, or nature, or photojournalism, and so on. I specialize in not specializing. It works for me.

Work hard to get lucky. Would-be freelance photographers tell me all the time how lucky I am to travel the world and take pictures. I respond, "The harder I work, the luckier I become." I have an office next to my house. Sometimes, I'm there at 5 A.M., working in my digital darkroom, wrapping packages, or taking out the garbage. I'm often there at 11 P.M. (and even 2 A.M., when I was working on this book), usually writing or editing my photos or sending out proposals. . . . or taking out the recycling bins.

I'm a firm believer that hard work pays off.

Never give up. I know we covered this, but it's very important. Never give up. Believe in yourself. You can be a freelancer, too. As my dad used to tell me about achieving your goals, "Even the president of the United States puts his pants on one leg at a time." My dad's point was that anyone can be anything he or she wants to be.

LESSON 106 | Make Your Own E-Book

Showcase your work in an e-book.

⇊ My first e-book, *The Camera Looks Both Ways,* features tips, tricks, and techniques for taking and making pictures. You will find it on the enclosed CD-ROM.

For some time, we have had e-mail and e-film. Now, we have e-books—books that are produced digitally and read digitally—on special e-book readers and on standard computers. Author Stephen King released one of the first e-books, which he offered exclusively on-line in serial installment format. Because it was one of the first major e-books, newspapers, magazines, and Web sites praised his effort. Other e-books have followed, and more companies are getting into the e-book business.

So, a few years back, as I was waiting at an airport with my e-ticket in hand, after reading a billboard about e-business, I started thinking: I have 20 books produced on paper. All are photography-oriented. My royalty was a few dollars per book, standard in the book publishing business. It is pretty rare to become rich from royalty income on photography books. Because my books are mostly travel-related, and traveling costs money, some books actually cost me more money to produce than they earned. Most of my photographer friends and I do not write books for the money. We do them because we are passionate about a subject and like having our work showcased in a book.

In addition, before book publishers accepted digital picture files, there was another downside to standard book publishing: I had to send my very best 35 mm slides to the

The Camera Looks Both Ways

By Rick Sammon

publisher, who in turn would send my work to a printer in Hong Kong or Singapore. Nothing was ever lost, but I did lose a few nights of sleep wondering where my one-of-a-kind pictures were.

With all that in mind, I decided to do my 21st book as an e-book, all by myself. That way, I'd have total control over everything. In addition to being the writer and photographer, I'd be the designer, publisher, and distribution house. I'd also be the accountant.

To create my e-book, I decided to use Microsoft's PowerPoint, because it is designed to handle photos and text. I set my e-book up so readers could view it as they would a slide show. I wanted my e-book to be accessible to just about everyone with a computer.

The experience creating *The Camera Looks Both Ways* was very rewarding. To view it, open the PowerPoint slide show on the CD-ROM that accompanies this book. Some of my photographer friends, such as Joe Farace, have now made their own e-books.

You can make your own e-book, too. It's a lot of fun. And maybe you can even sell a few copies. Here are the basic steps I followed in making my e-book using PowerPoint.

Step 1: The Idea

I wanted to produce a how-to book that would demonstrate a photography truism: "The camera looks both ways. In picturing the subject, we are also picturing a part of ourselves." As with any book, you need an idea before you can do anything.

Step 2: Selecting the Pictures

I spent a lot of time looking for pictures in my files that would illustrate my concept. I edited and edited and edited my selection until I had it down to about 100 pictures, which is around the number of pictures in some of my gift books. When choosing pictures for your e-book, keep in mind that no one else in the world wants to look at your entire portfolio.

Step 3: Preparation

Next I had to get the pictures into working order. Some of my pictures were already on my hard drive, scanned

from 35 mm slides or as files from my digital cameras. Others had to be scanned or transferred from a CD to my hard drive.

After I had all my images in Photoshop in my e-book folder, I had to go through the process of making them all the same size: 100 dpi at either 7 x 10 inches or 10 x 7 inches. I came up with that format so that each picture filled as much of the screen as possible when shown without any text on the page. I did this so I could use the exact same images in the exact same order as in a standard digital slide presentation at my photo workshops. I knew that in **PowerPoint**, I could easily resize each picture on each page for my e-book, so I could fit text on the page. This way, I had a dual-purpose project!

After all my pictures were the same size, I started to put them in order. To see the final order, I went to **View > Slide Sorter** (see Lesson 104).

Step 4: Setting Up the E-Book

As the designer, I had to think about the look and feel of the book. To make the pictures stand out on each page, I chose a black background for the entire e-book. Next, as a transition between each page, I chose Box Out to be different from the same old Dissolve that we see all the time (see Lesson 104).

Step 5: Pictures into PowerPoint

Getting pictures into PowerPoint, or any slide or album program, is relatively easy. Methods vary, but for PowerPoint, it's as simple as selecting **Insert New Page** and clicking on **Insert Picture**. Once the pictures were in place, I chose an outline or frame for each one, which made the picture stand out even more on the page.

Step 6: Resizing

Because I did not want every page to look the same, I experimented with varying the size of each picture. I also played around with placing the pictures in different places on the page. I knew I'd change that later, because the length of the text on each page would affect the page layout.

Step 7: Adding Text

⟹ Adding text was fun and a challenge. I know that people want information, but I also know they want to be entertained and don't have time to read "The Unabridged History of Photography" while sitting at a computer. So I tried to make the text as short, informative, and entertaining as possible. For all the how-to pages, I used white letters on a black background. For the intro page, I used blue letters on a black background. You can use lots of colors, but my advice is to use them sparingly.

All books have an editor. My dad, Robert M. Sammon, Sr., was my editor. He caught errors I never would have caught. Be sure to get someone to read each page carefully.

Tucan, Costa Rica

Step 8: Making Changes

Once my e-book was completed (well, almost), I let it sit a while. Actually, I let it sit only for a few hours at a time. I constantly changed the pages to improve the look of the book. Just as Ansel Adams said, "A print is never finished," an e-book is always a work in progress.

Step 9: Making Copies

When I was happy with my e-book, it was time to make copies. I spent hours "burning" CDs. Then, using a CD label-making kit I picked up at Office Depot, I applied to each CD a label that I had designed in QuarkXPress. Each CD was placed in a jewel case as a finishing touch. (Important note: CD labels must be circular and go around the entire CD, or the CD will be unbalanced and won't work properly.)

Step 9A: Saving Yourself Hours of Burning CDs

If you don't want to spend a lot of time making copies of your e-book, try a company called DiskDuper. For a few bucks each, they will copy and label your CDs.

Step 10: Marketing

I had to get the word out that I had an e-book, just as you will. I did this by posting an announcement on my Web site. I told everyone I knew about the project. I sent press releases to photo magazines. Slowly but surely, the word got out. As the marketer, I was also the head of the mail room. As individual orders came in, I packaged each CD, with detailed instruction on how to view it, in a padded envelope. Then I became the mail clerk, taking my orders to the post office.

Step 11: Customer Service

If you are going to be a publisher, you have to offer customer service. That means supplying your phone number and e-mail address on the packaging so people can call you with questions when they get the CD and try to use it. As always, the customer is always right.

So, the next time you are thinking about writing a book, consider an e-book. But keep in mind the Zen philosophy: Enjoy the process. You probably will not make a million dollars from your e-book, but I'm sure you will have fun turning your ideas, images, and words into an original work of art.

"I have not failed. I've just found 10,000 ways that don't work."

—Thomas Alva Edison

LESSON 107 | Lost and Found

⇊ If you think you have pictures on a memory card, this is the last message you want to see on your digital camera's LCD screen. While I was teaching a digital photography workshop with Joe Farace, three of the participants lost, or seemingly lost, their precious pictures. Here is what happened.

Photographer #1 had inserted his memory card into an inkjet printer's card reader, which lets you make prints directly from a memory card. He had selected the Contact Sheet mode on the printer, because he wanted a handy index of all his memorable shots. When the contact sheet started to print, he removed the card from the printer. When he put the card back in his camera, he got the prompt, "No Images."

Photographer #2 had made the mistake of removing the memory card from his digital camera before the writing of a picture file to the card was completed. When he put the card in his card reader, which was attached to his computer, his picture folder was empty.

In both these cases, the memory cards became corrupted.

Fortunately for these photographers, their "lost" images were recoverable using an image-recovery software program. Image-recovery programs and services are available from, among others, Lexar Media, Media Recover, Image Recover, and some camera stores. Data Rescue is another company that offers software that can restore images that were accidentally deleted from memory cards. PhotoRescue is a Mac- and Windows-compatible program that can recover "erased" photographs from SmartMedia, CompactFlash, Memory Stick, and IBM Microdrive media. The software is available only for Mac OS X and Windows 2000 and XP.

Image Rescue software for Lexar Media CompactFlash only is now commercially available at low cost. Previously, it was available only as a service through authorized professional photo dealers. Lexar's David Klenske told Joe Farace, "So long as a card is not physically damaged, Image Rescue can identify and retrieve almost any image

file. Image Rescue has been very successful in restoring lost pictures, recovering upwards of 95 percent of the images."

Photographer #3 did not fare as well. He had made the mistake of pressing the "Delete All Pictures" button on his camera without realizing it. It was the first time he had used the camera. Unfortunately, his images could not be recovered with the software at hand.

So, even when you get a "No Images" prompt on your camera, and when you see an empty picture folder on your monitor, your pictures may be recoverable.

But for picture safekeeping, always remember that you must wait until an image transfer is completed before removing a card from a camera, card reader, or printer.

A completed transfer is usually indicated by a blinking light on a card reader, printer, or camera. I never remove a card from my camera until the image record light has stopped blinking and I have turned off my camera.

Another way to protect digital pictures in your camera is to "lock" them, an option that is available on some prosumer and professional digital cameras. Once locked, even if you press "Delete All" by accident, those images will be saved.

Another option for image safekeeping is to use one of the new Secure Digital (SD) memory cards (not available for all digital cameras). Secure Digital cards feature a tiny tab that lets you lock the card so images can't be deleted.

Speaking of saving images, once your pictures are in your computer, it's essential to back up all of your "keepers." These days, I do that on a 20 GB external hard drive, because I store hundreds of high-resolution pictures. Storing pictures on a CD, DVD, or Zip disk is another option.

A closing thought: Keep in mind that if you sell or give someone a digital camera with a memory card, your pictures may still be on the card—even if your camera says "No Images."

⇈ Here's a look at what's inside a 512 MB CompactFlash card.

For more information, see Data Rescue, www.datarescue.com; Lexar Media, www.lexarmedia.com; Media Recover, www.mediarecover.com; Image Recover, www.lc-tech.com/photorecovery.asp.

> *"The limits of your language are the limits of your world."*
>
> —LUDWIG WITTGENSTEIN

Glossary

PHOTO BY BRAD MIKEL

Compiled by Joe Farace

Adjustable program: On automatic exposure cameras, a feature that lets the user change either the lens aperture or the shutter speed at the touch of a button or dial.

AI Focus AF: In cameras such as Canon's EOS 1D and D60, this is an autofocus mode that automatically switches from One-Shot AF to AI Servo AF when a subject moves.

AI Servo AF: Continuous autofocus mode with focus tracking and shutter priority, used for taking pictures of moving subjects.

Aperture: The size of the opening in the diaphragm of a lens through which light passes. Also known as an f-stop.

Aperture Priority mode: The automatic exposure mode in which the user sets the aperture and the camera automatically sets the appropriate shutter speed to produce a correct exposure. It is often used in landscape photography to produce greater depth of field by choosing small apertures.

Autofocus (AF): Automatic, motorized focusing.

Autofocus sensor: A sensor that determines where the lens is set for correct focus.

Average metering: Through-the-lens (TTL) exposure metering that takes into consideration the illumination over the entire image.

Bit (binary digit): Computers represent all data—including photographs—using the numbers 0 and 1. These numbers are called bits. *Note:* In a computer, each electronic signal is one bit; complex numbers or images are represented by combining these signals into larger, 8-bit groups called *bytes*. When 1,024 bytes are combined, you get a *kilobyte*. When you lasso 1,024 kilobytes, you have a *megabyte* (MB), usually shortened to "meg." And 1,024 megabytes are called a gigabyte (GB), or "gig."

Bit depth: See Color depth.

Bracketing: The technique of taking additional exposures that are over and under a "normal" exposure setting to ensure that a desired exposure is achieved from the several frames exposed. It is often used in tricky lighting conditions.

Bulb mode: An exposure mode that keeps the shutter open (or activated in digital cameras) for as long as the shutter release button is held down. Often used in nighttime photography for long exposures.

Byte: A combination of electronic signals into an 8-bit group.

Cable release: A cable device that allows for the remote release of the shutter. Helps prevent camera shake.

Card reader: A device for transferring pictures from a memory card into a computer.

CCD (charged coupled device) image sensor: The kind of light-gathering device used in scanners, digital cameras, and camcorders that converts the light passing through a lens into an electronic equivalent of the original image.

CD-ROM (compact disc read-only memory): A disc that resembles a music CD but can hold all kinds of digital information, including photographs.

CD-R (compact disc recordable): A CD on which you can write new data only once.

CD-RW (compact disk recordable writable): A CD on which you overwrite data many times. These disks cost more than CD-Rs.

CIELAB: A color system created by the Commission Internationale de l'Eclairage to produce a color space consisting of all visible colors. The CIELAB system, sometimes shortened to just "Lab," forms the basis for most contemporary color-matching systems and lets you convert, for example, RGB images to Lab to CMYK to produce accurate color-matching.

CMS (color management systems): Software that helps produce an accurate reproduction of your original color

photograph. A good CMS includes calibration and characterization aspects and is (mostly) software-based. CMS is used to match the color that you see on your monitor to the color from any output device, such as a printer, so that what you see on the screen is what you get as *output*. You might think of this as the last step in the WYSIWYG (what you see is what you get) process.

CMOS (complimentary metal oxide semiconductor): An alternative to the CCD (charged coupled device) imaging chips used by some digital cameras. The CMOS chip is simpler to make, so it costs less. It also uses less power than CCD chips, so it doesn't drain batteries as fast. The downside is that the chip does not perform as well as CCD imagers under low-light conditions, but recent digital SLR models from Kodak and Canon are said to have improved performance under less than ideal lighting conditions.

CMYK (cyan, magenta, yellow, and black): For printed reproduction an image is separated into varying percentages of these four colors, which is why CMYK output is called "separations". Computer printers also use CMYK dyes and inks to produce photographic-quality prints. Compare with RGB.

Coil sync cord: An extension cord for an accessory (shoe-mount) flash unit that permits off-camera flash. It allows for more creative photography, because you can control the specific direction of the light instead of producing the flat "flash-on-camera" look.

Color depth: Sometimes called "bit depth." A measurement of the number of bits of information that a pixel can store, which ultimately determines how many colors can be displayed at one time on your monitor. Also used to describe the specifications of devices such as scanners and digital cameras, as well as a characteristic of an image file.

ColorSync: A color management system (CMS) developed by Apple Computer that uses a reference color space based on the way humans see colors. ColorSync can predict the color you'll see when you send a set of RGB values to a monitor or CMYK values to a printer and will automatically adjust those values so that you'll see the same color—or as close as possible—on both devices.

Compression: A method of removing unneeded data to make a file smaller without losing any critical information or, in the case of a photographic file, image quality.

Continuous autofocus: An automatic focusing system that constantly tracks a moving subject. Useful in sports and action photography for keeping the principal subject in focus.

Contrast range: The difference in intensity between light and dark areas in a scene. High contrast scenes are difficult to expose correctly.

CPU (central processing unit): This powers your computer, although many cameras and lenses also have built-in CPU chips. Digital imagers need to have enough computing power to handle the kind, and especially size, of image they are working on. Shooting wildlife or sports is possible with a 50 mm lens, but the photographic experience will be much better—and less frustrating—when armed with a 400 or 800 mm lens. Similarly, choosing the right computer is first a matter of finding one with enough power to process digital images fast enough to minimize frustration and expedite creativity.

Daylight fill-in flash: The process of balancing the light from a flash with the available daylight.

Density range: The difference between the minimum and maximum tonal values that film or a digital camera's image sensor can register.

Depth mode: On Canon EOS cameras, a mode that lets the user take two distance readings (one of a near object and one of a far object), after which the camera sets the appropriate distance setting for maximum depth of field.

Depth of field: The distance of acceptable sharpness that is in front of and behind a specific focus point.

Diffuser: A device that diffuses, or softens, harsh sunlight for a more pleasing effect. Useful in outdoor portraiture.

Digital camera: A camera that records a picture using an image sensor (CCD or CMOS) to record images.

Digital noise: Appears as "grain" in digital image files. As a camera's ISO setting increases, digital noise also increases. Noise is also caused by slow shutter speeds in low-light conditions.

Digital sensor: The computer (imaging) chip inside a digital camera that captures an image.

Digital zoom: Not a true optical zoom lens, but rather a technique for enlarging part of the image sensor's frame. Not as sharp as an optical zoom.

Duotone: The process of adding one or more colors to a black-and-white image.

DVD: Originally this meant digital video disc, but there has been movement by some marketing mavens (although not much) to change the name to digital versatile disc. Unlike the 600+ MB capacity of CD-ROM discs, DVDs can store 4.7 GB or more on a single disc that is the same physical size. While competing formats exists for writable DVDs, this has not stopped a number of companies from installing writable DVD drives in computers or offering them as external peripherals. It is just a matter of time before the DVD format replaces *all* disc-based data media, including CD-ROMS and music CDs.

Dye-sublimation printer: A printer that applies dye from a dry ribbon onto specially treated paper. Heat from a print

head vaporizes the dye, which is transferred onto the paper to produce a true photo-quality print.

Dynamic Range: The range of f-stops that can be captured by a scanner from a print or slide; rated on a scale from 0.0 to 4.0, where 0.0 is a clean white and 4.0 is total black. Photographers may recognize these as the zones Ansel Adams called zones "IX" and "0" in his "Zone System." The maximum and minimum density values capable of being captured by a specific scanner are sometimes called dMax and dMin. If a scanner's dMin were 0.3 and its dMax were 3.5, its dynamic range would be 3.2.

EI (exposure index): The rating at which a photographer actually exposes a specific kind of film, therefore deliberately underexposing or overexposing it. This is accomplished by changing the camera's or hand-held meter's ISO film speed to reflect a number different from that recommended by the manufacturer.

E-TTL (evaluative through the lens): Flash-exposure metering used by Canon EOS film and digital cameras.

EV (exposure value): A numeric value used to describe the exposure. A variety of shutter speed and aperture combinations can produce the same exposure with a constant film speed: for example, 1/250 (of a second) + f/2 = 1/125 + f/2.8 = 1/60 + f/4 = 1/30 + f/5.6 = 1/15 + f/8, etc. *Note:* This is different from *exposure index.*

Exposure compensation: A feature found on both film and digital cameras that lets the user compensate (plus or minus) in an exposure setting in relatively small increments, such as one-half or even one-third of an f-stop to produce the desired exposure.

Exposure latitude: The contrast range that a specific type of film or digital image sensor can record.

Filter: A piece of glass or optical plastic that fits over a camera lens for a creative, protective, or corrective effect. Digital filters (Photoshop-compatible plug-ins) are also available for image enhancement and correction after a photograph has been captured.

Fixed focal-length lens: A lens with only one focal length, unlike a zoom lens which offers selectable focal lengths.

Flash extender: A device that attaches to an accessory flash that extends the flash's range. Useful in sports and wildlife photography.

Flash socket: A port on a camera that allows a cable from an off-camera flash or professional studio light to be attached.

Focal length: Measured in millimeters, the length of a lens.

Focus tracking: An automatic focusing system that tracks a moving subject. Useful in sports and action photography.

Fractal: A graphics term, originally defined by mathematician Benoit Mandelbrot, to describe a category of geometric shapes characterized by irregular shape and design and used by computer software, such as Genuine Fractals, as a mathematical model for resizing and enlarging image files.

F-stop: A measure of the size of the opening in a lens calibratred to a corresponding focal length. These numbers are typically stated as f/1.4, 2, 2.8, 5.6, 11, 16, 32, etc. Large f-stops (e.g., f/2.8) allow a lot of light to enter the camera. Smaller f-stops (e.g., f/22) allow less light to enter the camera.

Gaussian Blur: An Adobe Photoshop filter that gets its name from the fact that it maps pixel color values according to a Gaussian curve, which is typically used to represent a normal or statistically probable outcome for a random distribution of events and is often shown as a bell-shaped curve.

GIF (graphics interchange format): A compressed image file format that was originally developed by CompuServe Information Systems and is platform-independent, meaning that a GIF file created on a Macintosh is also readable by a Windows graphics program. Pronounced like the peanut butter.

Gigabyte (GB): A billion bytes or, more accurately, 1,024 megabytes.

Grain: Coarse dots that you can see in a picture. As the film's ISO increases, grain also increases.

Grayscale: A series of gray tones ranging from white to pure black. The more shades or levels of gray, the more accurately an image will look like a full-toned black-and-white photograph. Most scanners will scan from 16 to 256 gray tones. A grayscale image file is typically one-third the size of a color one.

Hot-shoe: Slot on the top of many cameras into which a portable flash unit is attached.

Icon: The little "pictures" that represent files, programs, or actions that are used in operating systems such as Macintosh OS or Microsoft Windows.

IDE (integrated drive electronics): A term to describe one kind of circuit board to control a computer's hard disk. The more commonly used current term is ATA (advanced technology attachment).

Image-editing program: A software program that allows digital photographs to be manipulated and enhanced to produce effects similar to those that could be produced in a traditional darkroom.

ImagePac: The system that Eastman Kodak uses to combine five (or six) different resolutions for the Photo CD process.

Image-writing speed: Speed at which a camera can write an image to memory card (or memory stick or CD).

In-camera exposure meter: An electronic device inside a camera that measures the reflected light level measured through the lens and helps determine the correct exposure for the film or digital imaging sensor.

Incident light meter: A hand-held light meter that measures the light falling *on* a subject.

Inkjet printer: A type of printer that sprays tiny streams of quick-drying ink onto paper to produce high-quality output. Circuits controlled by electrical impulses or heat determine exactly how much ink—and what color—to spray, creating a series of dots or lines that form a printed image.

Interlaced: Type of video signal that refreshes every *second* line of the image on a television or computer screen and then goes back to the top of the screen and refreshes the other set of lines. The average non-interlaced computer monitor refreshes its entire screen at 60 to 72 times a second (that is, 60 to 72 Hertz) but better ones refresh the screen at higher rates. Anything over 70 Hz is considered flicker-free.

Interpolated resolution: The effect of software that adds pixels to simulate higher resolution than that inherently produced by the hardware (the *optical* resolution). Scanners are measured by their optical as well as their interpolated resolution.

IS (image stabilization): Technology on Canon EOS lenses, called VR (vibration reduction) on Nikon lenses, that reduces camera shake.

ISO: Speed rating for film and equivalents (in digital cameras) that measures light sensitivity. The higher the ISO number, the greater the light sensitivity.

JPEG (Joint Photographic Experts Group): Method of compressing and storing photographic image files. JPEG was designed to discard information the eye cannot normally see and uses compression technology that breaks an image into discrete blocks of pixels, which are then divided in half until a compression ratio of from 10:1 to 100:1 is achieved. The greater the compression ratio that's produced, the greater the loss of image quality and sharpness. Unlike other compression schemes, JPEG is a "lossy" method. By comparison, the LZW compression method used in file formats such as TIFF is lossless—meaning no data is discarded during compression.

K: In the computer world, 2^{10}, or 1,024. A kilobyte (or KB) is, therefore, not 1,000 bytes but 1,024 bytes.

Landscape (mode): An image orientation that places a photograph across the wider (horizontal) side of the monitor or printer.

Layer: In image-enhancement programs (like Adobe Photoshop), one of several on-screen independent levels for creating separate—but cumulative—effects for an individual photograph. Layers can be manipulated independently and the sum of all the individual effects on each layer make up what you see as the final image.

LCD (liquid crystal display) screen: Preview panel on a digital camera that shows the photographs that have been captured, along with other data.

LED (light emitting diodes): Provide information in a camera's viewfinder, such as flash-ready and focus confirmation.

Lens flare: Hot spot in a picture that is caused by direct light hitting the front element of the lens and reflecting through all of the other glass elements in a lens.

Lens hood: A device that fits over the front of a lens to help reduce and possibly prevent lens flare.

LZW (Lempel-Ziv-Welch): A compression algorithm, currently owned by Unisys and used by Adobe Photoshop to perform lossless compression on TIFF files.

Macro lens: A lens specifically designed for close-up photography.

Manual mode: An exposure mode that requires the user to set both the shutter speed and f-stop.

Megabyte (MB): Used to describe file size. A megabyte is one million bytes of information.

Megapixel: Refers to the number of millions of pixels in a digital camera's image sensor. A 4 megapixel camera has an image sensor with 4 million pixels.

Memory card: Removable device used by digital cameras on which pictures are stored.

Metafile: A graphic file type that accommodates both vector and bit-mapped data. While metafile is more popular in the Windows environment, Apple's PICT format is also a metafile.

Metamerism: Phenomenon affecting prints made with pigment-based inks, making prints look very different depending on the color of the light source under which they are viewed. So, a print made at night in your darkened den may very well look different in your sunny office or living room, depending on the type of light source in each place. Newer high-end printers and pigmented ink produce prints that have a reduced tendency toward metamerism.

Moiré: Moiré patterns are an optical illusion caused by a conflict with the way the dots in an image are scanned and then printed. A single-pass scanner is all most people require for scanning an original photograph, but when scanning printed material, a three-pass scan (one each for red, green, and blue) will almost always remove the inevitable moiré pattern. Pronounced "mwah-RAY."

Montage: An image in which two or more different images are combined.

Motor drive sequence: Setting on a camera that allows pictures to be taken in rapid succession. Useful in situations in which there is a great deal of action.

NTSC (National Television Standards Committee): Sets the standards that apply to television and video playback on resolution, speed, and color. All television sets in the United States (and Japan too) follow the NTSC standard, and videotape and other forms of video display (such as games) meet NTSC standards.

Oversaturation: Has occurred when the colors in a picture are too vibrant and artificial.

Panning: The process of following a subject from left to right (or vice versa) in the viewfinder as it moves past the photographer. Using a slow shutter speed, the photographer takes an exposure (or several exposures) when the subject is directly in front of him or her. The result is a picture in which the background is blurred (streaked) and the subject is sharp, creating the feeling of motion and speed.

Photo CD: Eastman Kodak's proprietary digitizing process, which stores photographs onto a CD-ROM. The photo CD process can digitize images from color slides and black-and-white or color negatives; a master disc can store up to 100 high-resolution images from 35 mm film. Images on a photo CD are stored in five different file sizes (and five different resolutions).

Picture CD: A Kodak process that converts film-based images into digital files, using the JPEG format, and places them on a CD-ROM. This service can be ordered when you have your film processed by camera stores and other retail outlets.

Piezoelectric: A form of printhead design that is used by Epson in their Stylus Color family of inkjet printers. Name refers to the property of some crystals that oscillate when subjected to electrical voltage. On the other hand, *piezo-electric* (with a hyphen) technology generates electricity when applying mechanical stress.

Pixel (*picture element*): One of the thousands of colored dots of light that, when combined, produce an image on a computer screen. A digital photograph's resolution, or image quality, is measured by the width and height of the image as measured in pixels.

Plug-in: A small software application that is an "add-on" and that expands the capabilities of Photoshop or any compatible image-enhancement program.

Polarizing filter: A filter that can reduce glare on water, glass, and foliage. It can also darken a blue sky and whiten white clouds. Is not effective with metallic surfaces.

PPI (pixels per inch): See Device resolution.

Processor chip: A chip in a digital camera that processes digital information.

Program mode: An exposure mode on a camera that automatically sets both the aperture and shutter speed for a correct exposure.

RAM (random access memory): That part of your computer that temporarily stores all data while you are working on a image or a letter to Granny. Unlike a floppy disk or hard drive this data is *volatile*. If you lose power or turn off your computer, the information disappears. Most computer motherboards feature several raised metal and plastic slots that hold RAM chips in the form of DIMMs (double inline memory modules). The more RAM you have the better it is for digital-imaging work; there are economic considerations, too. As I write this, RAM is inexpensive, but like the media itself, prices can be volatile.

Red-eye. In dark conditions, an effect caused by light from a camera's flash reflecting off the blood vessels in the back of the eye. It can be reduced by making the room brighter, by using an off-camera flash, or by utilizing the red-eye reduction mode that some cameras and flashes offer.

Reflector: A device used to bounce (reflect) light onto a subject. Useful in outdoor portraiture.

Resolution: The number of dots per inch (dpi) or pixels per inch (ppi) that a computer device, such as a monitor or printer, can produce. A digital photograph's resolution, or image quality, is measured by the image's width and height as measured in pixels. The higher the resolution of an image—the more pixels it has—the better its image quality. An image with a resolution of 2,048 × 3,072 pixels per inch has better resolution and more photographic quality than the same image digitized at 128 × 192 pixels.

RGB (red, green, blue): Color monitors use red, blue, and green signals to produce all of the colors that you see on the screen. The concept is built around how these three colors of light blend together to produce all visible colors. Compare with CMYK.

Ringlight: A ring-shaped device that fits over a lens for even or ratio lighting in macro and close-up photography.

ROM (read-only memory): That memory in your computer that you can only *read* data from. It's a one-way street.

Saturation: A measurement of the amount of gray present in a color.

Selection tool: One of the most important tools found in an image-enhancement program, these allow you to highlight

or select portions of an image that will have an effect applied to them.

Self-timer: A setting on a camera that allows a delay in the release of the shutter. Useful to avoid camera shake at slow shutter speeds.

Shutter lag: The time delay between the pressing of the shutter release and the actual taking of the picture.

Shutter Priority mode: An exposure mode that lets the user choose the shutter speed while the camera automatically selects the appropriate aperture for a correct exposure.

Shutter speed: The actual length of time the shutter is open (or the digital image sensor is activated).

Skylight filter: A filter that reduces the blue cast in pictures, most noticeable when using daylight-balanced slide film. Also protects the front element of a lens from scratches and dings.

SLR (single-lens reflex): In an SLR camera, the image created by the lens is transmitted to the viewfinder via a mirror and the viewfinder image corresponds to the actual image area.

Spot metering: An in-camera metering mode that takes a reading of a small area in a scene. Useful when the subject is in a high-contrast setting.

Teleconverter: A device that fits between the lens and the camera to multiply the focal length of the lens.

Telephoto lens: A lens that, in effect, brings the subject closer. Useful in wildlife, portraiture, and sports photography.

Thumbnail: Small, low-resolution version of an original image.

TIFF (tagged image file format): A bit-mapped file format that can be any resolution and includes black-and-white or color images. TIFF files are supposed to be platform-independent, so files created on your Macintosh can (almost) always be read by any Windows graphics program.

TTL (through-the-lens): A metering system in which the camera measures the actual light entering the lens.

Unsharp mask: In Adobe Photoshop and other image-editing programs, a digital implementation of a traditional darkroom technique in which a blurred film negative is combined with the original to highlight the photograph's

edges. In digital form, it's a controllable method for sharpening an image.

URL (uniform resource locator): The address of a page on the World Wide Web. It includes the appropriate protocol, the system, path, and file name: for example, http://www.ricksammon.com/gallery/photoshopgallery. angel.jpg, where "www" is the system, "ricksammon.com/gallery/photoshopgallery" is the path, and "angel.jpg" is the file name.

Variable-output flash: A flash that lets the user control the amount of light. The intensity of light can be increased or decreased for specific effects.

Vignetting: The process in which edges of pictures are lightened or darkened.

Virtual memory: Chunk of a computer's hard disk used to store data temporarily and perform imaging calculations when not enough RAM is available. Sometimes called (by Adobe in Photoshop) a "scratch disk."

VRAM (video random access memory): In all computers, space is provided on the video card for video random access memory chips that temporarily store information that is constantly being redrawn on your monitor.

Warming polarizing filter: A filter that combines the effect of a warming filter and a polarizing filter. Often used in landscape photography.

White balance control: A feature on a digital camera that lets the user set the camera for the existing lighting conditions, such as sunny, shady, flash, florescent, and incandescent.

Wide-angle lens: A lens that takes in a wide view. Useful for landscape photography.

WYSIWYG (what you see is what you get): The ability to view text and graphics on screen in the same way that they will appear when printed. Pronounced "wizzy-wig."

Zoom: A tool found in most image-enhancement programs that lets you zoom into any photograph by clicking your mouse button. Zoom is depicted by a magnifying glass icon so often that it's often just called "magnifying glass."

Zoom-lens reflex (ZLR) camera: A digital camera with a built-in (noninterchangeable) zoom lens.

Web Sites for Image-Makers

To learn more about the companies, products, and services mentioned in this book, as well as some other useful products and services, check out these Web sites.

CAMERA MAKERS

Canon	www.canon.com
Kodak	www.kodak.com
Leica	www.leica.com
Minolta	www.minoltausa.com
Nikon	www.nikon.com
Olympus	www.olympus.com
Sony	www.sony.com

LENS COMPANY WEB SITES

Tamron	www.tamron.com
Tokina	www.thkphoto.com

PHOTO-ORGANIZING AND MANAGEMENT SOFTWARE

ACD Systems *ACDSee 4.0*	www.acdsystems.com
Apple *iPhoto*	www.apple.com
Cerious Software *ThumbsPlus*	www.cerious.com
Extensis *Portfolio*	www.extensis.com
Jasc Software *After Shot*	www.jasc.com
Microsoft *Windows XP Photo Wizard*	www.microsoft.com
Photodex *CompuPic 6.1*	www.photodex.com
Ulead Systems *Photo Explorer 7.0*	www.ulead.com

DIGITAL PROJECTORS

Canon	www.canonprojectors.com
Epson	www.epson.com

InFocus	www.infocus.com
Sony	www.sony.com
Toshiba	www.toshiba.com

REFLECTORS AND DIFFUSERS

Adorama	www.adorama.com
Bogen	www.bogenphoto.com
Photoflex	www.photoflex.com
Visual Departures	www.visualdepartures.com
F. J. Westcott	www.fjwescott.com

INKJET PAPER

Adorama	www.adorama.com
Legion Paper	www.bogenphoto.com
Epson	www.epson.com
Hewlett-Packard	www.hp.com
Kodak	www.kodak.com
Pictorico	www.pictorico.com

MAC UPDATES

New versions of Mac software	www.versiontracker.com

SITES OF OTHER COMPANIES MENTIONED IN THIS BOOK

Alsoft	www.alsoft.com
Micromat	www.micromat.com
Minds@Work	www.mindsatwork.com
nik multimedia	www.nikmultimedia.com
Noise Reduction Pro	www.theimagingfactory.com
SanDisk	www.sandisk.com

PHOTOGRAPHY WORKSHOPS

The Robert Farber Interactive Photography Workshop	www.photoworkshop.com
George Lepp Digital Workshops	www.leppinstitute.com
Maine Photographic Workshops	www.theworkshops.com
Popular Photography & Imaging Workshops	www.mentorseries.com
Rick Sammon Photography Workshops	www.ricksammon.com

"A library is a journey into the imagination."

—JERRY PINKNEY

Recommended Reading

Here are a few of my favorite books. Some can help you discover digital and film photography techniques. Others may help you discover a part of yourself— very important in any creative art.

The Art of Happiness: A Handbook for Living
DALAI LAMA AND HOWARD C. CUTLER
This book covers all the key areas of the human experience, including compassion, loneliness, friendship, love, honesty, and tolerance.
Riverhead Books

The Art of Outdoor Photography
BOYD NORTON
A comprehensive volume with outdoor-shooting techniques for the advanced amateur and professional. Chapters include "Shooting in the Boondocks of the World," "Cataloging and Filing Pictures," and "Publishing Your Work."
Voyageur Press

Basic Scanning Guide for Photographers
ROB SHEPPARD
From flatbeds to film scanners, this book covers the whole range of scanning in a highly visual guide.
Amherst Media

Beginner's Guide to Digital Imaging
ROB SHEPPARD
Everything from digital cameras and scanning to using image-processing programs and printing your image is covered in this well-illustrated text.
Amherst Media

Bird by Bird
ANNE LAMOTT
If you get overwhelmed with Photoshop or any aspects of image-making, pick up this wonderful book. It offers encouragement and inspiration for reaching one's creative goals.
Anchor

Digital Photolab: Advanced Black-and-White Techniques Using Photoshop
GEORGE SCHAUB
Covers techniques for making great black-and-white fine art and commercial prints using inkjet printers and Adobe Photoshop.
Silver Pixel Press

Examples: The Making of 40 Photographs
ANSEL ADAMS
This book, also written before the age of digital imaging, tells how 40 outstanding photographs were made. It provides inspiration and information for all photographers.
Bullfinch Press

How to Photograph in Natural Light

GEORGE SCHAUB

For photographers using film or digital cameras, this book combines how-to with visualization and appreciation to attain great outdoor images.
Stackpole Books

Perception and Imaging, 2nd edition

RICHARD D. ZAKIA

Many interesting examples on the role perception plays in image capture and critique.
Focal Press

The Photographer's Internet Handbook, 2nd edition

JOE FARACE

How photographers can get the most from the Web.
Allworth Press

Photography

HENRY HORENSTEIN AND RUSSELL HART

Essentially Photo 101, this richly illustrated text covers everything from f-stops to Photoshop, and includes both a history of photography by *New York Times* critic Vicki Goldberg and extended full-color portfolios of work by contemporary photographers.
Prentice Hall

Photography for Dummies

RUSSELL HART

In simple, nontechnical language, this best-seller explains step by step how to take extraordinary pictures with an ordinary point-and-shoot camera.
John Wiley

Photo-Imaging: A Complete Guide to Alternative Processes

JILL ENFIELD

Clear, step-by-step directions demonstrate a variety of photo-processing and digital-negative techniques from setup to final print.
Watson-Guptill

Photoshop 7 Artistry

BARRY HAYNES AND WENDY CRUMPLER

An intermediate-to-advanced reference and step-by-step example book, with a CD-ROM for photographers and artists.
New Riders/Pearson Education

The Print

ANSEL ADAMS

Written before the advent of the digital darkroom, this book offers many valuable techniques for making a photograph.
Little, Brown

Re-Engineering the Photo Studio

JOE FARACE

Bringing your photo studio into the digital age.
Allworth Press

Unconditional Life

DEEPAK CHOPRA

Discovering the power to fulfill your dreams.
Bantam

Using Your Digital Camera

GEORGE SCHAUB

A basic guide to digital photography tools and techniques aimed at those who want to enhance their digital photography experience.
Amphoto

I've saved my favorite books for last.

Oh, the Places You'll Go!

DR. SEUSS

After September 11, my friend Rob Sheppard, editor of
Outdoor Photographer and *PCPhoto*, sent me this book.
Originally a graduation speech, it offers inspiration for
all of us who want to go out and explore the world,
with or without our cameras.
Random House

Real Magic

WAYNE W. DYER

Real Magic teaches that miracles can be whatever we
would normally consider beyond our ability because of
perceived limitations. (I read this book during my
transition from an advertising/public relations
executive to a working travel photographer and writer.)
Harper Collins

"Thank you. I am not of many words, but I thank you."

—WILLIAM SHAKESPEARE

Acknowledgments

When I see Michael Jackson, Madonna, or Garth Brooks in a music video, I think about all the people who make them look good. They each have a director, a choreographer, a hair stylist, a makeup artist, a costume designer, a musical director, a camera operator, a sound engineer, a lighting director, and so on. This book, like a music video, or a film, is a collaboration of many people—people who cared about the project and about me, people who made me look good.

Leo Wiegman, my editor at W. W. Norton & Company, was the "conductor" of this book. He helped me compose the all-important outline, orchestrated all the elements that go into the production of a book, fine-tuned my copy, encouraged me along the way (something needed and much appreciated on a project of this nature), and was a good friend. Simply put, this book would not have happened had it not been for Leo. At the start of this project, Leo told me, "W. W. Norton has high standards." I made a small sign of Leo's words and kept it on my desk throughout this project. Those words helped guide me through this book. And they remind me of a quote: "If you settle for less than the best, you often get it."

Speaking of the best, Leo and I had the pleasure of working with some of the best in the publishing business during this project. Many thanks go to the book designer Rubina Yeh and especially layout artist Carole Desnoes for easy-to-read, dynamic pages; to project editor Don Rifkin, who caught mistakes I missed; to managing editor Nancy Palmquist for riding herd on the project; to media editor Seamas O'Brien for organizing the CD-ROM contents; to art director Ingsu Liu and art manager Veronika Schmidt Surla for the great cover; and to production manager Julia Druskin for maintaining a schedule despite the challenges. I am grateful for early critiques of the draft manuscript from a number of readers whose own knowledge of photography helped me shape a better book: Joseph Wiegman, Neil Ryder Hoos, Jamie Marshall, and Pete Wentz. Traci Nagle put her eagle eye to work as copy editor. And Bill Rusin, national trade sales manager at W. W. Norton and digital-photography convert, boosted our enthusiasm for the year-long book-production process.

Several members of the Sammon clan were instrumental in making this book turn out the way it did. My dad and friend, Robert M. Sammon, Sr., reviewed my text and photos before I submitted my work to Leo. His comments, edits, suggestions and encouragement helped make this book much better than it would have been. What's more, at 84, he learned about taking digital pictures and even learned Adobe Photoshop, and in the process actually caught some things I missed the first time around.

⇐ Here is a shot of my dad, which I took in 2002, posing with the Linhof 4x5 camera that he used on the popular 1950s TV program *Person to Person*. He helped me with this book, so I guess you could say he is still helping me with my homework.

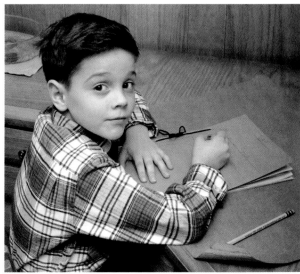

⇒ My dad is a good photographer. Here is one of my favorite shots of his. It's me doing my homework when I was about seven years old.

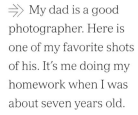

My wife, Susan, and son, Marco, also deserve a lot of credit for this book. Susan was my on-site expert assistant in Africa, Fiji, Nepal, India, Morocco, Costa Rica, Brazil, and California. At home, she was a constant source of encouragement during the project. She never bugged me when I was late for dinner, up before dawn, or working until well past midnight on this book. Marco helped me with several pictures, in front of the camera and behind the scenes. Perhaps most important, he was just Marco. Simply seeing his smiling face when I took a break from writing, selecting pictures, and Photoshopping refreshed me and gave me renewed energy to get back to work.

Joe Farace, my technical editor, Photoshop wizard, computer guru, adviser, and one my best friends, was a big help 24/7 for the duration of this project. He also contributed new ideas and useful techniques to this book. I think I may have

learned more from Joe than from any other photo pro I know. So I'll copy a similar sentiment that Joe used in the dedication of one of his many books: "Everyone should have a friend like him."

My photo assistant and friend John Costello was a big help while I was writing and taking some of the pictures for this book. His enthusiasm for photography and for helping me with my pictures is much appreciated.

My photo workshop students were, and always are, a tremendous inspiration for me. Many showed me new film and digital techniques, some of which I used in this book. During my workshops, I found an old Zen saying to be true: "The teacher learns from the student."

I've also been inspired by the pros who have taught workshops with me, especially Darrell Guline, whose affinity for wildlife and nature photography inspired me to take more landscape and wildlife pictures, and George and Grace Schaub, who have shown me the finer aspects of black-and-white photography. Fellow digital image-makers Rob Sheppard, the editor of *Outdoor Photographer* and *PCPhoto*, and Julieanne Kost of Adobe also get a big "thank you" from me. Reading their works and viewing their educational videos and CDs inspired many of the Photoshop techniques I share in this book.

Several of my friends in the photo industry have also helped me along the way. They include Rick Booth, Lou Desiderio, Russell Hart, Burt Keppler, Rudy Maschke, Terry McArdle, Michael J. McNamara, Dave Metz, Bonnie Paulk, Richard Rabinowitz, Mary Resnick, Ed Sanchez, Jamie Spritzer, Dan Steinhardt, Barry Tanenbaum, Chuck Westfall, Rudy Winston, and Mike Wong.

The CD-ROM that accompanies this book benefits tremendously from the assistance of several companies and individuals there who immediately wanted to help make the book a complete learning package: Dean Collins of Software Cinema, Josh Haftel of nik multimedia, Wendy Abeel of Extensis, Dan Leighton of Photoworkshop.com, and Amedeo Rosa of Alien Skin.

The guides whom I have met around the world also get my thanks. On many occasions they pointed out picture opportunities that I might not have seen. Three guides were especially helpful: Gilberto Galemancia in Panama, K.C. in Arizona, and Luis Magalhaes in Brazil.

Some friends also helped in a variety of ways. They include Robert Farber, Gonzalo Gonzales, Kayla Lindquist, and Tom Niccum.

If you have read this far, have not seen your name and are disappointed, I'm sorry. I'm sure I left out some people. Please forgive me— I can only claim that I'm running out of memory after compiling 1,020 pictures and writing 120,000 words for this book.

"Biography should be written by an acute enemy."

—A. J. (ARTHUR JAMES) BALFOUR

About the Author

The Complete Guide to Digital Photography is Rick Sammon's 22nd book. His other titles include *Camera Angles, Seven Underwater Wonders of the World, Rhythm of the Reef, Hide and Seek under the Sea, The Camera Looks Both Ways* (an e-book), and *Rainforest in 3-D* (one of six 3-D children's books that Rick has co-authored with his wife, Susan).

Photo by Marco Sammon.

Rick teaches photography workshops around the world for *Popular Photography and Imaging*, the Maine Photographic Workshops, Palm Beach Photographic Centre, the Lepp Institute, and eDigitalPhoto.

Rick has hosted ten episodes of the *Canon Photo Safari* (which has taken him around the world with television and movie stars) and has hosted two five-part photography series on the DIY (Do It Yourself) network: the *Digital Photography Workshop* and the *Photography Workshop*. He has shared his photographic tips on virtually every morning show in major cities across the country. Even Oprah had Rick as a guest!

Since 1990, Rick has written the weekly photography column "Camera Angles" for the Associated Press, for which he also writes travel features.

Readers of *Popular Photography and Imaging, Outdoor Photographer, PCPhoto, Shutterbug, Studio Photography & Design*, and eDigitalPhoto are familiar with Rick's writings on photography.

Rick lives in upstate New York with his wife, Susan, and son, Marco.

"Work hard, get lucky." —Chinese saying

Good Luck!

Here's an old Chinese saying passed down from generation to generation (or so I am told): Work hard, get lucky. I have found that to be true of the successful photographers I know. The harder they work, the luckier they become.

Good luck on your journey to becoming a good photographer! It's not always easy, and not always fun—especially when we are disappointed with a picture that we thought was a "keeper."

However, when everything comes together and you actually capture with your camera the scene you envisioned in your mind's eye, that's a feeling that can't be beat. You are an artist—someone who sees the world in a unique way.

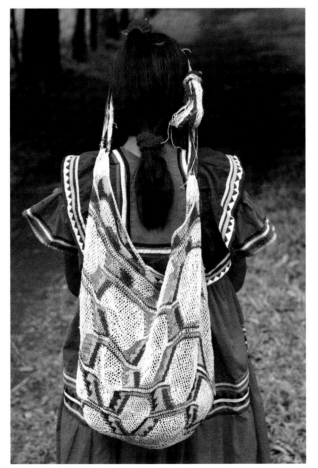

≪ A Ngabe-Bugle woman in Panama wearing a chacara, a hand-woven bag sturdy enough to carry a load of farm produce or even a load of bricks. She is walking along the same path that she takes every day to walk from her home to the planting fields—a three-mile walk. This particular part of the path is smooth; others are more difficult to maneuver. Learning photography takes a similar path: some parts are smooth, others are more challenging. The key is to keep on going—and to never, never give up.

Index